Henry Moore

Sculpting the 20th Century

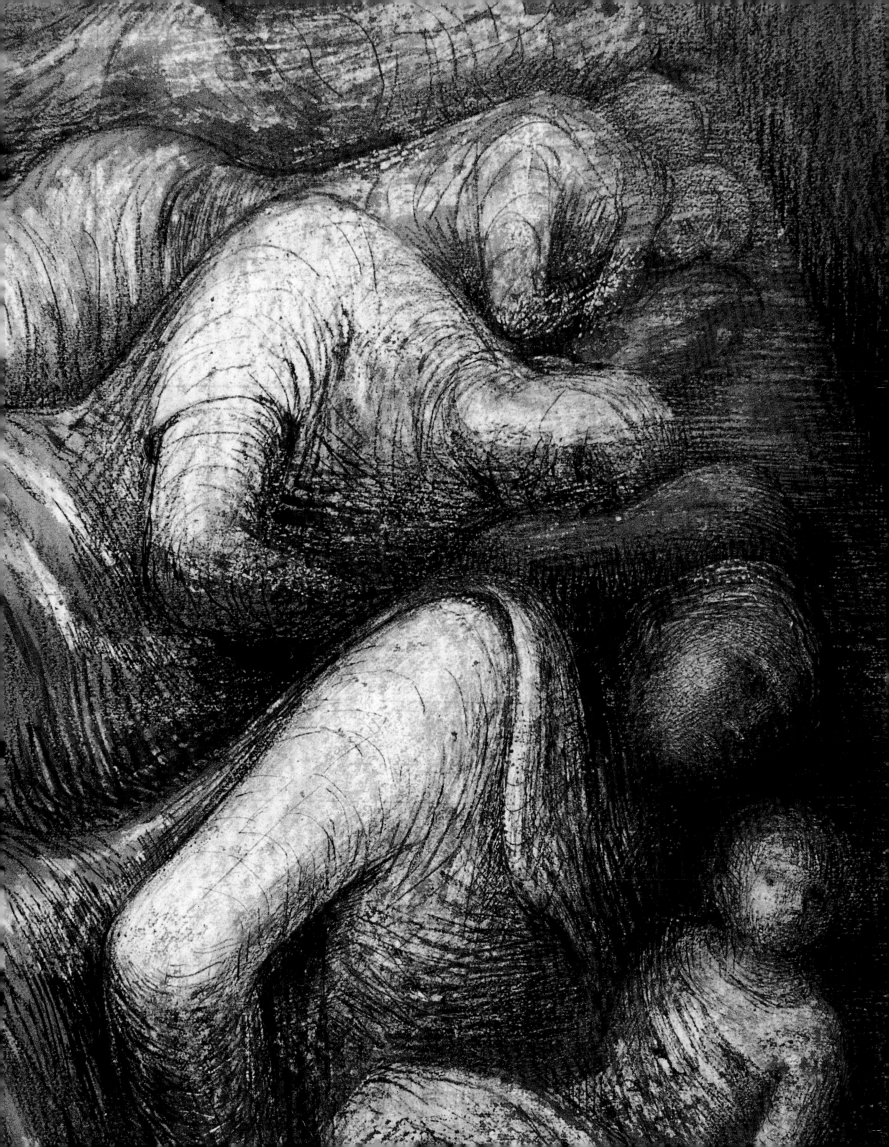

Henry Moore

Sculpting the 20th Century

Dorothy Kosinski

Contributions by

Julian Andrews

Anita Feldman Bennet

Elizabeth Brown

David Cohen

Steven A. Nash

Harriet F. Senie

Alan Wilkinson

With an illustrated chronology compiled by

Gail Davitt

Eik Kahng

Jed Morse

And a photographic essay by

Tom Jenkins

Dallas Museum of Art

Yale University Press New Haven and London

Note to the reader

The following abbreviations are used throughout this catalogue:

LH=*Henry Moore: Complete Sculpture,* 6 vols., London: Lund Humphries Publishers Ltd., 1944–88.

HMF=*Henry Moore: Complete Drawings,* 4 vols. to date, London: The Henry Moore Foundation in association with Lund Humphries Publishers, 1994–96. (Vols. 3 and 4 are forthcoming; 6 vols. are planned.)

CGM=*Henry Moore: Catalogue of Graphic Work,* vols. 1 and 2 (Gérald Cramer, Alistair Grant, David Mitchinson), Geneva: Gérald Cramer, 1973 and 1976; vols. 3 and 4 (Patrick Cramer, Alistair Grant, David Mitchinson), Geneva: Patrick Cramer, 1980 and 1986.

A complete bibliography is available: *Henry Moore: Bibliography,* 1898–1991, 5 vols., Much Hadham: The Henry Moore Foundation, 1992–94.

Henry Moore, Sculpting the 20th Century is organized by the Dallas Museum of Art with the generous collaboration of the Henry Moore Foundation.

Lead sponsorship is provided by The Dallas Foundation. Major corporate sponsorship is provided by TXU Electric and Texas Instruments. The exhibition installation and related programming are generously supported by the Dallas Museum of Art League.

Exhibition Itinerary

Dallas Museum of Art
February 25–May 27, 2001

Fine Arts Museums of San Francisco
June 24–September 16, 2001

National Gallery of Art, Washington, D.C.
October 21, 2001–January 27, 2002

Curatorial team: Dorothy Kosinski, the Barbara Thomas Lemmon Curator of European Art, Dallas Museum of Art; David Mitchinson, Head of Collections and Exhibitions, The Henry Moore Foundation; Anita Feldman Bennet, Curator, The Henry Moore Foundation

DMA Managing Editor: Debra Wittrup

Assistant Curator of European Art: Eik Kahng

Curatorial Assistant: Jed Morse

Publications Assistant: Catherine Proctor

Visual Resources Manager: Rita Lasater

Distributed by Yale University Press

Library of Congress Cataloging-in-Publication Data

Kosinski, Dorothy M.
 Henry Moore, sculpting the 20th century / Dorothy M. Kosinski with contributions by Julian Andrews . . . [et al.].
 p. cm.
 Exhibition itinerary : Dallas Museum of Art, Feb. 25–May 27, 2001, Fine Arts Museums of San Francisco, June 24–Sept. 16, 2001, National Gallery of Art, Washington, D.C., Oct. 21, 2001–Jan. 27, 2002.
 Includes bibliographical references and index.
 ISBN 0-300-08992-9
 1. Moore, Henry, 1898– .–Exhibitions. I. Andrews, Julian. II. Dallas Museum of Art. III. Fine Arts Museums of San Francisco. IV. National Gallery of Art (U.S.) V. Title.
N6797.M5 A4 2001
730'.92–dc21 00-065687

Frontispiece: *Row of Sleepers,* 1941. The British Council.

Edited by Wendy Wipprecht

Proofread by Jennifer Harris

Index by Bonny McLaughlin

Designed by Ed Marquand with assistance by Vivian Larkins

Typeset by Jennifer Sugden in Berthold Akzidenz Grotesk

Produced by Marquand Books, Inc., Seattle
 www.marquand.com

Printed and bound by CS Graphics Pte., Ltd., Singapore

Contents

Lenders to the Exhibition

Dr. M. Alali

Albright-Knox Art Gallery, Buffalo, New York

Art Gallery of Ontario, Toronto

Arts Council Collection, Hayward Gallery, London

The British Council, London

The British Museum, London

Trustees of the Cecil Higgins Art Gallery, Bedford, England

Richard C. Colton, Jr.

Mr. and Mrs. William Allen Custard

Dallas Museum of Art

The Detroit Institute of Arts

Fine Arts Museums of San Francisco

Aaron I. Fleischman

Fogg Art Museum, Harvard University Art Museums, Cambridge, Massachusetts

Robin Quist Gates

The Henry Moore Foundation, Much Hadham, England

High Museum of Art, Atlanta

Hirshhorn Museum and Sculpture Garden, Smithsonian Institution, Washington, D.C.

The Hunt Museum, Limerick

Imperial War Museum, London

Indiana University Art Museum, Bloomington

Ivor Braka Limited, London

King's College, Cambridge (Keynes Collection)

Kröller-Müller Museum, Otterlo, The Netherlands

Leeds Museums and Galleries (City Art Gallery), England

Modern Art Museum of Fort Worth

The Moore Danowski Trust

The Museum of Modern Art, New York

National Gallery of Art, Washington, D.C.

National Gallery of Canada, Ottawa

The National Trust, Willow Road, London

The Patsy R. and Raymond D. Nasher Collection, Dallas, Texas

Philadelphia Museum of Art

The Phillips Collection, Washington, D.C.

Portland Art Museum, Portland, Oregon

San Francisco Museum of Modern Art

Santa Barbara Museum of Art

Scottish National Gallery of Modern Art, Edinburgh

Tate, London

University of Michigan Museum of Art, Ann Arbor

Wadsworth Atheneum, Hartford, Connecticut

Wakefield Museums and Arts (City Art Gallery), England

Yale Center for British Art, New Haven

And the generous lenders who wished to remain anonymous.

Sponsors of the Exhibition

Organized by the Dallas Museum of Art
with the generous collaboration of
The Henry Moore Foundation

Lead sponsorship is provided by
**The Jean Baptiste "Tad" Adoue III Fund of
The Dallas Foundation**

Major corporate sponsorship is provided by
TXU Electric and **Texas Instruments**

The exhibition installation and related programming
at the DMA are generously supported by the
Dallas Museum of Art League

Director's Foreword

Henry Moore, Sculpting the 20th Century is the first major exhibition of the artist's work to appear in the United States in nearly twenty years. Given this relatively long hiatus in full-scale presentations of Moore's achievements, we took it upon ourselves to critically evaluate the long and distinguished career of an artist who is widely acclaimed as one of the twentieth century's greatest sculptors, yet has not recently enjoyed commensurate approbation in the worlds of contemporary criticism and contemporary art. This contradiction is at the center of the conceptualization of this project, one that aspires to reframe Moore's reputation and afford a better understanding of his undeniably crucial contribution to the art of the century immediately past. Particular attention has been given to Moore's role in the advancement of modernism; to the history of his critical reception, especially as his growing popularity shifted perception of the artist from "radical" to "mainstream," and from private to public figure; and to the part public art projects played in shaping the artist's career in the decades following World War II. In its retrospective form, the project presents the work of one of the major masters of twentieth-century sculpture through examination of a long career that spanned seven decades, from the twenties to the eighties. We see Moore evolve from the relative obscurity of an emerging radical modernist movement in Britain immediately following World War I, to a prominent role as an innovative member of the between-the-wars European avant-garde, to his engagement as an Official War Artist during World War II, and, finally, to his grand presence as a major cultural figure and outright celebrity during the final four decades of his life.

Henry Moore is a particularly appropriate initiative of the Dallas Museum of Art, an institution possessing a rich history and a strong present-day commitment to modern and contemporary art, both powerfully reinforced by the imminent inauguration of the Nasher Sculpture Center, designed by the architect Renzo Piano and the landscape architect Peter Walker and developed with the vision and beneficence of Raymond Nasher and The Nasher Foundation on a site contiguous to the Museum. There will be displayed the Patsy R. and Raymond D. Nasher Collection, widely regarded as the finest collection of modern sculpture in private hands anywhere. The prospect of the Nasher Sculpture Center joining the Museum in a vibrant visual arts partnership in the Dallas Arts District has offered us a special incentive to develop an ongoing dialogue with our new institutional neighbor, with which we share a dedication to fostering a deeper understanding of modern sculpture. The Museum will work within the broader context of the art of the modern era, and we regard *Henry Moore* as our initial contribution to this discourse. Its installation, both in the galleries and the Museum's own sculpture garden, is enhanced by the handsome spaces designed by the architect Edward Larrabee Barnes and the landscape architect Daniel Kiley that are exceptionally sympathetic to modern sculpture.

We offer great thanks to Dorothy Kosinski, the Museum's Barbara Thomas Lemmon Curator of European Art and head of liaison in matters related to scholarly and artistic collaborations with the Nasher Sculpture Center, for having conceived and directed *Henry Moore* and for her instrumental role in its splendid realization. She was joined in the role of co-curator by David Mitchinson, Head of Collections and Exhibitions at The Henry Moore Foundation. It was they, in association with Anita Feldman Bennet, Curator of The Henry Moore Foundation, who collaborated on the careful selection of the works populating this exhibition. We thank both of our British colleagues heartily and wish to make special mention of how much Mr. Mitchinson's decades-long personal knowledge of Moore and his works has enriched this project. I extend our profound gratitude to The Henry Moore Foundation and its Director, Timothy Llewellyn. The Foundation has been exceptionally forthcoming with expertise, personnel, technical assistance, and photographic and archival materials. At the Foundation we offer individual thanks to Margaret Reid, Assistant Curator; Janet Iliffe, Personal Assistant to the Head of Collections and Exhibitions; Emma Stower, Picture Researcher; Martin Davis, Information Manager; Robin Airey, Registrar; James Copper, John Farnham, Michel Muller, and Malcolm Woodward, Conservators and Geoff Robinson, Foreman. Indeed, the word "extraordinary" would be insufficient to describe the benevolence of The Henry Moore Foundation in collaborating with us on this project.

We also thank the artist's daughter, Mary Moore, for her intense interest and generous help in accomplishing this exhibition. People in the North Texas region hold great fondness for her, as they do for her father, whom the Dallas community came to know during his work on his commission for the city's most important municipal edifice. This special relationship is clearly evident in the many important works not only in the DMA's collection but also in private and institutional collections in Dallas–Fort Worth. Moore showed his appreciation of Dallas by making an important plaster, *Reclining Mother and Child*, 1974–76, part of our Museum's collection by means of a permanent loan from his Foundation. We are grateful, as well, to Ms. Moore's children and to the Moore Danowski Trust for their generous loans to the exhibition.

In Dallas the seminal force in bringing this project to fruition is The Dallas Foundation and its able, energetic, and enthusiastic Executive Director, Mary Jalonick. The Dallas Foundation's engagement with Henry Moore dates back to 1993 when it committed funds from the

Jean Baptiste "Tad" Adoue III Fund for the restoration of the *Three Forms Vertebrae* ("The Dallas Piece"). This monumental work by Moore had been selected by his friend, the architect I. M. Pei, to grace the plaza in front of the admirable, Pei-designed Dallas City Hall. Subsequently, The Dallas Foundation awarded additional resources from the Adoue Fund for the restoration of the "The Dallas Piece." Meticulously restored by conservators from the Henry Moore Foundation, the sculpture was rededicated in 1997, a renewed symbol of civic pride in our city. The Dallas Foundation was a forceful catalyst in the development of *Henry Moore,* making a major grant to the Museum for this exhibition and claiming the role of lead sponsor. Four successive chairmen of The Dallas Foundation Board of Governors, George R. Schrader, Caren H. Prothro, Ruben E. Esquivel, and the current Chairman, Erle Nye, have actively supported the Foundation's engagement with the project.

We warmly thank as well our major corporate sponsors. TXU Electric and Texas Instruments have stepped forward with major grants in support of the exhibition and its attendant publication and programs. We are grateful for the enthusiastic support of Erle Nye, Chairman of the Board and Chief Executive Officer of TXU Electric. We are very thankful for the engagement of Elwin L. Skiles, Jr., Senior Vice President, Texas Instruments, who serves as a Trustee of the Dallas Museum of Art, and Ann Pomykal, Director, Public Affairs and Contributions Manager, Texas Instruments.

The Dallas Museum of Art League is a highly important supporter of this undertaking and has very kindly designated funds derived from the Beaux Arts Ball 2000 benefit to support *Henry Moore, Sculpting the 20th Century.* We would in particular like to thank: Carol Resnick, Past President of the Dallas Museum of Art League, Cynthia Mitchell, President; Brooke Aldridge, "Icons of 20th Century Art & Design": Beaux Arts Ball 2000 Chair and the dedicated Ball volunteers she led; and the membership of the DMA League.

The exhibition has received further significant support from the Museum's Chairman's Circle: Linda and Bob Chilton, Adelyn and Edmund Hoffman, Barbara Thomas Lemmon, Joan and Irvin Levy, The Edward and Betty Marcus Foundation, Cindy and Howard E. Rachofsky, Deedie and Rusty Rose, and Mr. and Mrs. Charles E. Seay. I extend the Museum's deep appreciation to each of these benefactors for making possible the exhibition, its publication, and its interpretive programming.

Dr. Kosinski has engaged an outstanding group of scholars as authors in the catalogue, each offering unique perspectives on Moore's career. We are very grateful for the contributions of Julian Andrews, Anita Feldman Bennet, Elizabeth Brown, David Cohen, Steven A. Nash, Harriet F. Senie, and Alan Wilkinson. Gail Davitt, Head of School Programs and Gallery Interpretation, Eik Kahng, Assistant Curator of European Art, and Jed Morse, Curatorial Assistant at the DMA, assembled a richly illustrated contextualizing chronology. Tom Jenkins has afforded his talents to our publication with a photographic essay on "The Dallas Piece." We would also like to thank Valerie J. Fletcher, Curator of Sculpture at the Hirshhorn Museum and Sculpture Garden, for her invaluable assistance with the catalogue. The publication was copyedited by Wendy Wipprecht, designed and produced by Marquand Books, and copublished with Yale University Press, whose efforts we greatly appreciate.

We are very happy that this exhibition will be shown at the Fine Arts Museums of San Francisco's California Palace of the Legion of Honor and at the National Gallery of Art, Washington, D.C. I thank these Museums' respective Directors, my colleagues Harry S. Parker III and Earl A. Powell III, for their institutions' participation in this undertaking. The engagement of Steven A. Nash, Associate Director and Chief Curator at the Fine Arts Museums of San Francisco, and Jeffrey Weiss, Curator of Modern and Contemporary Art at the National Gallery of Art, has especially helped to make this project a success.

On behalf of Dr. Kosinski we wish to acknowledge the many other American and international colleagues and friends from across the globe who have assisted her in the research and compilation of this exhibition project, among them particularly: Douglas Baxter, Susan Ferleger Brades, Ivor Braka, Stephen Cadwalader, Martha Chawner, Linda Downs, David Finn, Kathe Hodgson, Jim Landman, James Mayor, Jason McCoy, Margaret McDermott, Mary Moore, Jim Murray, Raymond D. Nasher, Sandy Nairne, Michael Parke-Taylor, Vas Prabhu, Caren Prothro, Frank Ribelin, Laura Rivers, Deedie Rose, Nicholas Serota, Dodge Thompson, and Alice Whelihan.

A project of this magnitude and complexity is a vast collaborative endeavor. I wish to acknowledge the many Dallas Museum of Art staff members who have contributed in special ways to the success of *Henry Moore, Sculpting the 20th Century* with particular mention of Curatorial Assistant Jed Morse, whose endeavors in assisting Dr. Kosinski in every aspect of this exhibition's preparation have been tireless; Gail Davitt, who has worked closely with the curatorial team, including Eik Kahng, honing the concept of the project and guiding its presentation and interpretation; Gabriella Truly and Debra Wittrup, who have shepherded this venture through all technical aspects of its organization; newly arrived Deputy Director Bonnie Pitman, who provided important guidance just as the project was coming to crystallization; and Jacqui Allen, Carolyn Bess, Giselle Castro-Brightenburg, Judy Conner, Robin Davis, Diana Duke Duncan, Brad Flowers, Ellen Key, Carl Hardin, Rita Lasater, Mary Leonard, Michael Mazurek, Amy Owen, Debra Phares, Catherine Proctor, Leslie Ureña, Charles Venable, and Kathy Walsh-Piper.

We are deeply grateful to the lenders to *Henry Moore, Sculpting the 20th Century,* those listed in this publication as well as those who wish to remain anonymous, for their generous willingness to share their works of art with the audiences that will experience and enjoy this exhibition in Dallas, San Francisco, and Washington.

John R. Lane
The Eugene McDermott Director
Dallas Museum of Art

Compiled by Elizabeth Brown

Moore Photographs Moore

At many points in his career, Henry Moore photographed his own work. This photo essay features *Reclining Figure,* details (LH 263); *Family Group,* detail (cat. 52); *Reclining Figure: Festival,* details (cat. 55); plaster *Upright Internal/External Form,* and detail (LH 296); elmwood *Upright Internal/External Form,* detail (LH 297); bronze *Reclining Figure: External Form* (LH 299); *Reclining Figure: Internal/External Form,* detail (LH 299).

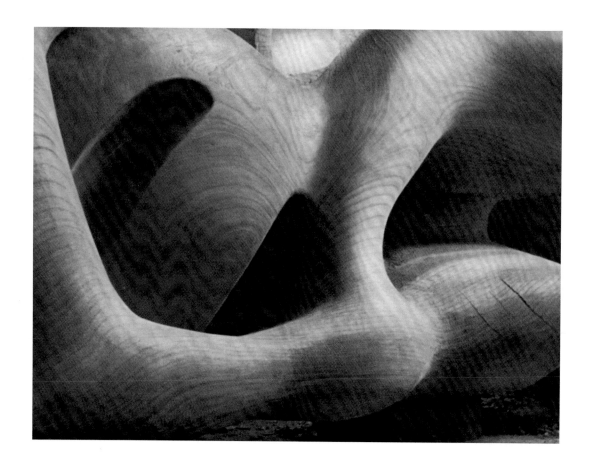

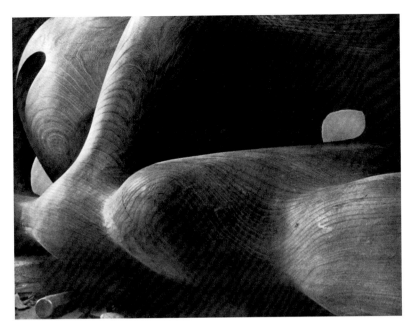

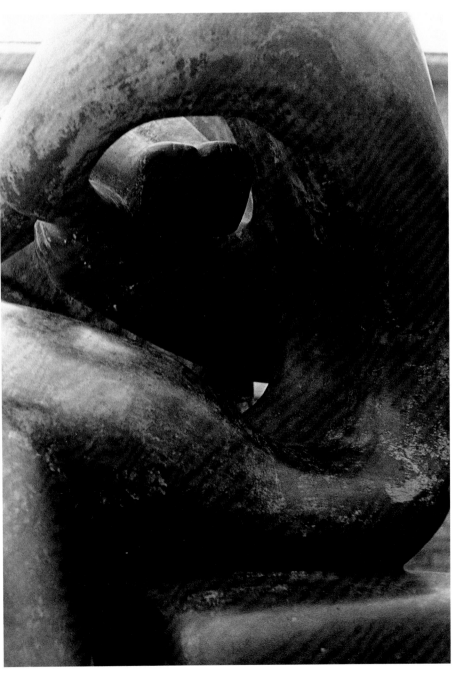

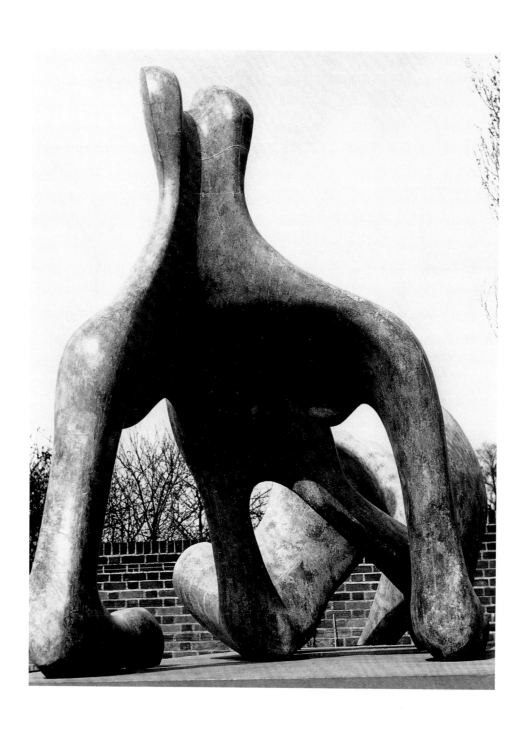

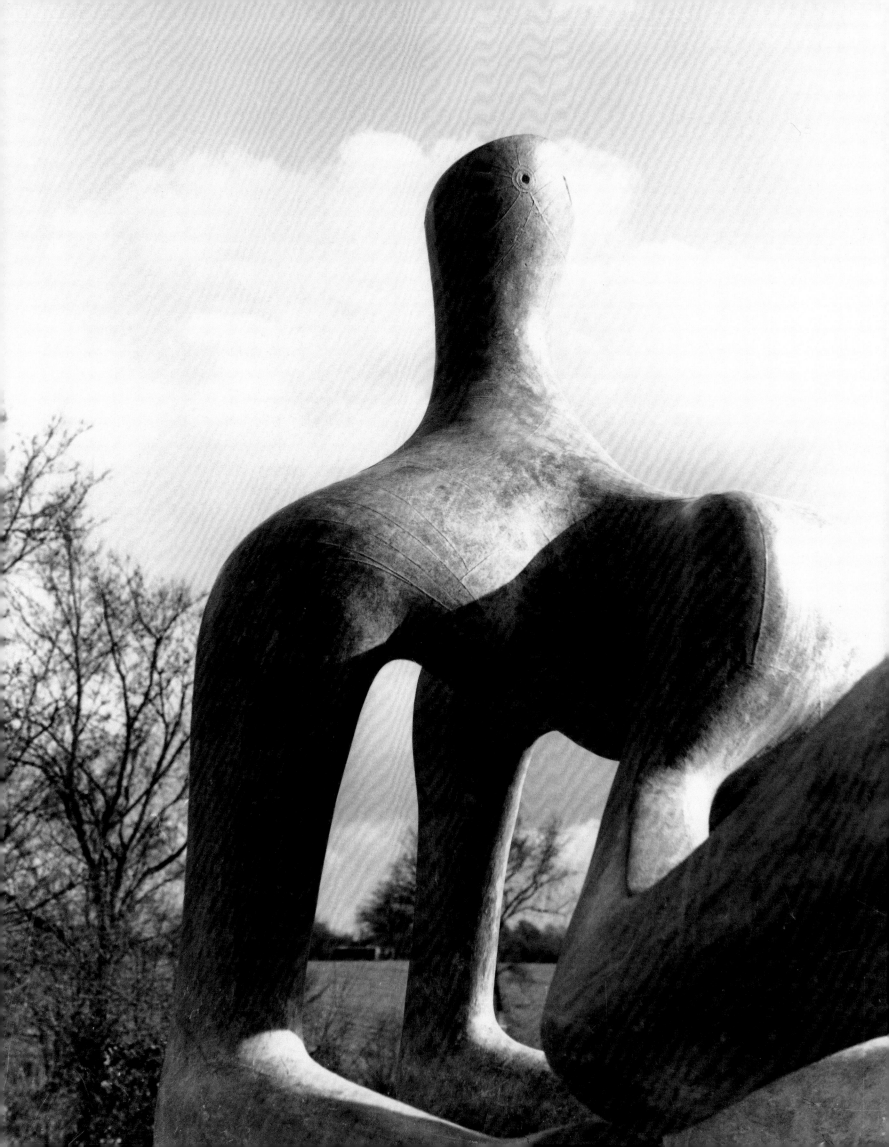

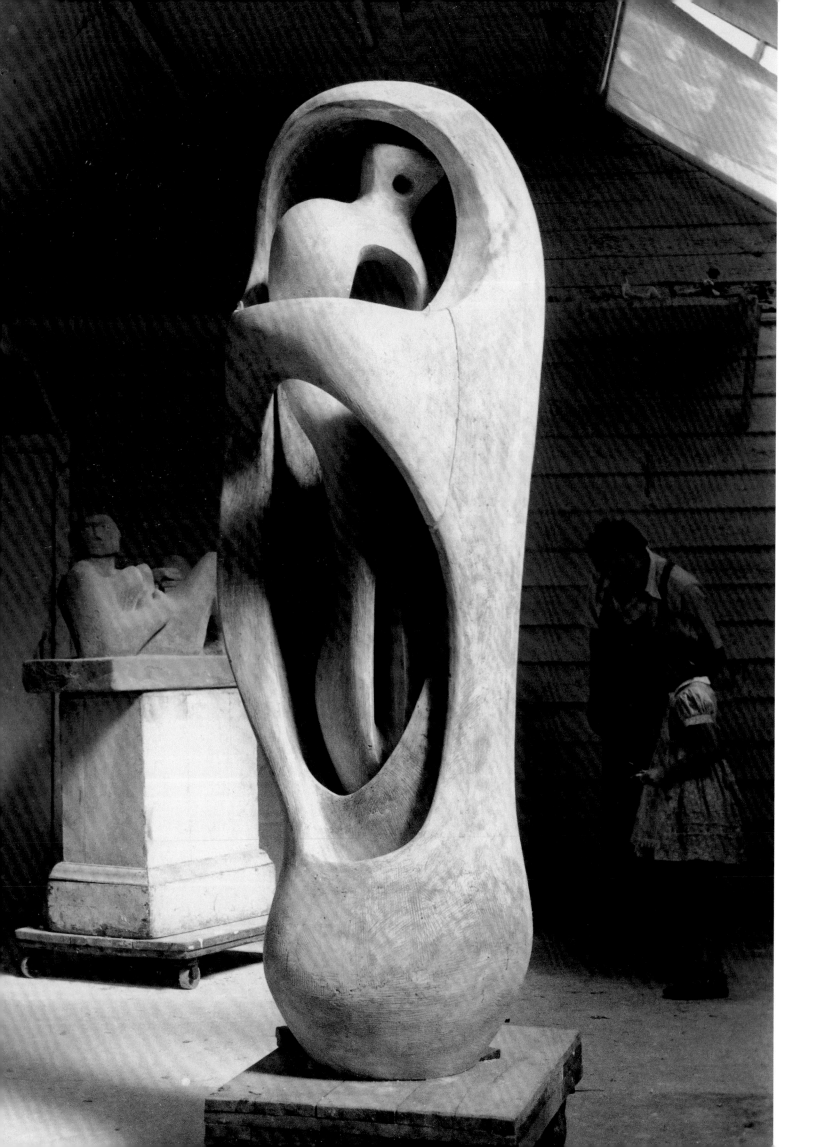

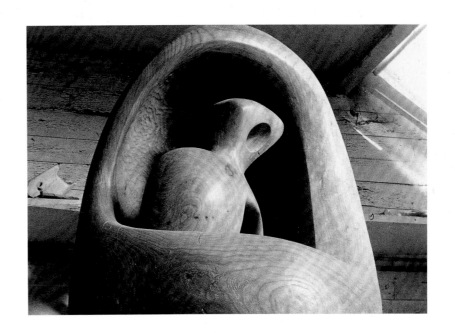

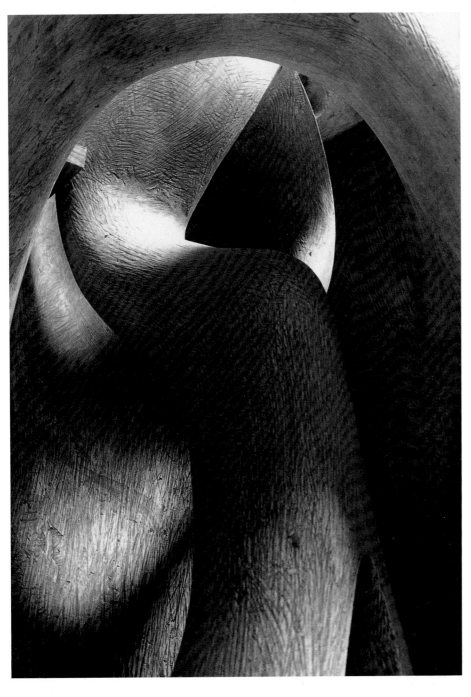

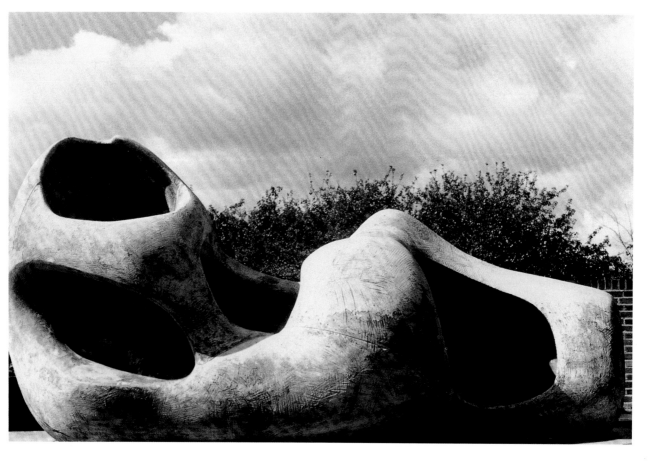

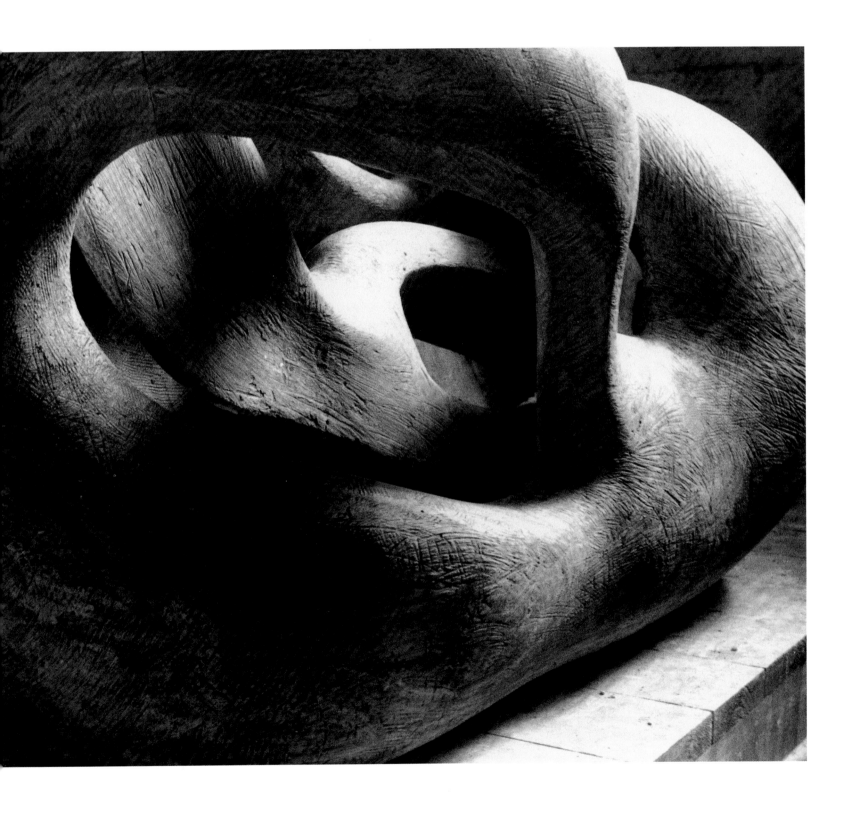

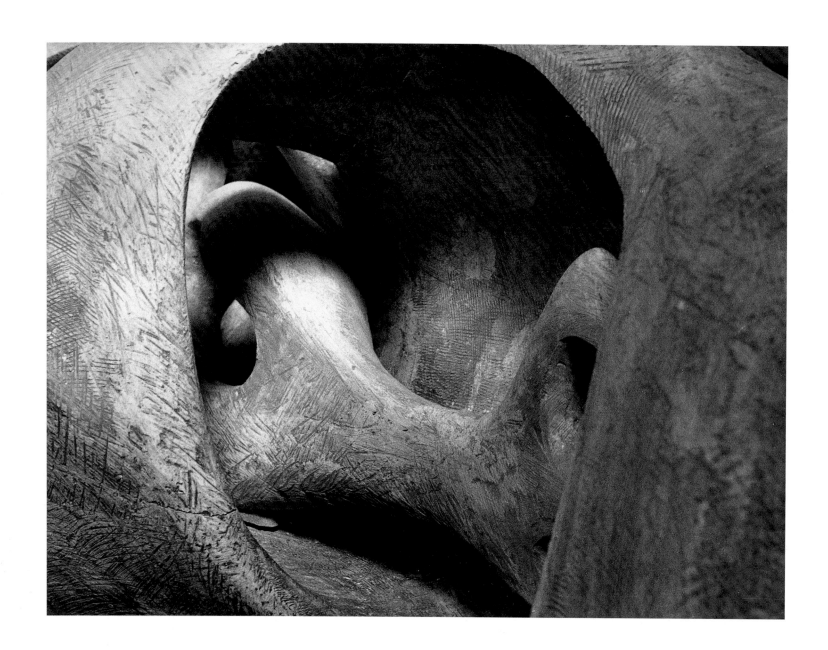

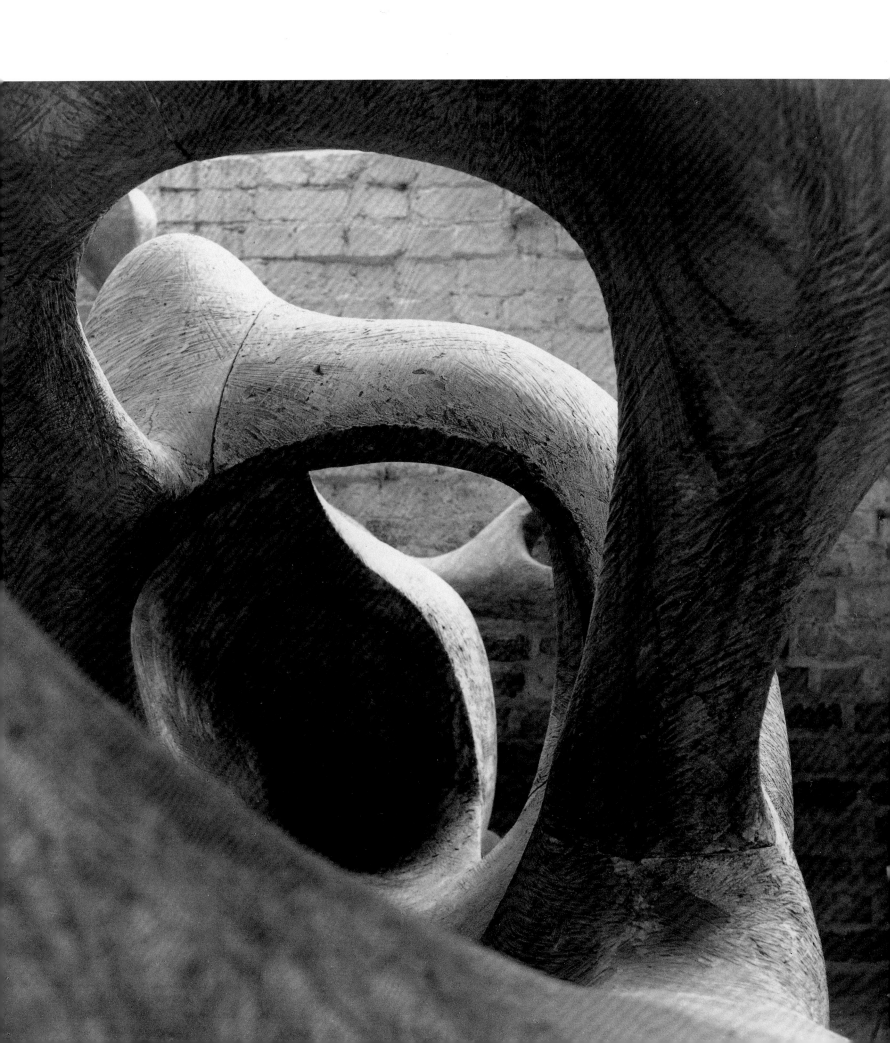

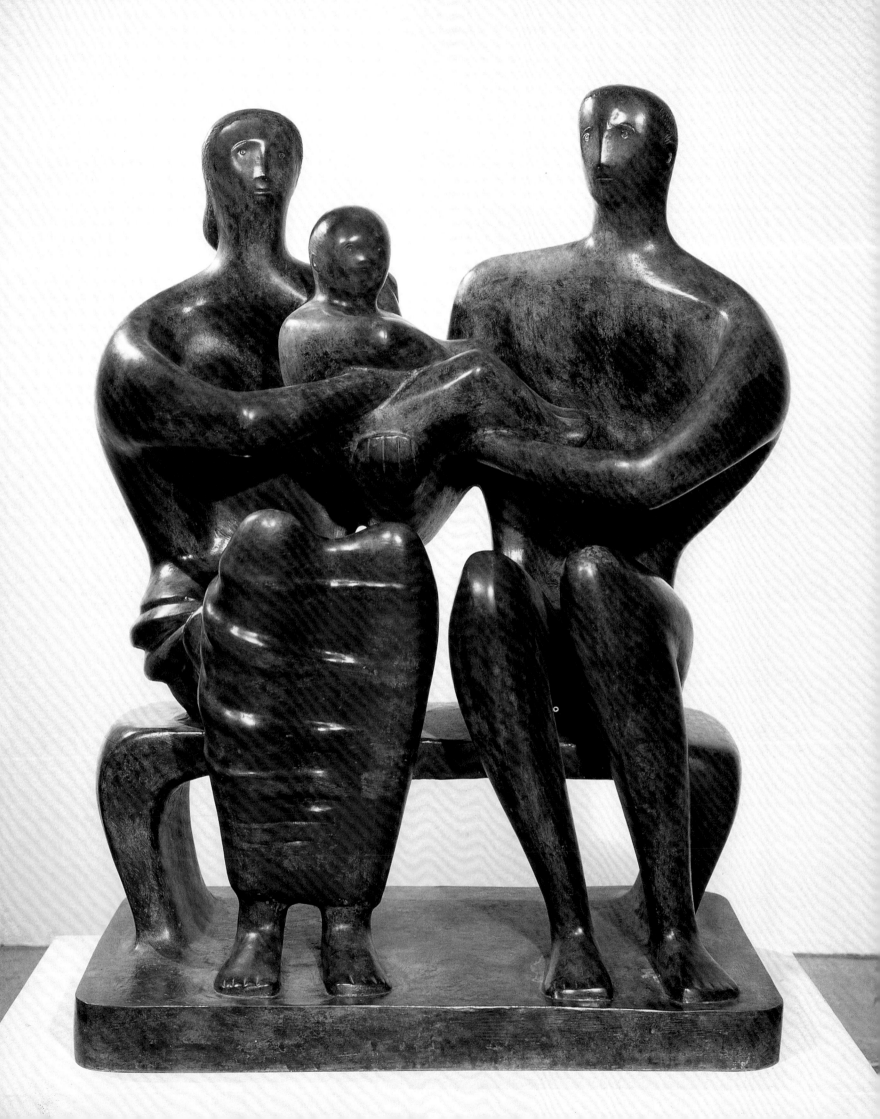

Dorothy Kosinski

Some Reasons for a Reputation

Henry Moore's staggering success and popularity define his reputa-
tion and simultaneously render the man and his work untouchable,
beyond critical discourse. Our trouble with Henry Moore is rooted
in an essential difficulty in appreciating his works and grasping his
long career. His early efforts, for the most part devoted to intimately
scaled carvings, were lionized by contemporary critics bent on estab-
lishing modernism in Britain. In his middle and late career, however,
Moore made a dramatic turnaround, as if trying to free himself from
the straitjacket of modernist ideology. He specifically escaped the
dogma of truth to materials, turning instead toward a public scale
and toward bronze casting.

In 1948, with the award of an international prize for sculpture at
the Venice Biennale, Moore emerged as an artist with a worldwide
reputation; his career unfolded over another almost forty years as a
list of prestigious one-man exhibitions, volumes of publications, major
public projects, distinctions, and awards. He became more than a
cultural figure and something like a celebrity. In his obituary, pub-
lished on 1 September 1986 in the *New York Times,* John Russell
described the widespread resonance of and related ambivalence
about Moore's work: "Somewhat to the annoyance of those who felt
he had altogether too large a share of the market, his work found vir-
tually universal favor. It was loved by people the world over–and not
least by those who had never looked at the work of another sculptor.
In a world at odds with itself, his sculpture got through to an enormous
constituency as something that stood for breadth and generosity of
feeling."[1] On 21 September 1959, Moore's face had appeared on the
cover of *Time* magazine; the accompanying article documented his
fame and the incredible, international popularity of his works, which
could be seen around the world in public settings such as buildings
and parks, and in at least fifty-three museums.[2]

Yet even as he attained such astonishing fame, and certainly
at least partially in reaction to the rapid growth of his reputation,
Moore became the object of sometimes bitter attacks. In the sixties,
Anthony Caro, who claimed to represent an entire group of younger
British sculptors–"My generation," he declared, "abhors the idea of

Family Group, 1948–49, bronze, height 59⅞ in. (cat. 52)

a father-figure"–held hands over ears "deafened at the applause."[3]
In the seventies, Rosalind Krauss used a broad broom to sweep aside
modern sculpture, which she deemed "essentially conservative"; she
also condemned Jean Arp and Moore, their colleagues, and their
champions for their "camp-meeting religiosity" about materials.[4] Curi-
ously, in 1947 (and in a specific cultural-political context that will be
discussed later) Clement Greenberg was already announcing that he
was bored with Moore and with his brand of modernism: "The very
fact that it meets our taste so ideally banishes all real difficulty or
surprise from Moore's art."[5] The trajectory of Moore's career seems
to have been outstripped by the accelerating consciousness of the
avant-garde, a phenomenon that has been described recently by
Hans Robert Jauss in *Toward an Aesthetic of Reception* as a change
in the "horizon of expectations."[6] Jauss explains the process in this
way: "There are works that at the moment of their appearance are
not yet directed at any specific audience, but that break through the
familiar horizon of literary expectations so completely that an audi-
ence can only gradually develop for them. When, then, the new hori-
zon of expectations has achieved more general currency, the power
of the altered aesthetic norm can be demonstrated in that the audi-
ence experiences formerly successful works as outmoded, and with-
draws its appreciation."[7] Clearly, from early on in his career, Moore's
popularity was written outside the context of avant-garde criticism.

There are also some elusive personal factors that play a role
in removing Moore's work from the ongoing and evolving stream of
critical discourse. Those who write about his work have often been
extremely partisan, indulgently cataloguing the artist's personal attri-
butes and thus rendering him unassailable or unimpeachable. Herbert
Read called Moore the "most inventive and experimental" sculptor of
his time, but invoked his qualities of "integrity of spirit and of vision"
rather than his creations as the basis for "his continuing influence
and power."[8] In the same spirit, A. M. Frankfurter's article of 1946,
"America's First View of England's First Sculptor," stressed the artist's
personal qualities, speaking of the "deep pleasure of knowing the
man himself–kind, sincere to a rare degree in a veiled society, alive
with ideas and strength, undidactic, in short with all the seldom
encountered marks of greatness."[9] Not only the earnestness of his

champions, but, it would seem, Moore's own personal seriousness (David Sylvester called it his "absence of wit"[10]) worked against him in an era of postmodernist irony. Perhaps, too, a certain complicity on the artist's part in making his own myth tended to isolate him from the evolving dialogue about modern sculpture. One is astonished by the tautological, self-corroborating thinking revealed by Moore's response to his first encounter with the huddled masses in the London Underground: "When I first saw it . . . I saw hundreds of Henry Moore reclining figures stretched along the platform."[11] Moore's dissimulation about the impact of his near contemporaries, including Aristide Maillol, Constantin Brancusi, Arp, Jacob Epstein, and his teachers at the Royal Academy, further contributed to his historical isolation. Dina Vierney nonetheless reports that late in life Moore admitted an enduring admiration for Maillol, offering to assist her with an exhibition and suggesting the Musée Maillol as the site for an exhibition of his own works.[12] Peter Fuller has aptly described Moore's "almost compulsive need to ablate the memory of those artists who had a significant short-range influence upon him, preferring to admit to having learned only from the like of Michelangelo and Masaccio."[13]

Birthing Modernism in Britain

Rosalind Krauss's irritation with the "religious ferocity" of the proponents of direct carving and the apostles of biomorphic abstraction and vitalism is linked to those artists' almost shamanistic identification with their materials and the forms lurking within. Moore describes a total physical and intellectual identification with his material. The sculptor is someone who "gets the solid shape, as it were, inside his head—he thinks of it, whatever its size, as if he were holding it completely enclosed in the hollow of his hand. He mentally visualizes a complex form from all round itself; he identifies himself with its center of gravity, its mass, its weight; he realizes its volume, as the space that the shape displaces in the air."[14]

Moore's close colleague Barbara Hepworth expresses similar ideas about direct carving: "At this time all the carvings were an effort to find a personal accord with the stones or wood which I was carving."[15] For Hepworth carving "is not an optical sensation: it's a matter of physical relationship."[16] She expresses this fusion of sculptor and object in another dramatic statement: "From a sculptor's point of view one can either be the spectator of the object or the object itself. For a few years I became the object. I was the figure in the landscape and every sculpture contained to a greater or lesser degree the ever-changing forms and contours embodying my own response to a given position in that landscape."[17] Their colleague, the sculptor John Skeaping, explained: "The material adapts itself to my ideas and unconsciously my ideas are created by my material and, such is the harmony, I do not feel limited in my expression."[18]

In an article in the Listener, in the form of a discussion between V. S. Pritchett, Graham Sutherland, Kenneth Clark, and Moore, Sutherland reveals his self-identification with Nature: "The landscape painter must almost look at the landscape as if it were himself—himself as a human being. . . . I'm interested in looking at landscapes . . . so that the impact of the hidden forms develops in my mind. . . . Thus follow forms which because of the excitement connected with their discovery, assume in their pictorial essence what one might call a certain strangeness."[19]

Moore and his colleagues were preceded and influenced, of course, by Arp, Paul Klee, Wassily Kandinsky, Joan Miró, and Alexander Calder. Jean Arp, for example, likened his work to a natural process: "It grows on me like toenails. I have to cut it and then it always grows back again."[20] Moore's vitalism, therefore, partakes of a utopian aesthetic philosophy that emerged from turn-of-the-century symbolism and fed the beginnings of abstraction. The biomorphic forms of early abstraction are emanations of the artists' intuition of profound meanings and connections in the cosmos—between macrocosm and microcosm, between plant and animal, and so on. This metaphysically grounded philosophy posits the artist as demiurge. Kandinsky wrote: "Every work is constructed like the cosmos—through catastrophes, which out of the chaotic screech of instruments, in the end form a symphony, the music of the Spheres. Artistic creation is world creation."[21] The attitude of the biomorphic abstractionists can be described as bioromanticism.

Herbert Read was Moore's greatest apologist, holding his work up as a paradigm of modern sculpture, justifying his subject matter, emphasizing his respect for material and the organic evolution of his forms.[22] Read is insistent on abstraction and formalism. "Sculpture is the creation of solid forms which give aesthetic pleasure. . . . They arise and are proliferated by laws which are formal and not representational. . . . Nothing, in the history of art, is so fatal as the representational fallacy."[23] Read thereby sets himself up to struggle with the fact that Moore was not an abstract artist, despite some of the near-abstract works he executed in the thirties. Read attempts to mollify this inconsistency by inscribing Moore's figuration within the broader scheme of biomorphic vitalism: "In all his work Moore is not only a humanist, in the sense that his work is intimately related to the human figure; but also in the wider sense of a man who has an acute awareness of the vital process itself, a feeling for organic form whether manifested in man, or animals, trees, plants, shells, fossils—whatever has been formed by the life-force in its endless procreative process."[24]

Writing in 1945, Nikolaus Pevsner also focused on Moore's vitalism but freely expressed his irritation with Read, whom he called *"plus royaliste que le roi."* Pevsner's aesthetically conservative goal is clearly to release Moore's work from the straitjacket of pure formalism, "an arbitrary aesthetic purism."[25] Though hardly approving of Moore's "sympathetic pessimism" and much preferring the postwar conventionally representational works such as the Northampton Madonna, Pevsner does seem to identify the animating force of all of Henry Moore's work: a prehuman or subhuman vitalism. "For Henry Moore has at no time ever been an abstract artist, although he has done abstract work. The particular emotional qualities of his work are determined by nothing more decisively than by his refusal to sacrifice natural appearance entirely. On the other hand natural appearance is nearly everywhere reduced to conveying a vitality, *lower* than that of the human (or the animal) body."[26]

In 1951, looking back thirty years to his earliest sculpture, Moore admitted that he and his colleagues had tended "to make a fetish" of the "doctrine of truth to material" and suggested, "It should not be a criterion of the value of a work. . . . Rigid adherence to the doctrine results in domination of the sculpture by the material. The sculptor ought to be the master of his material. Only, not a cruel master."[27] Moore struggled with the tyranny of his material, frustrated by "constantly searching for the right piece to embody each idea

that's working in his mind" or the difficulty of being "master" of the material when "trying to liberate from a particular piece of stone the form he feels it contains."[28] Moore would not limit his creativity and become one of those sculptors Krauss described as "direct carvers, who released the sculptural object like surgeons assisting a birth."[29] The most versatile of materials—bronze and its inherent procedures of modeling and enlarging works with the assistance of a team of craftsmen—provided him an escape from the tyranny of his own early modernism. For the youthful Moore, a scholarship student with a working-class background, modernism and especially the related fascination with non-Western art forms implied freedom from the demands and structures of the academic tradition of classical and Renaissance art. The cultural heterogeneity of the British Museum, like the espousal of "Negro Sculpture" by Roger Fry, Clive Bell, R. H. Wilenski, and Read, might have meant for him a more welcoming terrain outside of tradition. This expansion or redefinition of aesthetic tradition—specifically, the all-embracing history of sculpture—implied a liberation from previous dominant notions of subject matter and form and taste. For example, Moore was free to eschew traditional religious or mythological subjects and instead to evolve an iconography informed by his personal experiences. Charles Harrison has described the importance of the evolution of "new sculptural experiences" in avant-garde discourse, making it possible "to assert the relevance to sculpture of a range of interests and memories which would have been ruled out as irrelevant in the traditional pursuit of art; not just an interest in the products of cultures untouched by the classical tradition and by humanist ideals, but a devotion to the memory of the Yorkshire landscape or an interest in the shapes of stones and bones."[30]

Some critics have interpreted Moore's modernism as a manifestation of English romanticism. Peter Fuller, for instance, describes Moore's career as an oscillation between the romantic and classical that encompasses the two essential poles of the beautiful and the sublime, but reinvents those terms through his fusion of human and natural form. According to Fuller, modernism was only a detour for Moore: "I believe that the liberating force on Moore in the late 1930s was not his encounter with the modern movement but rather that great resurgence of English romanticism. . . . As the clouds of war began to gather . . . there was then a turning inwards on the part of British artists and a welling up of interest in the imaginative and romantic traditions of Britain's past. . . . Freed by the inhibiting restraints of modernity, and yet nourished by its formal and technical innovations, Moore was able to begin to achieve his full stature."[31]

Others have questioned the basic idea of British modernism. In 1947 Robin Ironside asserted that "the best British art relied upon a stimulus that might be ethical, poetic or philosophic, but was not simply plastic."[32] Along the same lines, Bernard Smith, in his recent *Modernism's History,* which analyzes modernism as a universalizing aesthetic, a style which is reduced to form, the "formalesque," argues for the superficiality of modernism in Britian. "Britain's major achievement in the Formalesque lies in its sculpture—Gaudier-Brzeska, Jacob Epstein, Barbara Hepworth and Henry Moore. In Moore, Britain produced the greatest sculptor of the century; his profound response to the nature of the human condition transcended the formal austerities of his time. The truth of the matter is that the Formalesque was never

radically institutionalised in Britain. It existed as one contemporary trend among others. . . . The transfigured ghost of John Ruskin's naturalism still seems to inhabit English soil."[33] This appraisal echoes the critic Geoffrey Grigson's comments about Moore (in the context of the Hampstead community of artists and specifically the *Axis* publication): "Moore and Wyndham Lewis are the only English artists of maturity in control of enough imaginative power to settle themselves between the new preraphaelites of *Minotaure* and the unconscious nihilists of extreme geometric abstraction." Grigson hails Moore's independence from dogma: "Product of the multiform inventive artist, abstraction-surrealism nearly in control; of a constructor of images between the conscious and the unconscious and between what we perceive and what we project emotionally into the objects of our world; of the one English sculptor of large, imaginative power, of which he is almost master; the biomorphist producing viable work, with all the technique he requires."[34]

Art and International Politics

Suspicion of the inauthenticity of Moore's modernism and a belief in his essentially English Romantic soul fueled the attacks of Clement Greenberg and Thomas Hess, who accused him of "tastefulness" and "attachment to the past" and of being "connected with a country garden of the soul." The arch-formalist Clement Greenberg, a successor to Fry and Bell, indicted Moore's "attachment to the past" and dismissed his work as "about halfway between the classical and the new" and "not too far from classical statuary."[35] For Greenberg, Moore is "a sincere academic modern,"[36] his works "a fumble and a stammer, a helpless fingering of archaeological reminiscences or a supine surrender to the best taste."[37] Greenberg, bored with classic modern sculpture, embraces instead "The New Sculpture"—work by David Smith, Theodore Roszak, David Hare, Herbert Ferber, Seymour Lipton, Richard Lippold, Peter Grippe, Burgoyne Diller, Adaline Kent, Ibram Lassaw, and Isamu Noguchi that is characterized by Cubist-inspired construction. By 1947, in Greenberg's eyes, Moore was guilty of pandering to the "popular demand for the heroic" and a "subservience to taste."[38] It is American sculpture that has captured Greenberg's critical fancy, casting a shadow of the old-fashioned on earlier European modernism.[39]

Thomas Hess's 1954 review of Moore's exhibition at Curt Valentin's gallery is remembered for his acid "country garden of the soul" phrase. As with Greenberg, there was undoubtedly a political as well as an aesthetic dimension to his criticism. His was an attack on British nationalism, European taste, metaphysical aesthetics, Britain's curious mixture of socialism and aristocracy, and the growing influence of "Official Modernity" as seen in "the honors and flattery of architectural commissions."[40] But it was also an indictment of politics, society, and culture after World War II.

Art was co-opted by realpolitik in postwar Europe. We have already come to understand how art was married to the ideological and propaganda goals of American foreign policy, which had been defined by 1950 as "a world-wide Marshall Plan in the field of ideas."[41] Clement Greenberg, James Thrall Soby, and E. A. Carmean became apostles for the role of avant-garde art in augmenting the image of America abroad, and Jackson Pollock emerged as their most notable "culture hero."[42] (As early as 1947 Greenberg had stressed the internationalism of the new painting, a theme that was taken up in 1959

by Lawrence Alloway as he took English critics to task for their less than enthusiastic reception of *The New American Painting,* an exhibition that was held at the Tate Gallery and subsequently toured Europe.[43]

Rebuilding Britain

Understandably, Moore had special symbolic significance in bomb-battered Britain, anxious to rebuild and eager to celebrate its survival. The Shelter Drawings seem to have galvanized Moore's popularity and were especially connected in the popular imagination with the wartime survival of Britain. John Russell singles out the Shelter Drawings as work that "came across with a power and an immediacy that turned Mr. Moore from an avant-garde artist with a relatively tiny audience into someone who seemed to speak for a beleaguered nation in terms to which everyone could respond."[44]

Margaret Garlake has deftly explored the role of the arts in Britain's wartime and postwar recovery propaganda: "An unexpected relationship between social reconstruction and the visual arts emerged after 1946 in the form of several important patronage schemes: in Hertfordshire County Council's schools, the New Towns, particularly Harlow, and, from the mid-1950s, the London County Council's properties. The political reality of social reform had established the conditions for an expanded art support system, while higher educational standards, full employment and increased leisure contributed to the basis for a more widespread interest in the arts."[45]

Moore's Madonnas and family groups were the perfect vessels for the message of renewed family values, assisting in the retooling of the workplace and, for instance, the return of working women to the hearth after the war effort.[46] The modernized classicism of his Northampton *Madonna and Child,* 1944, and the *Harlow Family Group* in 1954–55 were perfect symbols of a postwar return to order. (If Moore's family groups were congruent with postwar social policy in Britain, they apparently had originated before the war in a suggestion from Walter Gropius, who sought a sculpture for the Village College that he was to design for Impington near Cambridge. The New Towns, such as Harlow, were to provide the sites for these compositions after the war.)

Moore's meteoric rise to fame is tightly bound to the trajectory of political events. In 1933 critics warned people away from Henry Moore ("Sensitive people, especially women, must shudder in face of these monstrosities"), but twenty-five years later Moore was acknowledged as the world's greatest sculptor and chosen for prestigious projects such as the UNESCO monument.[47] If after the war Moore was caught between his identification with "the old avant-garde"[48] and simultaneous condemnation as an exponent of a morally corrupt "abstraction," it was the endorsement and patronage of important arms of the British government that transformed him into England's preeminent artist. (During the war, the British Council, one of the principal arts agencies of the government, was made part of the British Overseas Information Service.) His monumental outdoor figurative works were interpreted as humanist statements, expressly accessible to the general public of recovering Britain.

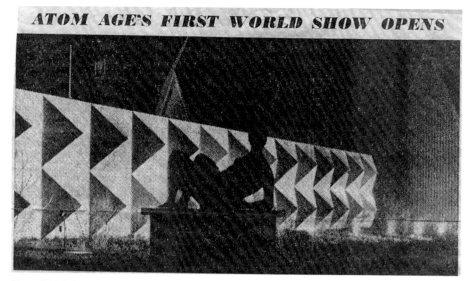

Fig. 1. British Pavilion at 1958 World Exposition, Brussels. *Daily Worker,* London, 17 April 1958

The 1951 Festival of Britain was redolent with political and economic significance for the empire that had survived the war. "Poised symbolically at the beginning of a decade and a new government, the Festival offers many readings: a celebration of survival, an efflorescence of romantic nationalism, a quasi-scientific trade fair, a farewell to socialism. It also contained elements of a new vernacular decorative manner which has seeped down as an instant picture of the 1950s and contributes to a sense of period. Asymmetric furniture with splayed legs and spherical finials, fabrics in acid colours and half-tones, complex black linear forms denote the style that became known as Contemporary . . . the vernacular equivalent of the avant-garde visual arts."[49] The goal of the Festival of Britain was to "demonstrate to the world the recovery of the United Kingdom from the effects of the war in the moral, cultural, spiritual and material fields."[50]

The Cold War

The government became involved in sponsoring art festivals, open-air sculpture exhibitions, and biennial exhibitions all across western Europe after the war. These were important art events but also conscious "acts of cultural diplomacy," as Margaret Garlake points out: "Cultural creativity, manifested by the modernity of contemporary art forms, was a crucial indicator of national survival and continuing vitality after the ravages of war."[51] A British foreign officer once proclaimed: "The 'cold war' is in essence a battle for men's minds. The British Council is one of our chief agencies for fighting it."[52]

The benevolent or nurturing images of Moore's recent works were entirely consonant with the philosophy articulated by the organizers of the 1948 Biennale: "Art invites all people, beyond national frontiers, beyond ideological barriers in a language which must invite them into a humanist understanding and universal family."[53] Moore was lionized at the exhibition, and it cemented his international reputation.

The Fine Art Department of the British Council capitalized on the 1948 success with a series of exhibitions that toured Europe, visiting Brussels, Paris, and Hamburg in 1949–50 and Athens, Berlin, and Vienna in 1951. There were also outdoor sculpture installations in the Netherlands at Sonsbeek near Arnhem in 1949, and at Middelheim (Antwerp), Belgium, Varese, Italy, and Hamburg. The director of the Albertina Museum acknowledged the political symbolism of the Moore

exhibition in Vienna: "We are really a long way east. It is vital that we keep open our relations with the great art centres of the west. If our museums are to lose this contact, then that is one more position that we surrender to the Powers of Darkness."[54] The fifties and sixties, the dark days of the cold war, were wracked with crisis after crisis: the Soviet invasion of Hungary in 1956, the Suez Crisis in 1956–57, and the erection of the Berlin Wall in 1961, to name but a few.

Moore's arguably neutral subject matter made his sculptures ideal vessels for the ideological content of cold war diplomacy, and he rapidly assumed the mantle of preeminent artist of western democracy. In 1958, for example, Moore participated in the jury to choose a memorial to be erected at Auschwitz.[55] The British Pavilion at the World's Fair in Brussels that same year figured prominently in the British press; coverage inevitably included photos of Moore's *Reclining Figure* (fig. 1). The international political weight of the exhibition was explicit: "A plane-load of 70 Soviet tourists arrived and several thousand are expected during the six months that the exhibition is open."[56] The press often co-opted images of Moore's work for political commentary. One photograph of Moore's *Warrior with Shield* bears the caption "Each side sees the other as an absolute threat." The caption in one newspaper for the bronze *Family Group* in the collection of the Museum of Modern Art reads "The dignity of man is the foundation of democracy."[57]

Rehabilitating Germany

Harry Brooks of Knoedler and Company commented about the different political climates that informed Moore's reception throughout the world: "I think at the beginning there was a reticence [*sic*] on the part of American collectors to accept some of the harsher forms in Moore's work. . . . Eventually it became easier to place the more difficult, truly huge pieces in Germany because there the buyers were nearly always museums of municipalities. In the late 1950s and the 1960s Germany was economically very prosperous. Many of the cities where there had been great bomb damage were looking for new monuments and they were certainly a lot more adventurous in picking their public pieces than their opposite numbers in the U.S. would be. . . . The English have probably been least adventurous when it comes to the truly large and challenging pieces with which Henry has amazed us in recent years."[58]

Moore's invitation to the *Mankind and Design in the Modern World Today* exhibition in the industrial center of Recklinghausen in 1952 is an indication of slowly improving relations between England and Germany, as well as symbolic of the regrowth of the European economy. Britain seems to have watched Moore's reception in Germany carefully. For instance, the British press comments on Moore at the giant 1958 international contemporary art exhibition Documenta, at Kassel, which had been bombed during the war: "But it is Moore, placed centrally and prominently, who is most severely tested by the grandest section of the ruin and who most admirably survives the ordeal. His huge lying and seated draped women . . . introduce a quality of intense pathos and sensibility into the monumental which renders them both distant and appealing. They are in many ways the high point of this exhaustive and sometimes exhausting display."[59]

For Klaus-Henning Bachmann, reviewing the large retrospective that was shown in Hamburg in 1960 and subsequently toured Essen, Munich, and Zurich, Moore's work is a positive and optimistic affirmation of the resilience of the human spirit, and the essential oneness of the human being with nature, essentially a statement of love in direct contrast to the destructive goals of the Nazi regime. "This grand retrospective demonstrates how the deformation [of the human form] serves to reestablish once again our own destroyed image of human kind, into organic unity. Indeed, the human image is recreated new and pure out of this context. There hardly exists a contemporary artist's lifework that expresses more clearly a love of mankind."[60] One would be hard pressed to find a more appropriate aesthetic retort to the erect, virile National Socialist monuments of Arno Breker so favored by Hitler than Moore's earthbound, biomorphic vocabulary of a prehuman vitalism.

One major project followed another in Germany. In 1961 Wolfsburg, where Volkswagen has its headquarters, became the fourth large German city to purchase an important work by Moore. In July 1961 Moore was named an honorary member of the Berlin Academy of Art, an honor coinciding with the inauguration of a major retrospective which had previously been seen in Rome, Amsterdam, and Paris and had been organized, yet again, by the British Council.[61] Moore lent a cast of *Relief Nr. 1,* 1959, to the new Berlin Opera, which had been designed by Fritz Borneman and which opened in the fall of 1961. These cultural events unfolded, of course, against the backdrop of the painful partition of Berlin, which strictly limited East Berliners' access to the western sectors. In 1974 Moore was awarded the first Kaiserring from the city of Goslar.

There were exceptions to this otherwise positive reception of Moore in postwar Germany, departures that reveal a great deal about the nuances of the political and cultural climate. In 1959 Moore's *Seated Woman,* installed before a new indoor swimming pool in Wuppertal, was literally tarred and feathered. One author interpreted this act of vandalism as the public's understandable outrage against the "totalitarianism" of abstract art.[62] The commentator found the equation of abstract art with democracy and realism with the political taboos of Nazi Germany to be unacceptable.

In 1960 Stuttgart installed a massive *Draped Reclining Figure* between the Opera and the State Parliament. This installation provoked a lengthy debate that ended with the eventual removal of the sculpture to a more remote public place (fig. 2). Finally, in 1984, it

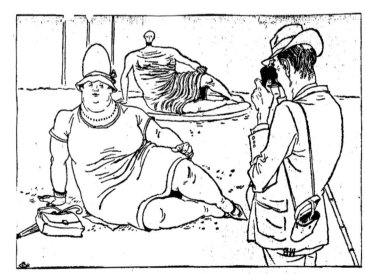

Kunst und Natur: „Mariele, paß uf, du kommst noh en d Model"

Fig. 2. Cartoon, *Stuttgarter Zeitung,* 6 May 1961

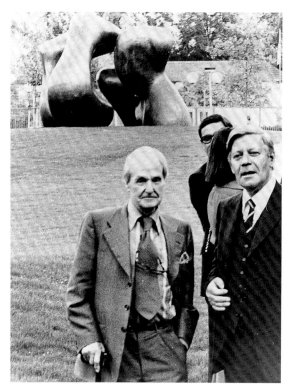

Fig. 3. Henry Moore with German Chancellor Helmut Schmidt in front of Moore's *Large Two Forms* in Bonn, September 1979

found a new place of honor on the terrace of the new Staatsgalerie. The building, ironically enough, had been designed by an English architect, James Stirling.

One of the most prominent and hotly contested projects was the installation in 1979 of Moore's *Large Two Forms* on the plaza in front of the State Chancellery in Bonn (fig. 3). This project was the result of the active engagement of Chancellor Helmut Schmidt, a close friend of Moore. The installation spurred debate concerning national chauvinism or cultural pride as opposed to the internationalism of a unified European community. Moore's generosity in making the important work available was overshadowed by its interpretation as a reflection of the impoverished cultural life of the German state and as an "expression of spiritual bankruptcy."[63]

Moore and Capitalist Globalization

Meanwhile Moore's potency as a symbol of political harmony and economic strength was not lost on the business and real estate sectors in America. An article entitled "Sara Lee's European Strategy Proves a Success"[64] featured a fascinating photo of CEO John H. Bryan standing in front of Moore's *Falling Warrior* (fig. 4), as though that sculpture embodied his business victories.

North America increasingly embraced Moore's work. A British journalist, writing in 1974, noted that "over two-thirds of his pieces of sculpture and drawings are in North American public and private collections."[65] This enthusiasm included innumerable important public projects: Lambert

Airport in St. Louis; *The Arch,* outside Bartholomew County Public Library in Columbus, Indiana; *Three Piece Sculpture Nr. 3, Vertebrae* at Seattle First National Bank; *The Atom Piece* in Chicago; and the *Reclining Figure* at Lincoln Center in New York. Kansas City acquired a cast of the giant *Sheep Piece* in 1974. Moore's *Conception* was installed on the plaza of the United States Fidelity and Guaranty Company building in Baltimore in August 1974. The Henry Moore Sculpture Centre at the Art Gallery of Ontario was inaugurated in 1974, but was greeted with protests by Canadian artists who felt pushed aside by the famed British sculptor. The city of Dallas, which had been hesitant to engage a foreign artist, purchased a major Moore for the plaza in front of the new City Hall designed by I. M. Pei. The new acquisition was a symbol of civic pride and the object of intense community engagement. City Manager George Schrader stated: "This building, and now this sculpture, have to be ranked with only one or two or three other municipal buildings in North America."[66] Moore reciprocated Dallas's enthusiasm, donating an important plaster to the Museum of Fine Arts in support of its campaign for a major new building.[67]

Deafened by the Applause

Moore's appearance on the cover of *Time* magazine in September 1959 may well have served as a lightning rod for an outpouring of negative comments on Moore's work and career. Sidney Tillim wrote of "Moore's strangulation by academic modernism" and declared: "It was as if he became a conservative after a single radical moment."[68]

In the 1970s, as we have already discussed, Rosalind Krauss took aim at the "monolithic idealism of modern sculpture," a sculpture, as she puts it, that preserves a "core" or "spine" and thereby the implicit notion of the internally coherent volume and the viewer's resulting sense of "possession," both physical and intellectual. For Krauss, Moore's brand of modern sculpture was essentially conservative.[69] Anthony Barnett, writing in 1988, entitled his review of Roger Berthoud's Moore biography "Breaking Through and Falling Off," posing the question of whether "his fame grew in inverse proportion to the quality of his work."[70]

In 1960 the eminent sculptor Anthony Caro expressed his profound ambivalence about his illustrious predecessor: "When you try

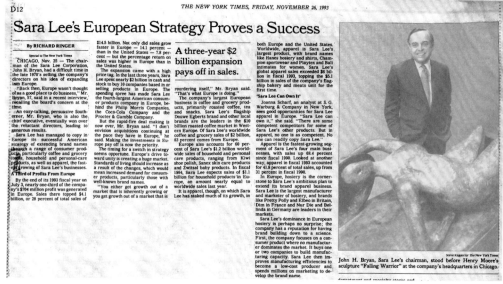

Fig. 4. Sara Lee Corporation CEO with Henry Moore's *Falling Warrior. The New York Times,* November 26, 1993

to think clearly about Henry Moore you are deafened by the applause. The picture is not man-size, but screen-size. It is as if the build-up into a great public figure has got out of hand, and, like a film star's big 'front' has clouded our view of the real Moore."[71] Caro attributed the intensity of his dismissal of Moore to youthful passion: "My generation abhors the idea of a father-figure, and his work is bitterly attacked by artists and critics under 40 when it fails to measure up to the outsize scale it has been given."[72]

Indebted to Moore

Moore's talent seems to become obscured by his celebrity. Dawn Ades struggled to recapture a fresh vision of Moore's radical work: "It is difficult to realize today that Moore for much of his life was the most controversial artist in Britain. . . . His work was seen as an attack on the sanctity of the human form and either too abstract or too distorted."[73] Other writers have acknowledged the breadth of his impact on the arts in Great Britain: "He ensured that sculpture would be taken seriously as a fine art in the United Kingdom. We are indebted to him for a significant expansion of British society's imaginative possibility."[74] Moore's work and his personal prominence, and also the enduring legacy of his foundation, which makes grants to younger artists and supports sculpture through exhibitions and publications, cannot be overestimated.

In the course of the 1960 article quoted earlier, Anthony Caro recanted his harsh words and readily admitted his entire generation's indebtedness to Moore: "All students of architecture are indebted to him, and all at one time or another in their careers are influenced by his work; he provides an alphabet and a discipline within which to start to develop. His success has created a climate for all of us younger sculptors and has given us confidence in ourselves which without his efforts we would not have felt. . . . I owe him a great debt. The doors of a whole world of art which I had not known as a student he opened for me."[75]

It is interesting that Caro writes of "students of architecture," underlining the sculptor's undeniably important contribution to art in the public space. This is arguably the most compelling reason for Moore's greatness, and one that transcends any individual work of art. The breathtaking acceleration of his career after the Venice Biennale in 1948—embodied in that astonishing string of public works installed over the next almost forty years from London to Paris to Berlin to Chicago to New York—forever changed the face of the art world, enabling it to expand into the public arena not only physically but also aesthetically and politically. The social function of the sculptor was emphasized by Moore's champion, Herbert Read, as early as 1944: "The sculptor is essentially a public artist. He cannot confine himself to the bibelots which are all that fall within the capacity of the individual patron of our time. The sculptor is driven into the open, into the church and the market-place, and his work must rise majestically above the agora, the assembled people."[76]

Jean Clay offers a different appreciation of Moore's vital contribution to modern sculpture: "Henry Moore was not made to shape the future, to herald innovation and change. While all modern sculpture is exploding and soaring, Moore sinks into the earth, archaic and immutable, closer to prehistory than to the year 2000, even though he was born in the heart of the industrial world. He was not made to speak of our era: speed, stridence, permanent metamorphosis,

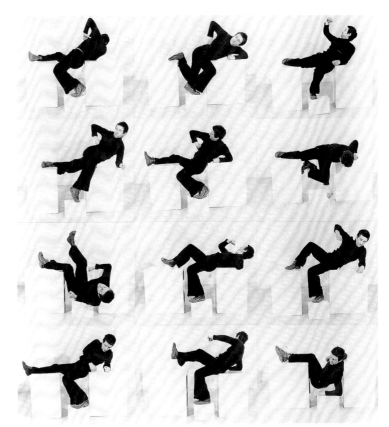

Fig. 5. Bruce McLean, *Pose Work for Plinths 3,* 1971. Tate, London

constant wear, flashing distractions. He was made to remind us of our peasant past, our umbilical cord with mother nature, our brotherhood with the primitive peoples and the cave man. In his quiet house surrounded by lawns in a provincial village this stubborn man has been watching the slow tumult of his unconscious for forty years. What he works out, day after day, is in fact the face of our lost secrets."[77] Clay's deeply sensitive psychological and physical reading of Moore's work is clearly inflected by his engagement with the anti-aesthetic philosophy of Georges Bataille and the Surrealist journal *Documents.* Clay's words echo the vitalist theories of Herbert Read and most specifically Pevsner's appreciation of the "pre-human" qualities of Moore's earthbound biomorphism. It would seem, then, that Clay establishes a link between Moore's globular, heavy, earthbound creations and the "formless" quality that emerges so significantly in the shapes and themes of more recent contemporary sculpture.[78] Considering that Moore had already objected to a Jungian interpretation of his work[79] and also continually insisted that his sculpture be seen against an expanse of sky, we might conclude that he would not agree with Clay's reading of his work, which is profoundly rooted in the subconscious and physically weighted to the earth.[80] Artists' responses to Moore's work range widely and reveal the scope of his impact. The flagging of minimalism—modernism's last gasp—seems to have made possible a new range of responses and insights. Bruce McLean, who had studied with Anthony Caro, created a parodistic photo series in which he places his own body in the positions of Moore's reclining figures (fig. 5).[81] This ironic confrontation with the quintessential modernist seems to be based on an intuitive response to Moore's profoundly serious personality—that "absence of wit"— a character that distinguishes him drastically, for example, from Picasso, who plays with "the sharply incongruous image."[82]

In the 1960s Bruce Nauman created three interrelating series of works explicitly dedicated to Henry Moore. *Seated Storage Capsule (for H.M.),* 1966 (fig. 6); *Study for Henry Moore Trap,* 1966–67; *Trap,* 1966; and *Seated Storage Capsule for H.M.,* 1966, are large-scale works on paper that focus on some of the most central elements of Moore's aesthetic: the theme of the seated figure, the theme of enclosed or interior forms, the idea of encapsulation or wrapping. The featureless figure's severe geometry recalls the Egyptian or Near Eastern statuary to which Moore turned for inspiration in articulating the dense, solid core that defines his sculpture. Nauman emphasizes the surface, a taut skin or shell, a swathing of tightly stretched material that is thematicized in any number of Moore's draped figures. As Coosje van Bruggen has suggested, Nauman's seated figure takes on the appearance of a sarcophagus, an iron maiden, or a mold used in the sculptural casting process. Van Bruggen also points to similarities with the seated coffin figures in René Magritte's *Perspective II: Le Balcon de Manet.* Nauman explains his title *Storage Capsule* by referring to the younger British sculptors' disparaging rejection of Moore in the 1960s: "Moore had been the dominant presence in British art for years; he was pretty powerful. I figured the younger sculptors would need him some day, so I came up with the idea for a storage capsule."[83]

Drapery or shroud is the main theme in Moore's intriguingly enigmatic drawing from 1942, *Crowd Looking at a Tied-up Object* (cat. 171), in which a group of figures hovers expectantly or even fearfully near a towering shape entirely draped (in the manner of Christo) and fastened with crisscrossing ropes. Though Nauman may not have known this drawing, the ropes figure in other works that are also a homage to Moore: *Bound to Fail,* 1966, charcoal on paper, and *Henry Moore Bound to Fail,* 1967, cast iron (fig. 7). The notion of binding or tying figures not only in Moore's 1942 drawing but also in his stringed sculptures from the thirties, as well as in drawings from the forties involving women pulling string. In many of Moore's drawings, forms are built up with a linear, repetitive movement, and furthermore laboriously elaborated with an accumulation of work in a variety of media. Nauman had a special fondness for Moore's Shelter Drawings, commenting on their reflection of the artist's "struggle."[84] Nauman's works seem linked on an emotional or intuitive level to this idea of struggle: the figures' arms push uncomfortably against the constraints of the ropes. One must consider, as well, how the idea of struggle and constraint is connected with Nauman's choice of the words "trap" and "fail," and especially "bound to fail." Nauman's sympathetic stance vis-à-vis Moore leads one to speculate about what is bound and by whom. Is Moore the prisoner of modernism, or of the oedipal reactions of the younger generation of artists, or of his own vocabulary of the human body, or of his own fame and success? There is also a connection (though surely an accidental one) with Moore's often-quoted account of massaging his mother's back as a young boy. And yet somehow Nauman's cast iron sculpture seems to communicate the tactility and symbolic significance of that remembered moment of intimacy, thereby suggesting a profoundly repressed sensuality that lurks in all of Moore's work.

Anish Kapoor's ineffable voids seem somehow far more profound than, and yet are (and despite the artist's protests to the contrary) unthinkable without, Moore's "mystery of the hole."[85] They also remind us of Clement Greenberg's use of the phrase "the look of the void"

Fig. 6. Bruce Nauman, *Seated Storage Capsule for H.M. Made of Metallic Plastic,* 1966. Hallen für neue Kunst, Schaffhausen, Switzerland, Crex Collection

in 1967 to express his boredom with the kind of lackluster minimalism that had "domesticated" some of the most pungent aspects of modernism.[86] Homi K. Bhabha has written perceptively about Anish Kapoor's *Making Emptiness:*

> If you think that you have seen "emptiness" as that hole at the heart of the material's mass, surrounded by a planished façade, then think again. To see the void as a contained negative space indented in the material is only to apprehend its physicality. To figure the depth of the void as providing a perspectival absence within the frame or the genre is to linger too long with the pedagogy of manufacture or the technology of taste. The practice of "true making" occurs only when the material and the non-material tangentially touch. The truly made thing pushes us decisively beyond the illustrational, the "look of the void"; the sign of emptiness expands the limits of available space. . . . To get to the heart of Kapoor's thinking and making we must register the difference between physiciality of void space and truly made emptiness. . . .
> The truly made work finds its balance in the fragility of vacillation. It is the recognition of this ambivalent movement of force, this "doubleness" or "otherness" of the literal and the metaphoric, the empty and the void, their side-by-side proximity, that inhabits Kapoor's work. Such an articulation through displacement allows us to decipher emptiness as a "sign," where we have really an exteriority of the inward, rather than to pander to the look of the void as it signals its need to be fulfilled.[87]

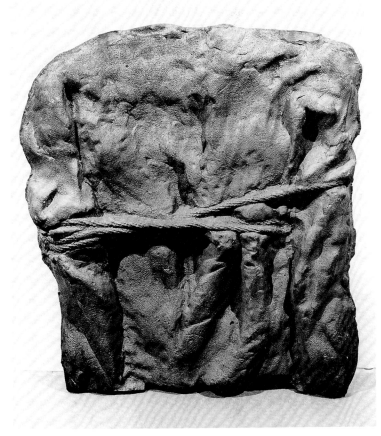

Fig. 7. Bruce Nauman, *Henry Moore Bound to Fail,* 1967

Kapoor's art is a metaphysical consideration of the void, a philosophical reexploration of the physical terrain made by Moore.

The craftsmanship that characterizes Richard Deacon's elaborate fabrications, as well as the cumbersome seriousness of their clumsy shapes, is different from and yet akin to the works of Moore. Peter Schjeldahl has pointed to this general affinity between Deacon's works and the idealist modernism of Moore, Mondrian, or Brancusi, forms "abstracted from life to a maximum degree, but in touch with life nonetheless."[88]

When one gets beyond a kind of binary operation of acceptance or rejection of the orthodoxy of modernism, Moore emerges as a complex and deeply influential figure. His impact on the history of modern and contemporary sculpture in Britain—witness the examples of Caro, Kapoor, and Deacon—is multifaceted and sustained. This impact is evident in innovative explorations of form and void; in the respectful manipulation of materials; in the enduring importance of art in dialogue with nature; and in the robust interaction of art and audience that occurs in the public realm. Moore's work (especially his prehuman vitalism) can also be inscribed in an art historical narrative written through the body—and especially embracing the bold challenges to the heroicized human form articulated, for example, in the works of Paul Cézanne, Francis Bacon, Jean Dubuffet, Alberto Giacometti, and Willem de Kooning.

Notes

1. John Russell, "Henry Moore, Sculptor of an Age, Dies at 88," *New York Times,* 1 September 1986, 1, 8.

2. "Maker of Images," *Time* (21 September 1959): 50–57, remarks: "At a recent showing in the small city of Galle in Ceylon, a crowd of 10,000 flocked to see his works in 3 days. A traveling show of 22 Moore pieces and 25 drawings will open next month behind the Iron Curtain in Warsaw."

3. Anthony Caro, "The Master Sculptor," *Observer* (27 November 1960): 21.

4. Rosalind E. Krauss, *Terminal Iron Works: The Sculpture of David Smith* (Cambridge, Mass., and London: MIT Press, 1971), 62, speaks of "their camp-meeting religiosity about stone, wood and the essential forms lying nascent within their materials."

5. Clement Greenberg, "Review of Exhibitions of Gaston Lachaise and Henry Moore," *Nation* (8 February 1947), reprinted in *Clement Greenberg, The Collected Essays and Criticism,* Volume 2, *Arrogant Purpose, 1945–1949,* ed. John O'Brian (Chicago and London: University of Chicago Press, 1986), 125–28.

6. Hans Robert Jauss, *Toward an Aesthetic of Reception* (Minneapolis: University of Minnesota Press, 1982), 26.

7. Ibid., 26–27.

8. Herbert Read, foreword to *Henry Moore,* exhibition catalogue (British Council, for Canada and New Zealand, 1955–57), n.p.

9. A. M. Frankfurter, "America's First View of England's First Sculptor," *Art News* (December 1946): 26–29.

10. David Sylvester, *Henry Moore* (New York and Washington, D.C.: Frederick A. Praeger Publishers, 1968), 36.

11. From Carlton Lake, "Henry Moore's World," *Atlantic Monthly* 209, no. 1 (January 1962) 39–45, reprinted Philip James, ed., *Henry Moore on Sculpture,* (New York: Viking Press, 1966), 226–30.

12. Dina Vierney, letter dated 28 April 2000, to the Dallas Museum of Art.

13. Peter Fuller, "Henry Moore, an English Romantic," in *Henry Moore* (London: Royal Academy of Arts, 1988), 39.

14. Henry Moore, "Notes on Sculpture," 1937, reprinted in *Complete Sculpture,* Volume 1, *Sculpture 1921–48* (London: Lund Humphries, 1988), xxxiii. First published as "The Sculptor Speaks" in the *Listener,* 18 August 1937.

15. *Barbara Hepworth: Carvings and Drawings,* with an introduction by Herbert Read (London: Lund Humphries, 1952), 339–50.

16. Edwin Mullins, *Barbara Hepworth* (London: British Council, 1970), n.p.

17. *Barbara Hepworth: Carvings and Drawings,* 19.

18. John Skeaping, "Contemporary English Sculptors," *The Architectural Association Journal* (London) 45, no. 516 (February 1930): 302.

19. "Art and Life," *The Listener* (13 November 1941): 657–59.

20. Arp, as quoted by Hubertus Gassner, "Realität der Sympathie. Parallelismus der Naturreiche," in *Elan Vital oder Das Auge des Eros, Kandinsky, Klee, Arp, Miro, Calder* (Munich: Haus der Kunst, 1994), 36.

21. "Jedes Werk entsteht technisch so, wie der Kosmos entstand–, durch Katastrophen, die aus dem chaotischen Gebrüll der Instrumente zum Schluss eine Symphonie bilden, die Sphärenmusik heisst. Werkschöpfung ist Weltschöpfung." Kandinsky, as quoted by Gassner, 29. This attitude has been referred to as "Bio-Romantik" by Ernst Kallai.

22. See David Thistlewood, "Herbert Read's Paradigm: A British Vision of Modernism," in Benedict Read and David Thistlewood, eds., *Herbert Read: A British Vision of World Art* (Leeds City Art Gallery/Henry Moore Foundation and London: Lund Humphries), 77.

23. As quoted in Nikolaus Pevsner, "Thoughts on Henry Moore," a review of Read's 1944 Lund Humphries publication in *Burlington Magazine* 86 (February 1945): 48.

24. Herbert Read, *Henry Moore, A Study of His Life and Work* (New York and Washington, D.C.: Frederick A. Praeger Publishers, 1965), 257.

25. As quoted in Pevsner, 48.

26. Ibid., 49.

27. From Arts Council of Great Britain, *Sculpture and Drawings by Henry Moore*, exh. cat., London: The Tate Gallery, 1951, reprinted in James, 115.

28. Ibid., 116.

29. Krauss, 62.

30. Charles Harrison, *English Art and Modernism 1900–1939* (London and Bloomington: Allen Lane and Indiana University Press, 1981), 221.

31. Fuller, 41.

32. Robin Ironside, *Painting Since 1939* (London: Longmans Green for the British Council, 1947), 10.

33. Bernard Smith, *Modernism's History* (New Haven and London: Yale University Press, 1998), 196.

34. Geoffrey Grigson, "Comment on England," in *Axis* (London) (1 January 1935): 8–11. For more on Geoffrey Grigson, a neo-romantic in the early 1940s, see Margaret Garlake, *New Art, New World: British Art in Postwar Society* (New Haven and London: Yale University Press, 1998), 87, especially her discussion of his biography of Samuel Palmer and his autobiography, *The Crest of the Silver*, 1950, "where he identified an individual, empathetic relationship with a nurturing landscape as its dominant element."

35. Greenberg, 126–27.

36. Ibid., 127.

37. Ibid., 128.

38. Ibid., 127.

39. Christoph Vitali follows suit, suggesting that by the early fifties, the fluid organic forms begin to lose their symbolic vitality, and become cookie-cutter petit bourgeois decorative impulses. See his "Einführung in die Ausstellung," in *Elan Vital*, 11.

40. Thomas Hess, as quoted in Henry J. Seldis, *Henry Moore in America* (New York: Praeger, in association with the Los Angeles County Museum of Art, 1973), 136.

41. Serge Guilbaut, *How New York Stole the Idea of Modern Art: Abstract Expressionism, Freedom, and the Cold War* (Chicago and London: University of Chicago Press, 1983), 192.

42. Ibid., 194.

43. Garlake, 81, notes 148 and 149.

44. Russell, 1, 8.

45. Garlake, 5.

46. Ibid., 8.

47. See Quentin Crewe, "The Man Who Made Women Shudder," *Evening Standard* (London), 20 January 1958.

48. Garlake, 19 and 38, quoting critics from 1949. Some of Moore's most prominent public pieces include: the bronze *Family Group* at Barclay Secondary School, Stevenage, 1948–49; the *Festival Figure*, 1951; the *Time-Life Screen*, 1953; *Draped Reclining Figure*, 1952–53; *King and Queen*, 1952–53; *Upright Motives*, 1955–56; *Warrior with Shield*, 1953–54; *Harlow Family Group*, 1956; *Falling Warrior*, 1956–57; Unesco *Reclining Figure*, 1958.

49. Ibid., 7.

50. Ibid., 73, note 93.

51. Ibid., 17.

52. Ibid., 18, note 39, quoting a Foreign Officer.

53. Secretary General Rodolfo Pallucchini, as quoted in Garlake, 236.

54. Garlake, 237, note 100.

55. Constantine FitzGibbon, "A Memorial to Mass Murder," *Observer*, 4 May 1958.

56. "Atom Age's First World Show Opens," *Daily Worker*, 17 April 1958.

57. Unidentified newspaper clippings, Henry Moore Artist File, Archives, The Museum of Modern Art, New York, presumably from the 1960s.

58. Quoted in Seldis, 118. The Germany referred to by Brooks and in this essay is the former West Germany, including West Berlin, officially known as the Federal Republic of Germany. When Germany was reunited in 1991, the former East Germany became part of the Federal Republic.

59. "Art Since 1945: International Stocktaking at Kassel," *Times* (London), 20 July 1959.

60. "In dieser grossartigen Ueberschau ist zu erkennen, wie die Deformierung dazu dient, die innerlich zerstörten formen des Menschenbildes wieder in den organischen Zusammenhang einzufügen, ja das Menschenbild aus diesem Zusammenhang neu und reiner zu erschaffen. Es gibt kaum ein zeitgenössisches Lebenswerk, das nachdrücklicher von der Liebe zum Menschen zeugte. Nur ein Regime, dem an Zerstörung des Menschen gelegen war, konnte eine Kunst, die ihr entgegenzuwirken trachtet, als entartet bezeichnen." Klaus-Henning Bachmann, "Für ein reineres Menschenbild," *Westfälische Rundschau* (Meschede), 1 June 1960.

61. Werner Langer, "Imposante Henry Moore-Ausstellung in der Akademie, Verwandlungen der Frau," *Der Abend*, 22 July 1961, 1.

62. An article in the *Industriekurier*, 24 December 1959.

63. Eberhard Fiebig, "Importiertes Pathos? Ein Wort an den Bundeskanzler," *Frankfurter Allgemeine Zeitung*, 1 October 1979.

64. In the *New York Times*, 26 November 1993, D12.

65. Terence Mullaly, "Foreign Fields Forever Henry Moore's," *Daily Telegraph*, 16 February 1974.

66. "Moore's Sculpture, 'Like a Whale,' Surfaces in Dallas," *New York Times,* 4 December 1978.

67. Janet Kutner, "Sculptor Bronzes His Support for New Dallas Art Museum," *Dallas Morning News,* 2 November 1979.

68. Sidney Tillim, "Month in Review," *Arts Magazine* (New York) 36, no. 9 (May–June 1962): 82–84.

69. Krauss, 3; see also 23: "What I would like, then, to put forward as the persistent meaning of the core is that it represents an ideological position that makes sculpture an investigatory tool in the service of knowledge."

70. Anthony Barnett, "Breaking Through and Falling Off," *Times Literary Supplement* (5–11 August 1988), 847–48.

71. Caro, 21.

72. Ibid.

73. Dawn Ades, "Henry Moore, Sculpture and Drawings," in *British Art in the Twentieth Century: The Modern Movement,* (London: Royal Academy, 1987), 211.

74. Barnett, 847–48.

75. Caro, 21.

76. Herbert Read, *Henry Moore, Sculpture and Drawings* (London: Lund Humphries, 1944), xxxvi.

77. Jean Clay, "Henry Moore's Venture into Mass," *Réalités* 174 (May 1965): 46–51, 88.

78. Yve Alain Bois, Rosalind Krauss, and others who have privileged Bataille and explored so thor[...] [...]rely, despite the visual evidence, vehemently obje[...]

79. See "Influen[...] [...]al *World of Henry* [...]

80. "To display [...] re-lates to the sky [...] [...]r-roundings. Onl[...] [...]nd so we are able [...] [...]ch viewing frees t[...]

81. Daniel Wh[...] Thames and H[...]

82. Sylvester, [...]

83. Quoted b[...] [...]8), 110.

84. Ibid., 111[...]

85. "The Scu[...]

86. Clement [...] *of* *the Sixties* (L[...] *nt* Greenberg, [...] *Ven-* geance, 195[...] *Chi-* cago Press, [...]

87. Homi K. [...] Berke-ley, Los Anç[...] [...]Gallery, 1998), 17–[...]

88. Peter S[...] [...]d *Drawings* [...]

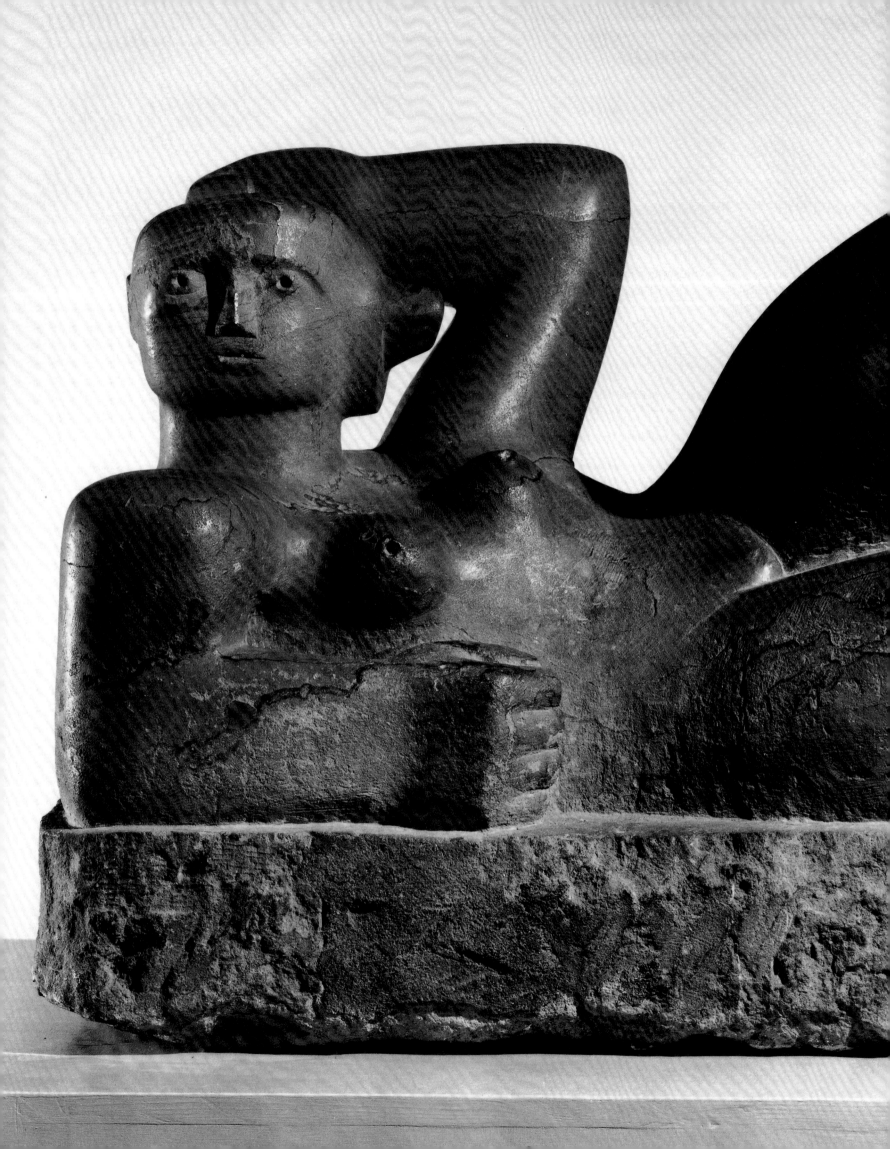

Alan Wilkinson

Moore: A Modernist's "Primitivism"

The term "Primitive Art" is generally used to include the products of a great variety of races and periods in history, many different social and religious systems. In its widest sense it seems to cover most of those cultures which are outside European and the great Oriental civilisations.[1]

In his drawings and sculpture, and in his writings and interviews, Henry Moore's dialogue with primitive art, as he used and understood the term, is unique in the history of modernist primitivism. During the 1920s and 1930s, and sporadically during the 1940s and 1950s, the influence of primitive art–prehistoric fertility goddesses, African, Oceanic, Peruvian, Inuit, and, above all, pre-Columbian sculpture– had, in my opinion, a more sustained impact on Moore's work than on the work of any other major twentieth-century painter or sculptor. With artists such as Paul Gauguin, Pablo Picasso, Henri Matisse, Amedeo Modigliani, Constantin Brancusi, Jacques Lipchitz, Jacob Epstein, Henri Gaudier-Brzeska, and Alberto Giacometti, there is little or no documentary evidence as to specific examples of primitive art with which they were familiar and which may have informed their work directly or indirectly. Moore, on the other hand, especially in his notebook drawings of the 1920s, provides us with an extensive and invaluable record of specific sculptures and artifacts which he had seen on his many trips to the British Museum, and in a number of books on primitive art, such as Carl Einstein's *Negerplastik* (1920), Ernst Fuhrmann's *Afrika* (1922), *Reich der Inka* (1922), and *Mexiko III* (1922), Herbert Kühn's *Die Kunst der Primitiven* (1923), and Leo Frobenius's *Kulturgeschichte Afrikas* (1933). I have identified drawings in the notebooks of the 1920s of prehistoric European, Egyptian, Sumerian, and Cycladic art, as well as the far more numerous copies of African, Oceanic, Peruvian, Northwest Coast, and Inuit artifacts and sculpture. These drawings not only document those sculptures which Moore particularly admired to the extent that he felt compelled to record them in his notebooks; but in a number of instances, they also reveal the exact sources in primitive art for specific sculptures, thereby revealing the creative process itself, that is to say, the way

in which a work has been assimilated and transformed, as Epstein commented, "according to the personality of the artist. A complete re-creation in fact through a new mind."[2] Moore's own writings about primitive art span more than fifty years, from his first and most important article on the subject, which appeared in the *Listener* on 24 August 1941, to the 1981 publication *Henry Moore at the British Museum.* Four of the six sections of photographs of fifty of his favorite sculptures in the British Museum, with commentaries by the artist, are devoted to primitive art: Aztec, Oceanic, African, and American and Caribbean sculpture. Among Moore's selection of tribal sculpture are four carvings which he had copied in his notebooks of the 1920s.

Moore first became aware of primitive art in 1920 when he read Roger Fry's *Vision and Design* (1920) during his last year at the Leeds School of Art. The importance of this book on the formation of Moore's ideas about sculpture cannot be overemphasized. Certain passages in the chapters "Negro Sculpture" and "Ancient American Art" not only prepared the young Yorkshire sculptor for the great ethnographic collections of the British Museum, but also shaped his ideas on two important concepts: direct carving and the full, three-dimensional realization of form. As Moore commented: "Fry opened the way to other books and to the realization of the British Museum."[3] Another influential book was Ezra Pound's *Gaudier-Brzeska: A Memoir* (1916), which Moore read either in Leeds or soon after he arrived in London in September 1921 to study at the Royal College of Art. A number of Moore's carvings of the early 1920s, such as the 1922 marble *Dog* (cat. 1), were influenced by Gaudier's Vorticist sculptures of 1913–14. In addition, Gaudier's impassioned account of the role of the modern sculptor–"That this sculpture has no relation to classic Greek, but that it is continuing the tradition of the barbaric peoples of the earth"[4]–is echoed in Moore's 1930 statement: "This removal of the Greek spectacle from the eyes of the modern sculptor . . . has helped him to realize again the intrinsic emotional significance of shapes instead of seeing mainly a representation value."[5] Gaudier had remarked: "The Indians felt the hamitic [African] influence through Greek spectacles."[6] One of Gaudier's most famous dictums, "Sculptural energy is the mountain,"[7] is, I think, clearly reflected in Moore's comment that

Reclining Figure (detail), 1929. Leeds Museums and Galleries (City Art Gallery) (LH 59)

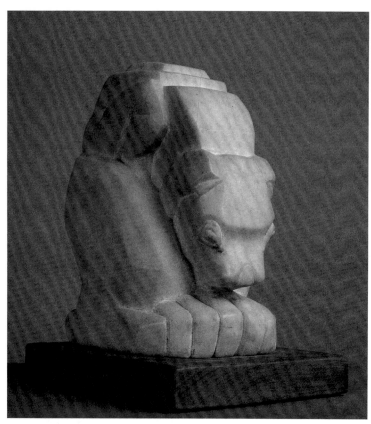

Cat. 1. Henry Moore, *Dog,* 1922. The Henry Moore Foundation: gift of the artist 1977 (LH 2)

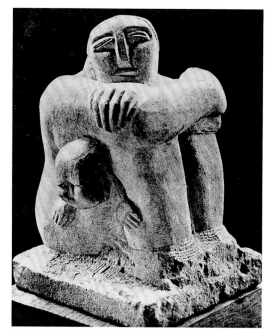

Fig. 1. Henry Moore, *Mother and Child,* 1922. Whereabouts unknown (LH 3)

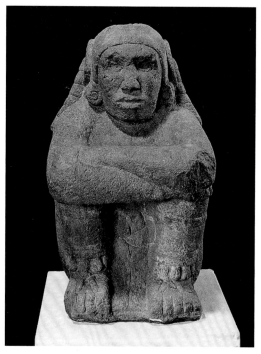

Fig. 2. Aztec stone seated man, c. 1400–1500 A.D. The British Museum, London

the sculpture that moves him most gives out "something of the energy and power of great mountains."[8]

In his article "Primitive Art" (1941) Moore takes us on a guided tour of the British Museum and describes his reactions during his first visits in 1921 to the collections of prehistoric, Egyptian, Sumerian, archaic Greek, African, Oceanic, and pre-Columbian sculpture. No other artist has provided us with such a detailed record of his encounter with primitive art. Moore explained why he particularly admired pre-Columbian sculpture, which was the most important formative influence on his work of the 1920s:

> Mexican sculpture, as soon as I found it, seemed to me true and right, perhaps because I at once hit on similarities in it with some eleventh-century carvings I had seen as a boy on Yorkshire churches. Its "stoniness," by which I mean its truth to material, its tremendous power in that loss of sensitiveness, its astonishing variety and fertility of form-invention and its approach to a full three-dimensional conception of form, make it unsurpassed in my opinion by any other period of stone sculpture.[9]

Moore's response to the pre-Columbian sculpture he had seen in the British Museum was almost immediate—as immediate as it could have been, given the demands of the academic curriculum during his first year at the Royal College of Art. In the summer of 1922 (it was during the holidays that he could give "a free reign to the interests I had developed in the British Museum"[10]) Moore executed his earliest carving inspired by pre-Columbian art, the Portland stone *Mother and Child* (fig. 1), which is, as John Russell has suggested, very close to the squatting pose and blocklike massiveness of the Aztec stone seated man, circa 1400–1500 A.D., in the British Museum (fig. 2).[11]

Several of Moore's stone heads and masks of the 1920s are almost pastiches of their pre-Columbian prototypes. The 1923 alabaster *Head* (cat. 2) is remarkably similar to the head of a man in the Völkerkunde Museum, Vienna (fig. 3), which is illustrated on page 10 of Ernst Fuhrmann's *Mexiko III* (1922). He may well have seen a copy of this publication at Zwemmer's bookshop in Charing Cross Road. Moore's little marble *Snake* of 1924 (cat. 3) was undoubtedly inspired by the coiled serpents of the Aztecs. With these three works, all one can do is suggest what appear to be obvious affinities between the Moore carvings and examples of pre-Columbian sculpture. We have no way of knowing whether the artist was actually inspired by the Aztec seated man, or by a specific mask or coiled serpent.

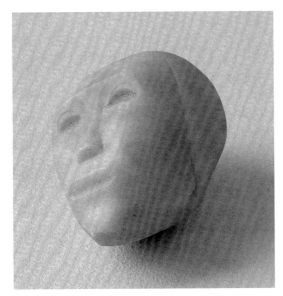

Cat. 2. Henry Moore, *Head,* 1923. The Henry Moore Foundation: acquired 1998 (LH 10)

Fig. 3. Head of a man, n.d., Mexico. Museum für Völkerkunde, Vienna. Published in Ernst Fuhrmann, *Mexiko III,* 1922

Cat. 3. Henry Moore, *Snake,* 1924. Private collection (LH 20)

Some of the most fascinating and revealing examples of the process of assimilation and transformation of a specific work of primitive art are the studies on page 105 verso of Notebook No. 3, 1922–24, in which the elongated form of the stone pestle, in the form of a bird, from northeast Papua New Guinea, in the British Museum (figs. 4, 5), has been radically altered. The key to understanding the creative process is the inscription "abstraction" near the top of the page. Moore is no longer interested in making straightforward copies of the stone pestle. For his purposes, he obviously found the New Guinea carving "too thin," as another inscription reads, and so he has created a less elongated and more compact form. He has also radically transformed its smooth surfaces, producing a complex series of planes and angles

that owes an obvious debt to the 1914 Vorticist sculpture of Gaudier-Brzeska, such as *Birds Erect* (fig. 6). Although the ideas inspired by the stone pestle were never realized in three-dimensional form, to be presented with direct evidence of a one-to-one dialogue with a known work of tribal sculpture is very rare indeed in the history of modernist primitivism.

The Chacmool reclining figure in the Museo Nacional de Antropología, Mexico City (fig. 7), was, Moore told me, "undoubtedly the one sculpture which most influenced my early work." I would add that it was the one sculpture that most influenced his lifelong obsession with the reclining figure theme. The accounts of when and where Moore first became aware of this Chacmool carving vary considerably.

Fig. 4. Stone pestle, n.d., Papua New Guinea. The British Museum, London

Fig. 5. Henry Moore, *Studies of Sculpture from the British Museum (Page 105 verso from Notebook No. 3),* 1922–24. The Henry Moore Foundation: gift of the artist 1977 (HMF 123v)

Fig. 6. Henri Gaudier-Brzeska, *Birds Erect,* 1914. The Museum of Modern Art, New York. Gift of Mrs. W. Murray Crane

Fig. 7. Aztec Chacmool figure, 900–1000 A.D., Mexico. Museo Nacional de Antropología, Mexico City

Fig. 8. Henry Moore, *Idea for Garden Bench (Page 59 from Sketchbook 1928: West Wind Relief),* 1928. The Henry Moore Foundation: gift of Irina Moore 1977 (HMF 639)

Herbert Read was, I presume, told by Moore himself that he had seen a plaster cast of the pre-Columbian sculpture in 1925 on a visit to the Musée d'Ethnographie in Paris, which occupied one wing of the Palais du Trocadéro.[12] Moore told David Sylvester that he saw an illustration of the Mexico City Chacmool in Walter Lehmann's *Altmexikanische Kunstgeschichte* (1922, plate 45) in Zwemmer's bookshop, probably around 1927.[13] However, on the evidence of the two small studies of reclining figures at lower right on page 93 of Notebook No. 2, 1921–22 (fig. 9), he had undoubtedly seen the Chacmool in 1922, either at the Trocadéro on his first visit to Paris in the spring of that year, or in Lehmann's book. When I showed him these two studies, he described them as "the first bit of influence of the Mexican [Chacmool] reclining figure. I might have seen a plaster cast of it in the Trocadéro." Moore almost certainly took Notebook No. 2 with him to Paris. On page 79 verso (fig. 10), we find the name and address of a Paris hotel, as well

as thumbnail sketches of seated figures that in my opinion unquestionably reflect that the impact of Cézanne's *Les Grandes Baigneuses,* 1898–1905, which Moore had seen in the Pellerin Collection in Paris, and which is now in the Philadelphia Museum of Art. Although the pose of the Chacmool is echoed in several other notebook drawings of the mid-1920s, it was not until 1928, toward the end of *Sketchbook 1928: West Wind Relief* (fig. 8)–which includes more than sixty studies for the relief carving–in the preparatory sketches for a garden relief of a "single reclining figure," that the shock of recognition resurfaced with a vengeance. From the studies for the garden relief evolved the definitive drawing for the 1929 Hornton stone *Reclining Figure* (fig. 11). In contrast to the symmetrical pose of the Chacmool, Moore has turned the body on its side, but the head, turned sharply at right angles to the body, is a feature directly based on the pre-Columbian carving. When I asked him why the Chacmool had made such a powerful impact on him, he replied: "Its stillness and alertness, a sense of readiness–and the whole presence of it, and the legs coming down like columns." I can think of no other single work of primitive art that has had such an overwhelming and sustaining influence on an artist as the Chacmool had on the sculpture of Henry Moore. Indeed, I do not think that he ever forgot the pose, the rhythms, and the massive weightiness ("without loss of sensitiveness") of the pre-Columbian stone carving, nor the sense of watchfulness and alertness that the head conveys. For example, the 1952–53 *Draped Reclining Figure* (fig. 12), for all its relative naturalism and strong echoes of the drapery of the Elgin marbles, is essentially a reinterpretation of the pose of the Chacmool, with the figure lightly camouflaged in classical attire.

During the 1930s Moore's interest in primitive art continued, but its influence was more sporadic than in the previous

Fig. 9. Henry Moore, *Studies for Sculpture (Page 93 from Notebook No. 2),* 1921–22. The Henry Moore Foundation: gift of the artist 1977 (HMF 66)

Fig. 10. Henry Moore, *Studies of Seated Figures (Page 79 verso from Notebook No. 2),* 1921–22. The Henry Moore Foundation: gift of the artist 1977 (HMF 60v)

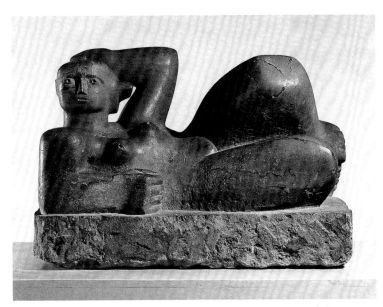

Fig. 11. Henry Moore, *Reclining Figure,* 1929. Leeds Museums and Galleries (City Art Gallery) (LH 59)

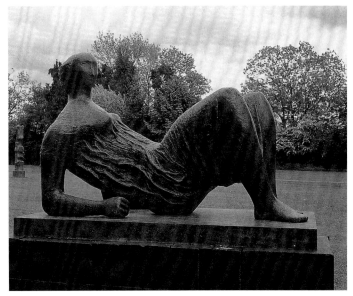

Fig. 12. Henry Moore, *Draped Reclining Figure,* 1952–53. The Henry Moore Foundation: gift of the artist 1977 (LH 336)

decade. In the 1920s, carvings such as the 1923 *Head* (cat. 2) and the 1929 Leeds *Reclining Figure* (LH 59), seem to me to be hybrids, their provenance, as it were, attributable in more or less equal measure to the sculptor and to pre-Columbian sculpture. In the 1930s Moore's primitivism is less blatantly obvious, as he distanced himself from his sources, and combined his passion for tribal art with the liberating influence of Surrealism, in particular the sculpture of Picasso, Jean Arp, and Giacometti–works such as Picasso's 1928 *Metamorphosis,* Arp's 1931 *Bell and Navels,* and Giacometti's 1934 *Woman with Her Throat Cut.* And, like his Surrealist colleagues, Moore turned to Inuit and above all Oceanic art for inspiration.

The 1931 Boxwood *Girl* (cat. 19) is one of the few sculptures to reflect the direct influence of Inuit art, although Moore had made

a sketch on page 99 verso of the Notebook No. 3, 1922–24 (fig. 13), of an Inuit needle case. The clue to the source of the Moore carving is found in the two studies of standing figures in the bottom half of the 1931 drawing *Studies of Primitive Sculptures* (fig. 14), which were based on Inuit bone and ivory figurative carvings. In *Girl,* the round head, the narrow shoulders, the spaces between the thin arms and the torso, and the legs truncated above the knees echo very closely the proportions of the exquisite little Inuit ivories (fig. 15), often not more than 10 centimeters, or about 4 inches, in height. In a much later sculpture, the 1955 bronze *Upright Motive: Maquette No. 11* (fig. 16), Moore blended organic forms with details that were almost certainly borrowed from Inuit art. The three curved, horizontal projections in the maquette have remarkable affinities to similar features found in Inuit ivory drum handles.

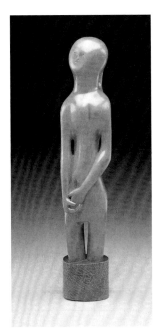

Cat. 19. Henry Moore, *Girl,* 1931. Dallas Museum of Art, Foundation for the Arts Collection, gift of Cecile and I. A. Victor (LH 112)

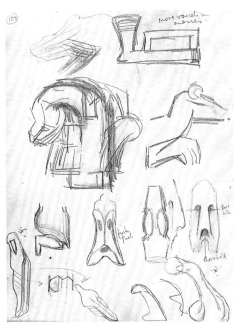

Fig. 13. Henry Moore, *Studies of Sculpture in the British Museum (Page 99 verso from Notebook No. 3),* 1922–24. The Henry Moore Foundation: gift of the artist 1977 (HMF 120v)

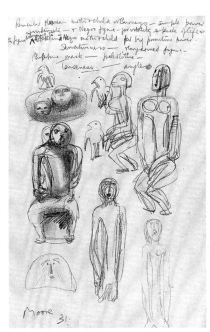

Fig. 14. Henry Moore, *Studies of Primitive Sculptures,* 1931. Whereabouts unknown (HMF 884)

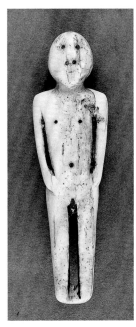

Fig. 15. Inuit ivory figure, n.d., North America. The British Museum, London

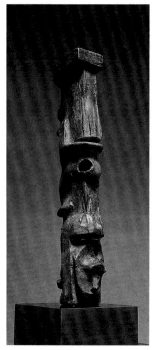

Fig. 16. Henry Moore, *Upright Motive: Maquette No. 11,* 1955. The Henry Moore Foundation: gift of the artist 1977 (LH 391)

Fig. 17. Henry Moore, *Internal/External Forms (Page from Sketchbook B)* c. 1935. The Henry Moore Foundation: gift of the artist 1977 (HMF 1226)

Fig. 18. Malanggan figure, c. 1900, New Ireland. The British Museum, London

In his 1941 article on primitive art, Moore remarked:

> Comparing Oceanic art generally with Negro art, it has a livelier, thin flicker, but much of it is more two-dimensional and concerned with pattern making. Yet the carvings of New Ireland have besides their vicious kind of vitality, a unique spatial sense, a bird-in-a-cage form.[14]

He is referring to the Malanggan figures from New Ireland. Of all the Oceanic tribal styles, it was the intricate Malanggan carvings that had the greatest formal impact on Moore's sculpture, second only in importance, in my opinion, to the pre-Columbian Chacmool discussed

above. The earliest evidence of his awareness of the New Ireland figures are the two studies at left in *Internal/External Forms (Page from Sketchbook B)* of circa 1935 (fig. 17), which were almost certainly based on a carving in the British Museum (fig. 18). In the larger study on the right of the sheet, Moore has transformed the Oceanic carving into an idea for sculpture. This was almost certainly the first of the internal/external form drawings executed between 1935 and 1940. Many years later, Moore described his fascination with the structure of Malanggan carvings:

> I realized what a sense of mystery could be achieved by having the inside partly hidden so that you have to move round the sculpture to understand it. I was also staggered by the craftsmanship needed to make these interior carvings.[15]

Moore's first internal/external form sculpture was *The Helmet,* 1939–40 (cat. 47), which was not in fact related to the New Ireland figures but was based on an illustration he had seen in *Cahiers d'art* (1934) of two prehistoric Greek utensils or implements (fig. 19). It was not until 1948, in drawings such as *Ideas for Sculpture: Internal and External Forms,* that he returned to the motif which he had first explored in the circa 1935 sketchbook page. The 1948 drawing (fig. 20) includes the study for the 1951 bronze *Maquette for Upright Internal/External Forms* (LH 294), the first of many subsequent sculptures on this theme, all of which have their ancestry in the Malanggan carvings from New Ireland. (The 1951 plaster working model [cat. 56] is shown here.)

Two sculptures of the late 1930s reflect affinities with Oceanic sculpture. I am convinced, although as far as I know there is no documentary evidence to support

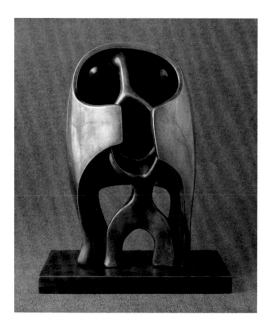

Cat. 47. Henry Moore, *The Helmet,* 1939–40. The Henry Moore Foundation: gift of Irina Moore 1977 (LH 212)

Fig. 19. Two Prehistoric Greek implements. National Museum, Athens. Published in *Cahiers d'art,* 1934

Fig. 20. Henry Moore, *Ideas for Sculpture: Internal and External Forms,* 1948. Smith College Museum of Art, Northampton, Massachusetts (HMF 2408)

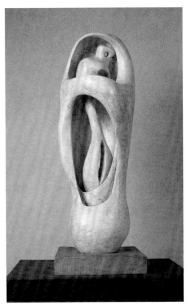

Cat. 56. Henry Moore, *Working Model for Upright Internal/External Form,* 1951. The Henry Moore Foundation: gift of the artist 1977 (LH 295)

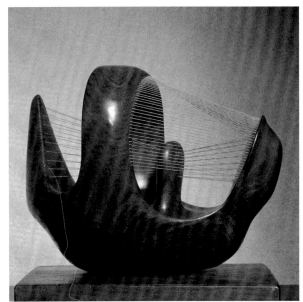

Cat. 43. Henry Moore, *Bird Basket,* 1939. Private Collection (LH 205)

Fig. 21. Friction drum, New Ireland. The Field Museum of Natural History, Chicago

my claim, that Moore's 1939 *Bird Basket* (cat. 43) was inspired by the friction drums from New Ireland (fig. 21). Extraordinarily disparate sources, including tribal art, have been suggested as the inspiration for the 1939–40 *Three Points* (cat. 46).[16] There are remarkable similarities between the Moore sculpture, with the three points practically touching, and the "hook" figures, or Yipwons, from the Karawari region of New Guinea (fig. 22), in which the penis is "protected" above and below by two pointed, riblike forms. However, given the some thirty variations on sharp, spike-like shapes in the circa 1939–40 *Pointed Forms* drawing in the Albertina (fig. 23), including at upper left the study for *Three Points,* I am now inclined to believe that the affinities with the "hook" figures may be merely fortuitous.

There are only a handful of drawings and sculpture from the 1940s and 1950s that reflect the continuing if sporadic impact of primitive

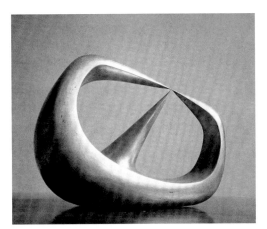

Cat. 46. Henry Moore, *Three Points,* c. 1939–40. The Henry Moore Foundation: gift of Irina Moore 1977 (LH 211)

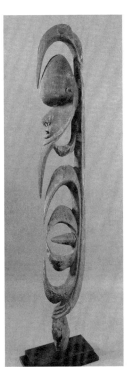

Fig. 22. Yipwon figure, Alamblak, Karawari River, East Sepik Province, Papua New Guinea. Friede Collection, New York

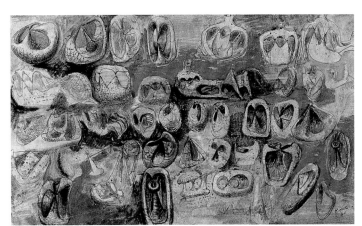

Fig. 23. Henry Moore, *Pointed Forms,* 1940. Graphische Sammlung Albertina, Vienna (HMF 1496)

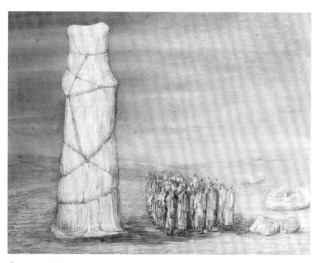

Cat. 171. Henry Moore, *Crowd Looking at a Tied-up Object,* 1942. The British Museum, London (HMF 2064)

Fig. 24. Nupe villagers, Nigeria, standing beside two veiled Dako cult dance costumes. Published in Leo Frobenius, *Kulturgeschichte Afrikas,* 1933

art on Moore's work. His most famous pictorial drawing, the 1942 *Crowd Looking at a Tied-up Object* (cat. 171) was directly based on a photograph in Leo Frobenius's book *Kulturgeschichte Afrikas* (1933) (fig. 24), a copy of which Moore owned, showing Nupe tribesmen in Northern Nigeria standing around two veiled (but not tied-up) Dako cult dance costumes. In the history of modernist primitivism, this drawing is one of the few works inspired not by a work of art, but by a photograph of a tribal ceremony. The 1952 bronze *Maquette for Mother and Child* (cat. 59) is, in the words of Erich Neumann, "perhaps the most negative expression of the mother and child idea in the whole of Moore's work."[17] For a number of years I was convinced that the sculpture was related to Picasso's paintings of the late 1920s and early 1930s, such as the menacing, bonelike forms of *Seated Bather* of 1930 (fig. 25). That was until I found a copy in Moore's library of Ernst Fuhrmann's *Peru II* (1922), with an illustration of a Chimu Peruvian pot (fig. 26). Eureka! Barbara Braun has explained the iconography of the mythological scene in pressed relief on the Peruvian pot:

This one depicts a struggle between two fantastic beings, the deity Ai-Aipec in the guise of an anthropomorphic bird versus a sea monster. Moore focused on the latter figure, who clutches and threatens to devour Ai-Aipec's serpent belt, transforming it into a rather sinister version of the mother and child theme. The serpent head metamorphoses into a child with a gaping mouth straining toward the upright breast of its mother, whose serrated head, breast, and outstretched arm derive from the toothy open maw and the arm of the monster.[18]

Moore's obsession with the mother and child theme is nowhere more tellingly illustrated than in his appropriation and transformation of the fantastic, complex imagery of the Peruvian pot. He was indeed, as he remarked, "conditioned, as it were, to see it in everything."[19]

In the history of modernist primitivism, Moore's borrowings from primitive art, perhaps more than the work of any other major artist,

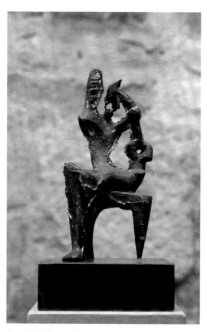

Cat. 59. Henry Moore, *Maquette for Mother and Child,* 1952. The Henry Moore Foundation: gift of Irina Moore 1977 (LH 314)

Fig. 25. Pablo Picasso, *Seated Bather,* 1930. The Museum of Modern Art, New York. Mrs. Simon Guggenheim Fund

Fig. 26. Chimu black war pot, c. 800–1300 A.D. Museum für Völkerkunde, Vienna. Published in Ernst Fuhrmann's *Peru II,* 1922

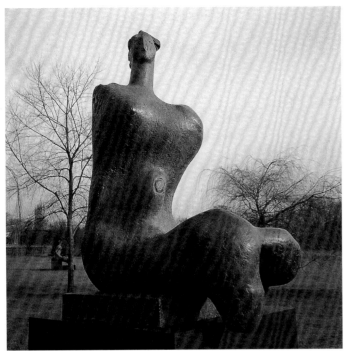

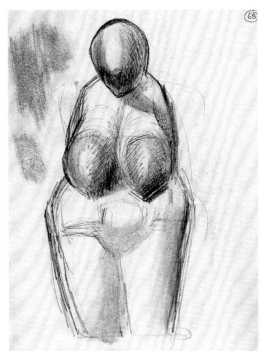

Fig. 27. Henry Moore, *Woman,* 1957. The British Council (LH 439)

Fig. 28. Henry Moore, *Study after 'Venus of Grimaldi'* *(Page 68 from Notebook No. 6),* 1926. The Henry Moore Foundation: gift of the artist 1977 (HMF 460)

refute Robert Goldwater's contention that "direct formal adaptations have been few, and, except perhaps for Brancusi himself, very little modern sculpture even recalls the general proportions and rhythm of any specific tribal style."[20] As we have seen, Moore's notebooks of the 1920s and 1930s not only recorded numerous examples of primitive art with which he was familiar, but in a number of instances the drawings also document the transformation of identifiable sources into ideas for specific sculptures. Through his writings, we experience those sculptural characteristics of primitive art that Moore so admired, its truth to the material, and its extraordinarily varied, conceptual re-creation of the human figure. In my many discussions with Moore about prehistoric European, African, Oceanic, and pre-Columbian sculpture, I cannot recall a single instance when he veered from his fascination with the formal, three-dimensional qualities of the works, as well as the often staggering technical brilliance with which these anonymous artists manipulated their materials, from the British Museum's prehistoric "tender carving of a girl's head, no bigger than one's thumbnail"[21] to the intricate, delicately carved Malanggan figures from New Ireland.

Moore's 1957–58 *Woman* (fig. 27) is one of the last sculptures to reflect the influence of primitive art. *"Woman,"* he commented, "emphasizes fertility like the Paleolithic Venuses (fig. 28) in which the roundness and fullness of form is exaggerated."[22] However, for the remaining twenty-nine years of his life, as collector and commentator, Moore never lost his admiration for primitive art, which in the 1920s and 1930s had played such a vital role in the formation and consolidation of his vision of three-dimensional form.

Notes

1. Philip James, ed., *Henry Moore on Sculpture* (London: Macdonald, 1966), 155, originally published as "Primitive Art" in *The Listener,* 24 August 1941.

I fully realize how problematic the usage of the term "Primitive Art" is. Nonetheless this loaded phrase held very specific, nonderogatory meaning for Moore and his contemporaries in the 1920s, 30s, and 40s.

2. Jacob Epstein, interviewed by Arnold Haskell, in Arnold L. Haskell, *The Sculptor Speaks* (London: William Heinemann, 1931), 96.

3. James, 49.

4. Ezra Pound, *Gaudier-Brzeska: A Memoir* (London and New York: John Lane, 1916), 35.

5. James, 57.

6. Pound, 10.

7. Ibid., 9.

8. James, 58.

9. Ibid., 159.

10. Ibid., 34.

11. John Russell, *Henry Moore* (London: Allen Lane, 1968), 14.

12. Herbert Read, *Henry Moore: A Study of His Life and Work* (London: Thames and Hudson, 1965), 64.

13. David Sylvester, *Henry Moore*, exh. cat. (London: Tate Gallery, Arts Council of Great Britain, 1968), 156, note 12.

14. James, 159.

15. Henry Moore, *Henry Moore at the British Museum*, photographs by David Finn (London: British Museum Publications, 1981), 81.

16. David Sylvester, in the 1968 Tate Gallery exhibition catalogue, has suggested that "one of those Picassos of the *Guernica* period with a woman's or a horse's mouth open in agony and a thrusting tongue with the form of a comical spike" could have been an unconscious source for the central spike in Moore's *Three Points*. Moore told Sylvester that his source of inspiration was a painting in the Louvre, the sixteenth-century School of Fontainebleau double portrait of Gabriella d'Estrées and her sister in the bath, showing the pinching of Gabrielle's nipple between her sister's forefinger and thumb. When I discussed the double portrait with Moore, he rather whimsically dismissed the connection, and indicated that he was leading Sylvester on a merry chase.

17. Erich Neumann, *The Archetypal World of Henry Moore*, trans. R. F. C. Hull (New York: Harper and Row, 1959), 174.

18. Barbara Braun, "Henry Moore and Pre-Columbian Art," *Res* 17/18 (Spring/Autumn 1989): 193.

19. John Hedgecoe, ed., *Henry Moore,* photographs by John Hedgecoe, words by Henry Moore (London: Nelson, 1968), 61.

20. Robert Goldwater, *Primitivism in Modern Art* (New York: Vintage Books, 1967), 246.

21. James, 157.

22. Hedgecoe, 326.

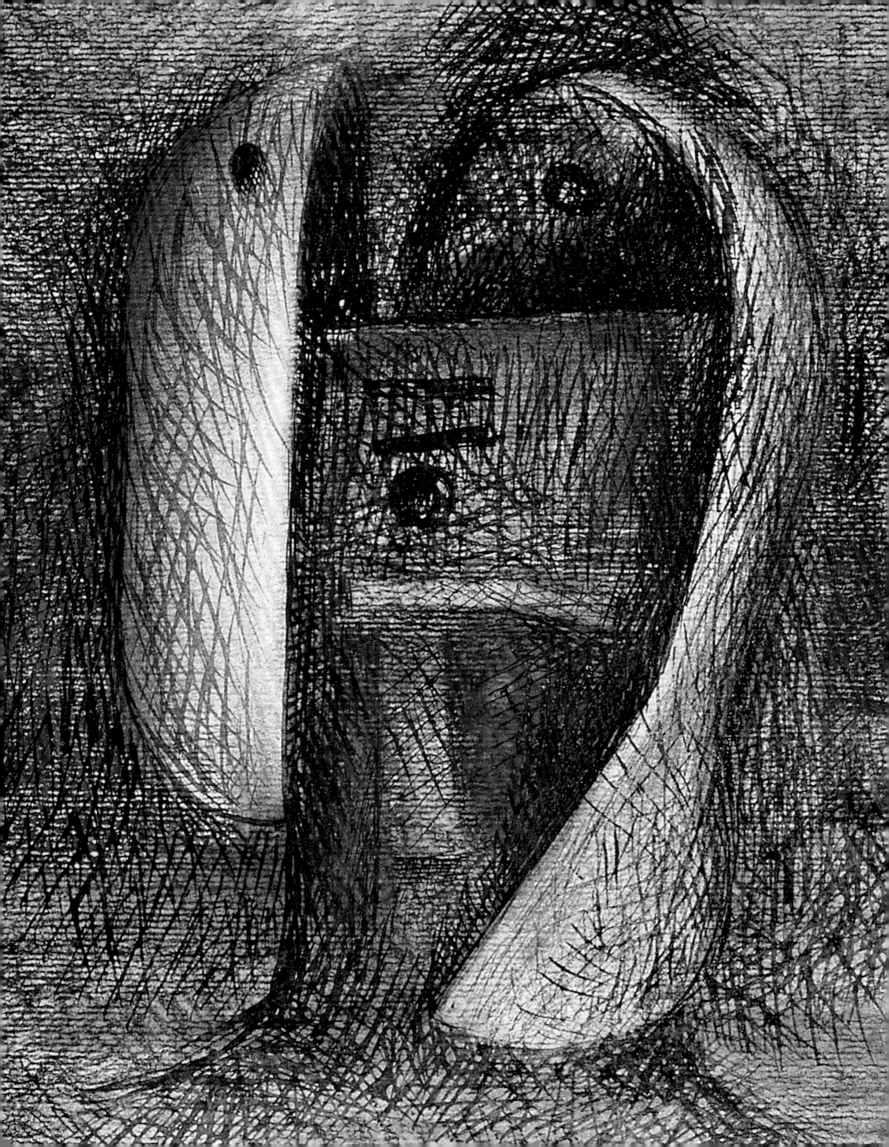

Steven A. Nash

Moore and Surrealism Reconsidered

In Henry Moore's long and productive career, the 1930s represent his most creatively experimental period. Building upon those elements that had given promising character to his work of the previous decade—most notably his interest in ancient and so-called primitive art and his attraction to modernism through such predecessors in English sculpture as Jacob Epstein and Henri Gaudier-Brzeska—he seemed suddenly to find new confidence and the inspiration to push his art into realms not previously explored. Abstraction, advanced forms of biomorphism, extreme anatomical distortion, and even a hint of the geometric language of Constructivism pulse through his sculpture and drawings of this period in an extraordinarily fertile process of exploration and growth that stretched considerably the boundaries of his sculptural thought. Many of the resulting works strike us even today as radical and out of character with Moore's long-range development. They had lasting significance, nevertheless, and helped fuel his progress from talented newcomer to major international figure.

What accounts for this daring departure? Several propitious circumstances had their effect. Moore was surrounded in his private and professional lives by a group of artists and critics united in their dedication to modernist principles, helping to bring a new spirit of innovation to English art. He traveled to Europe regularly in the late 1920s and early 1930s, gaining firsthand knowledge of contemporary trends, which he supplemented by examining various international art journals. He participated in several important exhibitions and enjoyed the security of a reliable teaching position that allowed considerable time for his art. In terms of his own development, however, the most crucial, energizing influence came from Surrealism and two sources in particular: the sculpture of Alberto Giacometti and the paintings, sculpture, and drawings of Pablo Picasso from the late 1920s, interpreted at the time as part of the orbit of Surrealism. Other sources certainly had importance, most notably the work of Constantin Brancusi and Jean Arp, complemented by Moore's continuing interest in the tradition of certain ancient and tribal cultures, especially Oceanic and pre-Columbian. But Picasso and Giacometti played the key roles, in ways more far-reaching and somewhat different in

character than generally recognized. They obviously appealed to the tumultuous, febrile side of Moore's creative imagination. In Picasso's work, Moore found reinventions of the human figure more varied and extreme than with any other artist alive, and Giacometti by the early 1930s had already introduced several new sculptural idioms while also bringing to modern sculpture a heightened level of emotionalism. Together, they had a liberating impact with long-lasting consequences.[1]

The history of Moore's involvement with Surrealism in England is now well known and can be quickly summarized.[2] With the growing internationalism of the French Surrealist movement in the late 1920s and early 1930s, its influence spread to England through a core group of artists and critics who shared a strong bent toward modernism and a leftward political bias. Friends of Moore's, including Roland Penrose and Herbert Read, were at the center of that group. In what had been relatively provincial territory, contact with the ideas of artists such as Joan Miró, Giacometti, Picasso, and Salvador Dalí and the writings of poets and theorists such as Paul Eluard and André Breton had a tremendously invigorating effect, even if differences of philosophy sometimes intervened. Moore is someone who never shared entirely the Surrealists' worldviews but benefited nevertheless from their artistic example. David Gascoyne, an enterprising writer and one of the prime movers behind Surrealism in England, characterized Moore in 1935 as an artist balancing abstraction and Surrealism and "a constructor of images between the conscious and the unconscious and between what we project emotionally into the objects of our world," an analysis that still seems apt today.[3]

During his regular trips to France—Moore told Alan Wilkinson that he traveled to Paris twice a year from 1922 to 1933–34, and he returned at least in 1937, when he had a famous encounter with Picasso—he met Giacometti, Miró, Arp, Picasso, Breton, and others in the Surrealist group.[4] He exhibited repeatedly in Surrealist circles in London, Paris, and New York during the thirties,[5] and was on the organizing committees for the infamous *International Surrealist Exhibition* in London in 1936, to which he contributed seven works, and also for the exhibition *Artists Against Fascism,* presented by the left-wing Artists International Association in 1935. Moore's work was

Two Heads: Drawing for Metal Sculpture (detail), 1939. The Henry Moore Foundation: acquired 1977 (cat. 151)

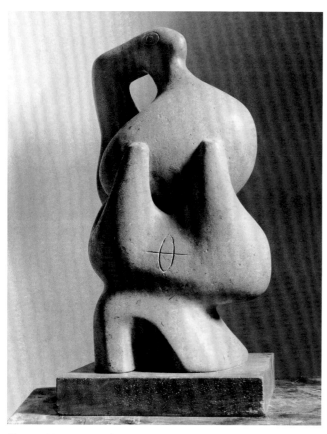

Cat. 13. Henry Moore, *Composition,* 1931. The Moore Danowski Trust (LH 99)

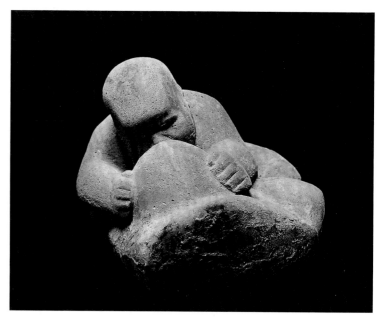

Fig. 1. Henry Moore, *Suckling Child,* 1927. Whereabouts unknown (LH 42)

reproduced fairly often in publications with strong Surrealist associations such as *Minotaure* and *Cahiers d'art* in Paris and the *International Surrealist Bulletin* and *London Bulletin* in London. His political sympathies were aligned with the antifascist stance of the Surrealists even if he did not subscribe to their unqualified support of communism. Among other activities, he participated in 1937 in a charitable exhibition in support of the Spanish Medical Aid Committee, signed published statements calling for an end to the British government's policy of nonintervention toward Spain, worked on behalf of the International Peace Campaign, produced a lithograph to be sold in support of the Spanish Republican cause, and was even invited by the Republican government to visit Spain in 1938 (the British Foreign Office refused the necessary permits).

Politics aside, there was much about Surrealism to which Moore did not respond. Its literary contrivances and emphasis on automatism had no place in his art, nor did its love of flagrant psychodrama, its tendency toward misogyny, or the blasphemous humor found, for example, in Picasso's art of the period. But even if unsympathetic by temperament to Surrealism's most extreme manifestations and never a doctrinaire member of the movement, Moore absorbed a great deal that helped shape his new languages of form and even the emotionally expressive side of his work. A well-known statement by Moore in 1937 reads like a Surrealist credo: "There are universal shapes to which everybody is subconsciously conditioned and to which they can respond if their conscious control does not shut them off."[6]

It was two sculptures from 1931, the *Reclining Figure* in lead and the carved *Composition* (cat. 13), that introduced most dramatically the emerging directions Moore was to take.[7] The first of these continued the theme of the reclining figure that already in the 1920s

had emerged as a major preoccupation. Whereas such works as the Leeds *Reclining Figure* of 1929 and the *Reclining Figure* in the National Gallery of Canada from 1930 have a powerful bulk and a compact rhythm of undulating masses that declare origins in pre-Columbian art but retain a basic faithfulness to human anatomy, the figure from 1931 departs more radically from naturalism. Its stretching and pinching of the body produces a sinuous morphology suggestive of an insect or even a fish. The hollowing out of the elongated thorax and insertion of three bars across its front is an especially bold device. Some critics have proposed a relationship between this form and the slender riblike protrusions found in certain types of Oceanic figures that appear in Moore's drawings.[8] There is also an echo, however, of several sculptures by Giacometti from the late 1920s. *Composition (Man and Woman)* of 1927, *Woman Dreaming* of 1929, *Man* of 1929, and *Three Figures Outdoors* of 1929 all use lattice or riblike structures as analogues for anatomical parts, mysteriously dematerializing the body into abstract pattern.[9]

In the case of *Composition,* an unusual opportunity exists to follow the development of the sculpture through an extended series of drawings and thus understand more completely the references it contains.[10] Certain of these drawings make it clear that Moore from the outset was thinking of a mother suckling her baby (fig. 2; cat. 121), with particular reference back to one of his own early sculptures, the *Suckling Child* of 1927 (fig. 1). This work, which had aroused critical ire when first exhibited,[11] eliminated with bold concision all but the breast of the mother and upper body of the child. Having already simplified his grouping, Moore then began to rethink its anatomical shorthand through the lens of Picasso's pneumatically distorted figures from the late 1920s, works well known to Moore from their publication in *Cahiers d'art* and other sources. On the same drawing as the reprised *Suckling Child* (fig. 2), Moore sketched at the left a standing figure whose long, tapering, flange-like legs, exaggerated breasts, single eye, and expanded upper body clearly derive from similar figures by Picasso (fig. 3).

As Moore's thinking on this theme evolved, it went through many stages recorded in other exploratory drawings, several of which

Fig. 2. Henry Moore, *Study of a Suckling Child*, c. 1930–31. The Henry Moore Foundation: gift of the artist 1977 (HMF 831)

Fig. 3. Pablo Picasso, *Figure*, 1927. Musée Picasso, Paris

Fig. 4. Pablo Picasso, *Metamorphosis*, 1928. Musée Picasso, Paris

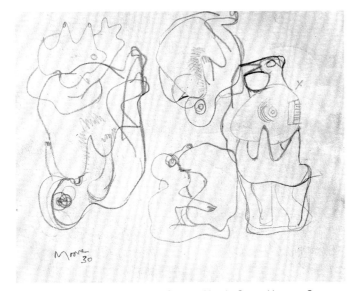

Cat. 121. Henry Moore, *Ideas for Composition in Green Hornton Stone (Page from No. 1 Drawing Book 1930–31)*, 1930–31. The Henry Moore Foundation: gift of the artist 1977 (HMF 832)

delineate the motif of a mother nursing her baby. *Composition* is the sculpture that finally emerged. The baby has disappeared, and the theme of nursing survives only metaphorically in the swollen torso and erect breasts of the mother. Again, as many writers have pointed out, the intervention of Picasso came into play through his sculpture from 1928 entitled *Bather* or *Metamorphosis* (fig. 4), his only work to render three-dimensionally the biomorphic distortions of his figures from this period.[12] Moore seems even to have aped the pose (a bent arm lifted to the head) and the incised markings for eyes and sexual organs. Certainly the general conception is Picasso's. In combination, the influence of Picasso and Giacometti had led Moore in these two works from 1931 to fantasize the body in ways he had not previously imagined, opening new paths for further exploration.

Numerous works from the period carry on the biomorphic stylizations of anatomy found in these two objects. Among the most pronounced examples of this new vocabulary are the *Composition* in African wonderstone of 1932, *Reclining Figure* in Corsehill stone of 1934–35 (cat. 27), *Mother and Child* in Ancaster stone of 1936,

and the wonderfully inventive *Reclining Figure* in Hopton-wood stone from 1937 (cat. 33).[13] In the smooth carving and rounded, purified contours of all these works, a debt clearly is owed to Brancusi and Arp. These works are among the most abstract that Moore produced in the thirties, but his underlying commitment to the human figure, strong even here, results in echoes or suggestions of bodily forms, albeit simplified and abstracted, that clearly make these sculptures "figures."

The departure from recognizable anatomy is most extreme in the *Reclining Figure* of 1937. Those unaccustomed to the body language found in Moore's preceding sculptures might be tempted to see this work as a giant foot or root. With preparation, we can see the protruding knob at the upper right as a head, the major forms stretching to the side as torso and legs, another knob as a breast, and the vertical protrusion at the end as a foot or raised knee. In the profuse record of experimentation found in Moore's contemporaneous drawings, a number of sketches relate to this work, and two in particular (fig. 5) link side-by-side a more recognizable reclining figure and a variant with biomorphic abstractions similar to those in the sculpture.

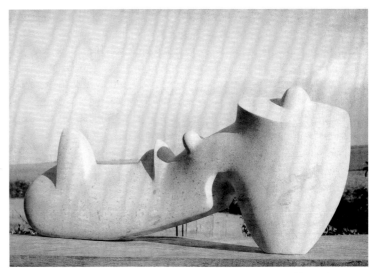

Cat. 33. Henry Moore, *Reclining Figure*, 1937. Fogg Art Museum, Harvard University Art Museums, Gift of Lois Orswell (LH 178)

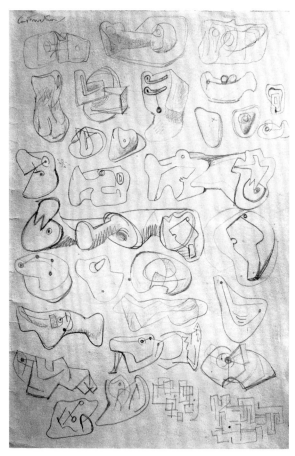

Fig. 5. Henry Moore, *Ideas for Sculpture*, 1934–35. The Henry Moore Foundation: gift of the artist 1977 (HMF 1134)

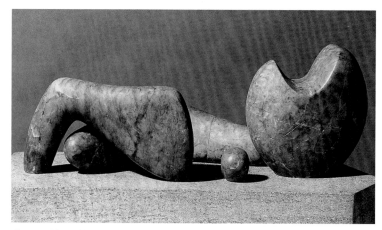

Cat. 26. Henry Moore, *Four-Piece Composition: Reclining Figure,* 1934. Tate. Purchased with assistance from the National Art Collections Fund 1976 (LH 154)

One sketch on this same sheet, showing an amorphous, mortarlike shape with two balls balanced on top, is particularly Arp-like in its family of forms, and Arp's stone carvings from around this same period might be invoked as an influence behind the *Reclining Figure.* Several aspects, however, point again in the direction of Picasso. The humanoid quality, so aggressively transformed, relates it more closely to Picasso, since Arp's sculptural references generally fall more into the animal and plant kingdoms. The sexuality of the figure, with the knobby breast and, just below, a sliced dome that might refer to female genitalia, nods toward Picasso. And the interesting qualities of scale in this work, shared with other of Moore's biomorphic figures, is another indication of Picasso's influence. Only 33 inches long, the sculpture projects a much grander sense of monumentality. Again, the closest precedent is Picasso's tumescent, monstrous figures from the late 1920s, which are small in actual dimension but suggestive of giant monuments. Some of the heads and bonelike standing figures that Picasso conceived as huge sculptures must have been particularly striking to Moore.[14] In their investigations of implied scale, use of bone forms as substitutes for the body, breakdown of the body into interlocked separate parts, and piercing of anatomy with holes, Moore would have found fertile ideas as he began to explore similar themes of his own.

Moore's ovoid stylizations, with their connotations of organic fecundity and bone structure, carry over into several works in composite, or multipart compositions, spread laterally atop a flat "table-top" base. The most famous of these is the *Two Forms* of 1934 in wood,[15] where the larger, hollowed-out shape is poised protectively close to the smaller, rounded form in a relationship often described

as connoting a mother and child, and two works similar in conception, the *Four-Piece Composition: Reclining Figure* (cat. 26), and *Composition,* both of 1934.[16] The latter two both are reclining figures, separated laterally into component parts reminiscent of bones and pebbles. This conscious effort to connect his inventions with natural shapes obviously had lasting significance for Moore, and *Composition* is also one of the earliest examples of another favorite device, the introduction of space into solid volumes with holes. The glyptic technique of incising fine lines onto a stone for suggestions of space and anatomy, as seen in *Four-Piece Composition: Reclining Figure*, is common in works from the 1930s but not beyond. It might derive from Ben Nicholson or Joan Miró, both of whom used similar linear codes in their paintings, or the incised lines found in certain sculptures by Giacometti, or might even represent another pre-Columbian influence via the Olmec art of incised celts.

The single most commonly quoted source for Moore's laterally displaced, composite figures is Giacometti's famous *Woman with Her Throat Cut* from 1932, an icon of Surrealism that had been published, among other places, in the issue of *Minotaure* from December 1933. The idea of spreading a sculptural composition across a flat base, so antithetical to the ancient tradition of the vertical statue, was very much "in the air" at the time. Moore would have seen examples in work by Arp and, as documented by his drawings, certainly was aware of Giacometti's repeated and highly inventive use of the device

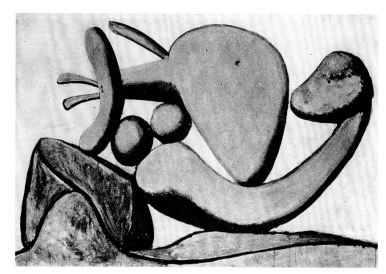

Fig. 6. Pablo Picasso, *Figure Carrying a Stone,* 1931. Private Collection

Fig. 7. Henry Moore, *Ideas for Wood Constructions,* 1934. The Henry Moore Foundation: gift of the artist 1977 (HMF 1136)

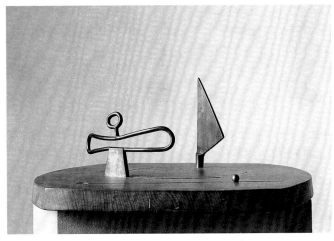

Fig. 8. Alberto Giacometti, *Man, Woman, and Child (Three Mobile Figures on a Ground),* c. 1931. Oeffentliche Kunstsammlung Basel, Kunstmuseum, Gift of Marguerite Arp-Hagenbach, 1968

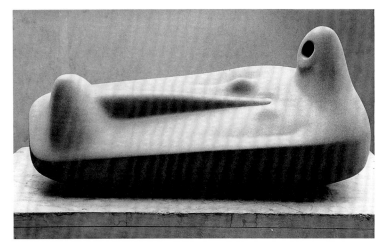

Cat. 27. Henry Moore, *Reclining Figure,* 1934–35. The Moore Danowski Trust (LH 155)

Fig. 9. Alberto Giacometti, *Landscape/Reclining Head,* 1932. Musée national d'art moderne, Centre Georges Pompidou, Paris

(compare figs. 7 and 8). It is interesting to note, for example, that Moore's *Reclining Figure* of 1934–35, with its ghostly vestiges of a figure fused onto a flat plane as a type of figural landscape, recalls so distinctly Giacometti's *Landscape/Reclining Head* of 1932 (compare figs. 13 and 14).

Invocation of *Woman with Her Throat Cut* as a primary influence behind Moore's two bonelike composite figures, however, misses the mark.[17] These two sculptures–*Four-Piece Composition: Reclining Figure* and *Composition*–have none of the spiky, metallic, insectlike quality of Giacometti's figure, nor do they show any of the sexual and psychological violence she projects. That Moore was not immune to the fascination with violence exploited by much of Giacometti's Surrealist work is demonstrated by his use of Giacometti's pointed,

clublike *Disagreeable Object* from 1931 as the model for his own *Sculpture to Hold* from 1936, a mysteriously threatening carving that counts among his most abstract sculptures and shows him dabbling in the Surrealist cult of object-as-sculpture.[18] In comparison with *Woman with Her Throat Cut,* however, the *Four-Piece Composition: Reclining Figure* and *Composition* are serene, psychologically neutral studies in formal balance and rhythmic variation. We have already seen Moore digging deeply into Picasso's rich iconography of biomorphic figures from the late 1920s. This is again the genealogy behind his two composite figures, with their rounded and dismembered but still tightly coordinated forms. Comparison with a work such as *Figure Carrying a Stone* (fig. 6) shows the close relationship. They avoid the sexual tension that is just as much a part of Picasso's work of this type as Giacometti's, but nevertheless celebrate a liberated approach to rethinking the human body.

Another theme that Moore explored repeatedly during the 1930s is that of the flattened or blocked-off "head" or "torso" often elaborated with incisions or carved geometric patterns. Major examples include the *Square Form* of 1936, *Carving* of 1936, and *Head* of 1937 (fig. 10).[19] In each of these, Moore gave the block of stone in one way or another a geometric character. Curved contours retain an organic note related to his biomorphic figures, but by flattening and squaring the frontal plane and truing some of the edges he introduced a new architectonic structure. One now reads the works in terms of a distinct frontal surface. The marking of these surfaces with carved

Fig. 10. Henry Moore, *Head,* 1937. Private collection, (LH 177)

Fig. 11. Alberto Giacometti, *Woman,* 1928. Collection of the Alberto Giacometti Foundation, Kunsthaus Zürich

circles or bars, incised right angles, and other incised shapes and drill holes helps produce variations of shadow and planes and sometimes even provides an anatomical sign language.

At work here was a response on Moore's part to Constructivism and geometric abstraction, such strong factors in the heady mix of artistic ideas then current in both England and Europe. His friend Ben Nicholson had begun his highly purified white reliefs in 1934, which seem to have a bearing, for example, on Moore's *Carving* from 1936. Moore knew and admired Piet Mondrian's work, befriended Naum Gabo and Mondrian when they emigrated to England in 1936 and 1938, and was closely involved with many of the artists and critics who published *Circle: International Survey of Constructive Art* in 1937, to which he contributed a statement. Moore's observation in his article "The Sculptor Speaks" in 1937 that he saw no conflict between Surrealism and abstraction is highly relevant in this context.[20] Both camps offered ideas worth exploring, and he did not hesitate to amalgamate them as he saw fit.

The group of works under discussion, for all their embrace of geometry, still are rooted in Surrealism, and the main source again is Giacometti. With his *Head of the Artist's Father* of 1927,[21] Giacometti first experimented with a Cubist-like flattening of the volumes of the human head, rendering the face as a triangular plane on which he scratched rather than modeled his father's features. This device rapidly evolved into his so-called plaques—wafer-thin geometric forms that substitute for a full body, torso, or head (fig. 11). Shallow indentations and incised lines symbolize different bodily parts and orifices, and the use of asymmetry and slightly warped or curved contours keep alive the notion of an organic being. In contrast, Moore's sculptures are never so conceptually simplified. Their bulky volumes preserve more of a corporeal presence, but their flattened planes and abstracted vocabulary of signs and marks follow Giacometti's

lead in the creation of totems that are part geometry and part biology. They are not among Moore's leading accomplishments of the period—their combination of sculptural mass, geometry, and surface markings seems not to spring from a unified concept—but they are among his most interesting. And they demonstrate again an inquiring mind and a willingness to take chances.

Even the works presumed to be Moore's most scientific from this period, his stringed pieces, show the penchant for ambiguity and transformation that typifies his attraction to Surrealism. The story of how these works came about is now well known. Moore himself attributed their origins to mathematical and scientific models he discovered in the Science Museum in South Kensington while still attending the Royal College of Art: "You know, those hyperbolic paraboloids and groins and so on, developed by Lagrange in Paris, that have geometric figures at the ends with coloured threads from one end to the other to show what the form between would be. I saw the sculptural possibilities of them."[22] His many sculptures and drawings of stringed objects came considerably later; all date from between 1937 and 1940. "I could have done hundreds," Moore related. "They were fun, but too much in the nature of experiments to be really satisfying. That's a different thing from expressing some deep human experience one might have had."[23] Others have pointed out that the initial conception of these pieces must have been more complicated. Alan Wilkinson, for example, cites the fact that Barbara Hepworth had begun to experiment with the use of strings in sculptures at about the same time and that Naum Gabo made drawings of objects with radiating lines suggesting strings as early as 1933.[24] By 1937 Gabo began to inscribe plastic surfaces with lines that evolved into thin plastic rods and then nylon filament. Moore was certainly aware of works of this type by both artists, but it is impossible now to establish a chronology of who did what exactly when. Moore also knew, through

Cat. 151. Henry Moore, *Two Heads: Drawing for Metal Sculpture,* 1939.
The Henry Moore Foundation: acquired 1997 (HMF 1462)

their publication in *Cahiers d'art* in 1936, of Man Ray's evocative photographs of scientific models with strings that were housed at the Institut Henri Poincaré in Paris.[25] Man Ray, of course, was not interested in these models for their explication of mathematical forms. He found in them, as we see from his photographs, a poetry of light and visual rhythm and, it appears, a provocative or mysterious quality made more poignant by its birth in the rationality of science. Moore, at least at first, would have been equally attuned to the expressive side of these objects.

In his sculptures and the drawings based on them, Moore created with stringing a formal play of linearity against mass and of one color and material against another. The strings appear at times to be lines of force, membranes or ligaments describing fragile organs, and at others, purely abstract notation. Whatever their function, they open up Moore's sculptural forms with a novel type of transparency. The shapes they create are virtual, fully invaded by light and space. As

Moore told one author, what excited him about the resulting effects was "the ability to look through the strings as with a bird cage and to see one form within another."[26]

The strings are thus a key part of the interaction of internal and external form that was then and would remain so crucial a theme in Moore's work, one also expressed in his related investigation of cages, helmets, and other emblems that fall into a category of containment or confinement. The spatial fusion of front and back, inside and outside had been one of the goals of Moore's sculpture since early in the 1930s, and had been achieved with various means. His piercing of volume with holes, tunneling out of heavy masses, creation of transparencies with strings, and, with *The Helmet* of 1939–40,[27] enclosure of one form within another, all worked to this end. The results were basic to Moore's understanding of the continuity of mass and space but also had important expressive dimensions. In that search for "some deep human experience one might have had," Moore was interested in more than purely formal realities, and the exploration of internal spaces helped move him into psychological territory familar to the Surrealists.

Toward the end of the 1930s a dark mood began to invade Moore's work, one out of keeping with the optimistic humanism that illuminates most of his art. It may be linked to the deteriorating social and political conditions in Europe, as the continent moved with greater inevitability toward war. The outbreak of the Spanish Civil War in 1936 politicized many artists who reacted with horror and sympathy to the plight of the Spanish people. Moore and others connected with the Surrealist movement in England played active roles in support of the Republican cause, as already noted. Two drawings that Moore made in 1939, the *Spanish Prisoner* and *Two Heads: Drawing for Metal Sculpture* (cat. 151),[28] show the intense expressionism that was becoming more commonplace in his work. The first was used for a lithograph to be sold in a fundraising effort for the Republicans, just as Picasso's famous *Dream and Lie of Franco* had been sold at the International Exposition in Paris in 1937. Its bizarre prisoner's head, with a face entrapped in a cagelike outer casing, refers in its general configuration to Moore's sculpture *The Helmet* and in its three bars down the front to the *Reclining Figure* of 1931 and certain Dogon Mother Masks that Moore had drawn earlier.[29] *Two Heads: Drawing for Metal Sculpture* has an even more sinister look. The two heads swim in a gloomy half-light and, in their opening up to reveal inner recesses, seem to delve into notions of secretiveness, concealment, and murky interior life. The motif of the cage head is repeated in the equally tenebrist *Two Women: Drawing for Sculpture Combining Wood and Metal* of 1939 (fig. 12), that springs from the imaginative metallic or wood assemblages in Picasso's *An Anatomy* from 1933 (fig. 13).

Other drawings from 1937–39 deal with similarly tense themes, featuring dark caves, strange masks engulfed by night

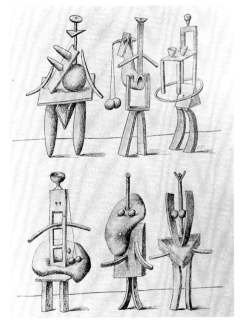

Fig. 12. Henry Moore, *Two Women: Drawing for Sculpture Combining Wood and Metal,* 1939. The British Museum, London (HMF 1445)

Fig. 13. Pablo Picasso, *Page from "An Anatomy,"* 1933. Reproduced in *Minotaure,* no. 1 (1933): 33–37

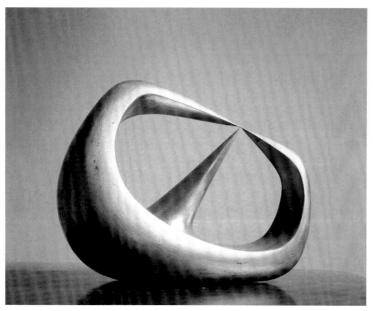

Cat. 46. Henry Moore, *Three Points,* 1939–40. The Henry Moore Foundation: gift of Irina Moore 1977 (LH 211)

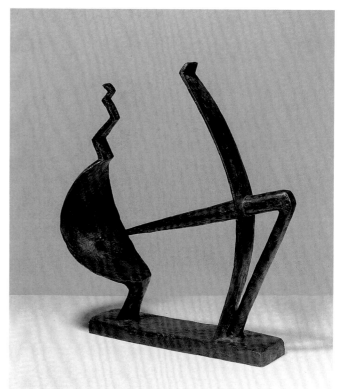

Fig. 14. Alberto Giacometti, *Man and Woman,* 1928–29. Musée national d'art moderne, Centre Georges Pompidou, Paris

or shadow, and figures trapped within confining interiors.[30] Moore's dialogues of internal and external form are a potent device in this context. In *The Helmet,* for example, we get some of the same "poisonous" sense of a "face peering out from inside a prison" that Moore identified in the later *Helmet Head No. 1* and *No. 2* of 1950.[31] A work such as *Three Points* from 1939–40 (cat. 46), with its two sharply pointed sides wrapping around and converging on the tip of another sharp spike that shoots up from inside, takes on a particularly aggressive quality when seen in the light of these other works. It may derive in part from Malanggan sculptures from New Ireland (a type of object that Surrealists such as Max Ernst and Echaurren Matta found highly evocative),[32] but surely it also references contemporary European art that uses menacing points for themes of attack and alarm, including Giacometti's *Point to the Eye* of 1931[33] and *Man and Woman* of 1928–29 (fig. 14) or Picasso's convulsed women and animals with spikes for tongues in *Guernica* and its related studies, exhibited in London in October 1938 and known earlier to Moore through a visit to Picasso's studio while he was working on *Guernica* in 1937.[34] Even Moore's many stringed figures, outwardly more benign, carry connotations of cages, as Moore pointed out. Giacometti earlier had developed the sculptural idea of the cage to a highly expressive pitch in works such as the *Palace at 4 A.M.* from 1932–33 and *The Cage* from 1931,[35] with their nightmarish evocation of isolation and confinement. Such works were well known to Moore. They find an echo in the transparency of his stringed figures and the secretive forms suspended inside his helmet heads, both modeled and drawn.[36]

England's entry into World War II and the German bombing of London and other cities would, of course, educe from Moore a long series of profoundly moving wartime drawings on themes of deprivation, fear, and perseverance. Many of his works from the 1930s, with strong ties to Surrealism, provide a meaningful prelude to these more overtly narrative images. They highlight the turbulent side of his imagination, generally suppressed in later years but alluded to by his friend Kenneth Clark as "the deep, disturbing well from which emerged his finest drawings and sculpture."[37]

It would be a distortion to try to apply these expressive themes too broadly to Moore's work of the 1930s. His indefatigable energy for formal invention and his generally practical, down-to-earth personality kept his work mostly on the level of rational investigation, unweighted by psychological or emotional burden. Nevertheless, the more aggressive approach to form and metaphorical content that his interests in Surrealism promoted left an important mark. This is seen, for example, in the magnificent elmwood *Reclining Figure* from 1939 in the Detroit Institute of Arts, a key link between Moore's Chacmool-inspired figures from the 1920s and his progeny of later reclining figures in various degrees of abstraction.[38] With its hollows penetrating into deep, shadowed recesses; its expanding and contracting rhythms of anatomy; and its small, carved-out head, this great sculpture is unthinkable without Moore's earlier excursions into the visual fantasies of Giacometti and Picasso. Its mysterious, otherworldly quality is fundamental and powerful, in a way that did not exist in the large reclining figures of the 1920s. That it appealed so strongly to the Surrealist painter Gordon Onslow-Ford, who bought it after its exhibition in *Surrealism Today* at the Zwemmer Gallery in June 1940, is not surprising.

Moore approached Surrealism selectively, taking from it what he wanted, mixing ideas with other influences, and making them his own. An important lesson, for example, was the fusion of disparate realities into a unified whole. The hybrid forms that resulted, partway between abstraction and representation, exalted ambiguity and the evocation of multiple experiences and associations. A new freedom of imagination encouraged metamorphic transformations and such implied correspondences, basic to his later work, as those between bodies and landscape, hollows and oral or genital openings, bones and pebbles and anatomical parts. Division of the body into separate formal units is an idea that derived from both Arp and the Surrealists.

Cryptic incisions, substitutions of geometric pattern for human anatomy, the poetic nature of mathematical models, biomorphic abstraction, the cage theme, and the tunneling out of bodily forms are all ideas that find earlier expression in works by Giacometti, Picasso, or other Surrealists. Certainly the darker, more emotionally distraught moods that seep into Moore's work not just during the Spanish Civil War and World War II but occasionally in later sculptures and drawings as well reflect back on Surrealist precedents.[39] Even if Moore's work in the immediate postwar period retreated to the safer ground of religious figures and family groups, his most radical sculptures and drawings of the 1930s should not be seen as merely experimental diversions. The liberation of invention and imagination they represent could not be reversed.

Notes

1. While numerous authors in recent years have touched upon the subject of Moore and Surrealism, several have given it particular focus. These include Alan Wilkinson in *The Drawings of Henry Moore*, exh. cat. (London and Ontario: The Tate Gallery and Art Gallery of Ontario, 1977), passim, and in "Henry Moore," *Primitivism in Twentieth-Century Art*, exh. cat. (New York: Museum of Modern Art, 1984), 594–613; Anna Gruetzner, "Some Early Activities of the Surrealist Group in England," *Artscribe*, no. 10 (1978): 22–25; David Sylvester, *Henry Moore* (New York and Washington, D.C.: Frederick Praeger, 1968), passim; Richard Morphet, "Four-Piece Composition: Reclining Figure," *The Tate Gallery 1976–78. Illustrated Catalogue of Acquisitions* (London: The Tate Gallery, 1979), 116–22; Christa Lichtenstern, "Henry Moore and Surrealism," *The Burlington Magazine* 123, no. 944 (November 1981): 644–58. I am particularly indebted to Lichtenstern's research and analysis. She and I reach similar conclusions on a number of points. In general, however, she places primary emphasis in her exegesis of Moore's work from the 1930s on the importance of tribal art and publications about it, whereas I believe the main causative force behind his development was European Surrealism.

2. In addition to the sources cited in note 1, reference should be made to Roger Berthoud's biography, *The Life of Henry Moore* (London: Faber and Faber, 1987), chapters 7 and 8.

3. David Gascoyne, "Comment on England," *Axis*, no. 1 (January 1935): 10.

4. See Alan Wilkinson, in David Mitchinson, ed., *Celebrating Moore: Works from the Collection of The Henry Moore Foundation* (Berkeley, Los Angeles, London: University of California Press, 1998), 110. On Moore's visit to Picasso's studio in the rue des Grands-Augustins in 1937, when Picasso was working on *Guernica*, see Roland Penrose, *Picasso: His Life and Work*, 3rd ed. (Berkeley and Los Angeles: University of California Press, 1981), 306–7. During their meeting, Picasso pinned a long streamer of toilet paper to the hand of one of the horrified women in his painting and quipped sardonically, "There, that leaves no doubt about the commonest and most primitive effect of fear." During that same trip to Paris, Moore lunched with André Breton, Ernst, Giacometti, and Paul Eluard. See John Russell, *Henry Moore* (London: Allen Lane, 1968; rev. ed. Pelican, 1973), 129–30. Moore told Christa Lichtenstern that he first met Giacometti, Arp, and Miró in Paris in 1931–32; see Lichtenstern, 645.

5. These exhibitions included *Fantastic Art, Dada, Surrealism* (New York: Museum of Modern Art, 1936–37); *The International Surrealist Exhibition* (London: New Burlington Galleries, 1936); *Exposition Internationale du Surréalisme* (Paris: Galerie des Beaux-Arts, 1938); *Realism and Surrealism* (Gloucester: Guildhall, 1938); *Exposición Internacional del Surrealismo* (Mexico City: Galería de Arte Mexicano, 1940); and *Surrealism Today* (London: Zwemmer Gallery, 1940).

6. From "The Sculptor Speaks," *The Listener*, 18 August 1937; reprinted in Philip James, ed., *Henry Moore on Sculpture* (London: Macdonald, 1966), 64.

7. See David Sylvester, ed., with introduction by Herbert Read, *Henry Moore: Complete Sculpture*, vol. 1, *Sculpture 1921–48*, 5th ed. (London: Lund Humphries, 1988), nos. 101, 99. This catalogue is referred to hereafter as LH 1. It was the *Reclining Figure* from 1931 that Alfred Barr selected from Moore's works to illustrate in his exhibition catalogue *Fantastic Art, Dada, Surrealism* (New York: Museum of Modern Art, 1936), fig. 445.

8. See Wilkinson, "Henry Moore," 604, and Lichtenstern, 657, figs. 13 and 14.

9. See Reinhold Hohl, *Alberto Giacometti* (New York: Harry N. Abrams, 1971), 42, 51, 52, 54.

10. See, for example, Ann Garrould, ed., *Henry Moore: Complete Drawings*, vol. 2, *1930–39* (London: The Henry Moore Foundation and Lund Humphries, 1998), nos. AG30.78, 30.79, 30–31.5 to 31.11.

11. For the mixed critical reactions to this work, see Berthoud, 91–92. It has been reported in the past that Jacob Epstein bought this work, but apparently this is not the case. He did own an alabaster *Suckling Child*. I am indebted to Martin Davis at the Henry Moore Foundation for his help with research on this work, and to Emma Stower, also of the Moore Foundation, for her patient assistance in tracking down photographs of this and numerous other works by Moore.

12. Among the numerous authors who have pointed out the close relationship between Moore's *Composition* and Picasso's *Metamorphosis* are Wilkinson, *Drawings of Henry Moore*, 83, and Sylvester, 35.

13. LH 1, nos. 119, 155, 165, 178.

14. See, for example, Christian Zervos, *Pablo Picasso*, (Paris: Cahiers d'art, 1955), vol. 7, nos. 84–109, 198–213.

15. LH 1, no. 153.

16. LH 1, nos. 154, 140.

17. The most thorough investigation of Moore's sources for these works is found in Morphet, "Four-Piece Composition: Reclining Figure." In discussing specifically the *Four-Piece Composition: Reclining Figure* with Morphet, Moore acknowledged several works that he felt had significance for his composition: Arp's *Bell and Navels*, 1931; Picasso's two drawings for *An Anatomy*, 1933, and his *Drawing: Project for a Monument*, 1928; Giacometti's *Woman with Her Throat Cut*, 1932, and *Objets mobiles et muets*, 1931. Within this general range of influences, it is the Picasso *Project for a Monument* and related works that seem to me most pertinent in terms of the abstracted bodily parts that Moore created.

18. Moore's *Sculpture to Hold* is LH 1, no. 173. Giacometti's *Disagreeable Object* is illustrated in Hohl, 291, fig. 33. See also Lichtenstern, figs. 4 and 5.

19. LH 1, nos. 167, 164, 177.

20. James, 67.

21. Reproduced in Hohl, 46.

22. James, 84.

23. Carlton Lake, "Henry Moore's World," *Atlantic Monthly* (January 1962): 39–45.

24. Alan G. Wilkinson, *Gauguin to Moore: Primitivism in Modern Sculpture*, exh. cat. (Toronto: Art Gallery of Ontario, 1981), 286.

25. *Cahiers d'art*, 11, no. 1–2 (1936): 4–20.

26. John Hedgecoe, *Henry Moore* (New York: Simon and Schuster, 1968), 105.

27. LH 1, no. 212.

28. Mitchinson, ed., *Celebrating Moore*, nos. 107, 106.

29. See Lichtenstern, figs. 1 and 10. The close-up view of the Dogon Mother Mask published in *Minotaure*, no. 2 (1933): 27, shows most clearly the resemblance to the head of Moore's *Spanish Prisoner*.

30. For example, see Garrould, *Complete Drawings*, vol. 2, nos. AG37.66v, 37.46–47, 37.73, 38.35–44, 38.46, 39.29, 39–40.25, 39–40.39.

31. Hedgecoe, 185.

32. See Wilkinson, "Henry Moore," 607.

33. Hohl, 64.

34. This point is made by Sylvester, 36.

35. Hohl, 67, 56.

36. Cagelike forms appear in Moore's drawings as early as 1933. See Garrould, *Complete Drawings*, vol. 2, nos. AG33.17–33.19.

37. Kenneth Clark, *Another Part of the Wood* (New York: Harper & Row, 1974), 256.

38. LH 1, no. 210.

39. Notable among these later works are, for example, the *Maquette for Mother and Child* of 1952 (Mitchinson, ed., *Celebrating Moore*, no. 165), *Helmet Head No. I* of 1950 (ibid., no.158), and the drawings *Head* from 1958 and *Rock Landscape with Classical Temple* from 1972 (Wilkinson, *Drawings of Henry Moore*, nos. 227, 248).

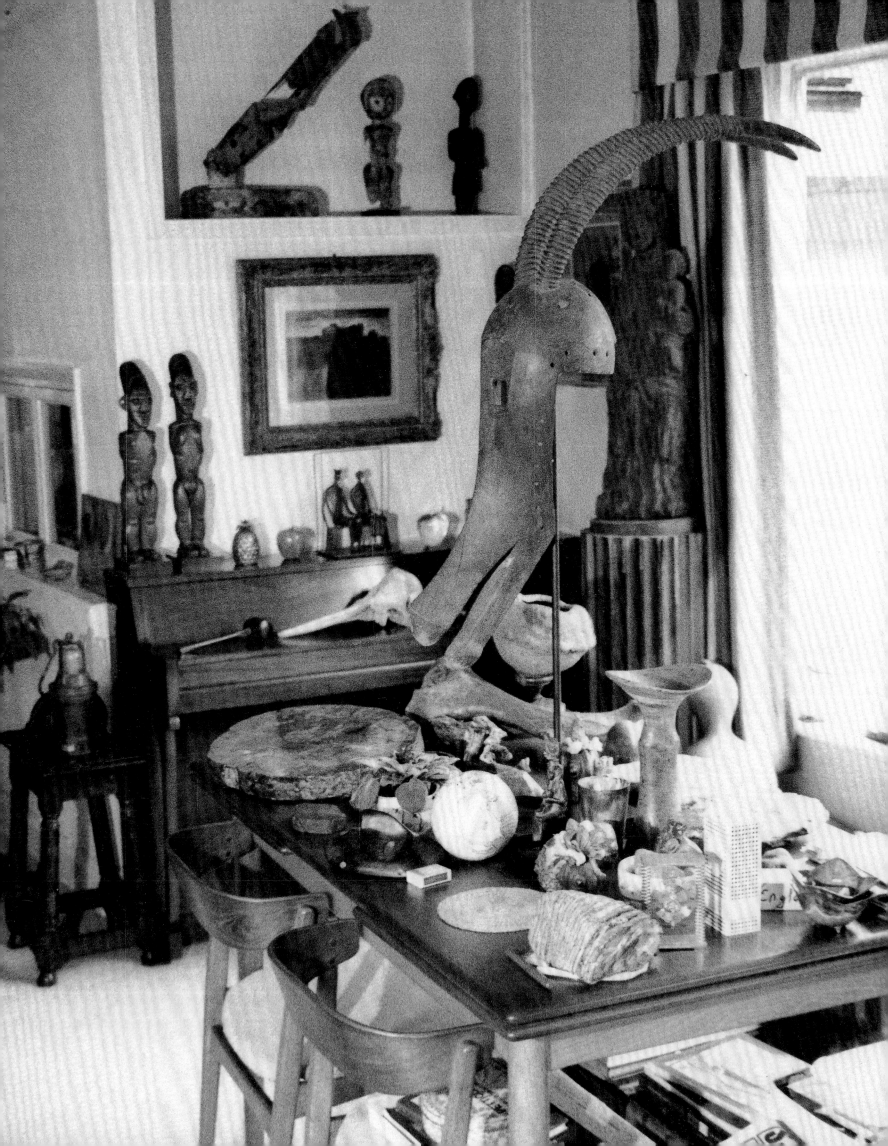

Anita Feldman Bennet

A Sculptor's Collection

The first time Henry Moore encountered modern art was not in a public museum but in a private home, and in a collection that was remarkably similar to that which the artist would assemble for himself nearly half a century later. At the age of twenty-three and the sole student of sculpture at the University of Leeds in 1921, Moore had been invited to the home of Michael Sadler, vice-chancellor of the university. Sadler later become one of Moore's most dedicated patrons and even assisted the sculptor with his first sale to a museum in the United States in 1936.[1] Moore enthusiastically recalled seeing not only canvases by Paul Cézanne, Paul Gauguin, Honoré Daumier, Gustave Courbet, Henri Matisse, Vincent van Gogh, and Wassily Kandinsky but also examples of ethnographic art for the first time. The ideas offered by these works left an indelible impression that can be seen in his interests as an artist and the shaping of his collection. When Moore could afford to purchase works by other artists, the pieces he selected—often quite late in life—were chosen because they dealt with themes and ideas that reflect his concerns as an artist. Rather than being a direct influence, they find a resonance in Moore's own work.

Moore acquired many of the objects in his collection when a new sitting room was added to his home, Hoglands, in 1960. This room, with a window overlooking the sculpture garden, contained the works the artist most wanted to be photographed and interviewed beside, contributing to his public image. For the most part, these consisted of non-Western artifacts and nineteenth-century French paintings. With the exception of a large Terry Frost, works he owned by British contemporaries such as Ivon Hitchens, David Bomberg, Paul Nash, and even Ben Nicholson were relegated to less public areas of the house, or abandoned to storage in the attic.

By 1969 Moore's collection was more or less complete. The sculptor had amassed a range of African, Cycladic, pre-Columbian and

Pacific Island carvings, as well as paintings and drawings that would spill over into every nook and cranny of the house. Beneath a Courbet seascape, a fourth-century Persian lynx stood over the contents of a sideboard, alongside an Ashanti Kuduo box, a dancing figure by Auguste Rodin, and an ancient Japanese Haniwa head. A Rembrandt self-portrait with Saskia, a drawing by Jacques-Louis David, and a figure study by Cézanne were balanced casually along a bookshelf beside a Songea caryatid stool from Zaire. Five Walter Sickert paintings could be found in his daughter's bathroom. Behind Moore's bed hung a *danse macabre* by Alphonse Le Gros. A striking Bobo antelope mask dominated a table strewn with found objects, surrounded by African carvings and drawings by Georges Seurat (frontispiece p. 52 and fig. 17). A twisted branch of ivy was displayed alongside Moore's stringed carving *Bird Basket* (cat. 43), above which hung a Jean-François Millet drawing, *La beurrière* (fig. 1). His collection included works by Jean-Baptiste-Camille Corot, Courbet, Edgar Degas, Fernand Léger, Rembrandt, Pierre-Auguste Renoir, Auguste Rodin, J. M. W. Turner, Edouard Vuillard, and many others—a rare indulgence for an otherwise frugal character.

The high-profile works Moore collected were displayed in an environment where they had equal status with other source materials, such as stones, bones, and seashells—even the shell of a giant sea turtle. Moore would occasionally challenge guests to identify which objects were formed by nature and which were man-made.[2] For the artist such distinctions were irrelevant. Despite the vast range of seemingly unconnected material accumulated in Hoglands, these objects generally tend to share the primary concerns and themes that preoccupied the sculptor throughout his sixty-year career: studies of heads and the human form, metamorphosis, exploration of an internal form contained within an external one, and the relationship between figure and landscape.

Moore's collection of African masks and pre-Columbian and other non-Western heads reflects his lifelong interest in the human face as a format for powerful expression. These display a range of intense, exaggerated features and purity of geometric forms (figs. 2–4, 7). The hollowed eyes and narrow slit mouth of the fifth-century Haniwa head (fig. 2) recall Moore's *Mask* in green gneiss stone, c. 1928

Large sitting room of Hoglands with (l–r), just visible on ledge: Joan Miró wood relief; on top of piano: Mangbetu male and female figures, n.d., Democratic Republic of Congo; *Maquette for King and Queen,* 1952 (LH 348); above piano: Georges Seurat, *Les deux charrettes* (fig. 17); beside window (just visible): Georges Seurat, *La lampe,* 1883; Romanesque standing Virgin and Child; recess above piano: Vanuatu canoe prod (fig. 13); Lega figure, n.d., Democratic Republic of Congo; Ashanti figure, n.d., Ghana; center of table: Bobo antelope mask, n.d., Burkina Faso

Fig. 1. Jean-François Millet, *La beurrière*, 1852–55, black crayon; *Bird Basket*, 1939 (cat. 43), lignum vitae and string; front: entwined ivy branch from the grounds of Hoglands

Fig. 2. Haniwa head, third–sixth century A.D., proto-historic Japan. Formerly Collection of Henry Moore

Fig. 3. Cycladic head, archaic Greece. Formerly Collection of Henry Moore

Fig. 4. Ibido deformation mask, n.d., Nigeria. Formerly Collection of Henry Moore

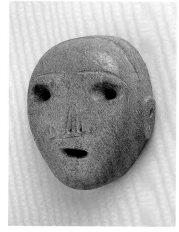

Fig. 5. Henry Moore, *Mask*, c. 1928. Tate, London (LH 54)

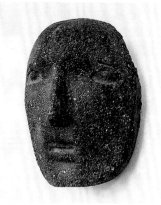

Fig. 6. Henry Moore, *Mask*, 1929. Private collection (LH 64)

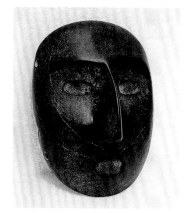

Fig. 7. Mezcala mask, tenth century A.D., Colima, Mexico. Formerly Collection of Henry Moore

(fig. 5). Similarities can also be found in his *Mask* in cast concrete of 1929 (fig. 6) and a tenth-century Mezcala mask from his collection (fig. 7). Both depict shallow oval eyes with a piercing gaze; sharply defined edges emphasize the facial features, long angular nose and mouth as an open cavity—as directly expressive as the eyes. Translucent alabaster heads such as *Head*, 1929, evoke a sense of Cycladic purity; a single line can be followed from the nape of the neck, tracing the profile of the head and leading to a stylized ear. The shape of the green stone of Moore's *Mask* of 1927 (cat. 7) evokes an aura of mystery reminiscent of Easter Island figures, one of which was on display in the British Museum when the mask was carved. It is infused with the expressive intensity of African masks: the small mouth is distorted, the eyes are asymmetrical, and a gash streaks across one side of the forehead. Despite the surprising juxtaposition of non-Western influences, the mask retains a simplicity that is immediately engaging. For Moore, "The most striking quality common to all primitive art is its intense vitality. It is something made by a people with a direct and immediate response to life."[3]

Exploration of the human form and its potential for expression informs Moore's collection of standing and seated figures. The body of the Nayarit standing figure, c.100 B.C.–A.D. 250 (fig. 8), has been reduced to a spatial plane with stylized hands resting on hips and small nubs for breasts, the head a series of geometric shapes; an unusual hollow beneath the bridge of the nose allows light to fall unexpectedly on the figure. The fingers, like the drapery, are rendered as simple painted lines. With the Jalisco standing female figure, c.100 B.C.–A.D. 250 (fig. 9), the woman's body has become a range of bulbous shapes, her arm extends upward to balance the pot (an olla) on her

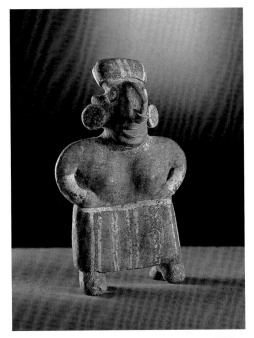

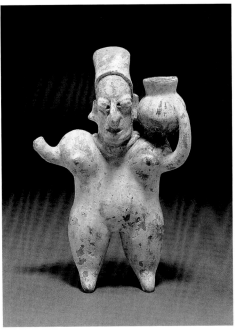

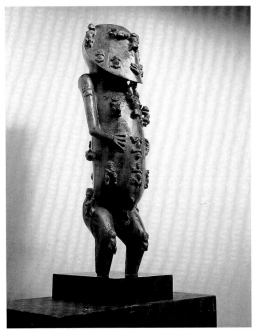

Fig. 8. Nayarit standing figure, c. 100 B.C.–A.D. 250, Mexico. Formerly Collection of Henry Moore

Fig. 9. Jalisco standing female figure, c. 100 B.C.–A.D. 250, Mexico. Formerly Collection of Henry Moore

Fig. 10. *Carved Wooden Figure,* Austral Islands, Polynesia, bronze (cast from the original in The British Museum, London). Formerly Collection of Henry Moore

shoulder, provoking consideration of the relationship between a large form and a small one, and echoing Moore's exploration of the concept through the theme of the mother and child.

Many of the sculptures in Moore's collection employ strikingly elongated features, providing emphasis to certain parts of the body as well as a vertical platform on which to experiment with an internal/external structure. The arms and breasts of the Dogon female figure are depicted as an outer shell encircling the core of the body. A similar enclosing structure occurs in the Mumuye standing figure, which features a helmet-like protective headpiece (fig. 11). This carving bears a strong resemblance to *Studies of Sculpture in the British Museum,* 1922–24 (cat. 110). Moore's sketch of a Mumuye figure predates his acquisition of a similar piece by nearly sixty years. Among Moore's final drawings are three of his Mumuye carving, each highlighting the characteristic enclosing form.[4]

As a gesture of recognition virtually unthinkable today, in 1981 the British Museum allowed Moore to make a bronze cast from an Austral Islands carved wooden figure in their collection, which he placed in the front hall of Hoglands (fig. 10). The original sculpture contained a receptacle at the back that could be opened for the placement of smaller sculptures within the figure. Moore explained: "The excitement of this piece comes from its sense of life-force, with all those small figures springing from the parent figure. . . . Its great round back repeats the shape of the full, round belly, but emphasises, by contrast, the thinness and sharpness of the jaw."[5]

The Batak wand (fig. 12), and the Vanuatu canoe prod (fig. 13), featuring stacked forms and hollows carved from a single piece of wood, recall Moore's series of upright motives (cats. 67, 68, 69) as well as sculptures such as *Working Model for Upright Internal/External Form* (cat. 56). This piece was followed in 1953–54 by a monumental version in elmwood in which the idea of opening out a form to its farthest possible extent was explored.[6]

Although the ethnographic objects in Moore's collection display an affinity with the formal concerns in his own sculpture, they generally did not provide direct inspiration. This he derived instead from a collection of found objects amassed in both his home and his studio that he referred to as his "library of natural forms." Dominating all others was the skull

Fig. 11. Mumuye standing figure, n.d., Northern Nigeria. The Henry Moore Foundation

Cat. 110. Henry Moore, *Studies of Sculpture from the British Museum (Page 105 from Notebook No. 3),* 1922–24. The Henry Moore Foundation: gift of the artist 1977 (HMF 123)

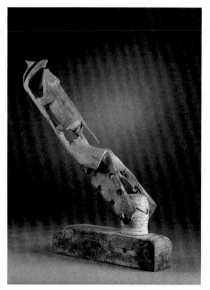

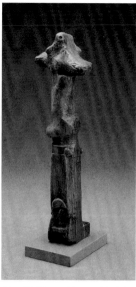

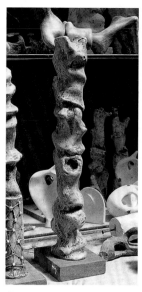

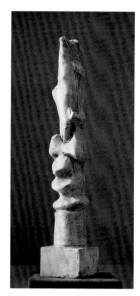

Fig. 13. Vanuatu canoe prod, n.d., Pacific Islands. The Henry Moore Foundation

Fig. 12. Batak wand, n.d., Pacific Islands. Formerly Collection of Henry Moore

Cat. 67. Henry Moore, *Upright Motive: Maquette No. 1,* 1955. Collection, Art Gallery of Ontario, Toronto. Gift of Henry Moore, 1974 (LH 376)

Cat. 68. Henry Moore, *Upright Motive: Maquette No. 10,* 1955. The Henry Moore Foundation: gift of the artist 1977 (LH 390)

Cat. 69. Henry Moore, *Upright Motive: Maquette No. 7,* 1955. The Henry Moore Foundation: gift of the artist 1977 (LH 385)

of an elephant. The skull with its dark cavities of space, arched forms, contrast of strong heavy solids with thin sharp edges, and shapes coming together at tense points became a catalyst for an album of etchings in 1969[7] and informs a variety of Moore's later sculpture, including *Oval with Points,* 1968–70 (cat. 90). Another prominent skull was that of a rhinoceros (fig. 14), which inspired a number of drawings including *Rhinoceros VII,* 1981 (cat. 200).

Many of the small bones, shells, flintstones, and other found objects were used as starting points in a creative process; often plaster was added to the object, physically transforming it into a human figure. A small bone with the addition of a plaster head was the genesis of *Large Standing Figure: Knife Edge,* 1976 (cat. 77). This element of metamorphosis is also evident in some of the non-Western works Moore admired, such as his Inuit whalebone figure (fig. 15) and a Kissi stone weeping woman from Sierra Leone.

The concept of transformation remained a feature of much of Moore's work from the 1930s onward. The use of storyboards in Picasso's 1937 etching *Guernica* (fig. 16), which hung in Moore's

kitchen, breaks down the picture plane into sequential frames, and could relate to the sudden predominance of film. Although this medium was of particular significance to the Surrealists, Moore had a history of working out a number of ideas on a single sheet. These images gradually became more defined as fully realized compositions in themselves. *Ideas for Sculpture in Landscape,* c. 1938 (cat. 149) and *Eighteen Ideas for War Drawings,* 1940 (cat. 154) are two examples. Another drawing, *Pictorial Ideas and Setting for Sculpture,* c.1939,[8] provides the first idea for *Crowd Looking at a Tied-up Object* of 1942 (cat. 171), one of Moore's most enigmatic works.

The connection between metamorphosis of the figure and studies of the relationship between figure and landscape can be found in Moore's work as early as 1930 in *Reclining Woman* in Green Hornton stone, originally titled *Mountains* (cat. 10). Herbert Read immediately recognized Moore's ability to metamorphose the female figure: "[Moore] will imagine . . . what a woman would look like if flesh and blood were translated into stone before him—the stone has its own principles of form and structure. The woman's body might then

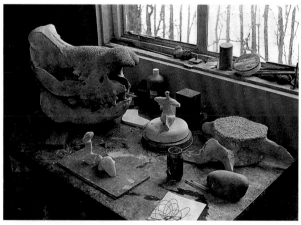

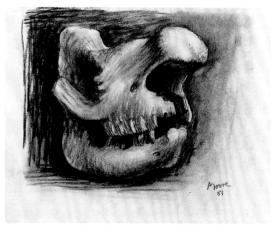

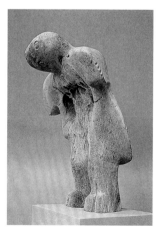

Fig. 14. Rhinoceros skull in Moore's studio, Perry Green; center: plaster *Maquette for Seated Woman with Arms Outstretched,* 1960 (LH 463); right: whale vertebrae; foreground: plaster *Maquette for Two Piece Reclining Figure: Cut,* 1978 (LH 755) on grid to be scaled up for enlargement (final version, fig. 33)

Cat. 200. Henry Moore, *Rhinoceros VII,* 1981. The Henry Moore Foundation: acquired 1987 (HMF 81(201))

Fig. 15. Inuit whalebone figure, n.d., North America. Formerly Collection of Henry Moore

Fig. 16. Pablo Picasso, *Guernica,* 1937. Formerly Collection of Henry Moore

Fig. 17. Georges Seurat, *Les deux charrettes,* 1883. Formerly Collection of Henry Moore

Cat. 149. Henry Moore, *Ideas for Sculpture in Landscape,* c. 1938. The Henry Moore Foundation: acquired 1990 (HMF 1391a)

Fig. 18. Henry Moore, *Lullaby Sleeping Head,* 1973. Based on the poem "Lullaby" by W. H. Auden, from the portfolio *Auden Poems/ Moore Lithographs,* published by Petersburg Press Ltd., London, 1974. The Henry Moore Foundation (CGM 250)

take on the appearance of a range of hills. Sculpture therefore is not a reduplication of form and feature; it is rather the translation of meaning from one material into another."[9]

By working in plaster and scaling up in bronze, Moore developed more freedom in the invention of form. His prewar adherence to the dictum of "truth to material" and the constraints imposed by direct carving in wood and stone eventually gave way to a much more fluid form and the ability to explore and open out the figure in new ways. His figures became increasingly submerged within and broken by forms of landscape. Ambiguously mingling man and nature, Moore asserted that man is part of the natural world and not just an ob-server. This approach is reflected in his collection of paintings and drawings that explore this relationship through lighting, fragmenta-tion, and fusion of the figure within landscape.

One of the draftsmen Moore most admired was Seurat, whose works drawn with conté crayon on highly textured paper allow the compositions seemingly to give off a light from the paper itself. Out-lines are abolished in preference to a hesitancy of form, which dis-solves into the background. Moore possessed three Seurat black drawings, including *Les deux charrettes* (fig. 17). Although Moore was not aware of Seurat's drawings when he was engaged in the

Coalmining series, he readily acknowledged their influence on his later work, stating: "[Seurat] came gradually to develop an entirely new way of drawing, using no outlines and fusing together space and form, light, depths and distances into a marvellous and mysterious unity of vision."[10]

It is this unity of vision, the fusion of figures with their surround-ings, that Moore was attempting in his series of lithographs in 1973 illustrating poems by W. H. Auden. In *Lullaby Sleeping Head* (fig. 18) the figures are virtually lost in the foreboding darkness; the light from the textured paper surface picks out only suggestions of forms. This is similar compositionally to a black chalk drawing by David, *Scène d'histoire romaine,* that Henry and Irina bought for each other as an anniversary present in the early 1970s (fig. 19). The hooded figure echoes Moore's helmet series, with the head protected and enclosed, and anticipates his *Mother and Child: Hood,* 1983 (fig. 20), rendered in luminous white travertine.[11] The form of the sculpture, however,

Fig. 19. Jacques-Louis David, *Scène d'histoire romaine*, n.d. Formerly Collection of Henry Moore

Fig. 20. Henry Moore, *Mother and Child: Hood*, 1983. On loan from The Henry Moore Foundation to St. Paul's Cathedral, London (LH 851)

Fig. 21. Plaster cast of animal bone used to create *Maquette for Mother and Child: Hood*, 1982 (LH 849) in the artist's studio, Perry Green

derives from an animal bone found on the grounds of Perry Green, which remains centrally placed on the turntable in the artist's maquette studio (fig. 21).

The atmospheric diffusion of light in Moore's watercolor by Turner provides a classical setting of timelessness and tranquillity (fig. 22). Moore much admired Turner's ability to create form out of atmosphere and made several attempts to re-create this effect in his own drawings. He reflected: "Turner—whether on canvas or paper—can create almost measurable distances of space and air—air that you can draw, in which you can work out what the section through it would be. The space he creates is not emptiness; it is filled with 'solid' atmosphere."[12] In 1982 and 1983 Moore created a number of compositions dealing with sea and sky in which the vessel and even the sea itself dissolve into the atmosphere in a great diffusion of light, form, and landscape. In *The Swimmer* (fig. 23), the figure swims alone in a vast, luminous sea under a brooding sky. The lack of any indication of land or boat deepens the quality of uneasiness, even of oblivion. A sense of solitude and timelessness is also achieved in Courbet's *Marine* (fig. 24), which presents a sweeping expanse of sky over a sea where the only indication of human presence is two diminutive boats.

In Moore's *Figure in a Forest* (fig. 25), the small figure provides a sense of tremendous scale to the engulfing woods. The strong form of the tree on the right contrasts with the remainder of the composition, in which the branches dissolve in diffused light. The fragile bent figure is overwhelmed by the grand trees with massive branches, evoking a feeling of monumental strength and permanence. Although the print was achieved through reworking a plate from the Auden portfolio, Moore may have also had in mind a painting in his collection by Corot, *Landscape at Fontainebleau*, 1873 (fig. 26), which bears compositional similarities.

Fusion of figure and environment was expressed in more spatial terms with Cézanne, whose compositions reduce both figure and background to a series of interconnecting planes. Moore said of *Les Grandes Baigneuses:* "The female bathers are shown in perspective

Fig. 22. Joseph Mallord William Turner, *Untitled*, c. 1840–50. Formerly Collection of Henry Moore

Fig. 23. Henry Moore, *The Swimmer*, 1983. HMF Enterprises

Fig. 24. Gustave Courbet, *Marine,* 1866. Formerly Collection of Henry Moore

Fig. 25. Henry Moore, *Figure in a Forest,* 1976. The Henry Moore Foundation (CGM 427)

Fig. 26. Jean-Baptiste-Camille Corot, *Landscape at Fontainebleau,* 1873. Formerly Collection of Henry Moore

Fig. 27. Paul Cézanne, *Trois Baigneuses,* 1873–77. Formerly Collection of Henry Moore

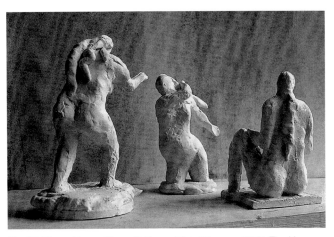

Fig. 28. Henry Moore, *Three Bathers—After Cézanne,* 1978. The Henry Moore Foundation (LH 741)

lying on the ground as if they'd been sliced out of mountain rock."[13] In acquiring *Trois Baigneuses,* a smaller version of one of the icons of twentieth-century art (fig. 27)—"It is the only picture I ever really wanted to own,"[14] Moore told an interviewer—the sculptor comfortably joined Matisse, André Derain, and Picasso, who also possessed paintings of bathers by Cézanne. Moore said that he could turn any of the figures into a sculpture very easily, a claim that he theatrically carried out in 1978, realizing the figures in plasticine in the presence of John Read and a BBC camera crew (fig. 28). One of the aspects that intrigued Moore about the bathers is that the subject had become a template for Cézanne to experiment with new ideas, in a similar way to which Moore used the motif of the reclining figure. He found that the reclining figure offered endless possibilities for the exploration of human and organic form. He explained: "Cézanne's bathers compositions were a subject that freed him to try out all sorts of things that he didn't quite know. With me, I think the reclining figure gave me a chance, a kind of subject matter, to create new forms within it."[15]

In Moore's work, however, he fragmented the figure in order to suggest forms of landscape. Moore's interest in cliffs and caves is often attributed to his admiration of Seurat's *Le Bec du Hoc, Grand-camp,* previously in the collection of his lifelong friend and patron

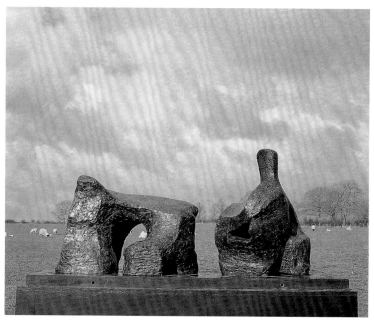

Fig. 29. Gustave Courbet, *La grotte de la Loue,* 1856. Formerly Collection of Henry Moore

Fig. 30. Henry Moore, *Two Piece Reclining Figure No. 2,* 1960. The Henry Moore Foundation: gift of the artist 1977 (LH 458)

Kenneth Clark.[16] But it is the overpowering cavity of darkness within the rock formations that would have intrigued him in Courbet's *La grotte de la Loue* (fig. 29). Moore's reclining figures became increasingly mountainous and fractured, while still retaining unity; the forms in sculptures such as *Two Piece Reclining Figure No. 2,* 1960 (fig. 30), were severed like rock and cliff faces drifting apart. By breaking down the figure he allowed the surrounding landscape to penetrate it visually and physically. The metamorphosis was complete. Referring to his work as a "metaphor for the human relationship with the earth,"[17] Moore explained: "I realised what an advantage a separated two piece composition could have in relating figures to landscape. Knees and breasts are mountains. Once these two parts became separated you can justifiably make it a landscape or a rock."[18]

Fragmentation of the reclining figure is also realized in Courbet's *Femme couchée dans l'herbe* (fig. 31). Here a nude is enveloped by the surrounding dramatic terrain, her body visually broken by her hair

and again by the drapery concealing her legs. Her head disappears into the surrounding darkness, while the piercing moonlight illuminates the shape of her back and hips. Similarities can be found in Moore's sculptures such as *Two Piece Reclining Figure: Holes,* 1975, in white marble (fig. 32). The reclining figure is broken into sections that emphasize the line of the hip. Whereas in the Courbet the legs are concealed by drapery, Moore has eliminated them altogether. Emphasis is on the separation of the two forms and the resulting activation of the space created between them, which is strengthened by the line of the hip in precisely the same way as in the painting. On a grander scale, Moore's *Two Piece Reclining Figure: Cut,* 1979 (fig. 33), sharply divides the figure in a similar way. The figure has been reduced, pared down to an essential core, leaving out the extremities of the limbs just as Courbet lost them in the darkness of the evening landscape. Despite Moore's fragmentation and engulfment of the figure within landscape, when his sculptures are sited in the open air

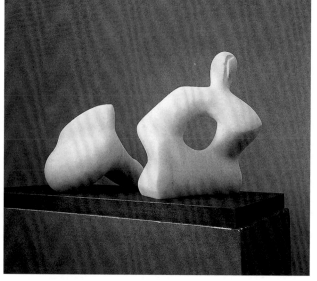

Fig. 31. Gustave Courbet, *Femme couchée dans l'herbe,* 1868. Formerly Collection of Henry Moore

Fig. 32. Henry Moore, *Two Piece Reclining Figure: Holes,* 1975. Private Collection, Hong Kong (LH 667)

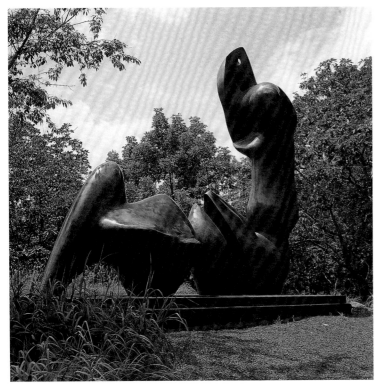

Fig. 33. Henry Moore, *Two Piece Reclining Figure: Cut,* 1979–81. The Henry Moore Foundation, on loan to Columbia University, sited at Arden House, New York (LH 758)

they appear at ease in their surroundings; it is a contradiction that lends a subtle complexity to Moore's later work.

After World War II Moore was able to synthesize his ideas and create a truly monumental sculpture, one that combined elements of non-Western art and modernism with an affinity for nature. His eclectic use of non-Western forms, coupled with an inventive manipulation of found objects, isolated him from the mainstream of the avant-garde. That Moore provided a sense of continuity with a world tradition of sculpture and a unity between figure and environment at a time when this was not highly regarded is now perceived as his strength. Moore offered an organic sculpture, attempting to inspire a sense of awe and mystery about the natural world. His personal collection reveals not only where his artistic sympathies lay but also in which context and artistic company he saw himself.

Notes

1. *Two Forms,* 1934 (LH 153), pynkado wood, Museum of Modern Art, New York.

2. Film made in 1992 to accompany *Moore: Intime,* a touring exhibition in which Hoglands was re-created with many of its original contents.

3. Henry Moore, "Primitive Art," *The Listener* (24 August 1941): 598–99.

4. Because of his increasingly frail health, in 1982 Moore took up the suggestion of Bernhard Baer of Ganymed Press to create a number of sketches of works in his home, with the intention of following through with a series of etchings or lithographs (HMF 83(8), 83(9), 83(41)).

5. *Henry Moore at the British Museum,* with commentary by the artist, photographs by David Finn (London: British Museum Publications, 1981), 83.

6. *Upright Internal/External Form,* 1953–54 (LH 297), height 103 in. (fig. 24), Albright-Knox Art Gallery, Buffalo.

7. *Elephant Skull Album,* 1969 (CGM 109–46), published by Gerald Cramer, Geneva, 1970.

8. The sculpture depicted at lower center is a variant of *Reclining Figure,* 1939 (cat. 42 [LH 202]).

9. Herbert Read, *The Meaning of Art* (London: Faber and Faber, 1931), xx.

10. *Auden Poems/Moore Lithographs,* introduction by Henry Moore (London: British Museum, 1974), xiv.

11. On loan from the Henry Moore Foundation to St. Paul's Cathedral, London.

12. *Auden Poems/Moore Lithographs,* xiv.

13. First seen by Moore during his first visit to Paris in 1923; now in the collection of the Philadelphia Museum of Art. For Moore's comment, see Huw Wheldon, *Monitor: An Anthology,* (London: Macdonald, 1962). Text of an interview with Moore on the television program *Monitor;* reprinted in part in Philip James, *Henry Moore on Sculpture* (London: Macdonald, 1966), 208.

14. Moore, speaking to Huw Wheldon; quoted in James, 208.

15. Artist's statement for the exhibition *Henry Moore: Drawings, Gouaches, Watercolours,* Galerie Beyeler, Basel, May–June 1970.

16. Now in the Tate Gallery, London.

17. Moore's *Monitor* interview, quoted in James, 266.

18. Carlton Lake, "Henry Moore's World," *Atlantic Monthly* 209, no. 1 (January 1962): 39–45.

Gail Davitt, Eik Kahng,
Jed Morse

Chronology and Plates

1898–1939

Note: All quotations in the Chronology sections are by Henry Moore unless otherwise noted.[1]

1898
Henry Spencer Moore is born on 30 July, the seventh of eight children born to Raymond and Mary Moore, at 30 Roundhill Road in Castleford, a mining town in northern England. His father was a miner and later became a pit submanager.

Castleford Townscape, c. 1900

1900
Publication of Sigmund Freud's *The Interpretation of Dreams.*

1902
Attends local elementary school at Temple Street. Excursions into the Yorkshire countryside, where he visits a favorite rock formation called Adel Crag; he is also impressed by the pyramid-like slag heaps around Castleford.

"Perhaps what influenced me most over wanting to do sculpture in the open air and to relate my sculpture to landscape comes from my youth in Yorkshire; seeing the Yorkshire moors, seeing, I remember, a huge natural outcrop of stone at a place near Leeds which as a young boy impressed me tremendously—it had a powerful stone, something like Stonehenge has—and also the slag heaps of the Yorkshire mining villages, the slag heaps which for me as a boy, as a young child, were like mountains. They had the scale of the pyramids; they had this triangular, bare, stark quality that was just as though one were in the Alps."[2]

1903
First airplane flight by Wright brothers.

1905
Einstein publishes his theory of relativity.

1906
Death of Cézanne.

1909
At about this time, while at Sunday school, he hears of the sculptor Michelangelo and resolves to become a sculptor himself.

1910
Wins scholarship to Castleford Secondary School. School visit to a nearby church at Methley, where Moore notices medieval stone carvings.

1911
Attends drawing and pottery classes with teacher Alice Gostick. Reads the art magazine *The Studio,* which reports on Continental art.

1913
Death of Moore's younger sister, Elsie.

1914: Marcel Duchamp exhibits his readymade sculpture *Bottlerack*

1914

War is declared.

The young British sculptor Henri Gaudier-Brzeska publishes his essay "Vortex," in which he describes "the modern sculptor" as "a man who works with instinct as his inspiring force. His work is emotional . . . light voluptuous modeling is to him insipid—what he feels he does so intensely and his work is nothing more or less than the abstraction of his intense feeling. [His] sculpture has no relation to classic Greek, but . . . is continuing the tradition of the barbaric peoples of the earth (for whom we have sympathy and admiration)."[3]

1915

Gains his Leaving Certificate and leaves school to become a student teacher.

Gaudier-Brzeska dies in battle.

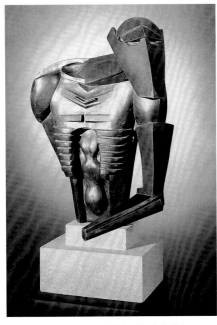

1915: Jacob Epstein exhibits *Rock Drill* in a group show in London

1916

Teaches at his old elementary school in Castleford.

1917

Travels to London to join the Civil Service Rifles. Visits the British Museum for the first time. Trains as a machine-gunner. Arrives in France and experiences trench warfare. Poisoned by mustard gas during battle at Bourlon Wood near Cambrai, he returns to England to recover.

Death of Rodin.

United States enters the war.

Russian Revolution.

1918

Recuperates at a hospital in Cardiff, Wales, then follows an army fitness course in Surrey. Promoted to lance-corporal, he qualifies as a bayonet instructor. Volunteers to return to active service but reaches France just as hostilities cease.

1919

Demobilized, he resumes teaching in Castleford. Takes pottery lessons with Alice Gostick.

The Bauhaus school of architecture and design is founded in Weimar, Germany, under the direction of the architect Walter Gropius.

1920

Gains place at Leeds School of Art with an ex-serviceman's scholarship, studying drawing and the history of European sculpture and architecture. Makes contact with Michael Sadler, a keen collector of contemporary painting and sculpture (Cézanne, Gauguin, Rouault, Matisse, Kandinsky) and of African art. A sculpture department is set up at Leeds, with Moore its first student.

1920: Russian sculptor Vladimir Tatlin exhibits *Monument* for the Third International

1921

Chance discovery of Fry's *Vision and Design* with essays extolling tribal sculpture: "Once you'd read Roger Fry, the whole thing was there."[4] Meets fellow student Barbara Hepworth. Moves to London to take up scholarship at the Royal College of Art. Rejects the classical ideal embodied in the college collection of Greco-Roman plaster casts, and starts to frequent the British Museum, where he develops an understanding of world art, sketching archaic and primitive artifacts, including Cycladic and Egyptian figures, Assyrian reliefs, African and Oceanic wood carvings, and pre-Columbian and North American objects. Begins visiting the controversial sculptor Jacob Epstein, who buys some of his pieces and shows him his collection of Egyptian and primitive art. Is taught by Leon Underwood, another collector of African art and a partisan of direct carving. Carves his first *Mother and Child* and embraces the precept of "truth to the material." Visits Stonehenge by moonlight.

"That is the value of the British Museum; you have everything before you, you are free to try to find your own way and, after a while, to find what appeals to you most. And after the first excitement it was the art of ancient Mexico that spoke to me most—except perhaps Romanesque, or early Norman. And I admit clearly and frankly that early Mexican art formed my views of carving as much as anything I could do."[5]

1922

His father dies. The family moves to Norfolk, where Moore stays with his sister at Wighton during vacations and begins collecting flintstones, driftwood, and other found objects.

James Joyce publishes *Ulysses.*

1923

First visit to Paris, where he is impressed by the paintings of Cézanne, especially the *Grandes Baigneuses*, which he likens to seeing Chartres cathedral. Discovers the ethnographic collections at the Musée de l'homme. Elects not to call on the prestigious sculptor Aristide Maillol. Makes his first sales as a professional artist.

Paul Cézanne, *Grandes Baigneuses,* 1906

1924

Copies a Virgin's head from a Renaissance original in the Victoria and Albert Museum, working directly in marble. His first carvings are exhibited in London. Awarded a Diploma and a travel scholarship to Italy, but postpones this to become sculpture instructor at the Royal College of Art.

1925

Undertakes travel scholarship to Italy, visiting Paris, Turin, Genoa, Pisa, Rome, Florence, Siena, Assisi, Padua, Ravenna, and Venice. Is most impressed by Michelangelo sculptures and the frescoes of Giotto and Masaccio. Resumes teaching at the Royal College of Art. Studies bones at the Natural History Museum, and investigates different types of English stone at the Geological Museum.

"Of great sculpture I've seen very little—Giotto's painting is the finest sculpture I met in Italy—what I know of Indian, Egyptian and Mexican sculpture completely overshadows Renaissance sculpture—except for the early Italian portrait busts, the very late works of Michelangelo and the work of Donatello—Donatello was a modeller, and it seems to me that it is modelling that has sapped the manhood out of Western sculpture, but the two main reasons are, don't you think, the widespread avoidance of thinking and working in stone—and willful throwing away of the Gothic tradition—in favor of a pseudo Greek."[6]

"I am beginning to get England into perspective—I think I shall return a violent patriot. If this scholarship does nothing else for me—it will have made me realize what treasures we have in England—what a paradise the British Museum is, and how high in quality, representative, how choice is our National Collection—and how inspiring is our English landscape. I do not wonder that the Italians have no landscape school—I have a great desire—almost an ache for the sight of a tree that can be called a tree—for a tree with a trunk."[7]

First television broadcast in Britain.

1926

Begins to make Transformation drawings prompted by analogies between the shapes of stones and human figures. Exhibits in group show at St. George's Gallery, London.

Release of Fritz Lang's *Metropolis.*

1927

Exhibits in group show at the Beaux-Arts Gallery, London.

Claude Monet's *Waterlilies* installed at the Orangerie.

Henri Bergson wins the Nobel Prize.

Charles Lindbergh crosses the Atlantic.

1928

His first solo show at the Warren Gallery, London, prompts one reviewer to extol the genius of a miner's son. Meets Irina Radetsky, a young Russian woman born in Kiev who had lived in Paris in her teens and is now a student at the Royal College. Moore begins work on *West Wind*, a relief sculpture for the London Underground Railway headquarters.

Introduced to Herbert Read by Sir Eric Maclagan, director of the Victoria and Albert Museum. Read visits Moore's studio, and decides to write an article about Moore for the *Listener*. "This was, I believe, the first time that a general article had been devoted to his sculpture and my appreciation of it was the beginning of a firm friendship and a mutual understanding that persist to this day."[8]

Publication of *Le Surréalisme et la peinture* by André Breton.

Moore carving *West Wind* relief, 1928–29

Herbert Read in his home at Parkhill Road, London

1929

Completes a *Reclining Figure,* carved in Hornton stone and inspired by a photo of a Toltec carving of the rain-spirit Chacmool. Marries Irina; the couple move to a flat and small studio at 11A Parkhill Road in Hampstead, an artists' colony in North London. Sketches his wife incessantly. Friendship with the sculptor Barbara Hepworth, the painters Ben Nicholson and Ivon Hitchens, and the influential critic Herbert Read. His relief sculpture *West Wind* is placed above the facade of the headquarters of the London Underground Railway.

Inauguration of The Museum of Modern Art in New York.

Release of *Un chien andalou* by Luis Buñuel and Salvador Dalí.

Crash of the stock market in New York.

1930

Joins the 7 and 5 Society, an avant-garde group in London. Exhibits in the British Pavilion at the Venice Biennale.

"The sculpture which moves me most is full-blooded and self-supporting, fully in the round, that is, its component forms are completely realised and work as masses in opposition, not being merely indicated by surface cutting in relief; it is not perfectly symmetrical, it is static and it is strong and vital, giving off something of the energy and power of great mountains."[9]

"Sculptural energy is the mountain. . . . Sculptural feeling is the appreciation of masses in relation."[10] —Gaudier-Brzeska

September 14: Nazis gain 107 seats in the Reichstag.

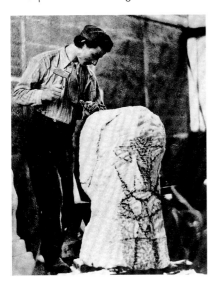

Gaudier-Brzeska carving *Head of Ezra Pound,* spring 1914

1931

Buys Jasmine Cottage in the village of Barfreston in East Kent, where he works during vacations. Leaves the Royal College to teach at Chelsea School of Art. Makes his first foreign sale to a museum in Hamburg, Germany, and holds his second solo exhibition at the Leicester Galleries in London. In the catalogue Epstein announces that "here is something to startle the unthinking out of their complacency."[11] Several press reports are hostile, for example, "Aesthetic detachment is bound to atrophy soul and vision and lead to revolting formlessness such as offends sensitive people."[12]

"Since the fifteenth century sculpture has been a lost art in England. Perhaps it has been a lost art in Europe generally, for it is possible to argue that the whole Renaissance conception of sculpture was a false one [because] the sculptor of the Renaissance sedulously copied its

[the classical art of ancient Greece and Rome] external appearances. We may say without exaggeration that the art of sculpture has been dead in England for four centuries; equally without exaggeration I think we may say that it is reborn in the work of Henry Moore."[13]

Matisse retrospective held at The Museum of Modern Art, New York.

November: Inauguration of the Whitney Museum of American Art.

Publication of Virginia Woolf's *The Waves.*

1932

Appointed head of new sculpture department at Chelsea College of Art.

Naum Gabo leaves Berlin to join his brother Anton Pevsner in Paris and to become a member of the Abstraction-Création movement.

Amelia Earhart becomes the first woman to make a solo transatlantic flight.

Franklin Delano Roosevelt is elected president of the United States.

The Bauhaus moves to Berlin from Dessau.

1932: The Abstraction-Création movement publishes the first issue of its journal

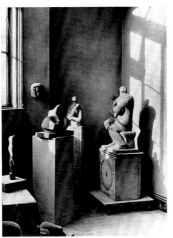

Corner of Moore's studio at Parkhill Road, London, 1932

1932: Alexander Calder exhibits sculptures that resemble mechanical engines at the Galerie Vignon in Paris

1933

Joins the elite avant-garde group Unit One, with Hepworth, the painters Paul Nash and Edward Burra, and the architect Wells Coates. The group exhibits at the Mayor Gallery, London. Contributes to its collective volume with a text on sculpture: "Beauty, in the later Greek or Renaissance sense, is not the aim of my sculpture."[14] Travels to Paris and meets the sculptors Alberto Giacometti, Jacques Lipchitz, and Ossip Zadkine.

January 30: Hitler is named chancellor of Germany.

February 2: Burning of the Reichstag.

Roosevelt launches the New Deal.

Léger opens his Académie d'art contemporain.

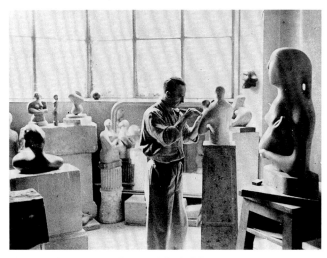

Moore working in his studio at 11A Parkhill Road, 1933

1933: Herbert Read publishes his book *Art Now*

1934

Contributes to Unit One exhibition at the Mayor Gallery, London. On a motoring holiday to Spain, visits Bordeaux, Madrid, Toledo, and Barcelona, and the prehistoric caves at Altamira, Les Eyzies, and Font de Gaume, as well as the site of his battle experiences near Cambrai.

Walter Gropius takes refuge in London.

Publication of the Futurist manifesto *La plastica murale futurista*.

Publication of André Breton's *Qu'est-ce que le surréalisme?*

6 March 1934: *Machine Art* exhibition opens at The Museum of Modern Art in New York

1935

Moves from Barfreston to nearby Kingston, close to Canterbury, Kent, buying a bungalow called Burcroft where there is open land for showing large sculpture: "I feel that the sky and nature are the best setting for my sculpture." Employs sculptor Bernard Meadows as his assistant. Writes an enthusiastic review of Christian Zervos's book on Mesopotamian art. Solo exhibition of drawings at the Zwemmer Gallery, London. Begins practice of working from small maquettes.

Herbert Read publishes, "5 Essays on Revolutionary Art." Describes Surrealism as "literary, subjective and actively Communist," while he describes abstraction as "sometimes called non-figurative, constructivist, geometric" and "plastic, objective and ostensibly non-political." Groups Moore along with Piet Mondrian, Nicholson, and Miró as abstract artists. Sees Surrealism negatively as "the art of a transitional period."[15]

Marcel Breuer and Moholy-Nagy move to London.

Last exhibition of the 7 and 5 Society, a group devoted to pure abstraction, at the Zwemmer Gallery, London.

AAA (American Abstract Artists) organization formed in New York.

Giacometti breaks with the Surrealist group.

Rupture between the Surrealist group and the Communist Party after the publication of André Breton's treatise against Stalinism.

Important exhibition of the sculpture of Jacques Lipchitz. The catalogue's preface is an essay by Elie Faure.

Exhibition of African art at The Museum of Modern Art, New York.

Exhibition of abstract art at the Whitney Museum, New York.

Hitler attacks modern art in a congressional speech given in Nuremberg.

Constructivist sculptor Naum Gabo, 1938. Gabo arrived in London in 1935

1936

Anxiety about the worsening political situation in Europe. Spanish Civil War breaks out. Moore supports Artists International Association. Signs a manifesto drawn up by the English Surrealist Group against British nonintervention in Spain. Max Ernst visits him in his studio. Completes *Reclining Figure,* the first in a cycle of six elm-wood carvings on this theme spanning thirty years. Moore participates in the *Abstract and Concrete* exhibition at Lefevre Gallery, London. The exhibition then travels to Liverpool, Oxford, and Cambridge.

1936: Moore participates in the *International Surrealist Exhibition* at New Burlington Galleries, London

Installation of the *International Surrealist Exhibition* at the New Burlington Galleries, London, 1936

Roland Penrose, *Last Voyage of Captain Cook,* 1936

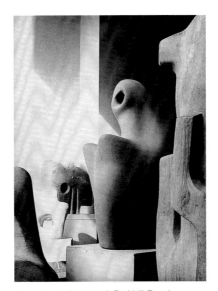

Moore's studio at 11A Parkhill Road, Hampstead, c. 1936

Founding of the FIL (For Intellectual Liberty) in London. "Its object was to be a rallying point for those intellectual workers who felt that the condition of the world called for the active defence of peace, liberty and culture and its means were letters and personal representations to M.P.s, Ministers and other authorities; deputations to foreign embassies and the publication or other dissemination of information not easily come by elsewhere."[16]

Abdication of Edward VIII; George VI assumes the throne.

1937

With Giacometti, Ernst, Paul Eluard and André Breton, visits Picasso's studio in Paris, where *Guernica* is being painted. Attends British Artists' Congress, an anti-Fascist event. Defends abstraction in "The Sculptor Speaks," emphasizing the meaningfulness of the hole in his sculpture, and contributes to *Circle: International Survey of Constructive Art* (edited by Ben Nicholson and Naum Gabo), a publication sponsoring Constructivism. For a while produces sculpture influenced by mathematical models, often implementing string. Saves a woman from drowning while on holiday at the Kent coast.

Moore supplies the cover for an issue of *Contemporary Poetry and Prose* dedicated to the Republican efforts against Francisco Franco in the Spanish Civil War

Non-ferro metals displays designed by Walter Gropius at the *Deutsches Volk, Deutsche Arbeit* exhibition, Berlin, as illustrated in *Circle*

"Undoubtedly the source of my stringed figures was The Science Museum. Whilst a student at the Royal College of Art I became involved in machine art which in those days had its place in modern art. Although I was interested in the work of Léger, and the Futurists, who exploited mechanical forms, I was never directly influenced by machinery as such. Its interest for me lies in its capacity for movement, which, after all, is its function. I was fascinated by the mathematical models I saw there, which had been made to illustrate the difference of the form that is halfway between a square and a circle. . . . It wasn't the scientific study of these models but the ability to look through the strings as with a bird cage and to see one form within another which excited me."[17]

German Art and *Degenerate Art* exhibitions in Munich.

Explosion of the dirigible *Hindenburg* in New York.

Mathematical model (oscillating developable of a cubic ellipse), Institut Henri Poincaré, Paris

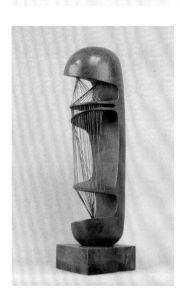

Cat. 35. Henry Moore, *Stringed Figure,* 1937

1937: Roland Penrose founds the London Gallery. Press coverage of a Surrealist exhibition at the London Gallery in its inaugural year. Moore is pictured drinking a beer at the opening in the photo at top right. *Weekly Illustrated,* 4 December 1937

1938

Exhibits alongside Paul Klee, Mondrian, Brancusi, and others at the *International Exhibition of Abstract Art* at Stedelijk Museum, Amsterdam. Foreign Office refuses him permit to visit Spain. Befriends Kenneth Clark, director of the National Gallery in London. Uses a small foundry to produce lead figurines; modeling and casting now take precedence over direct carving.

Brancusi completes *Endless Column at Tirgu-Jiu.*

Inauguration of the Musée de l'homme in Paris.

Picasso's *Guernica* exhibited in London. Anthony Blunt's negative criticism gives rise to a debate with the Surrealists.

Mondrian moves to London.

Roland Penrose takes Max Ernst to visit Moore in his Hampstead studio.

Moore exhibits work at the Guggenheim Jeune on Bond Street. Advertisement that appeared in *London Bulletin,* no.1, April 1938

1939

Resigns from Chelsea School of Art on its wartime move to Northampton. Takes over Hepworth's old studio in Hampstead when she and Nicholson move to Cornwall. Sells first elmwood *Reclining Figure* to a museum in Buffalo, New York. Contributes to *Art for the People* at the Whitechapel Gallery, London. After long resistance, his stone *Recumbent Figure* enters the Tate Gallery Collection.

Britain declares war on Germany.

Graham Bell publishes *The Artist and His Public.*

John Steinbeck publishes *The Grapes of Wrath,* and James Joyce, *Finnegans Wake.*

Sigmund Freud dies in London.

1939: Moore completes another elmwood *Reclining Figure* (cat. 45), arguably his masterpiece. Moore (behind the sculpture), Bernard Meadows, and an unknown helper moving the elmwood *Reclining Figure;* the work is now in Detroit

1939: The Museum of Modern Art, New York, celebrates the opening of its new building on West 53rd Street with the exhibition *Art of Our Time* and the acquisition of Pablo Picasso's painting *Les Demoiselles d'Avignon.* Here, the museum trustees pose in front of the new acquisition. From left to right: J. H. Whitney, Mrs. W. T. Emmet, A. Conger Goodyear, N. A. Rockefeller, Mrs. J. Sheppard, E. Ford, and Mrs. J. Parkinson

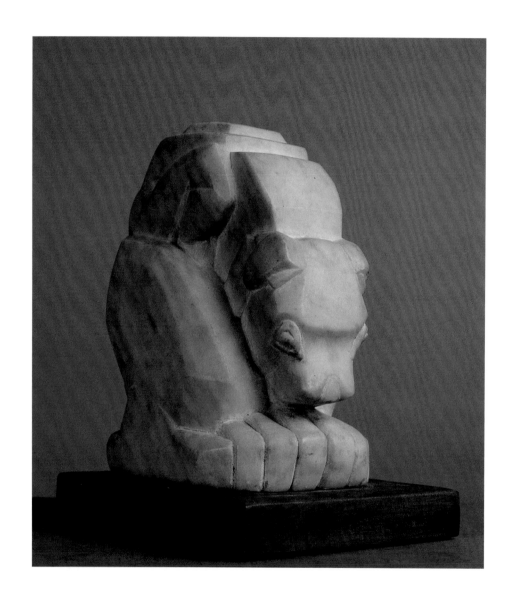

1. *Dog,* 1922
Marble, height 7 in.
The Henry Moore Foundation:
gift of the artist 1977
(LH 2)

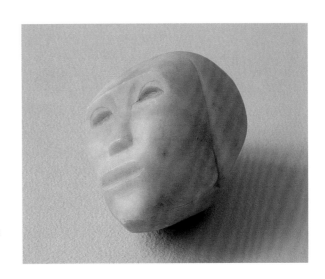

2. *Head,* 1923
Alabaster, height 4¾ in.
The Henry Moore Foundation:
acquired 1998
(LH 10)

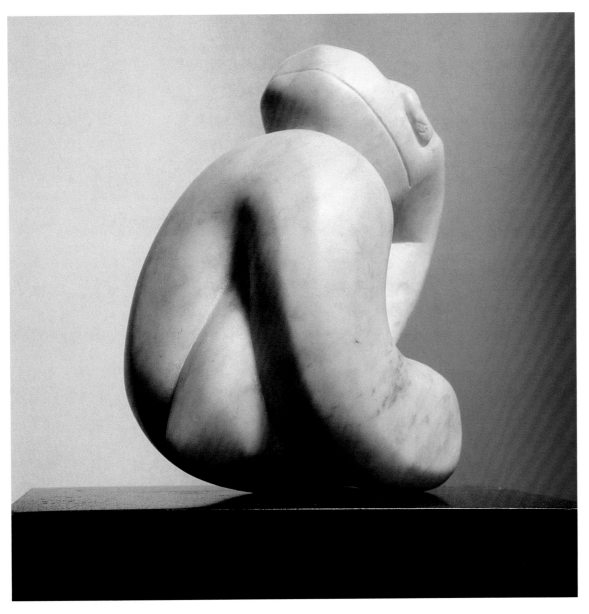

3. *Snake,* 1924
Marble, height 6¾ in.
Private collection
(LH 20)

109. *Four Studies of a Seated Figure,* 1922
Pencil, brush and ink, and watercolor on paper, 17½ × 14½ in.
The Henry Moore Foundation: gift of the artist 1977
(HMF 81v)

110. *Studies of Sculpture from the British Museum
(Page 105 from Notebook No. 3),* 1922–24
Pencil on paper, 8⅞ × 6¾ in.
The Henry Moore Foundation: gift of the artist 1977
(HMF 123)

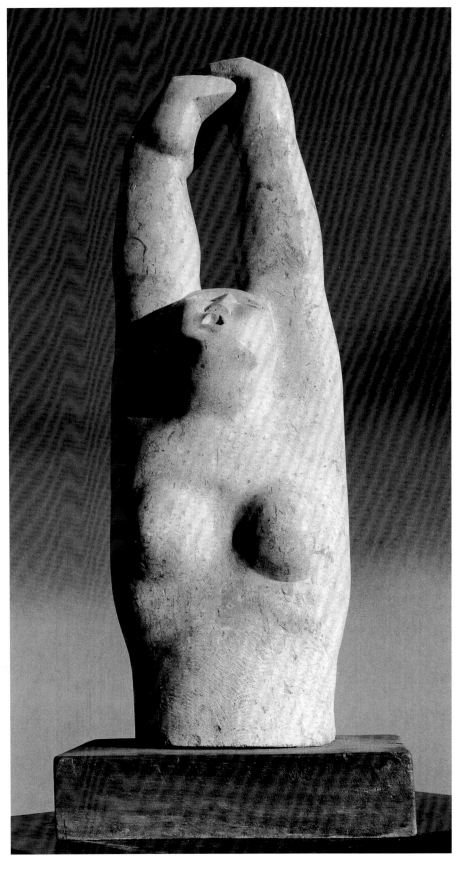

111. *Standing Girl,* 1924
Pen and ink, crayon, and wash on cream
medium-weight wove paper, 20 × 7⅝ in.
The Henry Moore Foundation: gift of the artist 1977
(HMF 214)

5. *Woman with Upraised Arms,* 1924–25
Hopton Wood stone, height 17 in.
The Henry Moore Foundation: gift of the artist 1977
(LH 23)

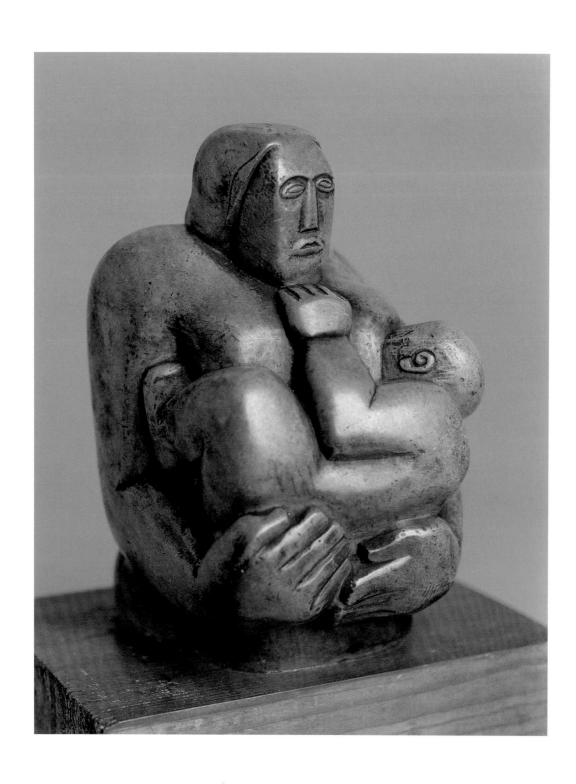

4. *Maternity*, 1924
Hopton Wood stone, height 7¾ in.
Leeds Museums and Galleries (City Art Gallery)
(LH 22)

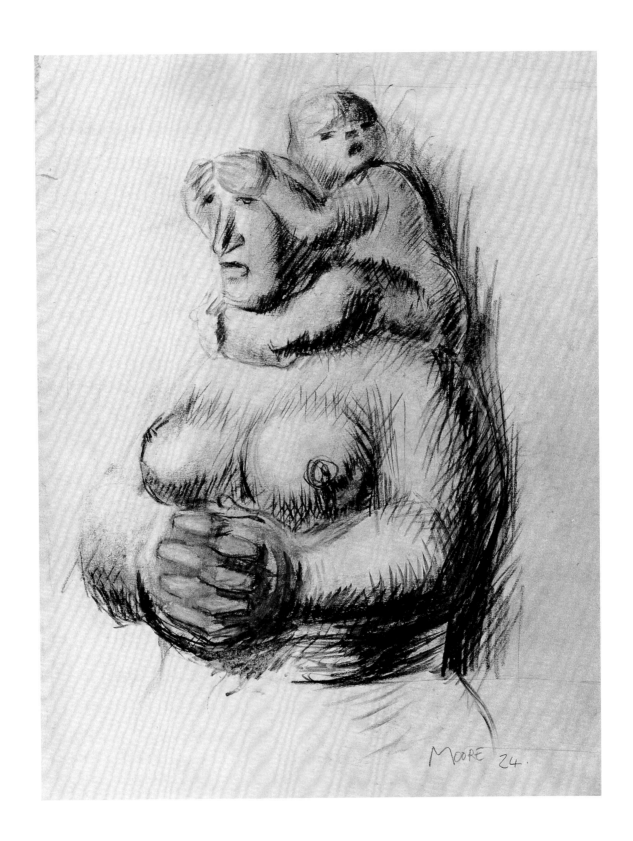

113. *Mother and Child,* 1924
Brush and ink, crayon, and chalk on cream
medium-weight wove paper, 22⅛ × 14⅞ in.
The Moore Danowski Trust
(HMF 264)

112. *Standing Figure: Back View,* c. 1924
Pen and ink, brush and ink, chalk, and wash on
off-white medium-weight wove paper, 17¾ × 11 in.
The Henry Moore Foundation: gift of the artist 1977
(HMF 228)

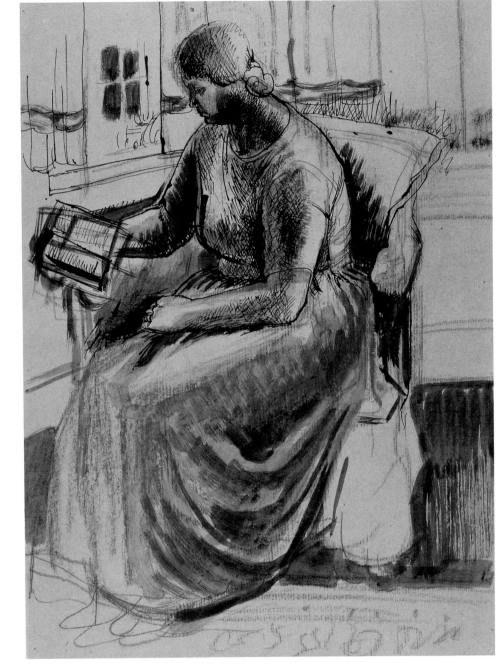

114. *The Artist's Sister Mary,* 1926
Pen and ink, chalk, watercolor, and wash
on lightweight manila paper, 17½ × 13 in.
The British Council
(HMF 470)

115. *The Artist's Mother,* 1927
Pencil (rubbed), pen and ink, brush and ink wash on
cream medium-weight wove paper, 11 × 7½ in.
The Henry Moore Foundation: gift of Mary Moore Danowski 1979
(HMF 488)

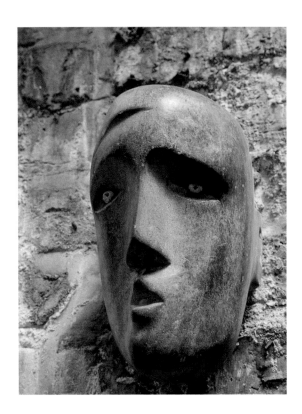

7. *Mask,* 1927
Green stone, height 8¼ in.
The Henry Moore Foundation:
acquired 1997
(LH 46)

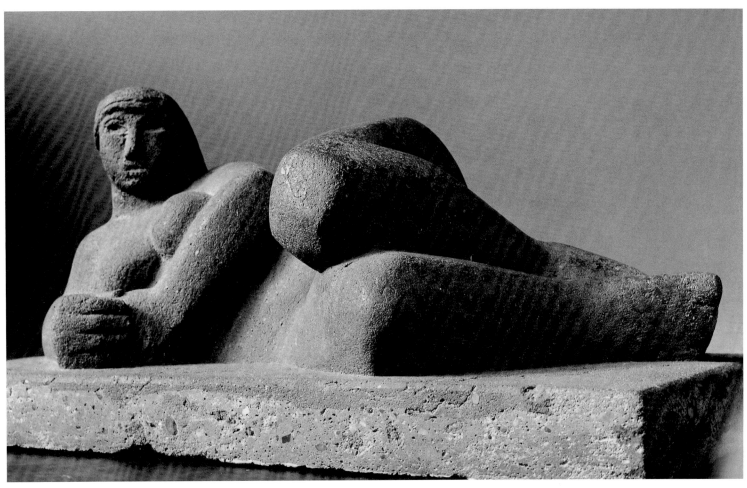

6. *Reclining Woman,* 1927
Cast concrete, length 25 in.
The Moore Danowski Trust
(LH 43)

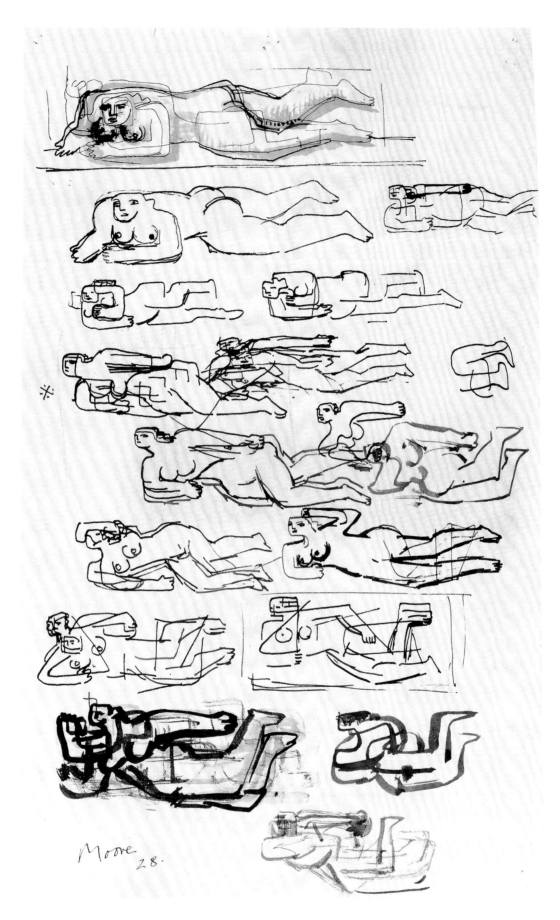

116. *Ideas for West Wind Relief,* 1928
Pen and ink, brush and ink on wove paper, 14½ × 9 in.
Collection, Art Gallery of Ontario, Toronto.
Gift of Henry Moore, 1974
(HMF 647)

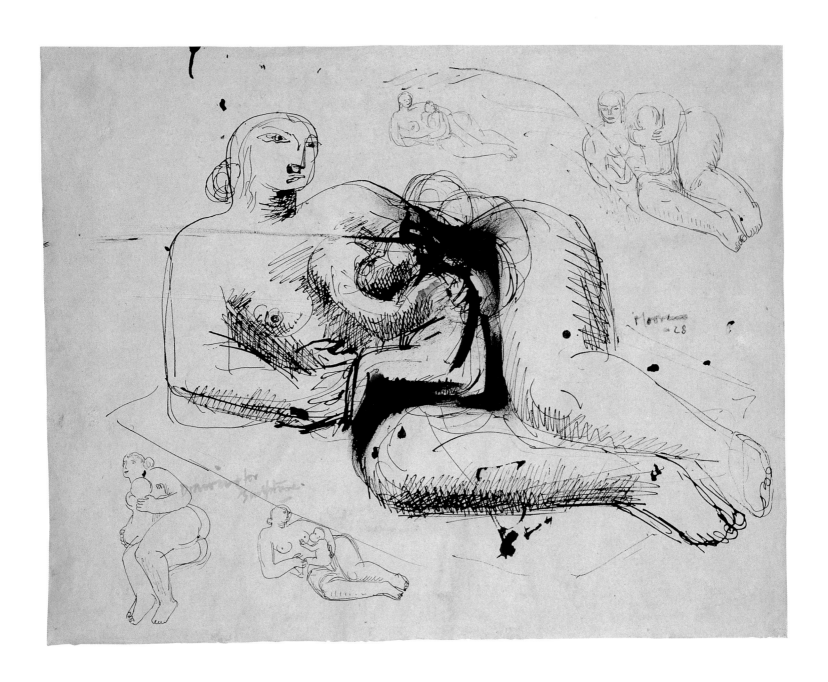

117. *Reclining Figure with Child,* 1928
Pen and ink, and watercolor wash on off-white
lightweight wove paper, 12⅞ × 16¾ in.
The Henry Moore Foundation: gift of the artist 1977
(HMF 682)

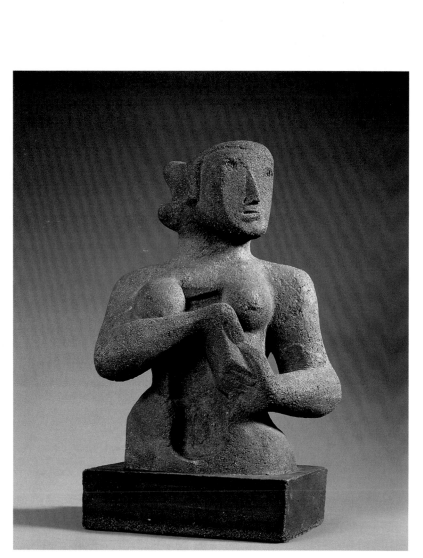

9. *Half-figure,* 1929
Cast concrete, height 14½ in.
Courtesy Ivor Braka Limited, London
(LH 67)

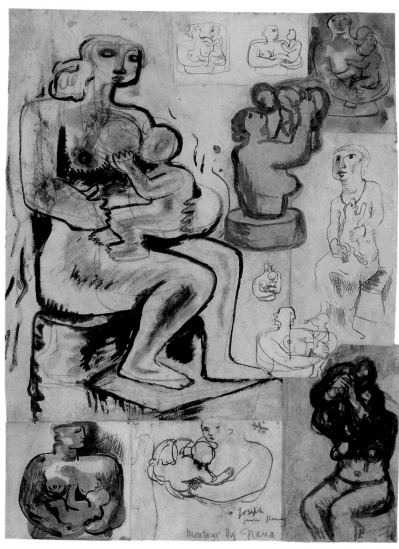

118. *Montage of Mother and Child Studies,* c. 1929–30
Pencil, pen and ink, brush and ink, colored pencils, chalk,
watercolor, and collage on wove paper, 19 × 14⅝ in.
Collection, Art Gallery of Ontario, Toronto. Purchase, 1976
(HMF 731)

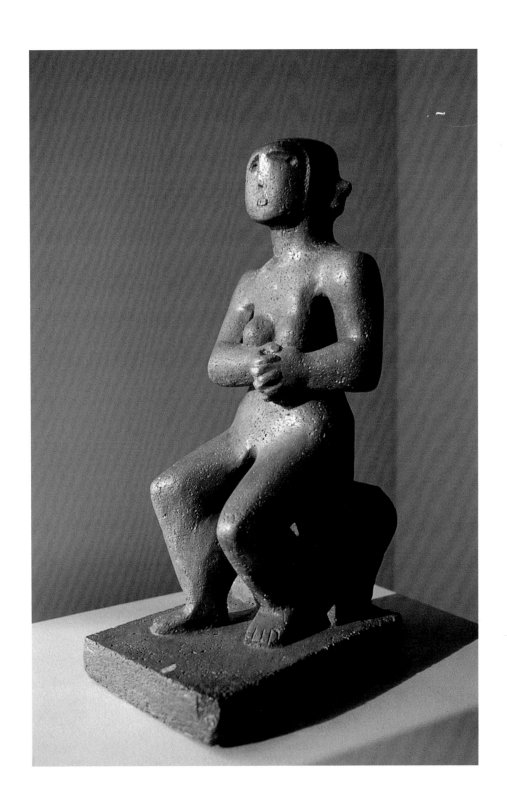

8. *Seated Figure,* 1929
Cast concrete, height 17¾ in.
The Henry Moore Foundation:
gift of Irina Moore 1979
(LH 65)

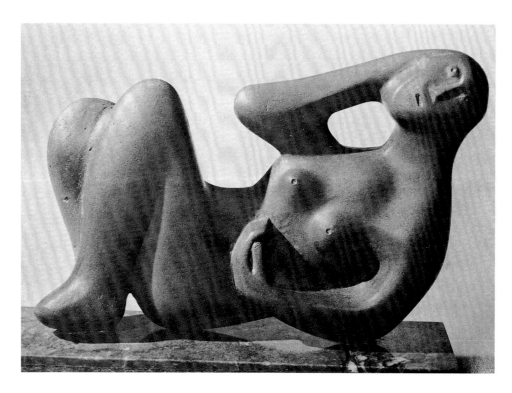

11. *Reclining Figure,* 1930
Bronze, height 6¾ in.
The Henry Moore Foundation:
gift of the artist 1977
(LH 85)

119. *Woman in an Armchair,* 1930
Brush and ink, and oil paint on
cream-buff wove paper, 13½ × 16 in.
The Moore Danowski Trust
(HMF 774)

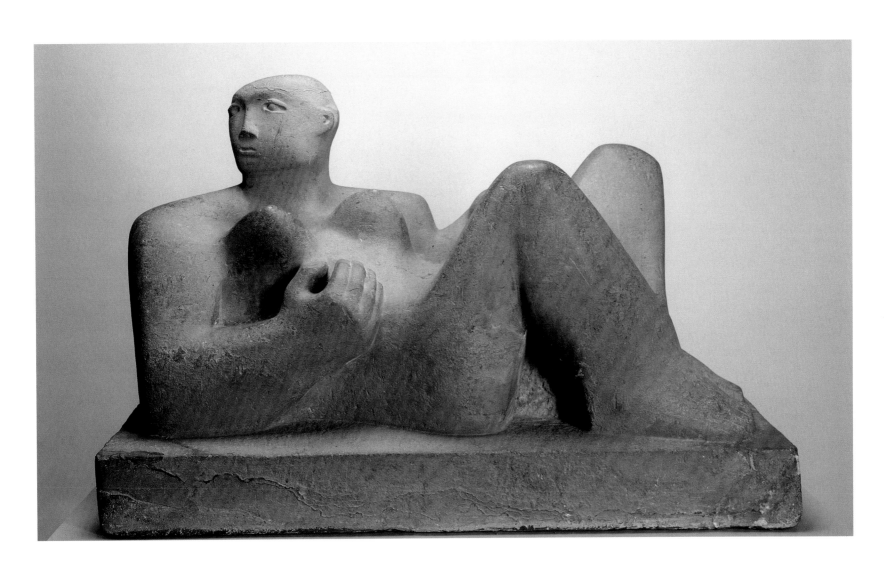

10. *Reclining Woman,* 1930
Green Hornton stone, 23½ × 36½ × 16¼ in.
National Gallery of Canada, Ottawa.
Purchased 1956
(LH 84)

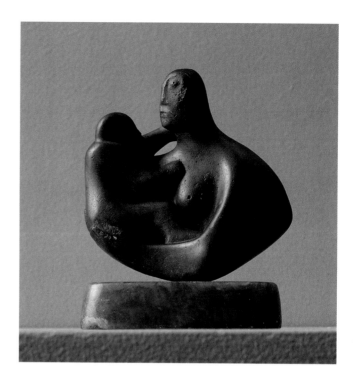

12. *Mother and Child,* 1930
Ironstone, height 5 in.
The Henry Moore Foundation: acquired 1998
(LH 86)

120. *Ideas for Sculpture,* 1930
Pen and ink on wove paper, 7⅛ × 4½ in.
Collection, Art Gallery of Ontario, Toronto.
Gift of Henry Moore, 1974
(HMF 808)

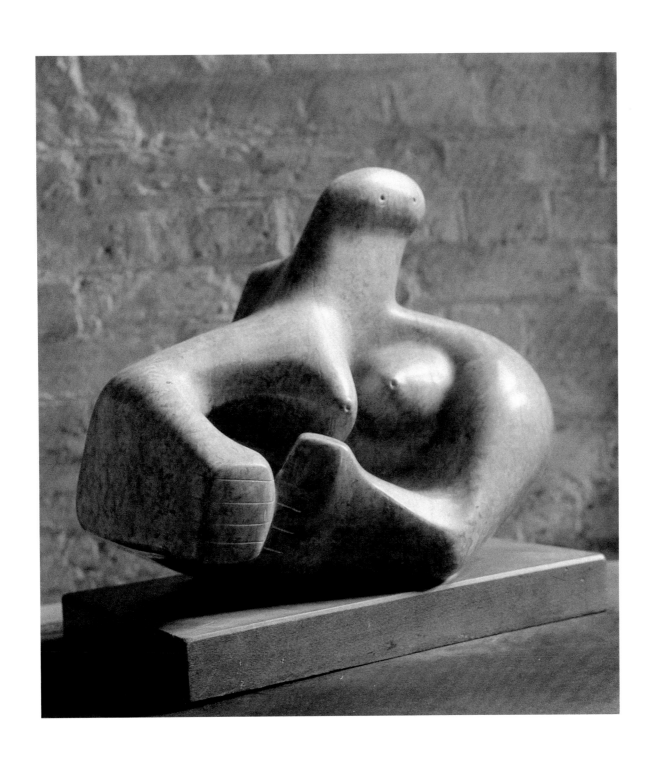

15. *Composition,* 1931
Cumberland alabaster, length 16⅜ in.
The Henry Moore Foundation: gift of Irina Moore 1979
(LH 102)

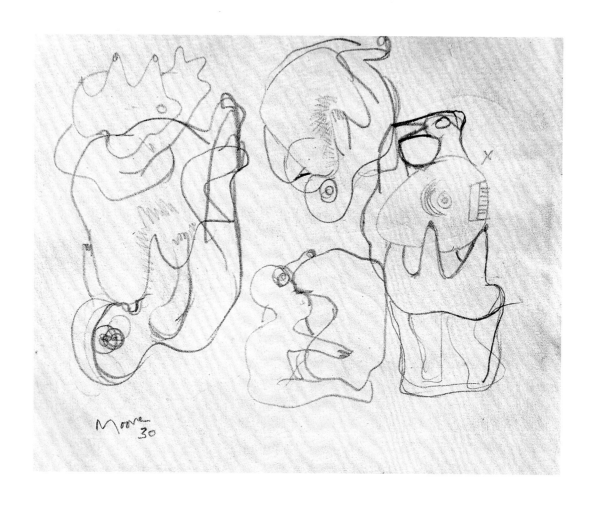

121. *Ideas for Composition in Green Hornton Stone*
(Page from No. 1 Drawing Book 1930–31), 1930–31
Pencil on cream lightweight wove paper, 6⅜ × 7⅞ in.
The Henry Moore Foundation: gift of the artist 1977
(HMF 832)

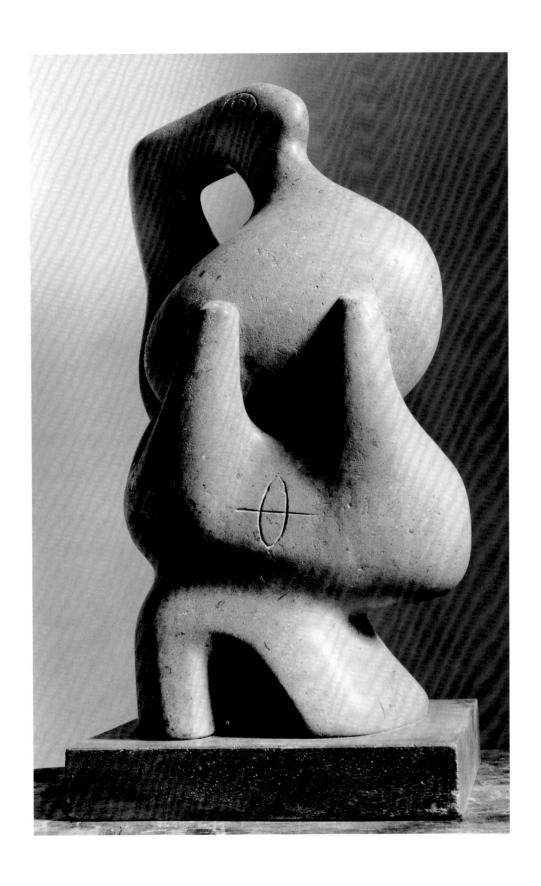

13. *Composition,* 1931
Green Hornton stone, height 19 in.
The Moore Danowski Trust
(LH 99)

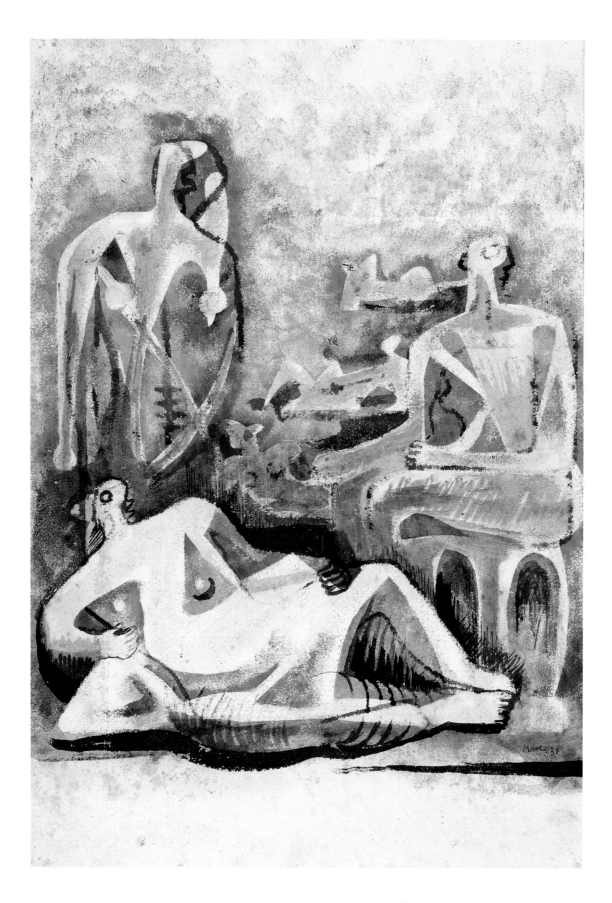

122. *Seated and Reclining Figures,* 1931
Pen and ink, brush and ink, watercolor, wash, and
gouache on cream heavyweight wove paper, 22 × 15 in.
The Henry Moore Foundation: acquired 1999
(HMF 853)

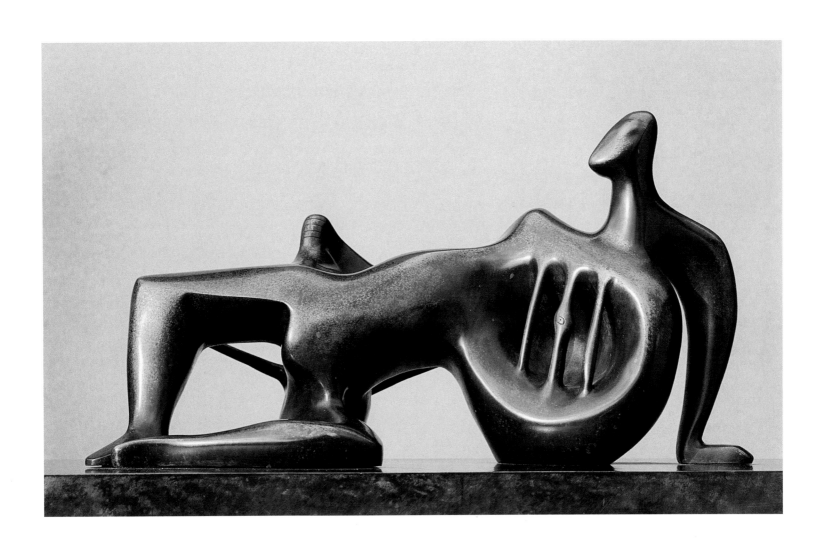

14. *Reclining Figure,* 1931
Bronze, length 17 in.
The Henry Moore Foundation:
gift of the artist 1977
(LH 101)

16. *Relief,* 1931 (cast 1968)
Bronze (unnumbered [2/3]), height 18¼ in.
The Henry Moore Foundation: gift of the artist 1979
(LH 103)

24. *Two Forms,* 1936
Ironstone, 7¼ × 6 × 2½ in.
Private collection
(LH 146)

17. *Half-figure,* 1931
Veined alabaster, 13½ × 4⅝ × 3¾ in.
Private collection
(LH 108)

18. *Girl,* 1931
Ancaster stone, 29 × 14½ × 10¾ in.
Tate. Purchased 1952
(LH 109)

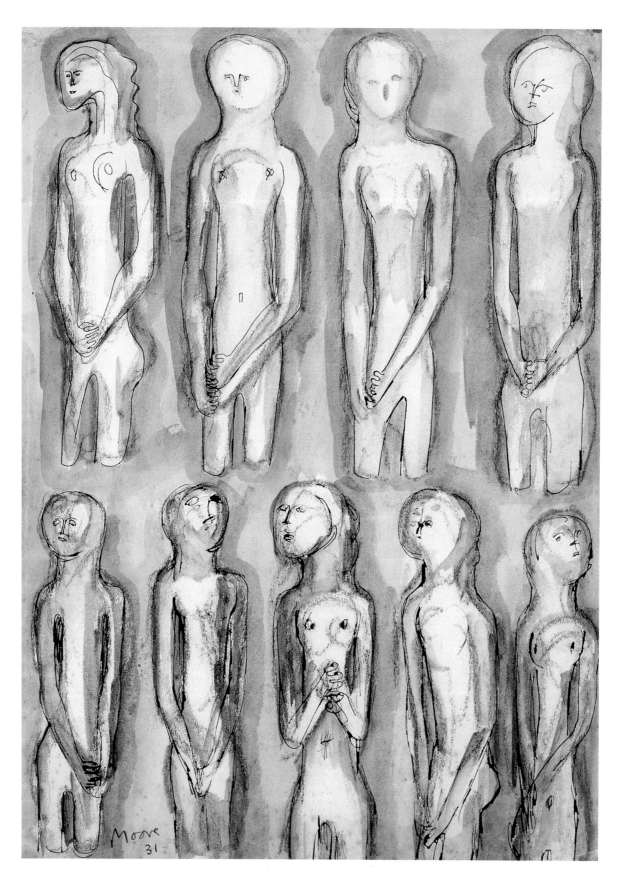

123. *Ideas for Sculpture: Studies for Boxwood Standing Girl,* 1931
Chalk, brush and ink, pen and ink, and wash on off-white wove paper,
14¾ × 10¾ in. Dallas Museum of Art, Foundation for the Arts Collection,
gift of Cecile and I. A. Victor
(HMF 870a)

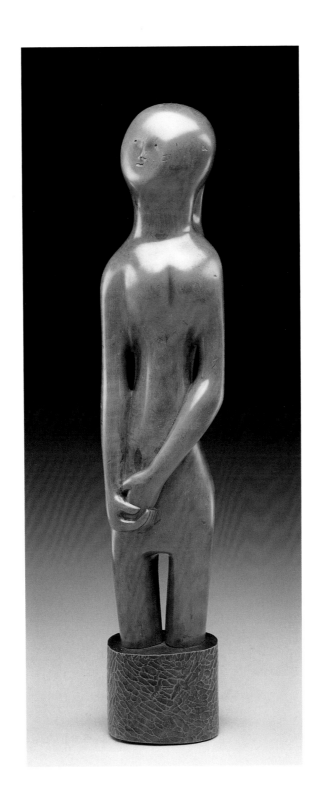

19. *Girl,* 1931
Boxwood, 14½ × 3⅛ × 2⅝ in.
Dallas Museum of Art, Foundation for the
Arts Collection, gift of Cecile and I. A. Victor
(LH 112)

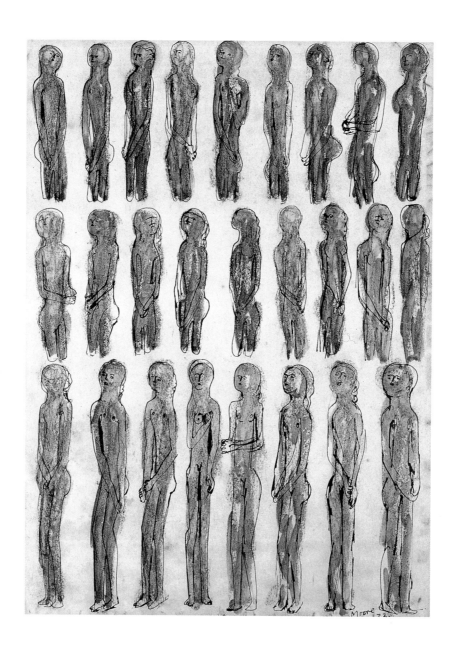

124. *Ideas for Boxwood Carving,* 1932
Ink on paper, 15¼ × 11½ in.
The Hunt Museum, Limerick
(HMF 922b)

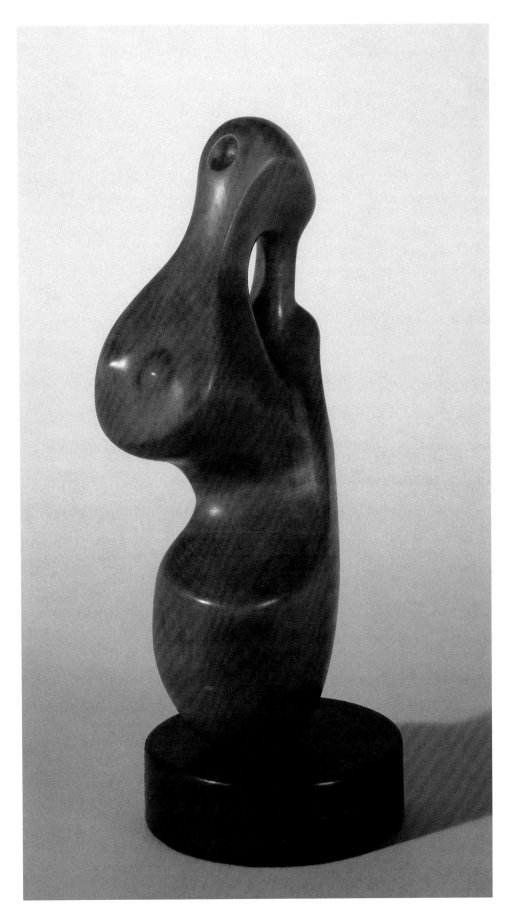

20. *Composition,* 1932
Beechwood, 14 × 4⅛ × 6⅜ in.
High Museum of Art, Atlanta, Georgia,
Gift of Rich's, Inc.
(LH 115)

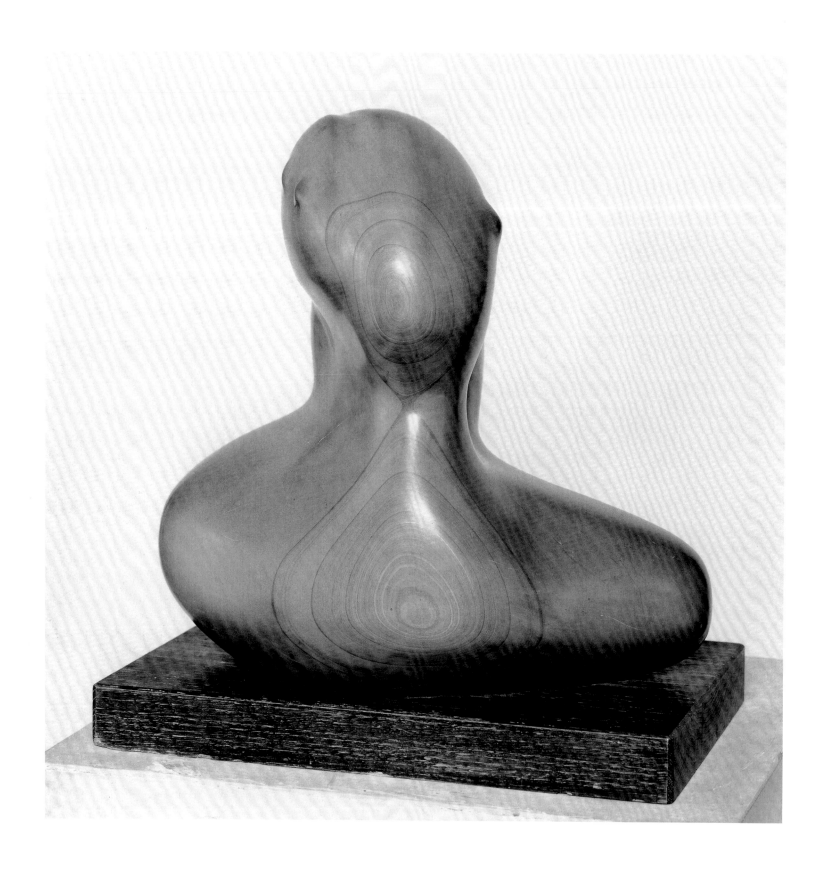

21. *Composition,* 1932
African wonderstone, 17½ × 18 × 11¾ in.
Tate. Presented by the Friends of the Tate Gallery 1960
(LH 119)

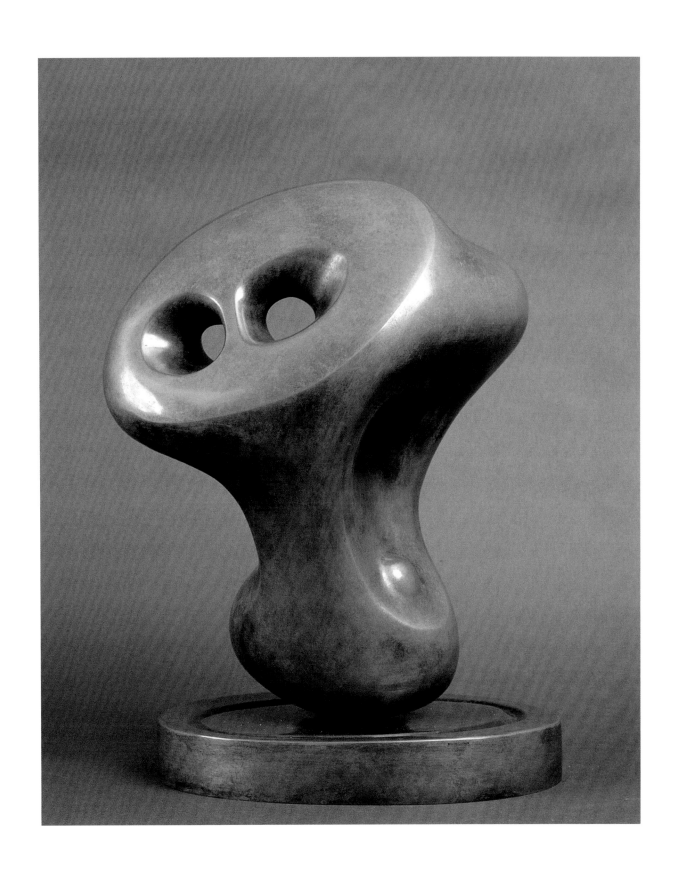

22. *Composition*, 1933
Bronze (unique cast), height 14 in.
The Henry Moore Foundation: acquired 1991
(LH 132)

126. *Ideas for Sculpture,* 1932
Pencil on off-white lightweight wove paper, 9½ × 7 in.
The Henry Moore Foundation: gift of the artist 1977
(HMF 949)

127. *Ideas for Sculpture,* 1932
Pencil on off-white lightweight wove paper, 9½ × 7 in.
The Henry Moore Foundation: gift of the artist 1977
(HMF 951)

125. *Ideas for Sculpture,* 1932
Pencil on off-white lightweight wove paper, 9½ × 7 in.
The Henry Moore Foundation: gift of the artist 1977
(HMF 944)

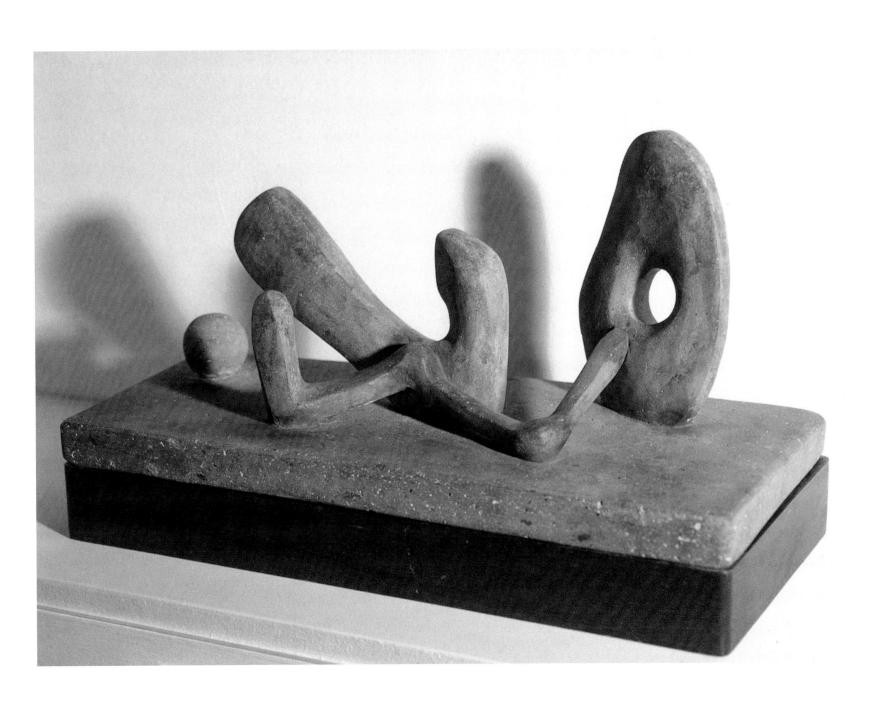

23. *Composition,* 1934
Cast concrete, length 17½ in.
The Henry Moore Foundation:
gift of the artist 1977
(LH 140)

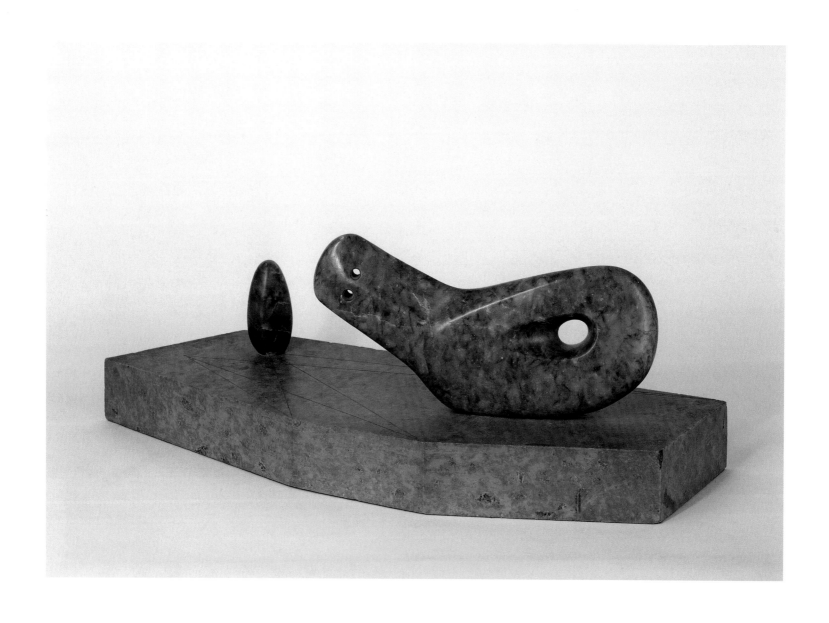

25. *Bird and Egg,* 1934
Cumberland alabaster, 8⅛ × 22 × 9½ in. (with base)
Yale Center for British Art, Paul Mellon Collection
(LH 152)

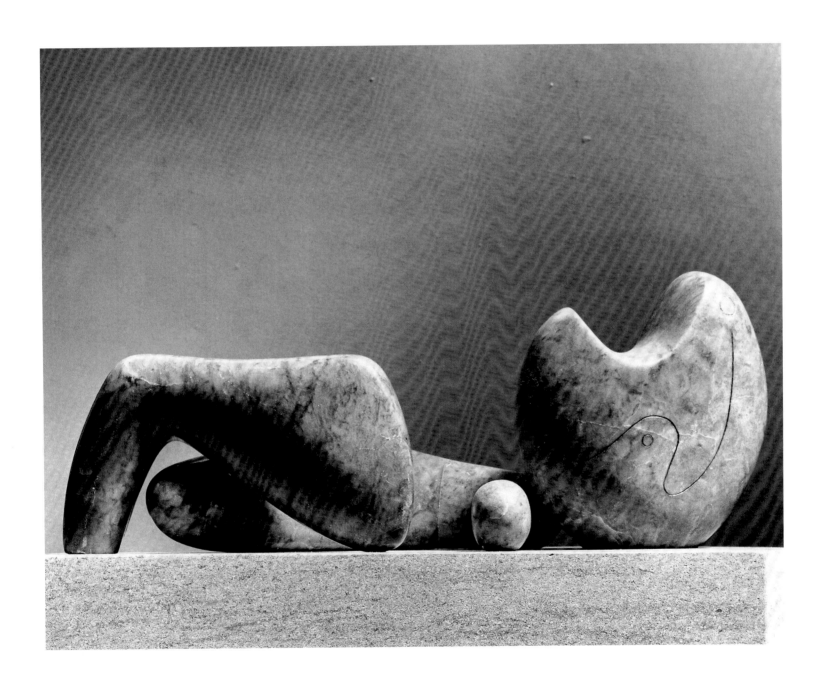

26. *Four-Piece Composition: Reclining Figure,* 1934
Cumberland alabaster, 6⅞ × 18 × 8 in.
Tate. Purchased with assistance from the
National Art Collections Fund 1976
(LH 154)

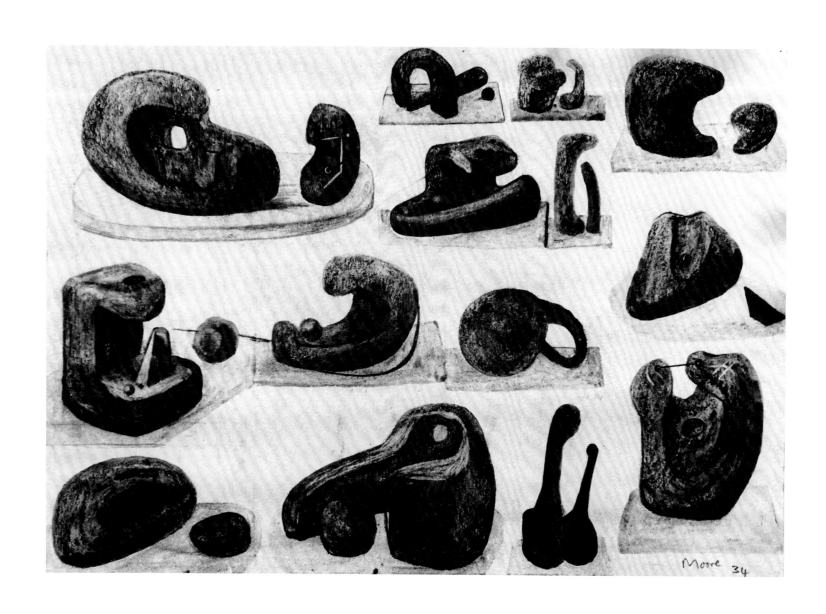

130. *Reclining Figures,* 1934
Charcoal, watercolor, wash, and pen and ink on paper,
14⅝ × 21⅝ in.
Kröller-Müller Museum, Otterlo, The Netherlands
(HMF 1085)

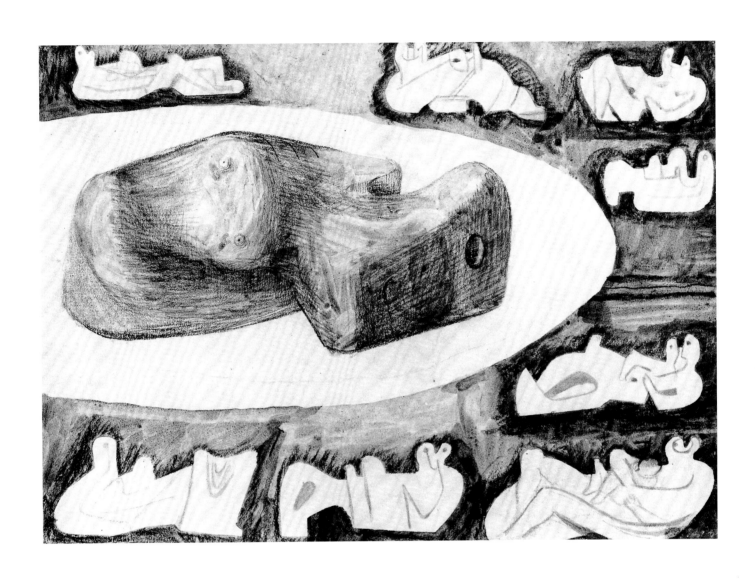

131. *Study for Recumbent Figure,* 1934
Black pencil, brush and ink, and wash on wove paper, 11 × 15¼ in.
Collection, Art Gallery of Ontario, Toronto. Gift from the Junior Women's
Committee Fund, 1961
(HMF 1089)

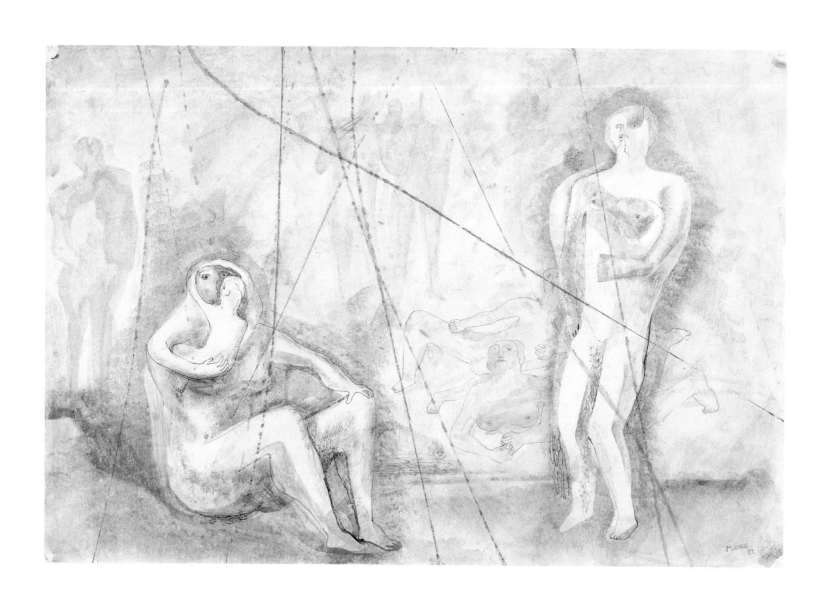

128. *Figure Studies: Seated Mother and Child, Standing Man,* 1933
Pencil, charcoal, pen and ink, and wash on
cream medium-weight wove paper, 14⅞ × 22 in.
The Henry Moore Foundation: gift of the artist 1977
(HMF 1015)

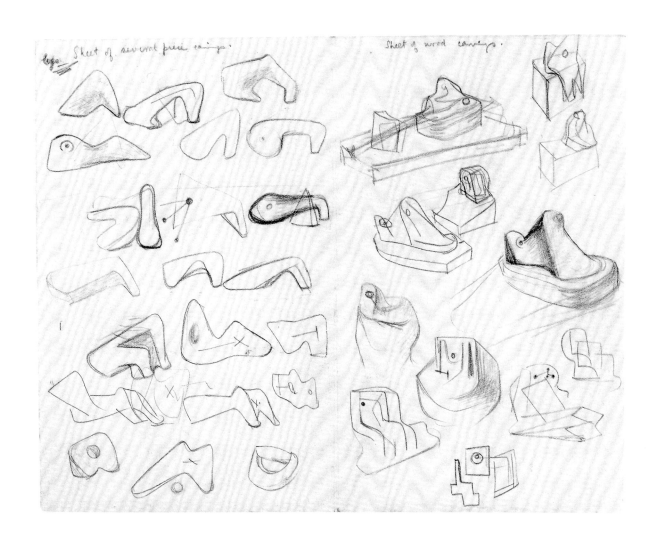

134. *Studies for Several-Piece Compositions and Wood Carvings,* 1934
Crayon (part-rubbed) on off-white lightweight wove paper, 8⅜ × 10¾ in.
The Henry Moore Foundation: gift of the artist 1977
(HMF 1102)

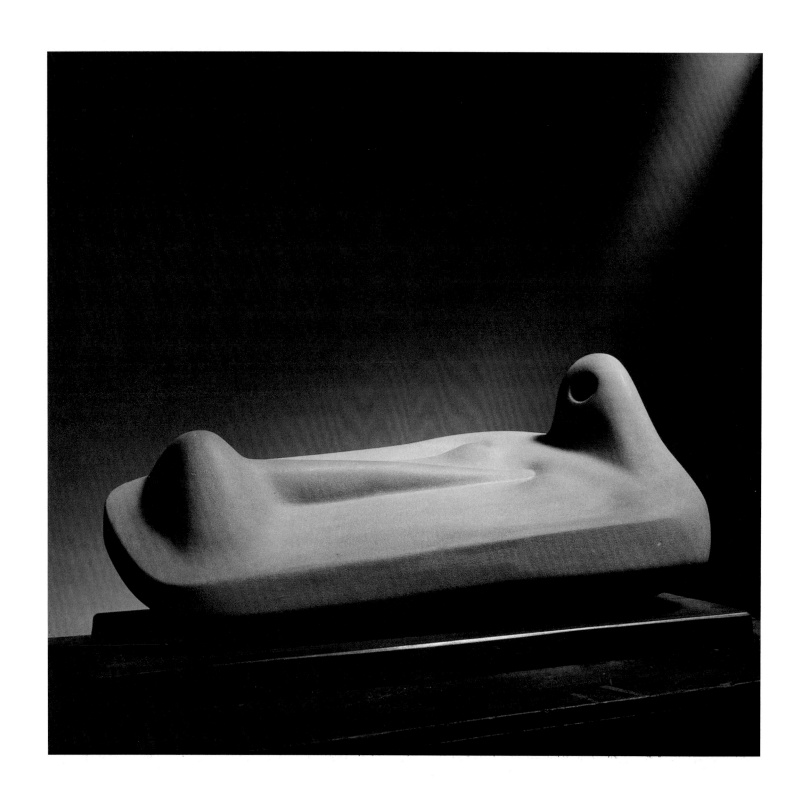

27. *Reclining Figure,* 1934–35
Corsehill stone, length 24⅛ in. (with base)
The Moore Danowski Trust
(LH 155)

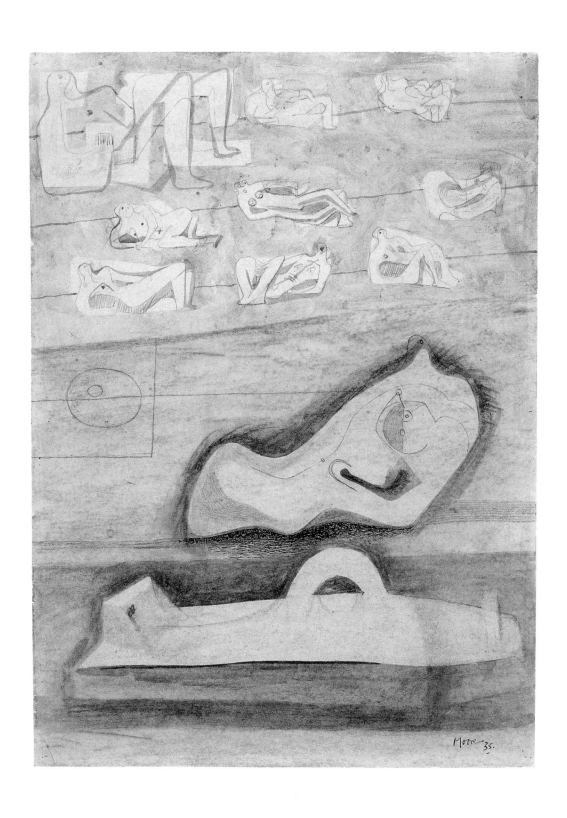

136. *Eleven Ideas for Sculpture: Reclining Figures,* 1935
Pencil, charcoal (rubbed and washed), crayon, pen and ink, brush and ink,
and watercolor wash on cream lightweight wove paper, 14⅞ × 10⅞ in.
The Henry Moore Foundation: acquired by exchange 1981
(HMF 1150)

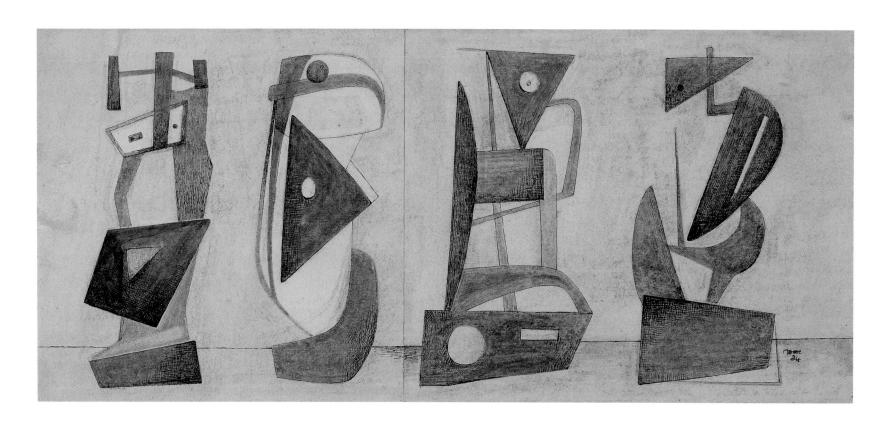

133. *Ideas for Metal Sculpture,* 1934
Pen and ink, colored chalks and watercolor on wove paper, 11 × 24¾ in.
Collection, Art Gallery of Ontario, Toronto. Gift of Henry Moore, 1974
(HMF 1098 and 1099)

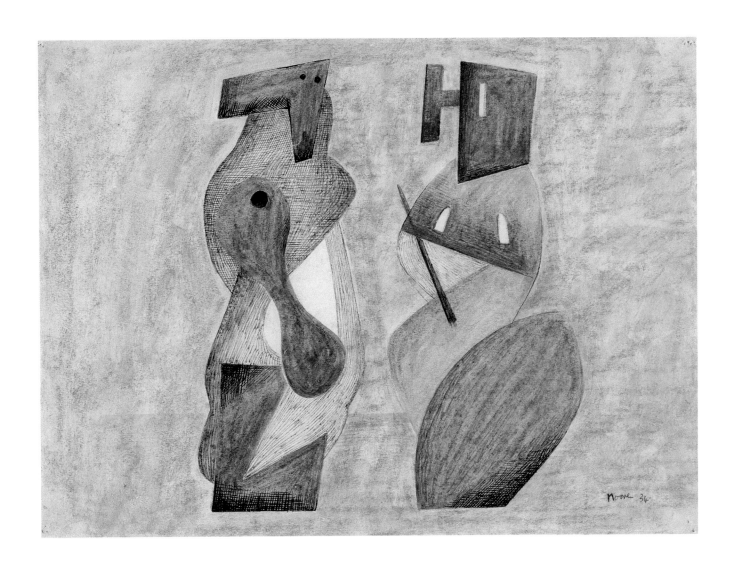

132. *Drawing for Metal Sculpture,* 1934
Pencil, chalk, watercolor, wash, and
pen and ink on paper, 10¾ × 14¾ in.
The Moore Danowski Trust
(HMF 1097)

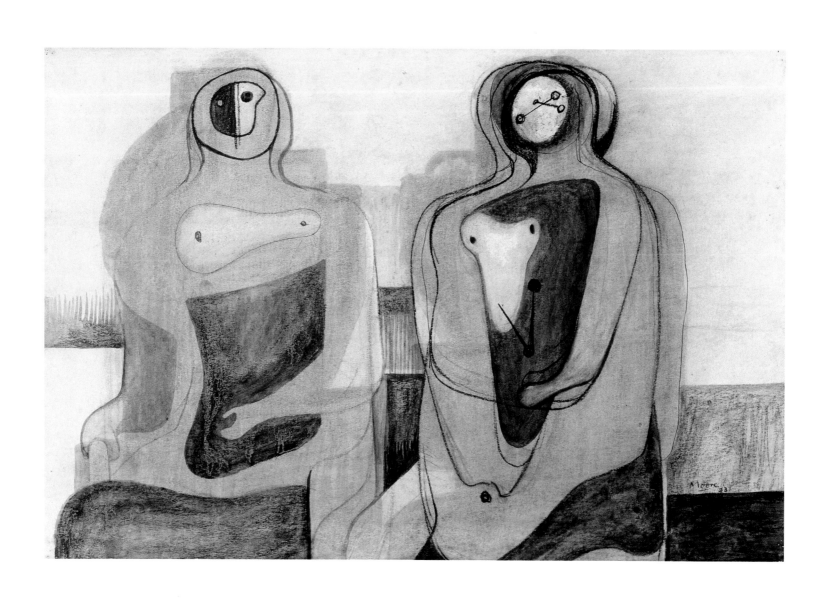

129. *Two Seated Women,* 1934
Pen and ink, charcoal, crayon, watercolor, and wash
on off-white lightweight wove paper, 14⅝ × 21¾ in.
The Henry Moore Foundation: acquired 1983
(HMF 1077)

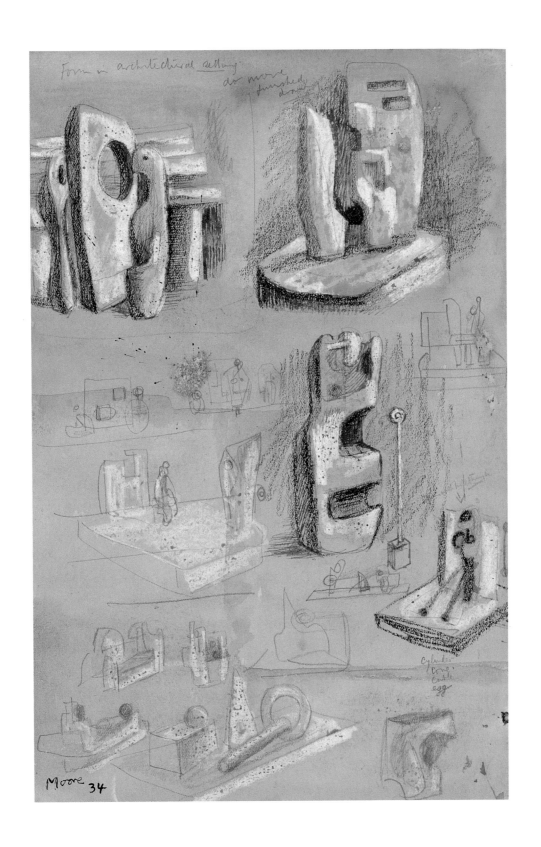

135. *Monoliths,* 1934
Pencil, crayon, pen and red ink, watercolor, and wash
on cream medium-weight wove paper, 11 × 7¼ in.
The Henry Moore Foundation: acquired 1996
(HMF 1127)

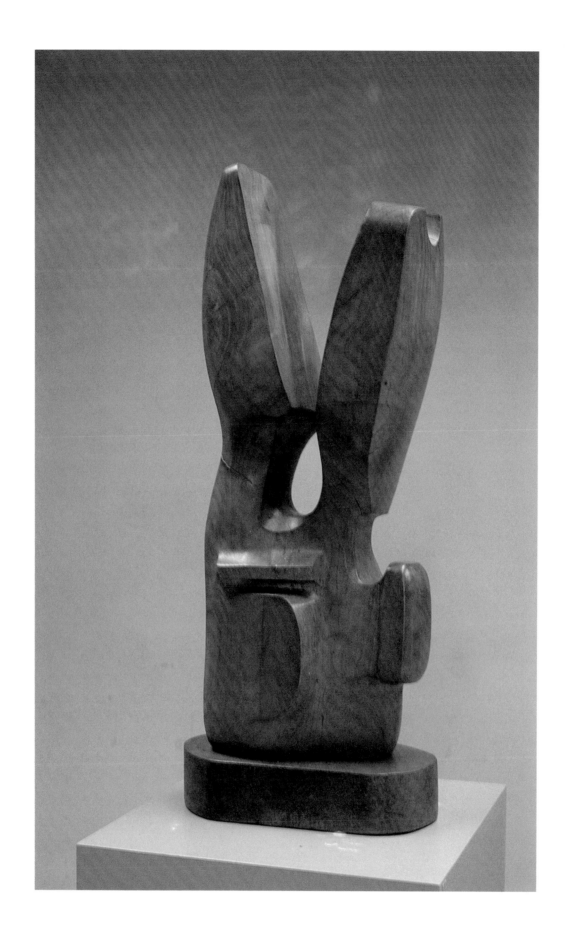

28. *Family,* 1935
Elmwood, height 40 in.
The Henry Moore Foundation:
gift of the artist 1977
(LH 157a)

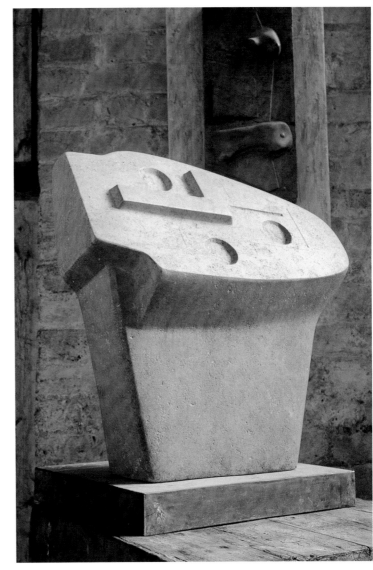

29. *Carving,* 1936
Travertine marble, height 18 in.
The Henry Moore Foundation:
gift of Irina Moore 1977
(LH 164)

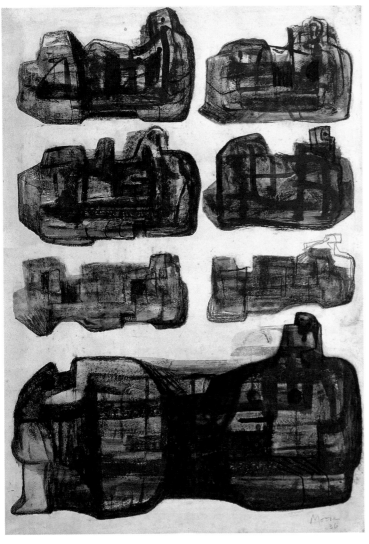

137. *Square Form Reclining Figures,* 1936
Chalk and wash on cream medium-weight
wove paper, 21⅞ × 15½ in.
The Henry Moore Foundation: gift of the artist 1977
(HMF 1242)

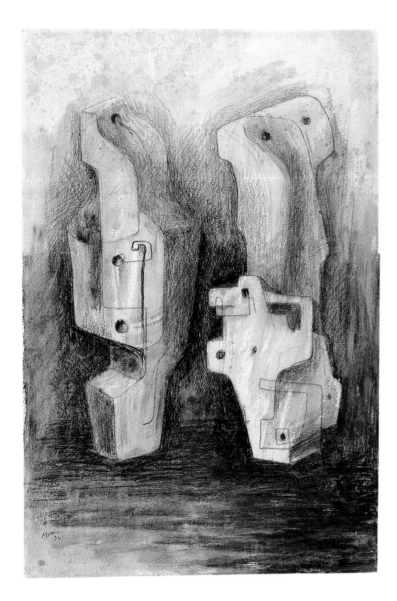

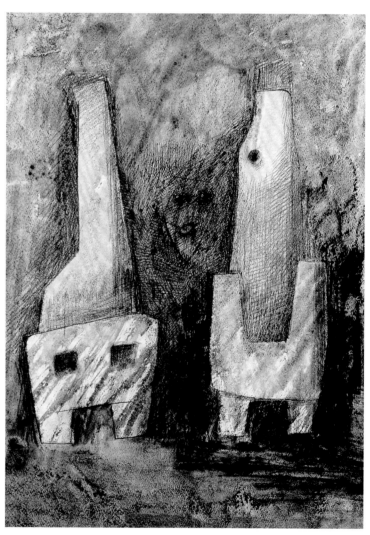

138. *Two Upright Forms,* 1936
Pencil, chalk, pen and ink, and wash on off-white
heavyweight wove paper, 22¼ × 15⅛ in.
The Henry Moore Foundation: acquired 1998
(HMF 1253)

139. *Two Upright Forms,* 1936
Crayon, charcoal (rubbed), wash,
wax crayon, and pen and ink on cream
heavyweight wove paper, 19½ × 14 in.
The British Museum, London
(HMF 1254)

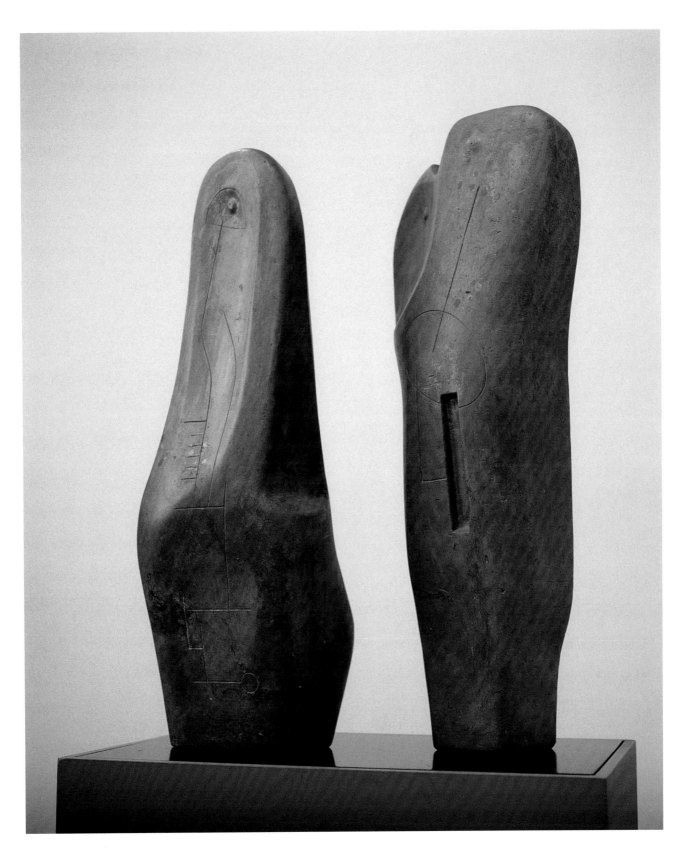

30. *Two Forms,* 1936
Hornton stone, 42 × 18 × 8 in. and 40¼ × 14 × 12 in.
Philadelphia Museum of Art. Gift of Mrs. H. Gates Lloyd
(LH 170)

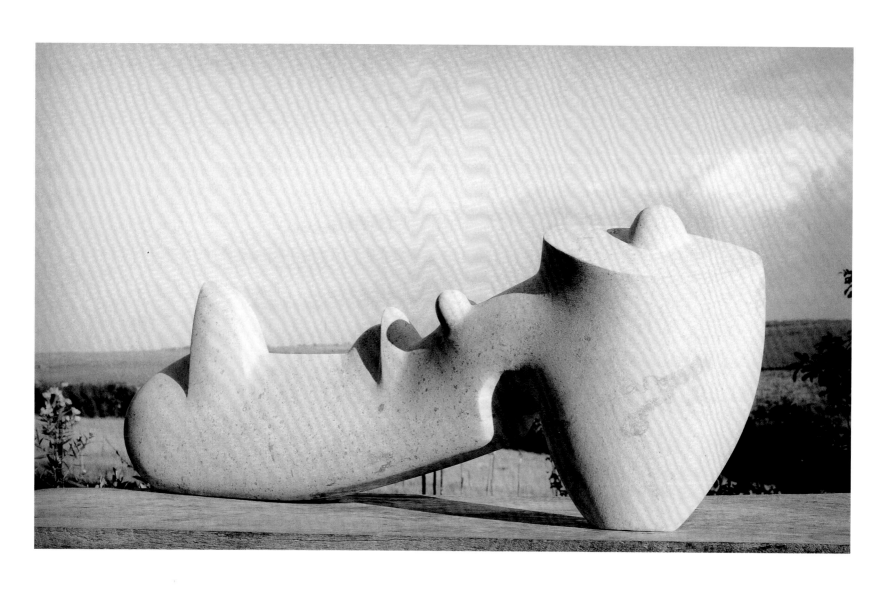

33. *Reclining Figure,* 1937
Hopton Wood stone, 13 × 4 × 38 in.
Fogg Art Museum, Harvard University Art Museums,
Gift of Lois Orswell
(LH 178)

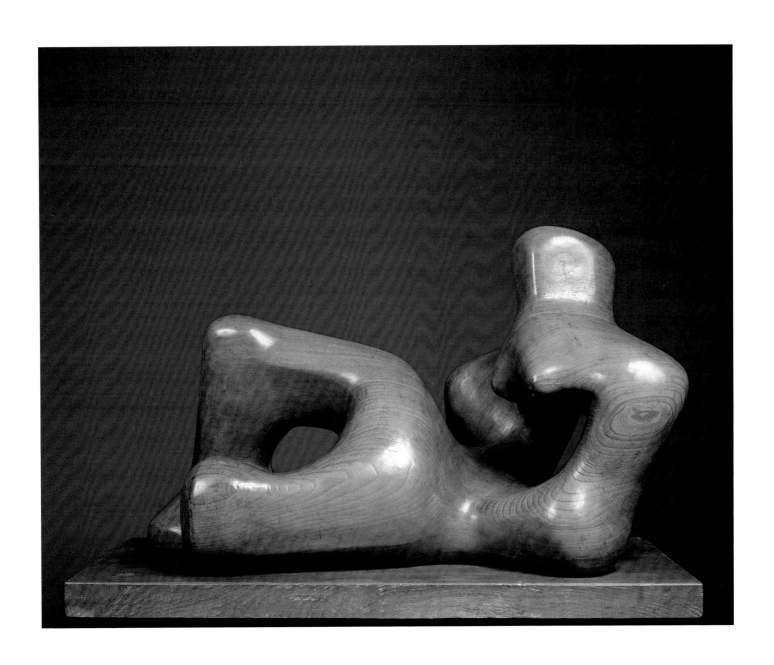

32. *Reclining Figure,* 1936
Elmwood, length 42 in.
Wakefield Museums and Arts. Purchased by Wakefield Corporation
with support from the Victoria and Albert Museum, Mr. E. C. Gregory
and the Wakefield Permanent Art Fund, 1942
(LH 175)

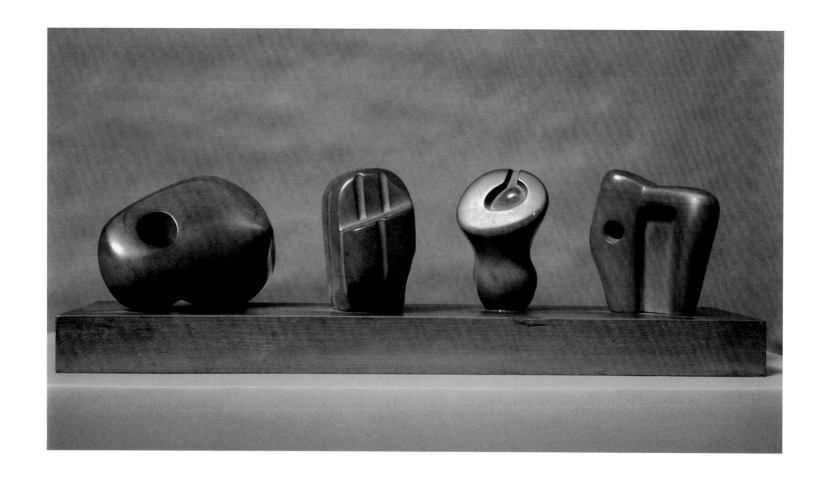

31. *Four Forms,* 1936
African wonderstone, 7¼ × 25⅛ in.
Indiana University Art Museum: given in honor
of Dr. Roy Elder by Sarahanne Hope-Davis
(LH 172)

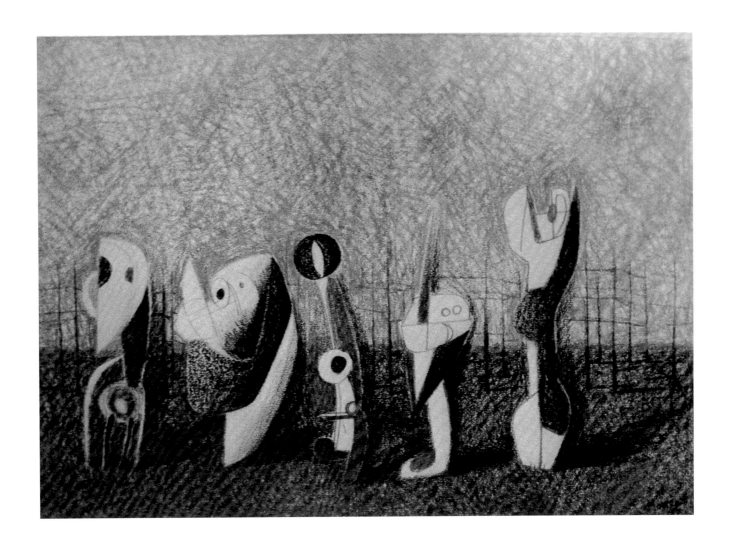

140. *Five Metal Forms,* 1937
Crayon and chalk on paper, 15¾ × 22⅝ in.
Wakefield Museums and Arts. Given by Mrs. Hazel King-Farlow
through the Wakefield Permanent Art Fund, 1937
(HMF 1317)

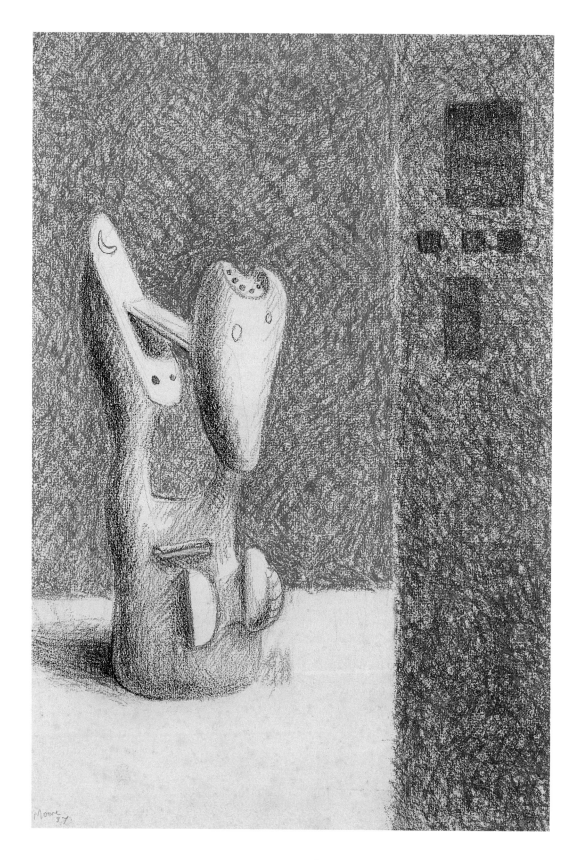

141. *Sculpture in a Setting,* 1937
Chalk on off-white heavyweight wove paper, 22 × 15 in.
The Henry Moore Foundation: gift of the artist 1977
(HMF 1318)

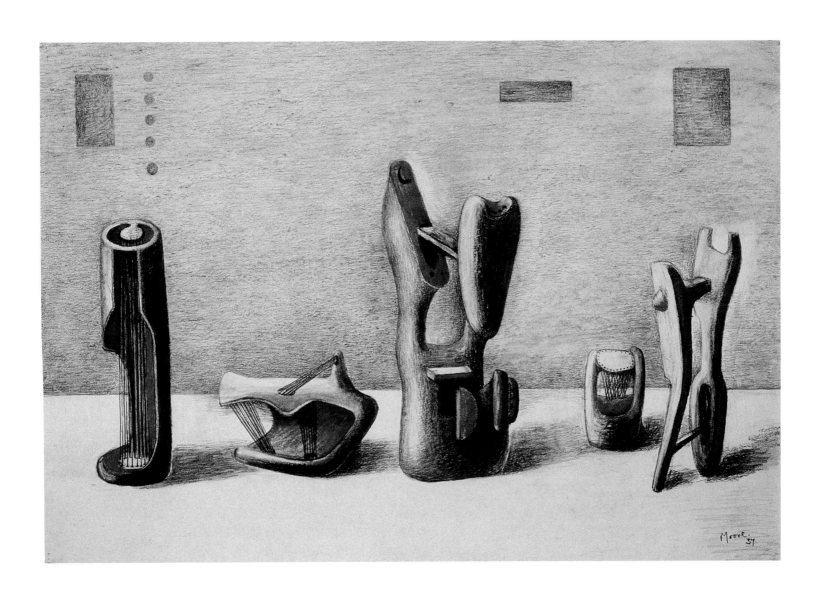

142. *Five Figures in a Setting,* 1937
Charcoal (rubbed), pastel (washed), and crayon on
cream medium-weight wove paper, 15 × 21⅞ in.
The Moore Danowski Trust
(HMF 1319)

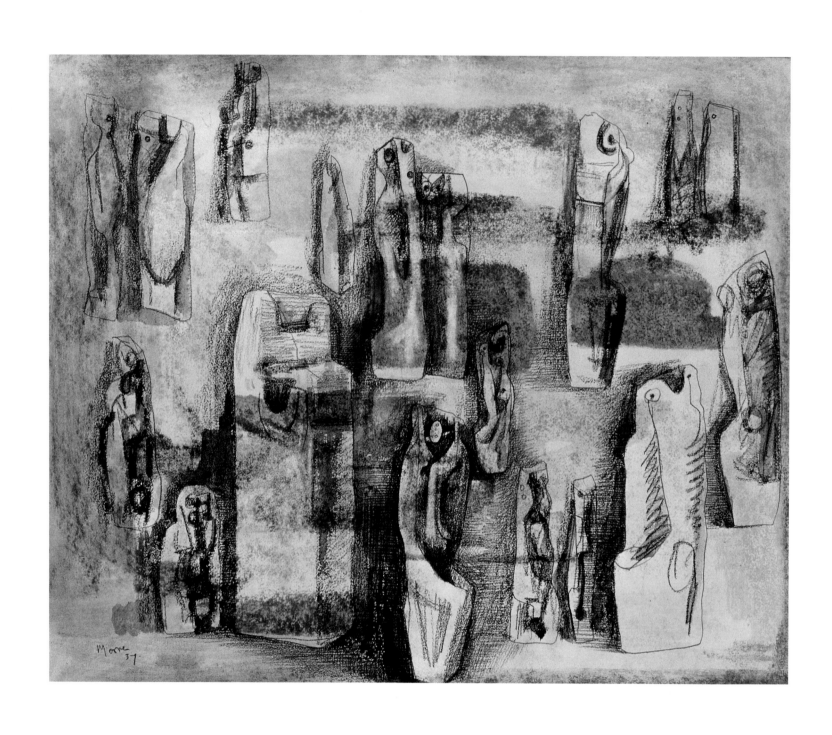

143. *Drawing for Stone Sculpture,* 1937
Pencil, chalk, watercolor, and wash on cream
heavyweight wove paper, 19½ × 23⅞ in.
The Henry Moore Foundation: bequeathed by
Gérald Cramer 1991
(HMF 1320)

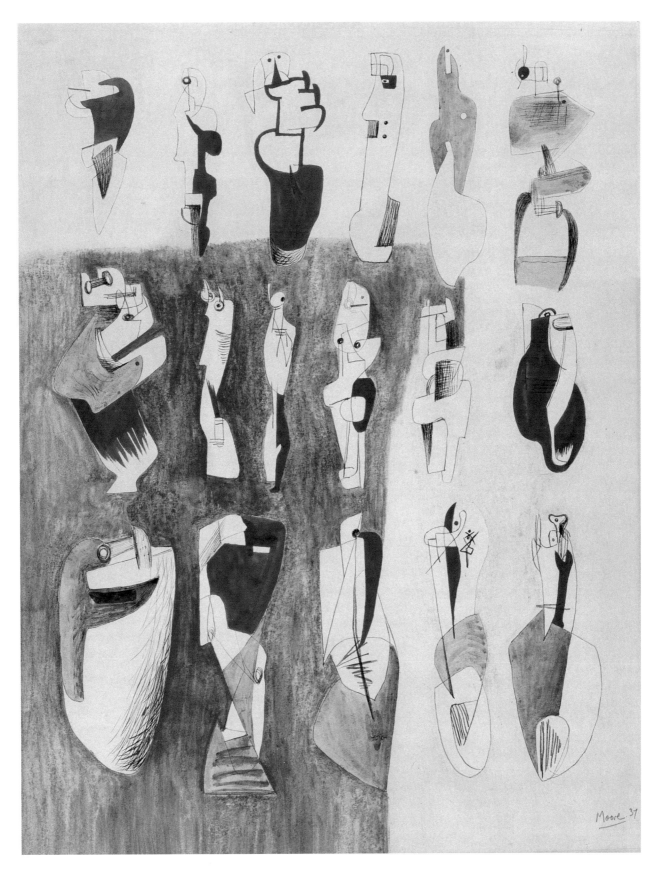

144. *Seventeen Ideas for Metal Sculpture,* 1937
Pencil, pastel (washed), watercolor, pen and ink, and gouache
on cream medium-weight wove paper, 26¼ × 20⅜ in.
The Henry Moore Foundation: gift of the artist 1977
(HMF 1321)

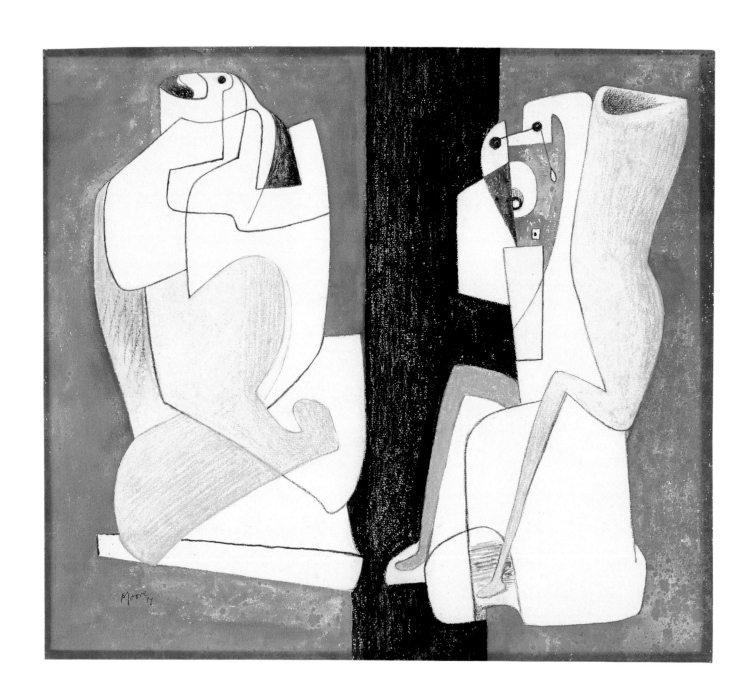

145. *Drawing for Sculpture,* 1937
Chalk, watercolor, and gouache on cream
heavyweight wove paper, 19 × 21½ in.
The Henry Moore Foundation: gift of the artist 1977
(HMF 1325)

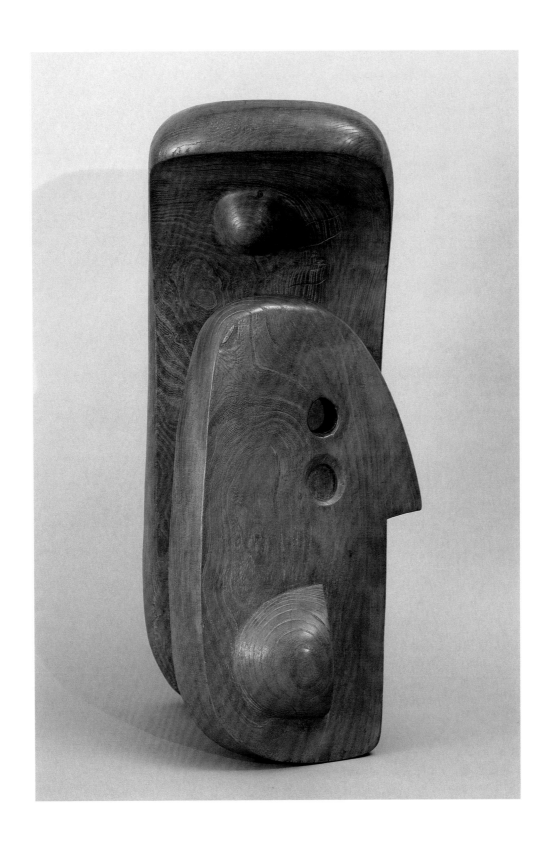

40. *Mother and Child,* 1938
Elmwood, 30⅜ × 13⅞ ×15½ in.
The Museum of Modern Art, New York.
Acquired through the Lillie P. Bliss Bequest, 1953
(LH 194)

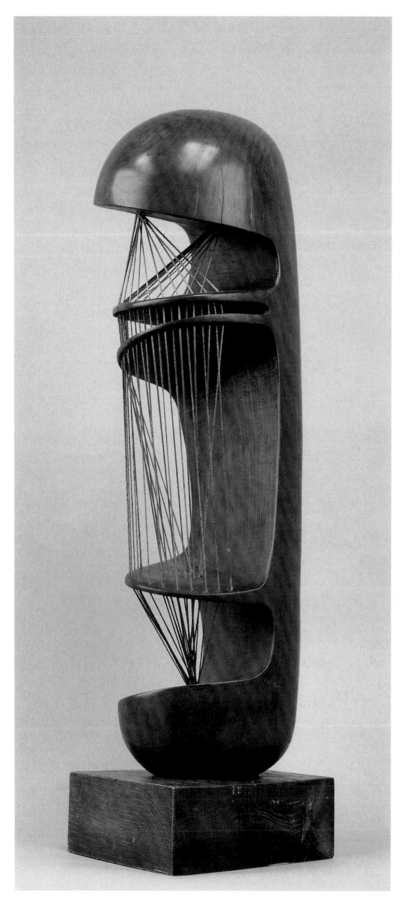

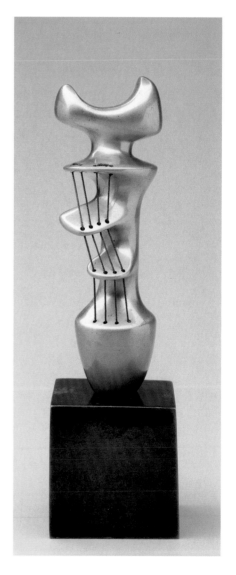

35. *Stringed Figure,* 1937
Cherry wood and string on oak base, 2⅜ × 5⅜ × 6⅝ in.
Hirshhorn Museum and Sculpture Garden, Smithsonian Institution.
Joseph H. Hirshhorn Purchase Fund, 1989
(LH 183)

37. *Stringed Figure,* 1938 (cast 1966)
Bronze and string, 4⅞ × 1½ × 1¾ in.
Dallas Museum of Art, Foundation for the Arts
Collection, bequest of Margaret Ann Bolinger
(LH 186e)

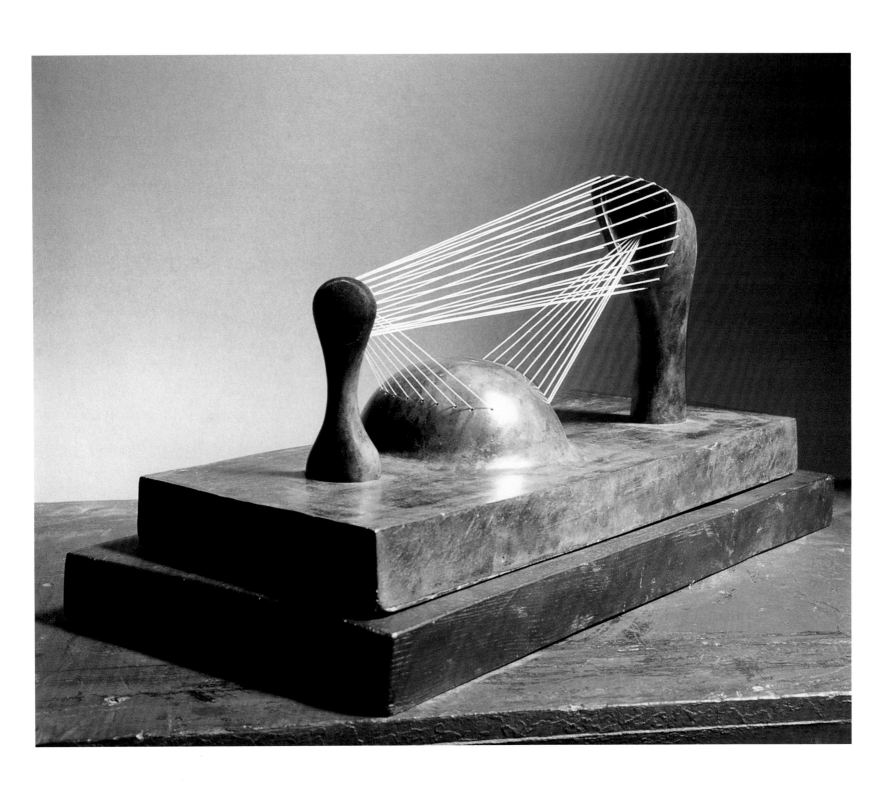

34. *Stringed Relief,* 1937 (cast 1976)
Bronze and nylon, length 19½ in.
The Henry Moore Foundation: gift of the artist 1977
(LH 182)

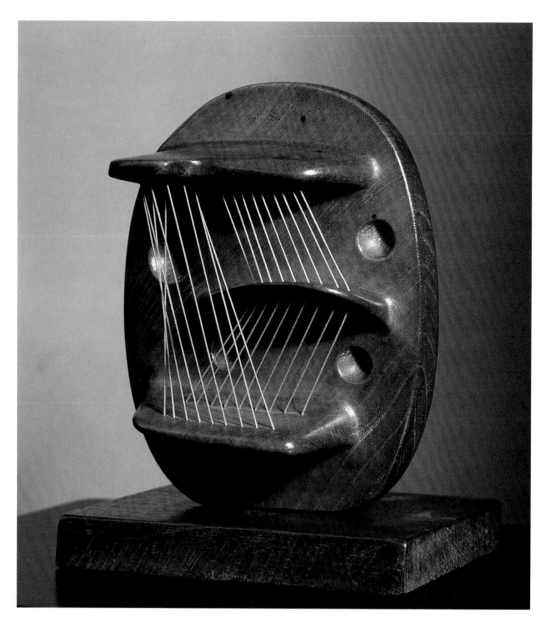

38. *Head,* 1938
Elmwood and string, height 8 in.
The National Trust, Willow Road
(LH 188)

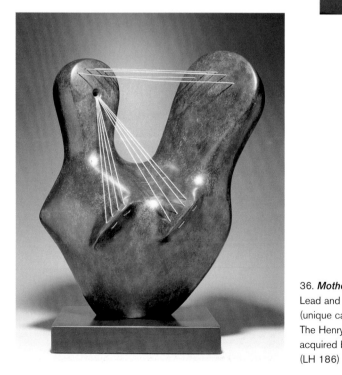

36. *Mother and Child,* 1938
Lead and yellow string
(unique cast), height 3¾ in.
The Henry Moore Foundation:
acquired by exchange 1996
(LH 186)

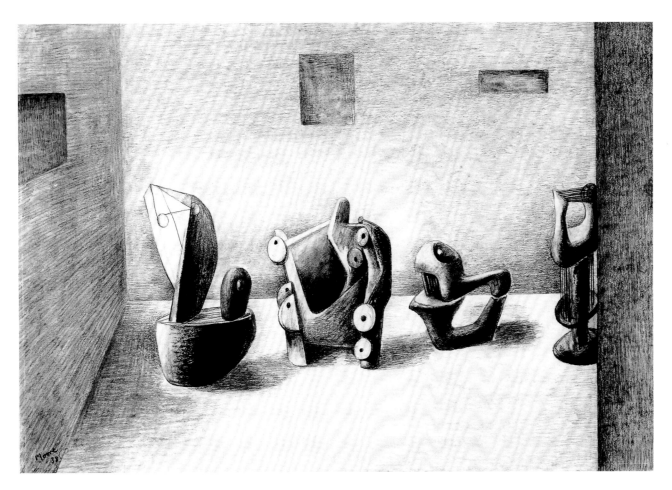

147. *Ideas for Sculpture in a Setting,* 1938
Charcoal (washed), chalk, and ink wash on
heavyweight wove paper, 15 × 22 in.
The Moore Danowski Trust
(HMF 1374)

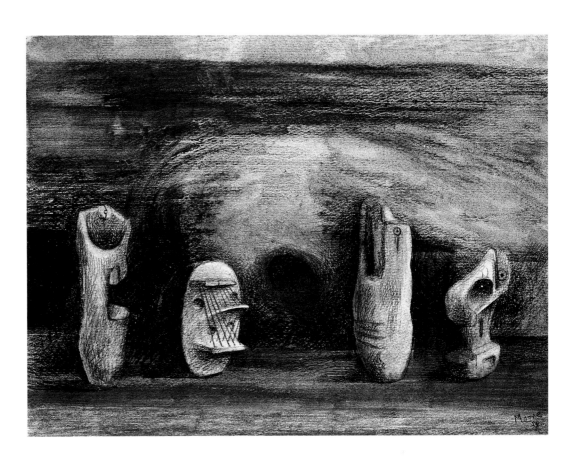

148. *Four Forms,* 1938
Chalk, crayon, wash, and pen
and ink on paper, 11 × 15 in.
Tate. Purchased 1959
(HMF 1379)

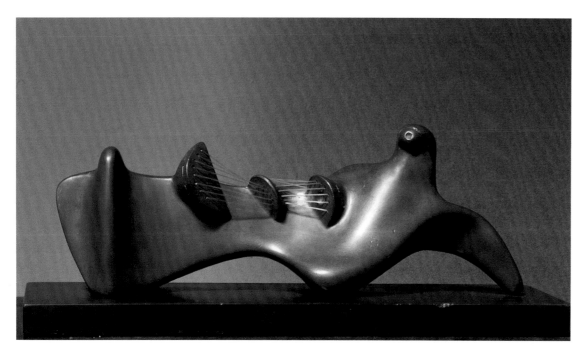

41. *Stringed Reclining Figure,* 1939
Bronze and string, 4½ × 12¼ × 3¾ in.
University of Michigan Museum of Art.
Bequest of Mrs. Florence L. Stol
(LH 197)

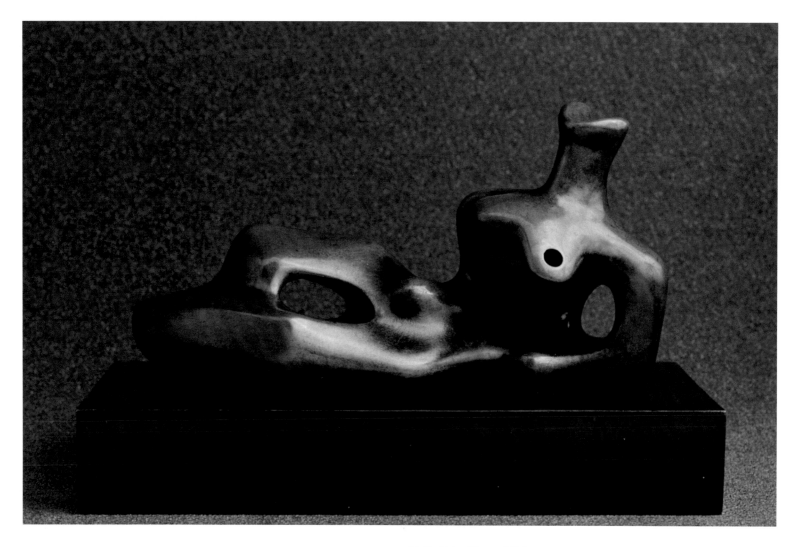

42. *Reclining Figure,* 1939
Bronze, length 11 in.
The Henry Moore Foundation: acquired by
exchange with the British Council 1991
(LH 202)

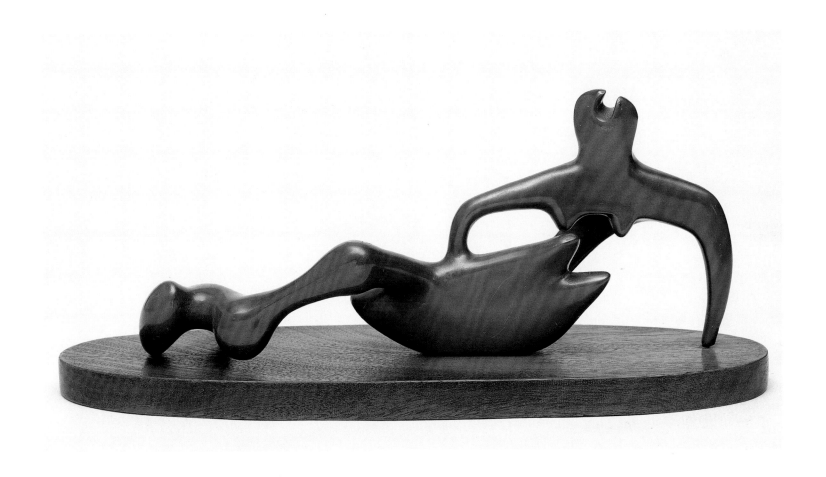

39. *Reclining Figure,* 1938
Lead, 5¾ × 13 in.
The Museum of Modern Art, New York.
Purchase 1939
(LH 192)

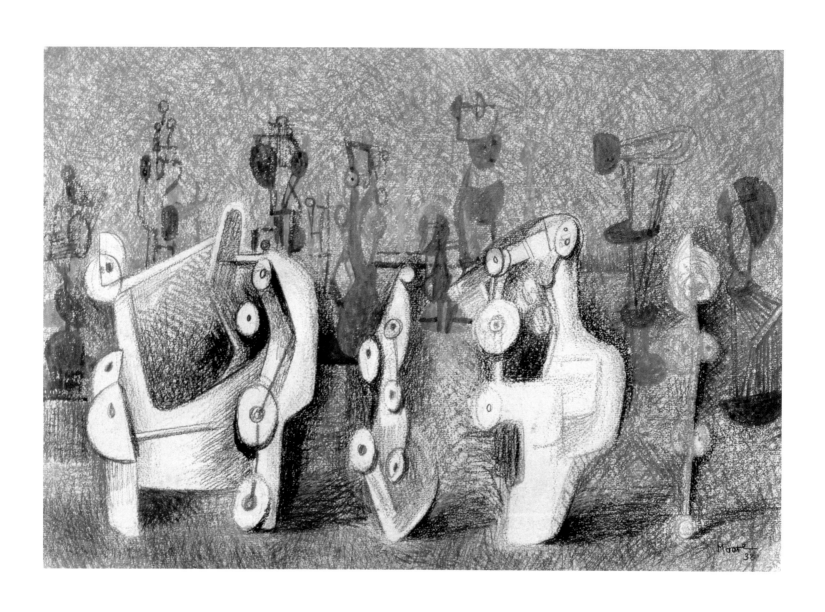

146. *Mechanisms,* 1938
Chalk and wash on cream heavyweight wove paper,
15⅝ × 22½ in.
The Henry Moore Foundation: acquired 1988
(HMF 1367)

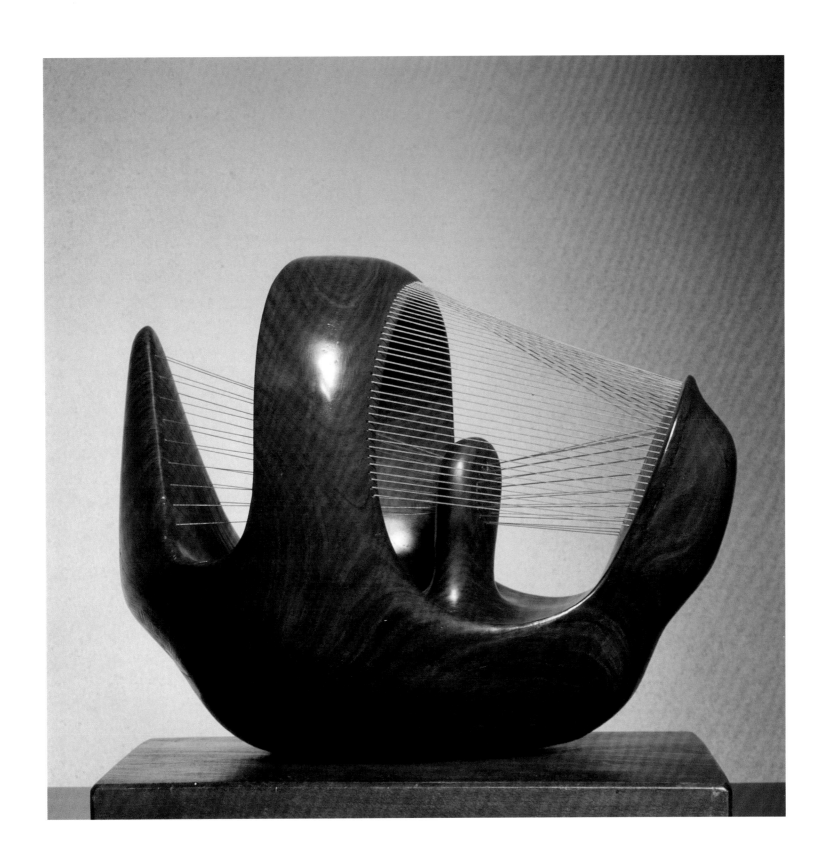

43. *Bird Basket,* 1939
Lignum vitae and string, length 16½ in.
Private collection
(LH 205)

149. *Ideas for Sculpture in Landscape,* c. 1938
Pencil, wax crayon, watercolor, and pen and ink on
cream medium-weight wove paper, 11 × 15 in.
The Henry Moore Foundation: acquired 1990
(HMF 1391a)

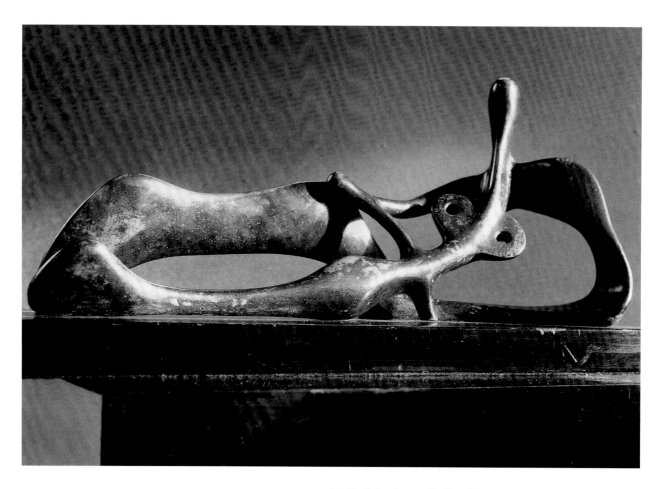

44. *Reclining Figure: Snake,* 1939
Bronze, length 11⅜ in.
The Henry Moore Foundation:
gift of the artist 1979
(LH 208a)

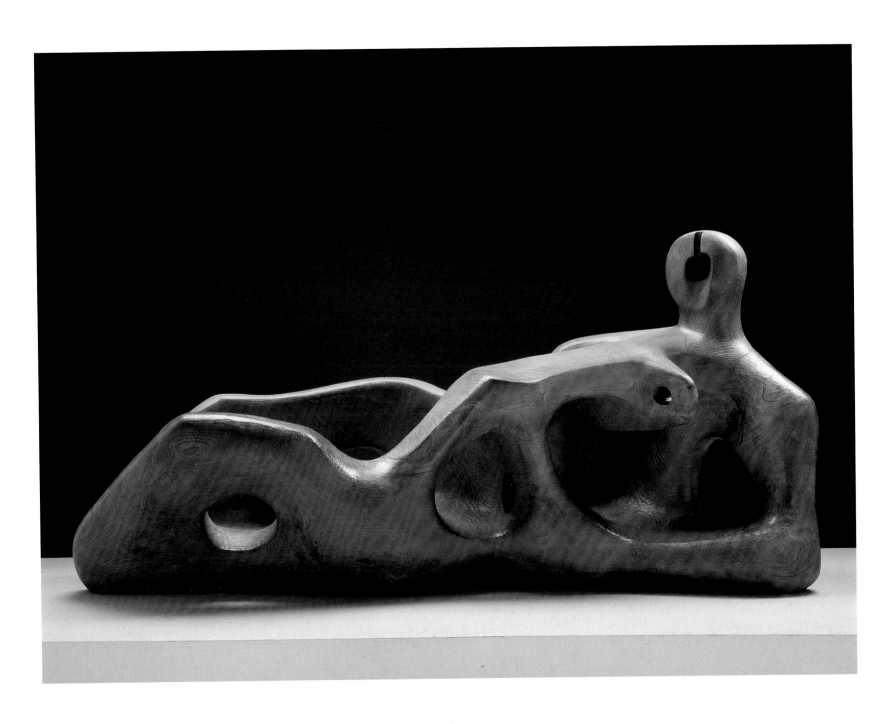

45. *Reclining Figure,* 1939
Elmwood, 37 × 79 × 30 in.
The Detroit Institute of Arts, Founders Society Purchase
with funds from the Dexter M. Ferry, Jr. Trustee Corporation
(LH 210)

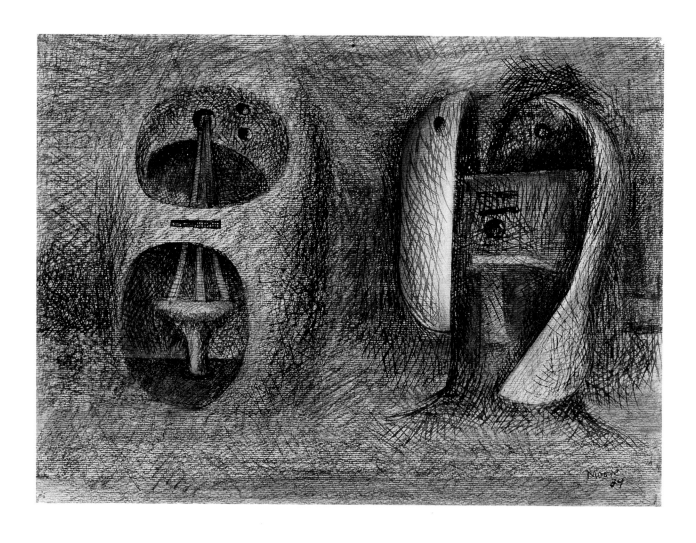

151. *Two Heads: Drawing for Metal Sculpture,* 1939
Charcoal, chalk, watercolor, wash, and pen and ink on
cream heavyweight wove paper, 10⅞ × 15⅛ in.
The Henry Moore Foundation: acquired 1997
(HMF 1462)

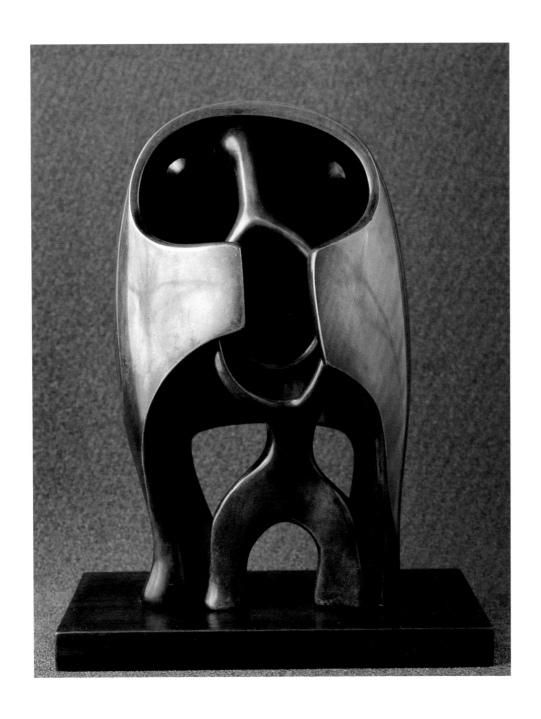

47. *The Helmet,* 1939–40 (cast 1959)
Bronze (unique cast), height 11½ in.
The Henry Moore Foundation:
gift of Irina Moore 1977
(LH 212)

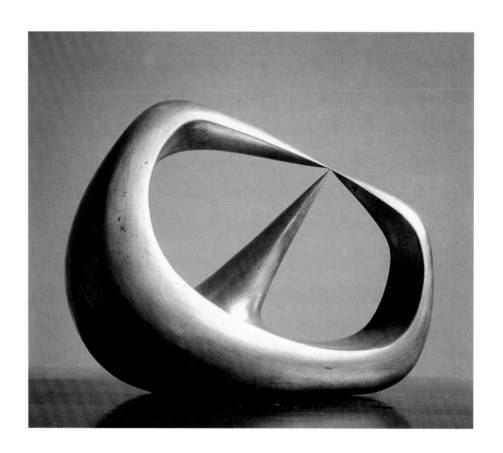

46. *Three Points,* 1939–40
Cast iron, length 7⅞ in.
The Henry Moore Foundation:
gift of Irina Moore 1977
(LH 211)

150. *Studies for Sculpture in Various Materials,* 1939
Pencil, wax crayon, pen and ink, crayon, and watercolor
wash on off-white lightweight wove paper, 10 × 17 in.
The Henry Moore Foundation: acquired 1983
(HMF 1435)

Julian Andrews

Henry Moore: The War Years

At 11:15 on the morning of Sunday, 3 September 1939, the listless voice of the prime minister, Neville Chamberlain, announced to the British people that they were "at war with Germany." Henry Moore had served in the infantry in World War I, and had been fortunate to survive a tough German counterattack at Cambrai in November 1917, when he and his fellow soldiers were gassed. Relief that at the age of forty-one he would not be liable for instant call-up in this latest conflict was tempered by concern that he would probably be losing his post as an art teacher, uncertainty as to whether he would be able to go on working as a sculptor, and anxiety about the air raids that everyone believed were imminent. His reaction to Chamberlain's broadcast was to get into his car with his wife, Irina, and head for the coast near Dover, where they bathed near the Shakespeare Cliffs. His feelings were expressed symbolically in a powerful drawing, *September 3rd, 1939* (cat. 153), in which a group of female bathers with gas-mask heads stand in the water with their backs to the English cliffs, gazing out to sea in anticipation of the unknown threat from across the Channel.

Quite early on in the war Moore was approached by his friend Sir Kenneth Clark, asking him whether he would consider working as a salaried War Artist. Moore refused the offer, feeling that his work was unsuited to war subjects. Privately, however, he worried about how to find an artistic role for himself, and by the summer of 1940 was making sketches of possible war subjects, including crashed German aircraft, ruined buildings, and victims of air raids trapped under debris— these last being purely imaginary. *Standing, Seated and Reclining Figures against Background of Bombed Buildings* (cat. 155), showing three classic Moore poses against a stage set of ruins, is one of these early experiments, while the beautiful sheet *Eighteen Ideas for War Drawings* (cat. 154) includes a surreal image of cows in flames, as well as more typical war subjects. Dramatic photographs of bomb damage (carefully vetted by censors) were appearing in the daily papers, and Moore sometimes used such images as the source of his drawings. *Morning After the Blitz* (cat. 156) is an example.

By this time he had been forced to leave his house in Kent, an area seen as the obvious landing place for Hitler's invasion fleet. Shortly afterward he was to lose his London base as well, when the Mall Studios, where he was renting a space from Ben Nicholson, suffered severe bomb damage. At this precise time, purely by chance, he discovered the subject that was to occupy him for most of the next two years. Returning one evening from dinner with friends in central London, he and his wife were forced to wait on the platform of Belsize Park Underground station while a heavy raid was in progress above. Here, for the first time, he saw the scenes of Londoners taking shelter in the security of the deep tunnels. In his words: "It was like a huge city in the bowels of the earth. When I first saw it . . . I saw hundreds of Henry Moore reclining figures stretched along the platform. I was fascinated, visually. I went back again and again. . . . Here was something I couldn't help doing. Naturally I could not draw in the shelter itself. I drew from memory on my return home . . . putting down ideas for drawings to be carried out later."[1]

Two complete sketchbooks of Shelter Drawings have survived, each containing originally about seventy pages. A third, partially filled sketchbook was subsequently dismantled and the pages sold off as separate drawings. But in addition, Moore made larger versions of a number of the sketchbook pages, using the technique of "squaring up" an existing drawing. When Clark saw the first sketchbook, late in 1940, he realized that Moore had found his subject, and persuaded the War Artists Advisory Committee to purchase four of the larger drawings. By the end of the war they had acquired a total of thirty-one works, which were then distributed to museums and galleries all over Britain. However, many others were exhibited and sold from dealers' galleries during the war, at least two of the purchasers being American servicemen stationed briefly in London.

With *Grey Tube Shelter* (cat. 157), *Row of Sleepers* (cat. 158), and *Tilbury Shelter Scene* (cat. 159) we enter the claustrophobic subterranean world that so fascinated Moore. Here whole families and groups of complete strangers are thrown together in a mass of writhing humanity that permitted no individual privacy and in which sanitary facilities were the most basic. Moore's drawings of these scenes convey not only the huddled intimacy of the groupings but also the fetid atmosphere, the dust-filled air, the dim light, and the hard, gritty surfaces of the platforms on which people lay for hours at a time, struggling to find a comfortable position. Most symbolic of

this group of drawings is *Tube Shelter Perspective* (cat. 160), a work that was much reproduced. The rows of figures lining the walls of what was an unfinished tunnel at the Liverpool Street Underground station have become larvae or cocoons of human beings, buried beneath the earth, waiting for the end of the destruction taking place above before they can come to the surface to begin a new life. The sense of isolation felt by individual shelterers, even within the crowded mass, is powerfully conveyed in works such as *Woman Seated in the Underground* (cat. 164), while in *Pink and Green Sleepers* (cat. 165) the image of total exhaustion, combined with open mouths and skeletal hands, suggests vulnerability and mortality.

If in these drawings Moore manages to achieve a fusion of sculptural form with human compassion, an additional element is added in works such as *Group of Draped Figures in a Shelter* (cat. 161) and the *Figures in a Setting* drawings of 1942 (cats. 175, 176, 177). Here the figures, which in the Phillips Collection drawing still seem to be in a recognizably subterranean space, take on the dignity and separateness of the chorus in a Greek tragedy, observing and commenting on the events from a place apart. A sense of Fate is present in these drawings—something Moore himself described as "a tension in the air."

The group of Coalmining drawings (cats. 166, 167, 168, 169, 170) also included in this section date from later in the war, when Moore accepted a commission from the War Artists Committee to record the labor of miners in the same Yorkshire pit where his own father had worked. The experience gave him his first opportunity to make an intensive series of studies of the male figure, while the challenge of portraying the muscular backs of men, gleaming in lamplight out of the darkness of the coal seam, echoed his preoccupation with the black drawings of Georges Seurat, two of which he owned (see p. 57).

The wartime years, when Moore was forced to concentrate on drawing, led to a loosening of his style. The appearance of elements such as drapery, organic forms, and family groups would come to play an increasing role in his postwar sculpture. In the three drawings included in this exhibition that show reclining figures against a background of rocks (cats. 172, 173, 174), it is noticeable that the sculptures are recognizably forms developed in the prewar period, while

the background shapes—particularly in *Reclining Figure and Red Rocks* (cat. 174)—foreshadow the monumental two- and three-piece figures the sculptor would produce in the 1960s and beyond. Finally, in the mysterious *Crowd Looking at a Tied-up Object* (cat. 171), Moore has produced a drawing that might appear at first sight to foreshadow the works of Christo and Jeanne-Claude—except that one can always see what it is they have wrapped, whereas here the object remains unknown. Various sources have been conjectured for this marvelously surreal subject, including an African tribal costume, but to an Austrian critic writing just after the war it was an echo of the roped barrage balloons used for antiaircraft defense, gazed at by crowds of silent Londoners in the parks of the capital—an interesting comparison with a symbolism of its own.

The publicity given to the Shelter Drawings in particular brought Moore's work to the attention of a much wider public. While he himself had initially seen the shelterers as sculptural subjects, providing an infinite variety of ideas for drawings, ordinary people identified themselves with what they saw as a deeply felt, shared experience, which dented even the supposedly impenetrable carapace of British class consciousness—temporarily, at least. The work of an artist hitherto considered "difficult" had suddenly become more accessible.

Note
1. Quoted in Carlton Lake, "Henry Moore's World," *Atlantic Monthly* 209, no. 1 (January 1962) 39–45.

1940

Battle of Britain, then London Blitz. Makes drawings of people sheltering in the Underground. Appointed an Official War Artist.

> "I went into London two or three days a week to do my shelter drawings. It's curious how all that started. The official shelters were insufficient. People had taken to rolling their blankets about eight or nine o'clock in the evening, going down into the tube stations and settling on the platforms. The authorities could do nothing about it. Later on, the government began to organise things better. They put in lavatories and coffee-bars down there and began building four-tiered bunks for the children. It was like a huge city in the bowels of the earth. When I first saw it quite by accident— I had gone into one of them during an air raid—I saw hundreds of Henry Moore Reclining Figures stretched along the platforms. I was fascinated, visually. I went back again and again."[18]

The Hampstead studio is bombed, and the Moores leave London to live in a farmhouse called Hoglands in the hamlet of Perry Green, near Much Hadham in Hertfordshire; from now on it will be their permanent home. Joins the local Home Guard. Finds it impossible to engage with sculptural projects during wartime.

Photograph of Moore sketching in the London Underground taken during the filming of *Out of Chaos,* a 1943 documentary about official War Artists

Henry Moore's elmwood *Reclining Figure* in *Surrealism Today* exhibition at Zwemmer Gallery in London, June 1940

1941

Becomes a trustee of the Tate Gallery, London; serves until 1956. Publishes the article "Primitive Art," celebrating the British Museum collections. Exhibits at Temple Newsam House in Leeds with painters Graham Sutherland and John Piper. Visits Wheldale Colliery in Castleford, once managed by his father, to sketch coal miners at work; it is his first time down a mine.

> "Primitive art is a mine of information for the historian and the anthropologist, but to understand and appreciate it, it is more important to look at it than to learn the history of primitive peoples, their religions and social customs. Some such knowledge may be useful and help us to look more sympathetically, and the interesting tit-bits of information on the labels attached to the carvings in the Museum can serve a useful purpose by giving the mind a needful rest from the concentration of intense looking. But all that is really needed is response to the carvings themselves, which have a constant life of their own, independent of whenever and however they came to be made, and remain as full of sculptural meaning today to those open and sensitive enough to receive it as on the day they were finished."[19]

December 7: Bombing of Pearl Harbor; United States enters war.

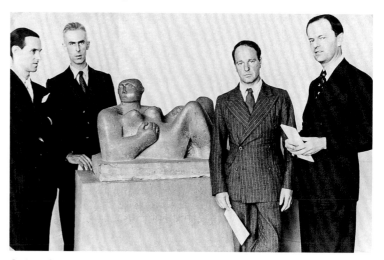

Graham Sutherland, John Piper, and Henry Moore standing next to Moore's *Reclining Woman,* 1930, at their 1941 group exhibition at Temple Newsam House, Leeds. Kenneth Clark stands at far right

1942

Continues work on Coalmining drawings. Designs cover for *Poetry London,* no. 8.

Peggy Guggenheim opens "Art of This Century" Gallery in New York with an exhibition of Surrealism.

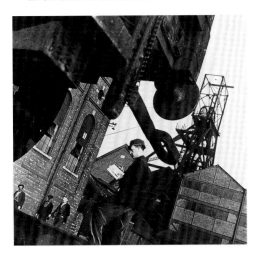

Henry Moore at work as an Official War Artist drawing at the pithead, Wheldale Colliery, West Castleford, 1942

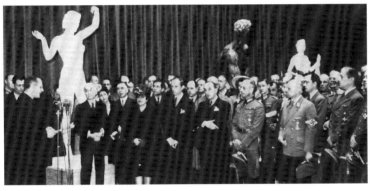

Exhibition of the sculpture of Arno Breker, the favorite sculptor of Nazi Germany, at the Orangerie in Paris

1943

Geoffrey Grigson publishes a monograph, *Henry Moore.*

First exhibition of Jackson Pollock at Peggy Guggenheim's "Art of This Century" Gallery in New York.

HENRY
MOORE

40 Watercolors
& Drawings

May 11 – 29, 1943

BUCHHOLZ GALLERY
CURT VALENTIN
32 EAST 57TH STREET, NEW YORK

Moore's first solo exhibition abroad, organized by his American dealer Curt Valentin

1944

On commission, carves controversial *Madonna and Child* in brown stone for a Northampton church. His ailing mother dies at age eighty-six. Produces book illustrations for *The Rescue* by Edward Sackville-West, a radio play on Homeric themes. A documentary film by Jill Craigie about war artists includes footage on Moore's Shelter Drawings. Begins the concerted production of small bronze pieces, which ensure a reliable income.

Death of Kandinsky in Paris.

Death of Mondrian in New York.

Normandy Invasion.

Liberation of Paris.

Publication of a selection of the Shelter Drawings in facsimile. "These intimations of mortality, in which the daily experiences of thousands of people were sublimated, seemed 'to get through to a much larger public' than he had reached before. For the first time he could earn his living without recourse to teaching."[20]

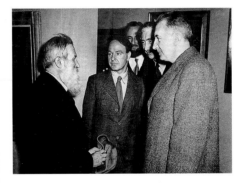

Moore visits Paris and meets the aging master Constantin Brancusi (left), 1945

1945

Begins *Memorial Figure* in Hornton stone, installed next year at Dartington Hall. Receives honorary doctorate from Leeds University, the first of a deluge of national and international awards during the coming years.

Exhibits in a group show called *Quelques artistes anglais contemporains* at the British Council Gallery, Champs Elysées, Paris.

Appointed to the arts panel of the British Council.

First atom bomb dropped on Hiroshima.

End of World War II.

Francis Bacon, *Figure in a Landscape,* 1945

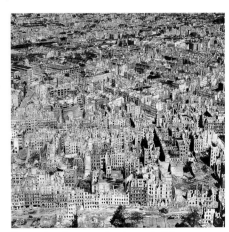

Europe lay devastated at the end of the war. Photograph of Berlin, 1945

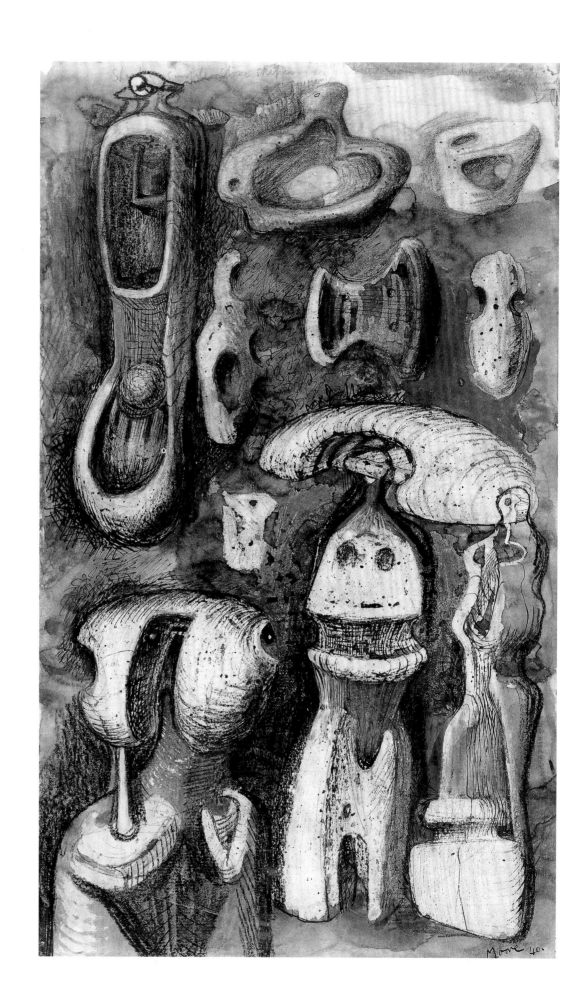

152. *Ideas for Sculpture,* 1940
Pencil, wax crayon, watercolor,
crayon, pen and ink, and gouache
on paper, 17 × 10 in.
Fogg Art Museum, Harvard University
Art Museums, gift of Lois Orswell
(HMF 1489)

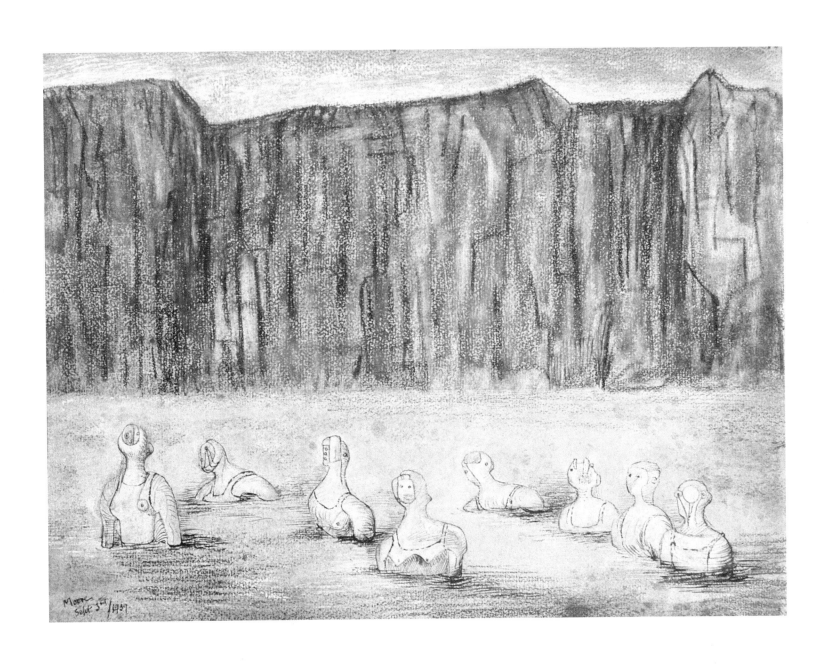

153. *September 3rd, 1939,* 1939
Pencil, wax crayon, chalk, watercolor, and pen and ink
on heavyweight wove paper, 12⅛ × 15¾ in.
The Moore Danowski Trust
(HMF 1551)

154. *Eighteen Ideas for War Drawings,* 1940
Pencil, wax crayon, pen and ink, chalk, watercolor, and
wash on cream medium-weight wove paper, 10⅞ × 14⅞ in.
The Henry Moore Foundation: gift of the artist 1977
(HMF 1553)

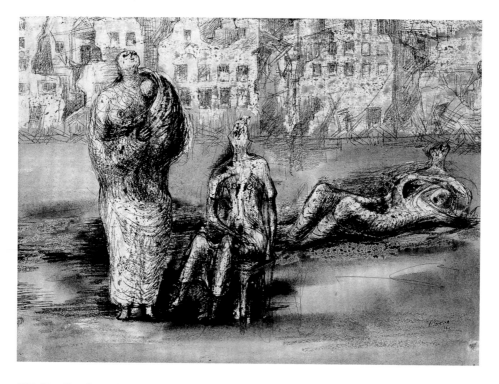

155. *Standing, Seated, and Reclining Figures against Background of Bombed Buildings,* 1940
Pen and ink, colored chalks, and watercolor on paper, 11 × 15 in.
By kind permission of the Provost and Fellows of King's College, Cambridge.
King's College (Keynes Collection), on loan to the Fitzwilliam Museum, Cambridge
(HMF 1556)

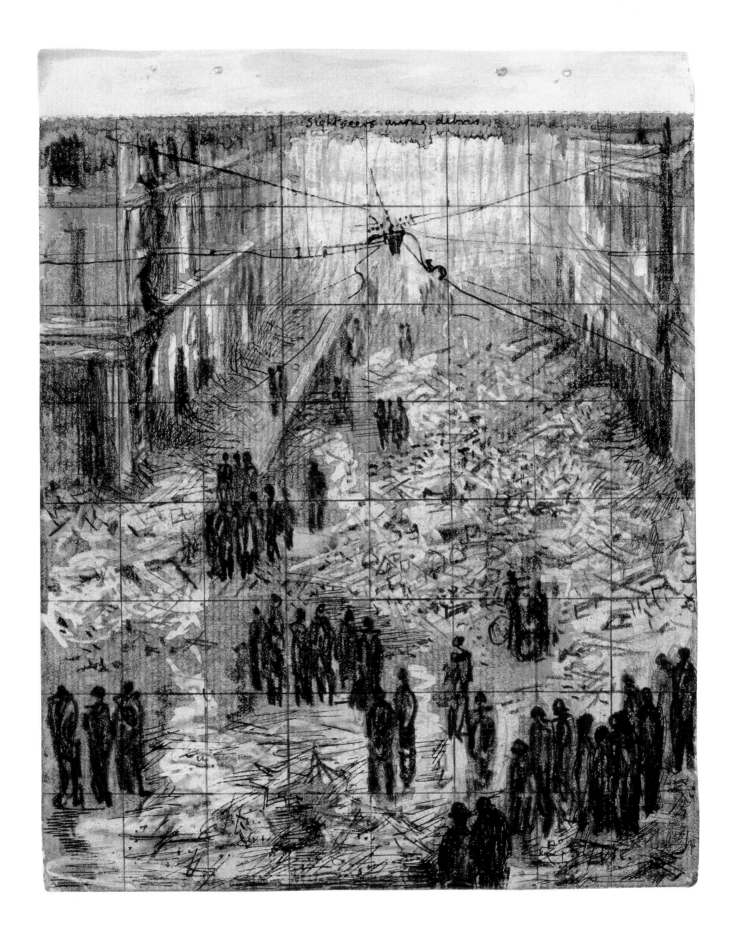

156. *Morning After the Blitz,* 1940
Crayon, watercolor, and gouache on paper, 25 × 22 in.
Wadsworth Atheneum, Hartford, Connecticut.
The Ella Gallup Sumner and Mary Catlin Sumner
Collection Fund
(HMF 1558)

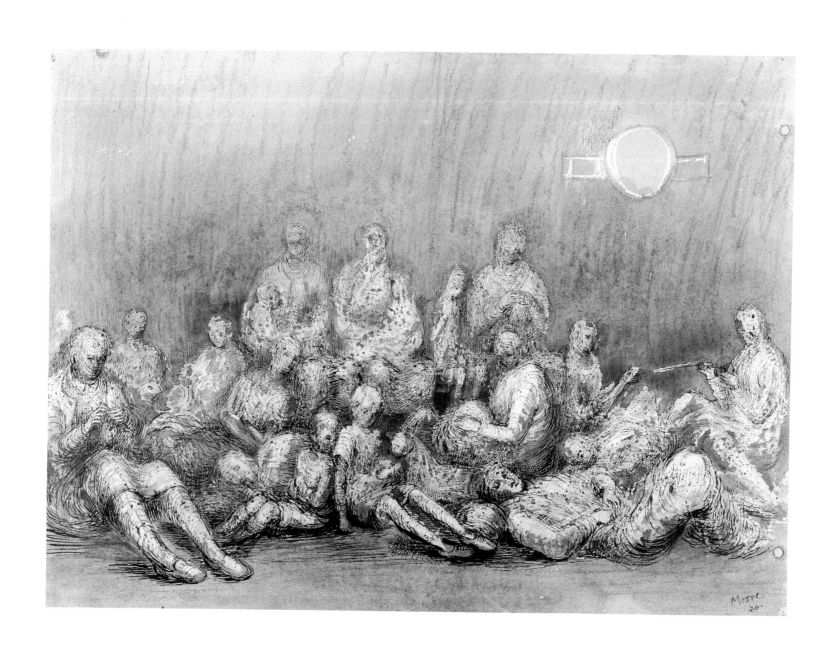

157. *Grey Tube Shelter,* 1940
Pen and ink, chalk, wash, and gouache on paper, 11 × 15 in.
Tate. Presented by the War Artists Advisory Committee 1946
(HMF 1724)

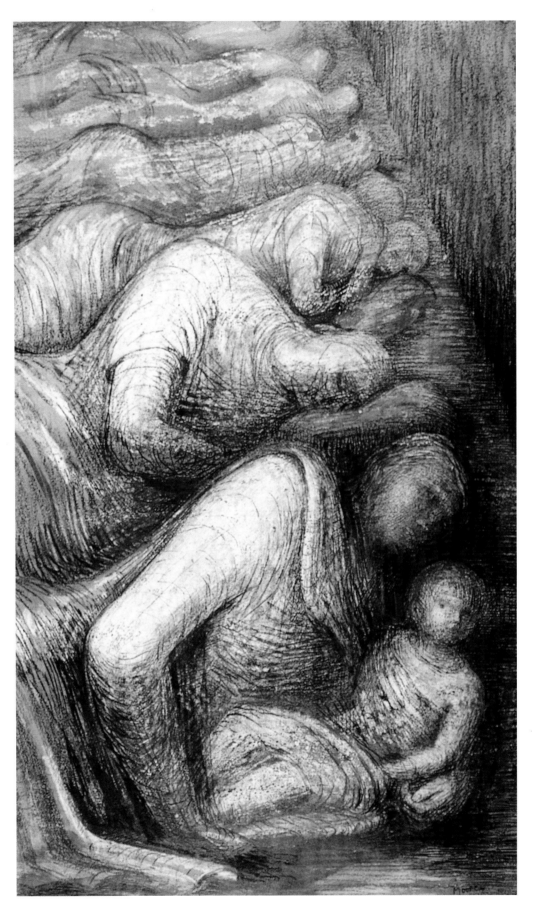

158. *Row of Sleepers,* 1941
Crayon, chalk, pen and ink, watercolor, and
wash on off-white medium-weight wove paper,
21½ × 12⅝ in.
The British Council
(HMF 1799)

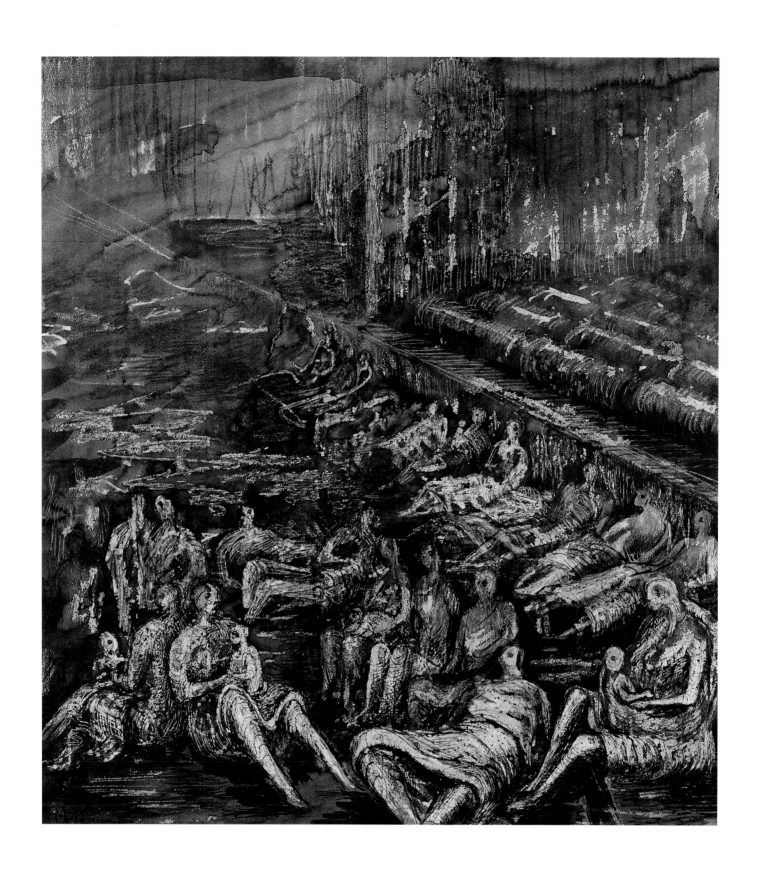

159. *A Tilbury Shelter Scene,* 1941
Pen, chalk, wash, and gouache on paper, 16½ × 15 in.
Tate. Presented by the War Artists Advisory Committee 1946
(HMF 1800)

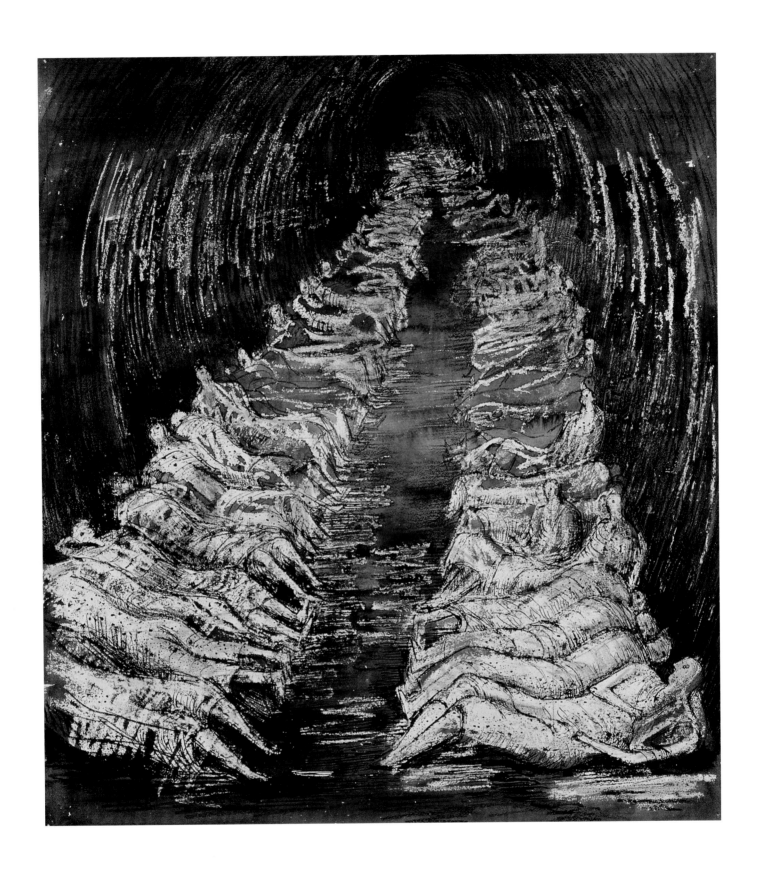

160. *Tube Shelter Perspective,* 1941
Pen, chalk, watercolor, and gouache on paper, 19 × 17¼ in.
Tate. Presented by the War Artists Advisory Committee 1946
(HMF 1801)

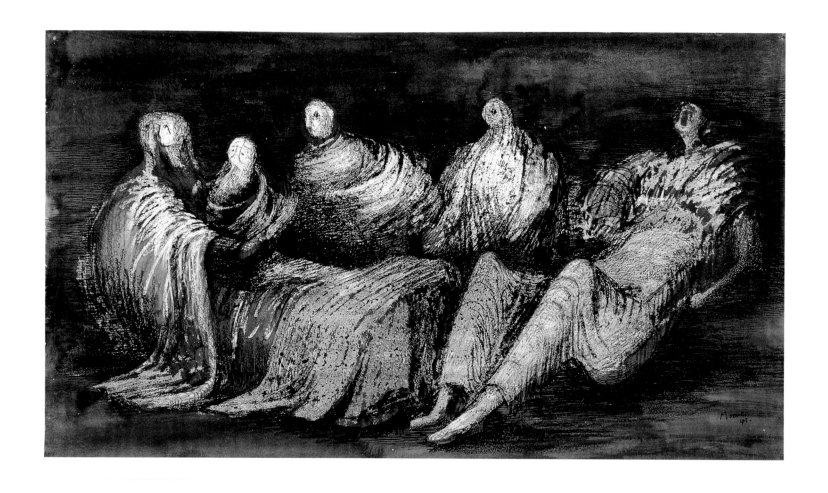

161. *Group of Draped Figures in a Shelter,* 1941
Chalk, crayon, pen and ink, gouache, and watercolor
on cream medium-weight wove paper, 12¾ × 22½ in.
The Henry Moore Foundation: acquired 1982
(HMF 1807)

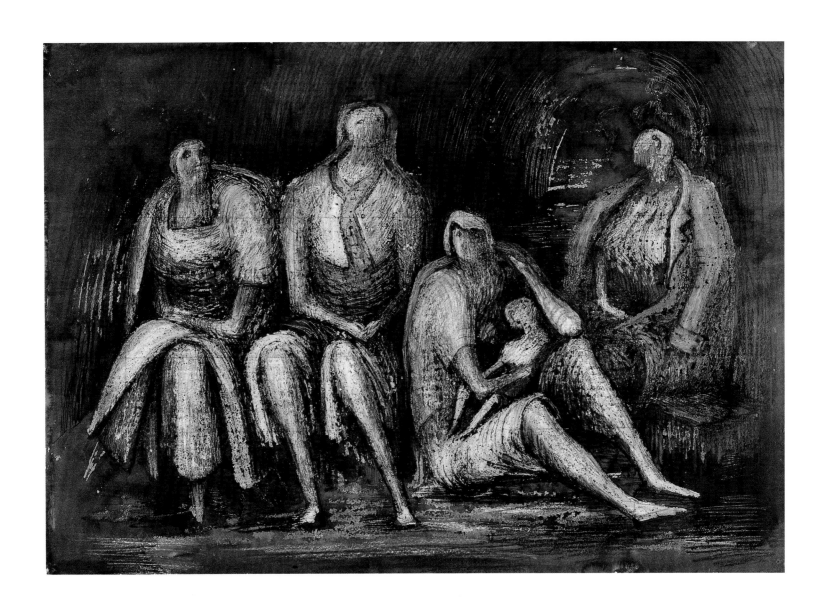

162. *Group of Shelterers During an Air Raid,* 1941
Graphite, pen and ink, brush and ink, wax crayon,
chalks, and scraping on wove paper, 15⅛ × 21⅞ in.
Collection, Art Gallery of Ontario, Toronto. Gift of the
Contemporary Art Society, 1951
(HMF 1808)

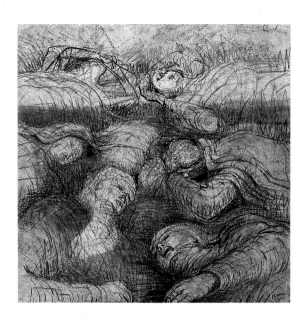

163. *Shelter Drawing: Sleeping Figures,* 1941
Pencil, wax crayon, pen and ink, and watercolor wash on
off-white medium-weight textured wove paper, 12 × 12⅛ in.
The Henry Moore Foundation: acquired 1983
(HMF 1816)

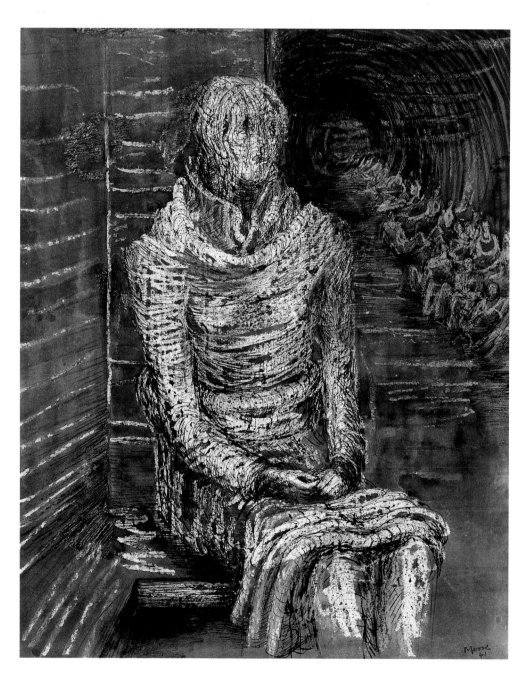

164. *Woman Seated in the Underground,* 1941
Pen, chalk, and gouache on paper, 19 × 15 in.
Tate. Presented by the War Artists
Advisory Committee 1946
(HMF 1828)

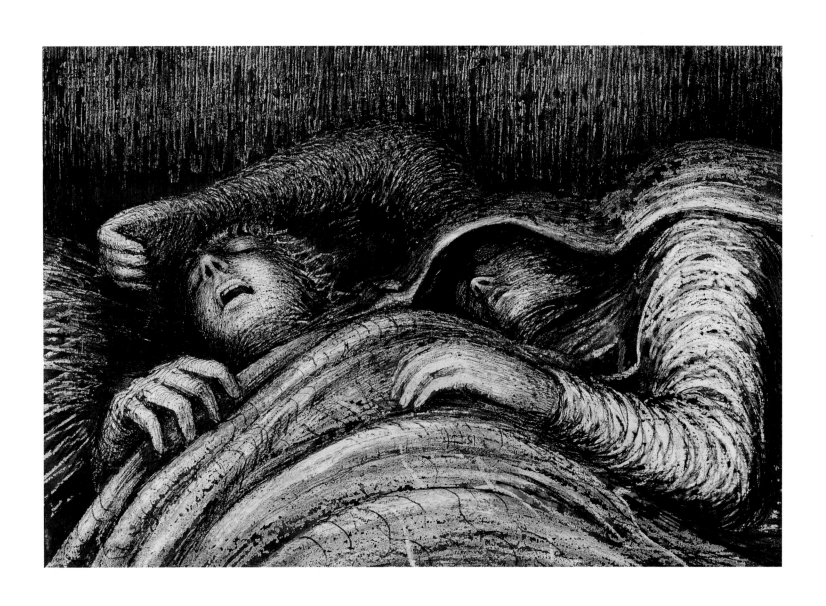

165. *Pink and Green Sleepers,* 1941
Pen, wash, and gouache on paper, 15 × 22 in.
Tate. Presented by the War Artists
Advisory Committee 1946
(HMF 1845)

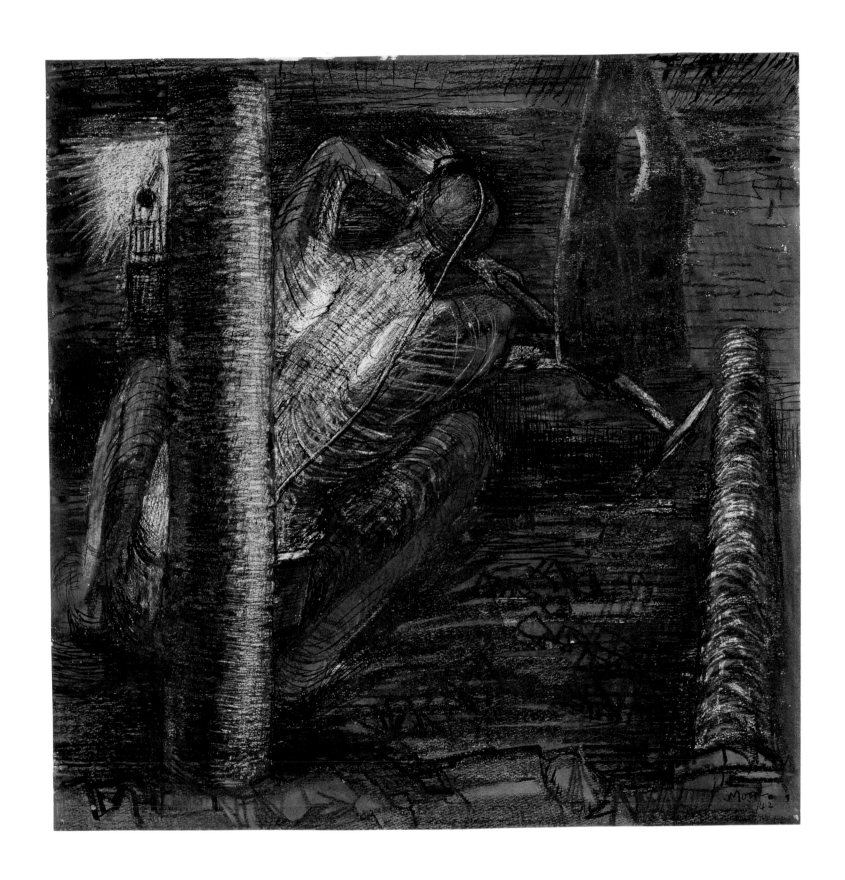

166. *Miner at Work,* 1942
Ink, chalk, and gouache on paper, 19½ × 19½ in.
Imperial War Museum, London
(HMF 1987)

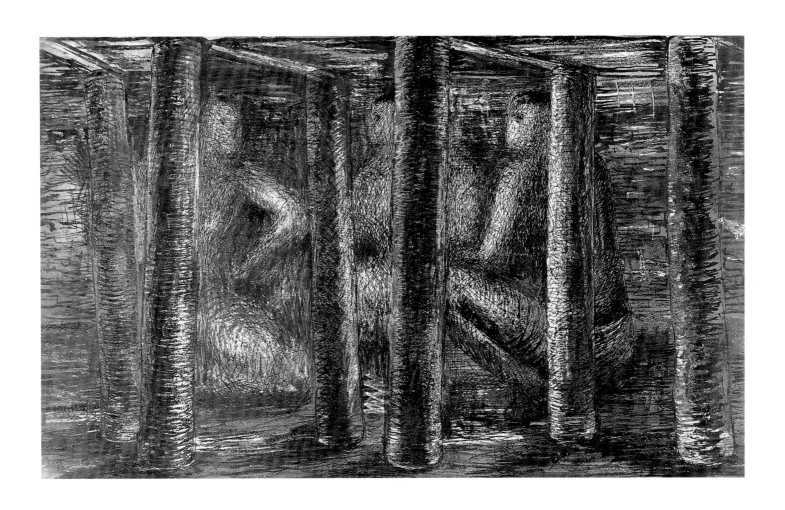

167. *Miners Resting During Stoppage of Conveyor Belt,* 1942
Pen and ink, chalk, wax crayon, watercolor,
and pencil on paper, 13⅜ × 20 in.
Leeds Museums and Galleries (City Art Gallery)
(HMF 1997)

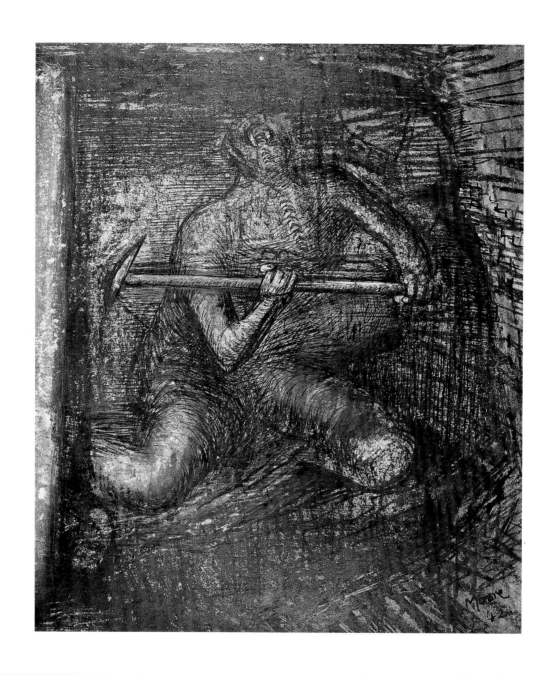

168. *Miner at Work,* 1942
Pencil, crayon, pen and ink, watercolor, and wash on
cream medium-weight wove paper, 12¼ × 10½ in.
The Henry Moore Foundation: gift of the artist 1977
(HMF 1999)

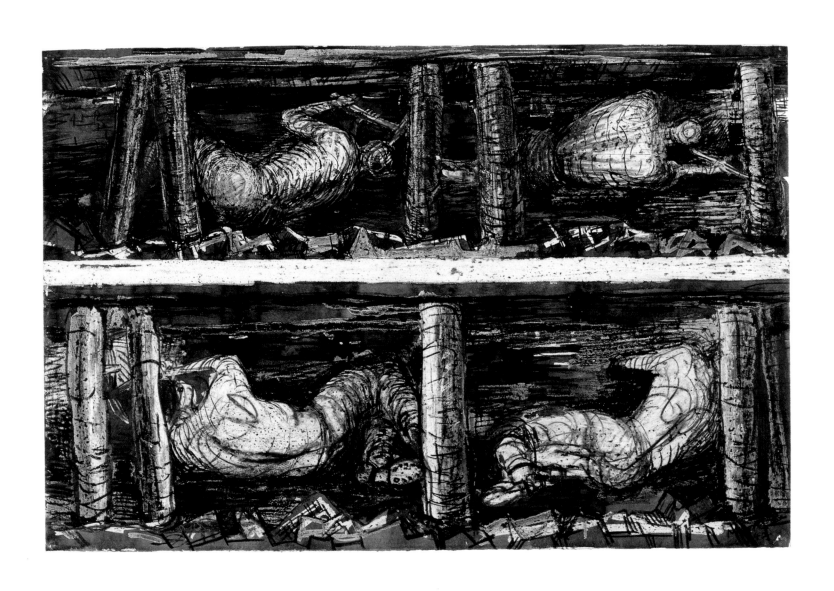

169. *Four Studies of Miners at the Coalface,* 1942
Pencil, wax crayon, pen and ink, watercolor, and wash on
off-white medium-weight wove paper, 14⅜ × 22⅛ in.
The Henry Moore Foundation: acquired 1984
(HMF 2000a)

170. *Miner Drilling in Drift,* 1942
Crayon, pen and ink, and watercolor on paper, 20¼ × 15⅛ in.
Portland Art Museum. Gift of Francis J. Newton
in memory of his brother Joseph Newton
(HMF 2007)

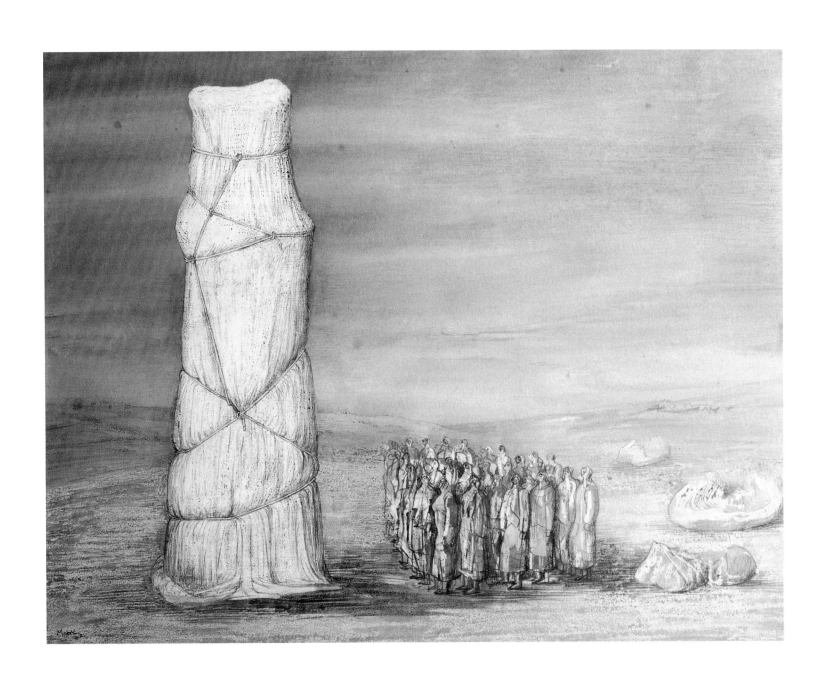

171. *Crowd Looking at a Tied-up Object,* 1942
Pencil, wax crayon, watercolor wash, crayon, and
pen and ink on paper, 17 × 22 in.
The British Museum, London
(HMF 2064)

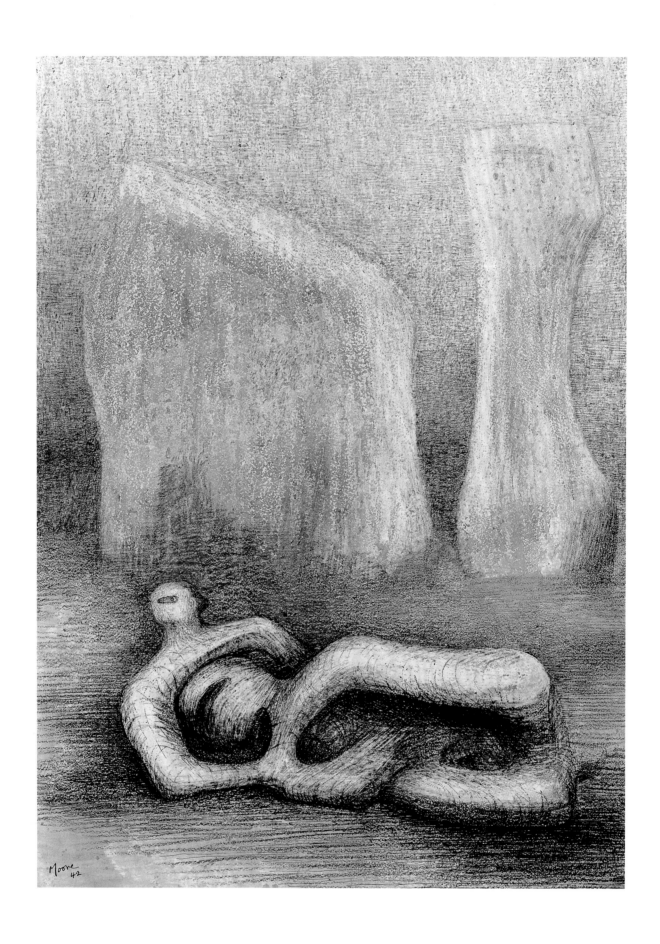

172. *Reclining Figure and Pink Rocks,* 1942
Pen and ink, watercolor, and wax crayon on paper, 22 × 16½ in.
Albright-Knox Art Gallery, Buffalo, New York.
Room of Contemporary Art Fund, 1943
(HMF 2065)

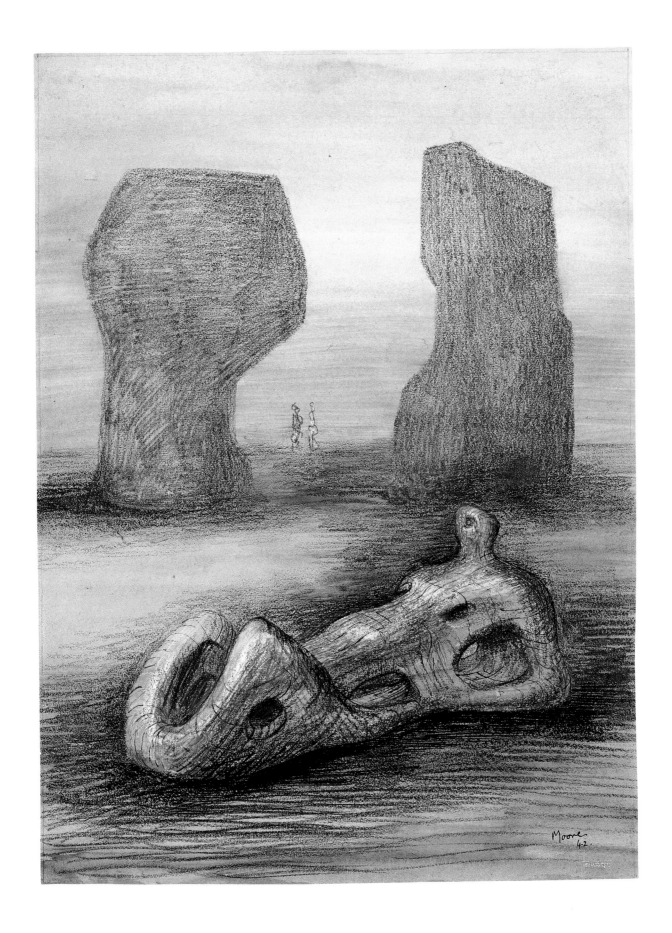

173. *Sculpture and Red Rocks,* 1942
Crayon, wash, and pen and ink on paper, 19⅛ × 14¼ in.
The Museum of Modern Art, New York. Gift of Philip L. Goodwin
(HMF 2066)

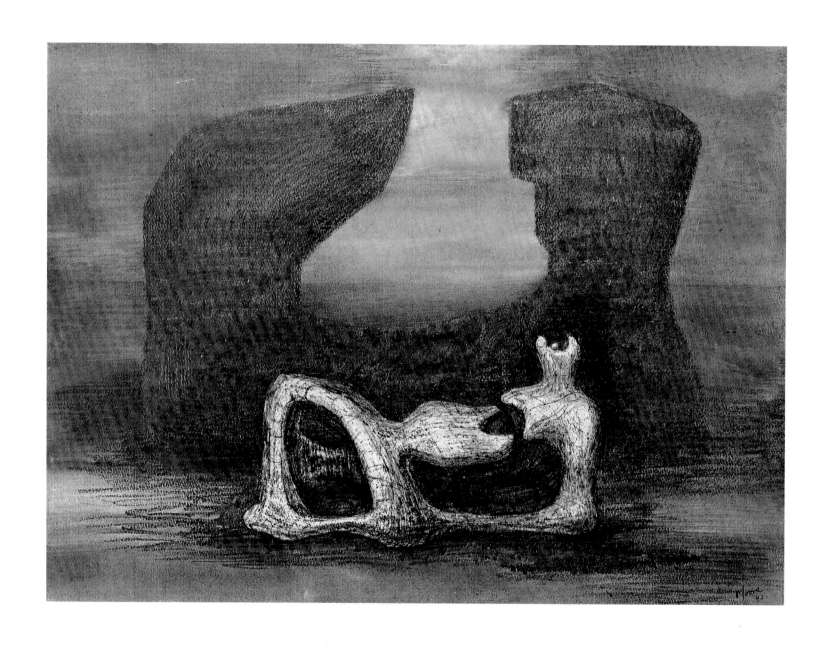

174. *Reclining Figure and Red Rocks,* 1942
Pencil, wax crayon, watercolor wash, crayon, and
pen and ink on paper, 11 × 15 in.
The British Museum, London
(HMF 2067)

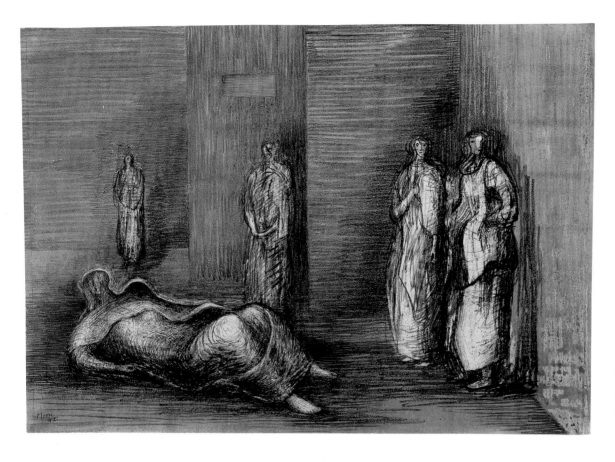

176. *Figures in a Setting, No. 1,* 1942
Ink, watercolor, crayon, and graphite on
wove paper, 14¾ × 21⅛ in.
Fine Arts Museums of San Francisco.
Bequest of Ruth Haas Lilienthal
(HMF 2095)

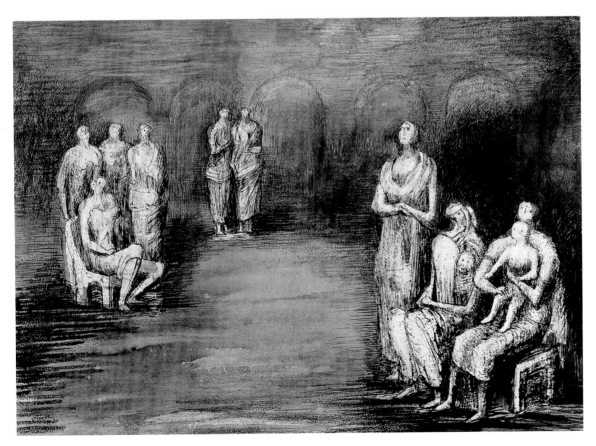

175. *Figures in a Setting,* 1942
Wax crayon, watercolor, pen and ink,
white gouache, and graphite pencil on
wove paper, 14¼ × 20¼ in.
The Phillips Collection, Washington, D.C.
(HMF 2093)

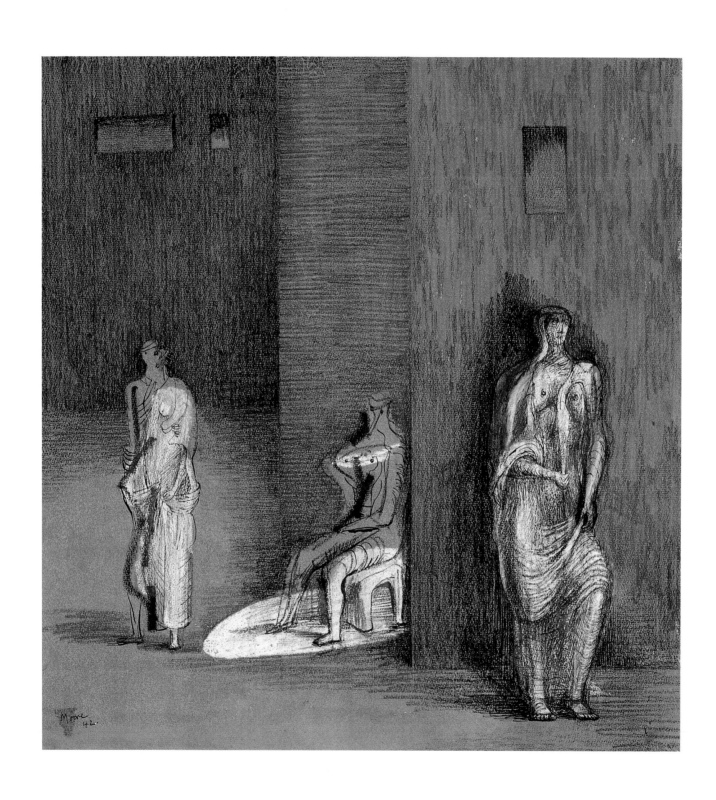

177. *Three Figures in a Setting*, 1942
Ink and wax crayon on gray paper, 17¾ × 16¾ in.
Santa Barbara Museum of Art, gift of Wright S. Ludington
(HMF 2099)

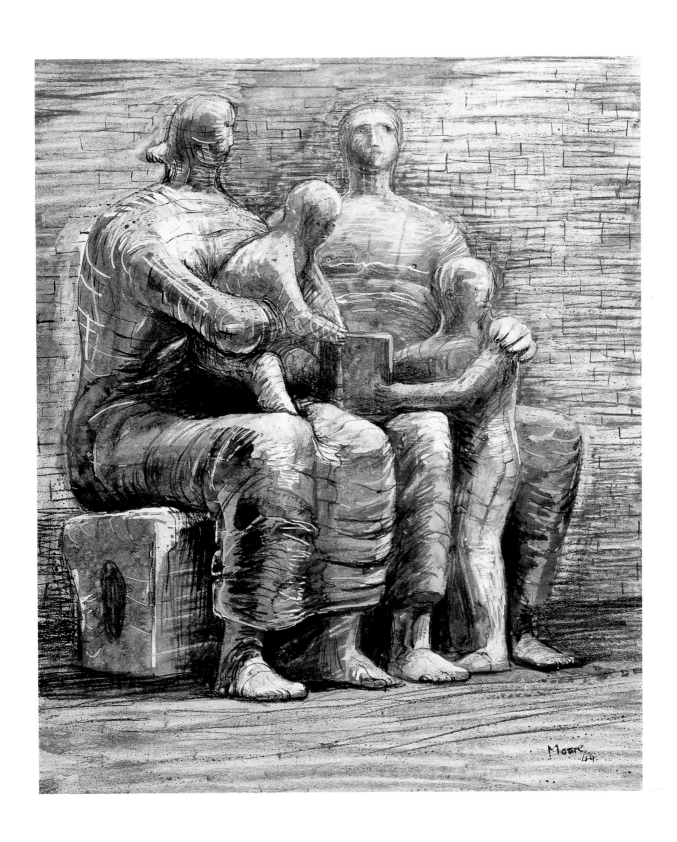

178. *Family Group,* 1944
Watercolor, ink, crayon, and chalk on paper, 20 × 16⅝ in.
Scottish National Gallery of Modern Art, Edinburgh
(HMF 2237a)

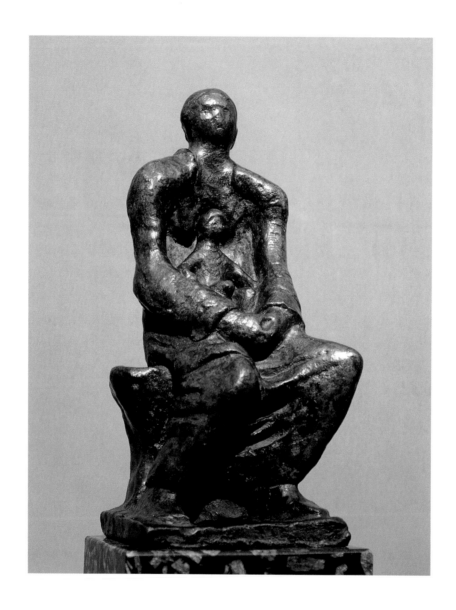

48. *Madonna and Child,* 1943
Bronze, height 7¼ in.
The Henry Moore Foundation: acquired
in honor of Sir Alan Bowness 1994
(LH 222)

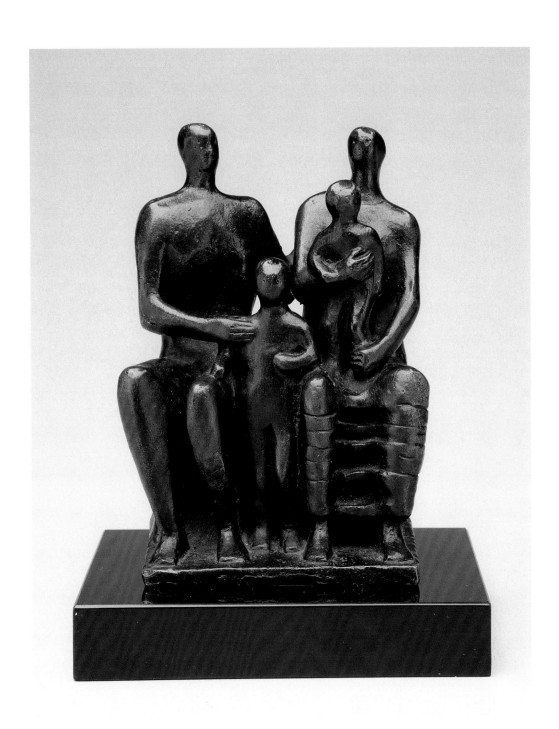

49. *Family Group,* 1944
Bronze, 5⅞ × 4¼ × 2⅞ in.
Dallas Museum of Art, Foundation for the Arts
Collection, bequest of Margaret Ann Bolinger
(LH 230)

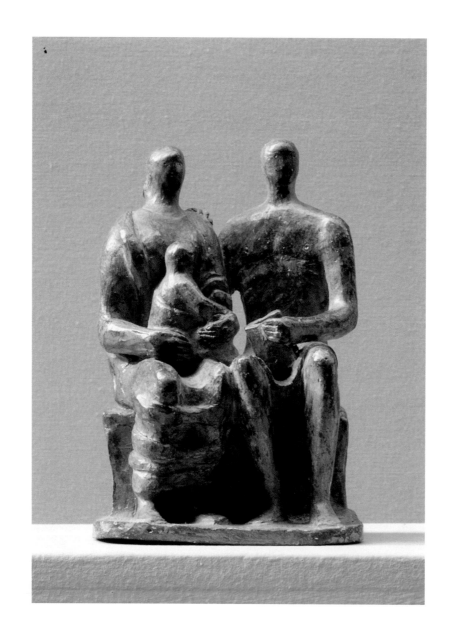

50. *Family Group,* 1944
Terra-cotta, height 6⅛ in.
The Henry Moore Foundation:
gift of the artist 1977
(LH 231)

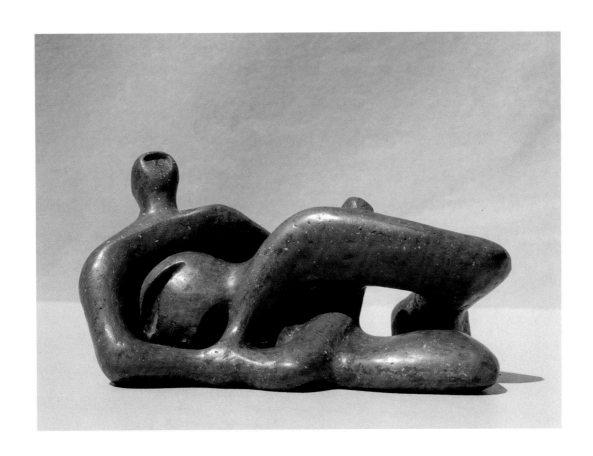

51. *Reclining Figure,* 1945
Terra-cotta, length 6 in.
The Henry Moore Foundation:
gift of the artist 1979
(LH 247)

1946

Completes another *Reclining Figure* in elmwood. Mary, his only child, is born. Joins art panel of the Arts Council of Great Britain (1946–51 and 1955–60). First visit to New York for his major retrospective at the Museum of Modern Art; it later travels to Chicago and San Francisco, then in reduced form to Australia. Visits Boston; Washington, D.C.; and Philadelphia, where he sees Cézanne's *Grandes Baigneuses* once again, and meets Jackson Pollock, Georgia O'Keeffe, Mark Tobey, and other prominent American artists.

Death of Paul Nash.

The 1946 Moore retrospective exhibition installed in the galleries at The Museum of Modern Art, New York

1947

British Council exhibition of Moore travels to Australia: Sydney, Melbourne, Adelaide, Hobart, and Perth. Is conspicuously absent from first major postwar show of Surrealism in Paris.

Appointed member of the Royal Fine Arts Commission.

Inauguration of the Musée national d'art moderne in Paris.

India gains independence from Britain.

Fernand Léger, *Adieu New York,* 1946

1948

Three Standing Figures shown by a lake in open-air sculpture exhibition in Battersea Park, London. Attends Venice Biennale for his solo show in the British Pavilion, winning International Prize for Sculpture. Befriends the sculptor Marino Marini. Revisits Padua to see Giotto frescoes and Florence for the Masaccio frescoes. Georges Braque visits Hoglands at about this time.

Invention of the first computer by IBM/SSEC.

Invention of the transistor in the United States.

Assassination of Gandhi.

Proclamation of the State of Israel.

Beginning of the cold war.

Photograph of Peggy Guggenheim, looking at *Reclining Figure* (cat. 39) at the 1948 Venice Biennale

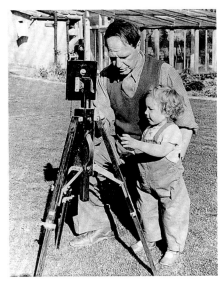

Photograph of Moore and Mary with camera, 1948

1949

Madonna and Child installed in church at Claydon, England. A touring exhibition of Moore's work, organized by the British Council, opens in Wakefield, travels to Manchester City Art Gallery, and then visits the Palais des Beaux-Arts in Brussels, the Musée national d'art moderne in Paris, the Stedelijk Museum in Amsterdam, and galleries in Hamburg, Düsseldorf, Berne, and Athens. Moore visits Belgium, Holland, and Switzerland. *Family Group* (cat. 52) installed at Barclay School, Stevenage.

Reappointed trustee of the Tate Gallery, London.

Publication of *1984* by George Orwell.

Proclamation of the People's Republic of China.

NATO established.

USSR tests atomic bomb.

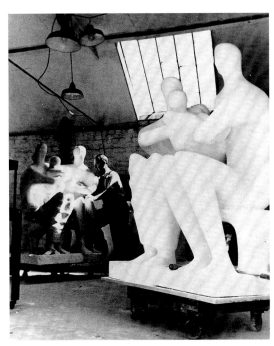

Moore in his studio at Perry Green c. 1949, with the plaster of *Family Group,* the bronze cast of which would be installed at Barclay School, Stevenage, later that year

Charles Eames, Low Armchair, designed 1949

1950

British Council exhibition of Moore drawings in Mexico. Léger visits Moore's studio.

Henri Matisse is awarded first prize at the Venice Biennale.

Korean War begins.

Photograph of Moore visiting with Giacometti, Zadkine, Karl Hartung, and Pevsner in the gardens of the Musée Bourdelle c. 1950

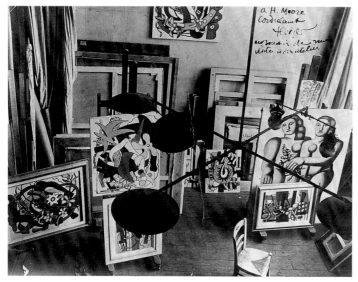

Photograph of Léger's studio inscribed "à H. Moore, cordialement Léger, un souvenir de mon visite à son atelier," c. 1950

1951

Travels to Greece for the first and only time, on the occasion of his exhibition at Zappeion Gallery in Athens. Visits Mycenae, Corinth, Delphi, Olympia, and the Acropolis: "The Parthenon against a blue sky . . . is the greatest thrill I've ever had." [21]

"When I began to make sculptures thirty years ago, it was very necessary to fight for the doctrine of truth to material (the need for direct carving, for respecting the particular character of each material, and so on). So at that time many of us tended to make a fetish of it. I still think it is important, but it should not be a criterion of the value of a work. . . . Rigid adherence to the doctrine results in domination of the sculpture by the material. The sculptor ought to be the master of his material. Only, not a cruel master." [22]

First retrospective in London, at Tate Gallery, with catalogue essay by David Sylvester. Begins work on helmet head series, and takes up animal themes.

Betty Parsons Gallery shows the recent work of Robert Rauschenberg.

First television broadcast in color in the United States.

First test of the hydrogen bomb by the United States.

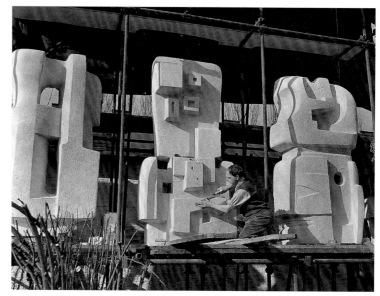

Moore in Perry Green working on *Time-Life Screen* c. 1952

1952

Begins *King and Queen* (cat. 61), which will become his trademark piece. Delivers a paper titled "The Sculptor in Modern Society" at International Conference of Artists in Venice sponsored by UNESCO, arguing for the artist's independence within a patronage system.

"But what is my purpose in such activity [making sculpture]? It might, of course, be merely a desire to amuse myself, to kill time or create a diversion. But then I should not find it necessary, as I do, to exhibit my sculpture publicly, to hope for its sale and for its permanent disposition either in a private house, a public building or an open site in a city. My desire for such a destination for my work shows that I am trying, not merely to express my own feelings or emotions for my own satisfaction, but also to communicate those feelings or emotions to my fellow men. Sculpture, even more than painting (which generally speaking, is restricted to interiors) is a public art." [23]

Harold Rosenberg defines the new painting in America with the term "action painting."

1953

Period of intense production. Begins elmwood carving *Upright Internal/External Forms*, which will take over two years. Installation high above Bond Street in London of the *Time-Life Screen* and *Draped Reclining Figure*. A section of the latter is cast as a deliberate fragment and entitled *Draped Torso*. Moore writes: "What pleased and surprised me about it was how Greek it looks." [24]

> "My thought was that the wall should be pierced in places to show that there was nothing behind it. . . . That weekend in my studio I played with the idea and made some small maquettes with sculptures in open alcoves, as it were, but fitted so that each could be turned to be seen at different angles—full views, three-quarter views, side views, and so on. . . . When it came to the practical problem of making the sculptures turn, the architect couldn't satisfy the official safety regulations. Some of these blocks were eight or nine feet high and weighed ten to fifteen tons. If they were to turn, they could have only one pivot. In fifty years' time, fixings could deteriorate, and the blocks might fall on the street. This was too much of a risk to take. The idea was good but not practical." [25]

Moore, as a trustee, is embroiled in the so-called Tate Affair, in which Moore's friend and supporter, director John Rothenstein, was accused of misusing acquisition funds. The attack is led by the art historian Douglas Cooper, who accuses Rothenstein of passing up chances to buy fine works by the School of Paris. Moore, who sided with Rothenstein, becomes a lifelong enemy of Cooper, and vice versa.

Wins International Sculpture Prize at Sao Paulo Biennale. Travels to Brazil, then Mexico, where he visits Toltec pyramids and meets the artist Diego Rivera.

Discovery of the structure of DNA by Crick, Watson, and Wilkins.

Korean War ends.

Photograph of Moore and a young Anthony Caro, whom Moore engaged as a part-time assistant for two years

1954

His worldwide reputation grows swiftly. Designs a red brick relief for the wall of the Bouwcentrum in Rotterdam, the Netherlands. Travels to Italy and Germany, as well as The Netherlands.

Moore's American dealer Curt Valentin dies suddenly of an embolism while on holiday with Marino and Marina Marini on the Italian Riviera.

Jean Arp, Max Ernst, and Joan Miró awarded first prizes at the Venice Biennale.

Death of Matisse.

Beginning of the Algerian War.

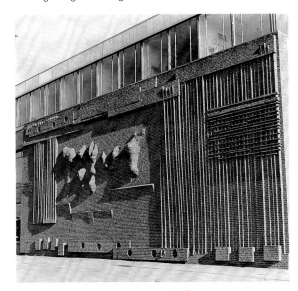

Henry Moore, *Wall Relief,* 1955, brick. Bouwcentrum, Rotterdam (LH 375)

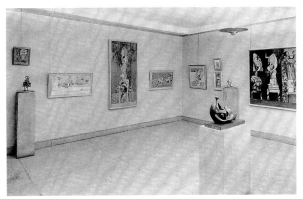

Exhibition of Sutherland and Moore at the Curt Valentin Gallery, New York, 2–26 April 1954

Jasper Johns begins work on *Flag,* 1954–55

1955

Visits Yugoslavia on the occasion of another British Council exhibition. Named a Companion of Honour by Queen Elizabeth II, having previously declined a knighthood. He is by now the most famous living British artist. Elected foreign honorary member of the American Academy of Arts and Sciences. Becomes a trustee of the National Gallery, London (until 1974). Buys more land adjacent to Hoglands to accommodate a larger studio. Exhibits with Oskar Schlemmer at the Kunsthalle Basel.

First Documenta exhibition held in Kassel, Germany, presenting an overview of modern art since 1900. Moore is represented, as one of the more recent artists.

Death of Léger.

Clement Greenberg coins the term *color field* painting.

1956

Visits The Netherlands. Controversial installation of *Family Group* in Harlow New Town, not far from his home.

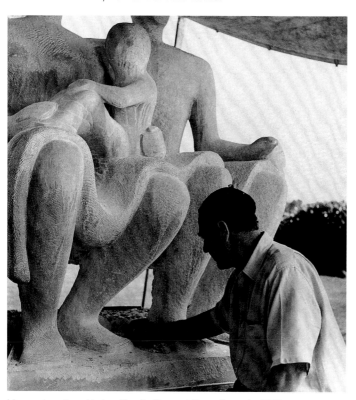

Moore at work on Harlow *Family Group* at Perry Green in 1955

1957

Begins work on major commission for UNESCO, visiting the Henraux stoneyard at Querceta in Italy, which Michelangelo had once frequented. Awarded the Stefan Lochner Medal by the City of Cologne.

Jack Kerouac publishes *On the Road.*

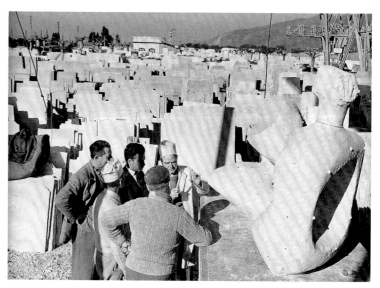

Moore at work on the *Unesco Reclining Figure* in Querceta, Italy, 1958

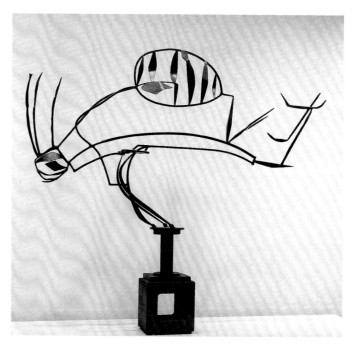

1958: The Museum of Modern Art, New York presents the revolutionary work of American sculptor David Smith, including, *Australia,* 1951

1958

Installation of massive *Reclining Figure* in travertine marble outside the UNESCO Building in Paris, the first in a series of monumental public sculptures. (The UNESCO Building also includes works commissioned from Appel, Calder, Matta, Miró, Picasso, and Tamayo.) Travels to Auschwitz as chairman of the Auschwitz Memorial Committee. Begins an association with Marlborough Fine Art in London. Travels to the United States; visits Harvard University and San Francisco. First contact with the Noack Foundry in Berlin, which will henceforth produce his large bronzes. Moore exhibition organized by the British Council shown in Warsaw, Krakow, Poznan, Wroclaw, Stettin.

Dancer and choreographer Merce Cunningham stages his ballet *Artic Meet* to the music of John Cage, with set design by Robert Rauschenberg.

United States creates NASA and launches its first satellite, *Explorer I.*

Moore's *Working Model for Unesco Reclining Figure* wins second prize at the Pittsburg Bicentennial International Exhibition of Contemporary Painting and Sculpture at the Carnegie Institute, 1958. An Alexander Calder mobile takes first prize

Le Corbusier's Philips-Pavillon at the 1958 International Exposition in Brussels, which highlighted new forms of architecture

1959

Receives awards from institutions in Poland, Britain, Japan, and Brazil. Exhibitions in Portugal, Spain, United States, Poland, and Japan; wins sculpture prize at Tokyo Biennale. Works on a *Reclining Figure* in two separate parts. Publication of Erich Neumann's Jungian study, *The Archetypal World of Henry Moore,* which the sculptor declines to read.

"Recently there was a book published on my work by a Jungian psychologist; I think the title was *The Archetypal World of Henry Moore.* He sent me a copy which he asked me to read, but after the first chapter I thought I'd better stop because it explained too much about what my motives were and what things were about. I thought it might stop me from ticking over if I went on and knew it all. . . . If I was psychoanalyzed I might stop being a sculptor."[26]

Death of Epstein: Moore writes a warm obituary.

Robert Rauschenberg exhibits *Monogram* at the Leo Castelli Gallery in New York.

Allen Kaprow invents "the happening."

Fidel Castro takes power in Cuba.

Moore's *Falling Warrior* at Documenta II exhibition in Kassel, Germany, 1959

1959: Swiss sculptor Jean Tinguely displays his kinetic sculpture in Paris. Tinguely with his "Méta-Matic" 17 in front of the Eiffel Tower

1959: Solomon R. Guggenheim Museum, designed by Frank Lloyd Wright, opens in New York

180. *Two Women Bathing a Child,* 1948
Chalk, pen and ink, and watercolor on paper, 28 × 23 in.
Private collection, New York
(HMF 2501)

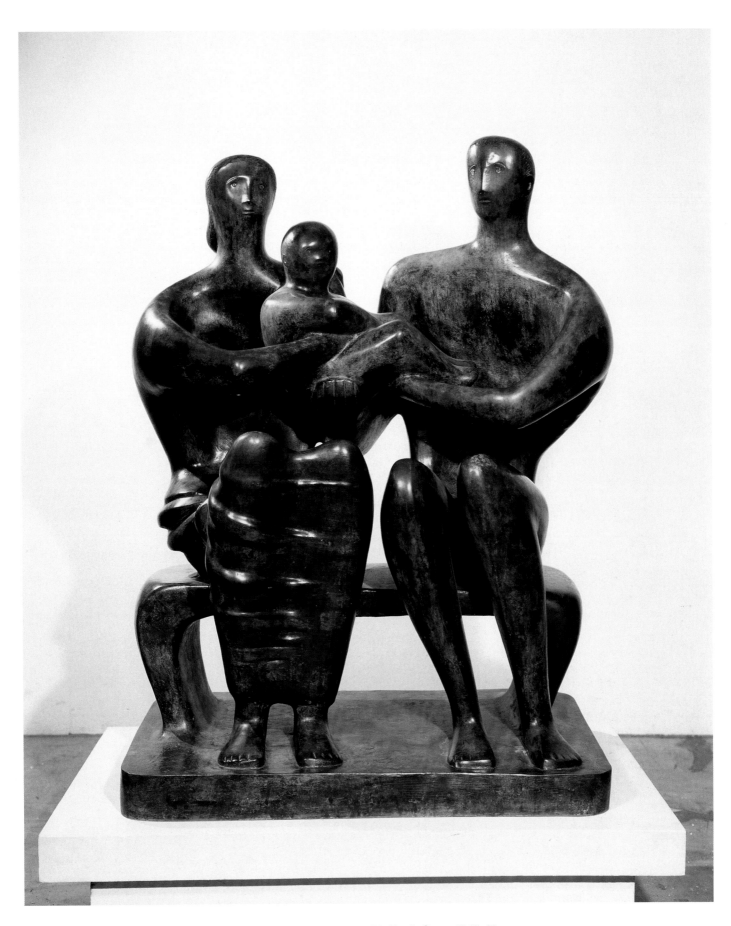

52. *Family Group,* 1948–49
Bronze, 60 × 45½ × 30¾ in.
Tate. Purchased 1950
(LH 269)

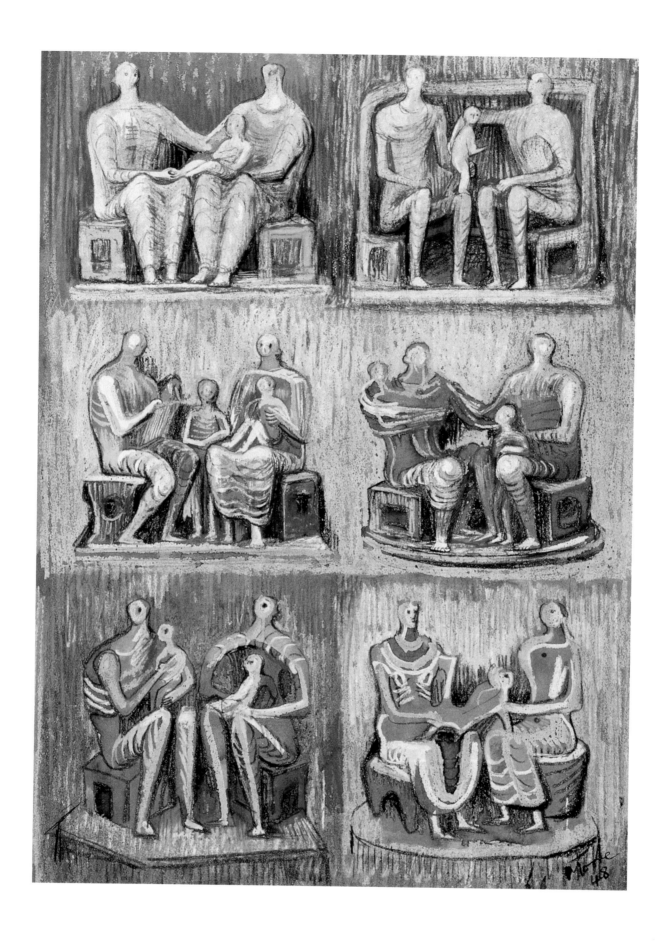

181. *Six Studies for Family Group,* 1948
Pencil, wax crayon, pen and ink, gouache, and watercolor
wash on cream heavyweight wove paper, 20¾ × 15⅛ in.
The Henry Moore Foundation: acquired 1984
(HMF 2501a)

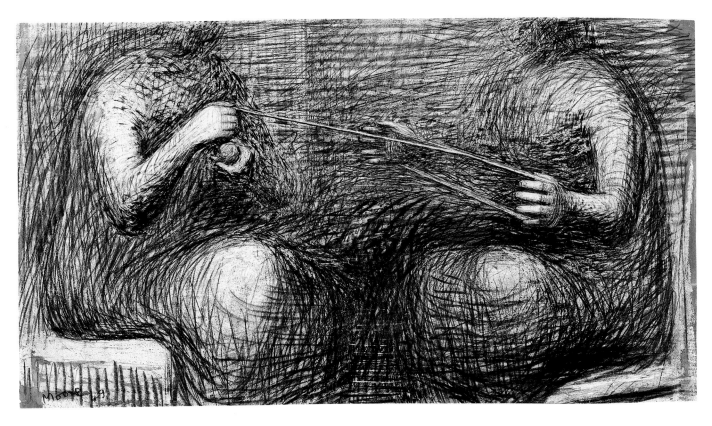

182. *Women Winding Wool,* 1949
Crayon and watercolor on paper, 13¾ × 25 in.
The Museum of Modern Art, New York.
Gift of Mr. and Mrs. John A. Pope in honor of Paul J. Sachs
(HMF 2530)

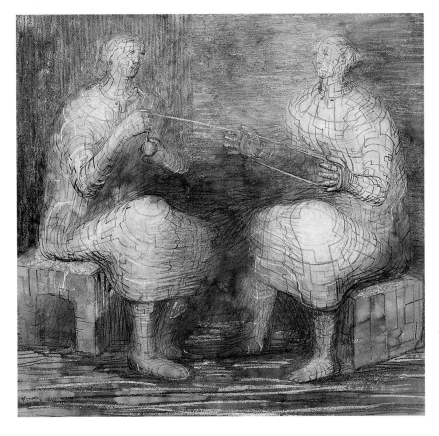

179. *Women Winding Wool,* 1948
Watercolor, pencil, and chalk on paper, 21½ × 22 in.
Arts Council Collection, Hayward Gallery, London
(HMF 2497)

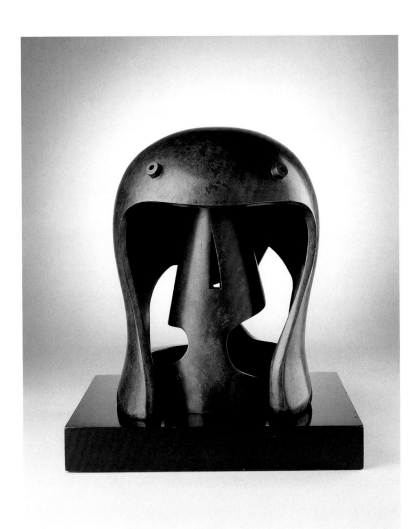

53. *Helmet Head No. 1,* 1950
Bronze, 14½ × 13½ × 10¼ in. (including base)
Trustees of the Cecil Higgins Art Gallery and
Museum, Bedford
(LH 279)

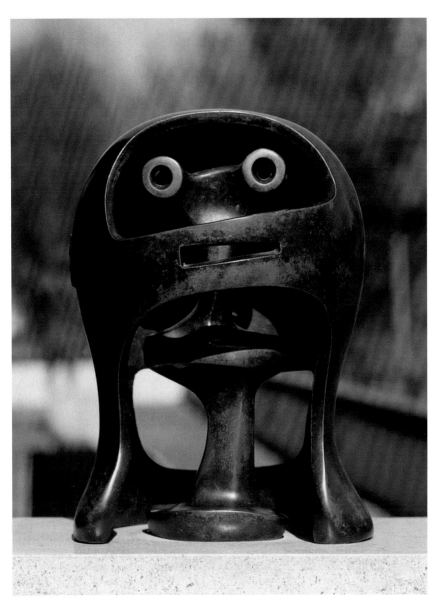

54. *Helmet Head No. 2,* 1950
Bronze, height 13½ in.
Courtesy Ivor Braka Limited, London
(LH 281)

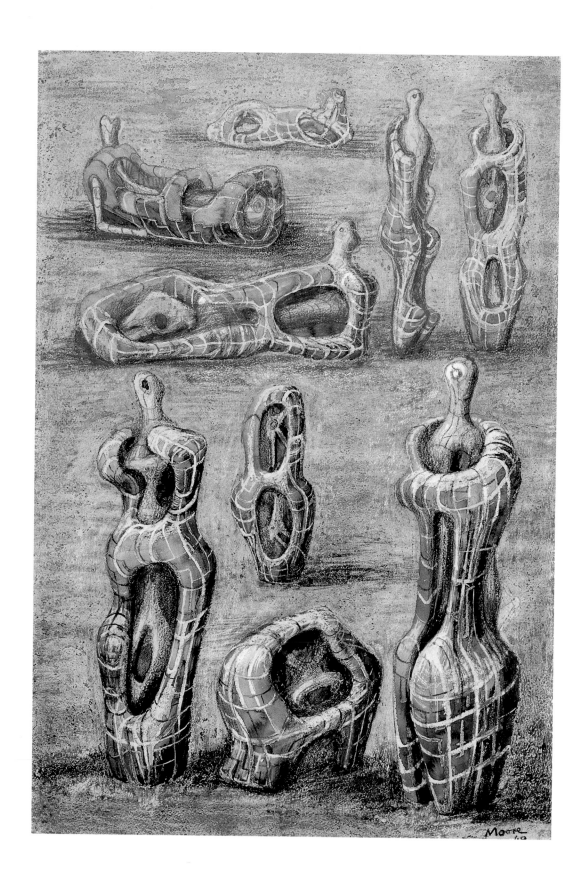

183. *Studies for Sculpture: Ideas for Internal/External Forms,* 1949
Pencil, wax crayon, chalk, pen and ink, gouache, and watercolor on
cream heavyweight wove paper, 23 × 15¾ in.
The Henry Moore Foundation: acquired 1990
(HMF 2540a)

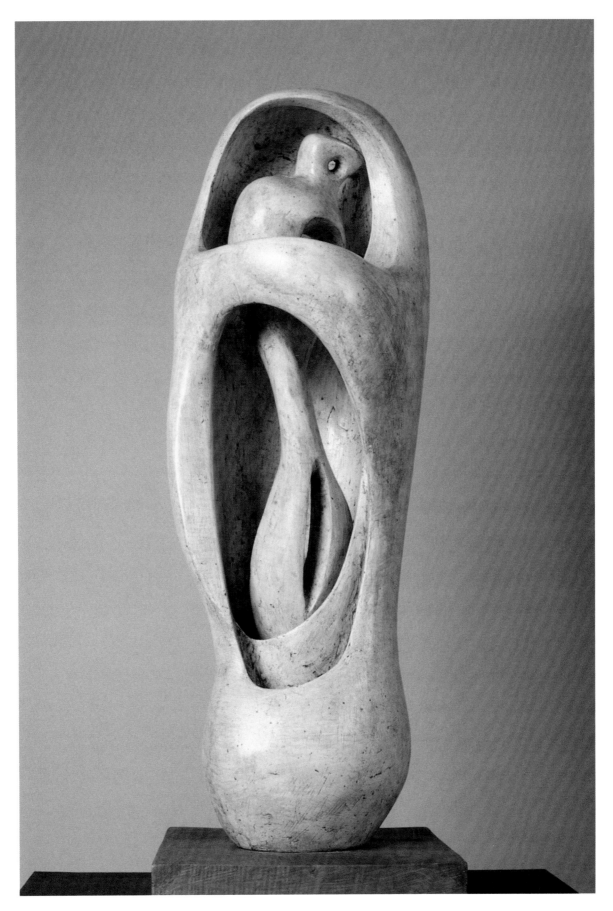

56. *Working Model for Upright Internal/External Form,* 1951
Plaster, height 24⅞ in.
The Henry Moore Foundation: gift of the artist 1977
(LH 295)

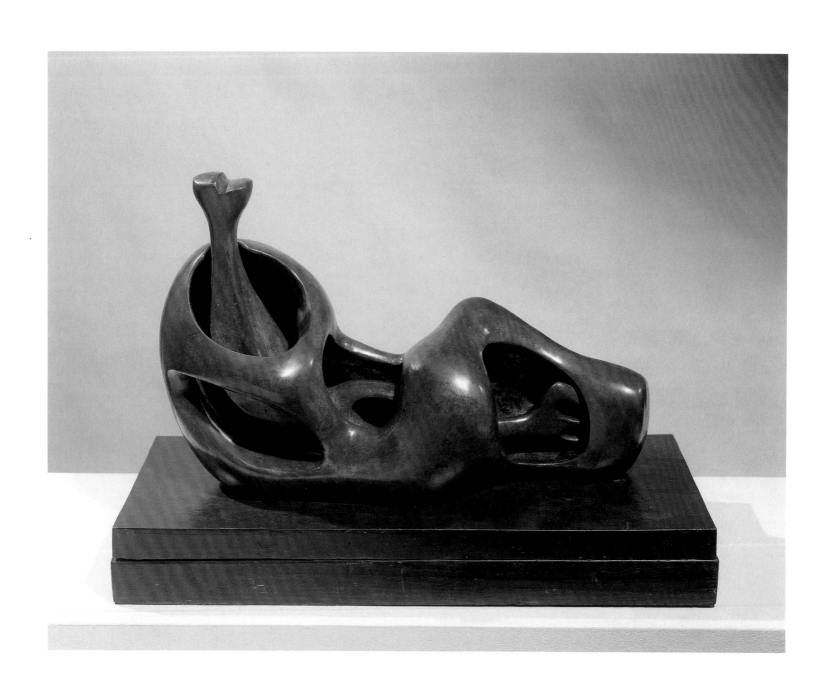

57. *Working Model for Reclining Figure: Internal/External Form,* 1951
Bronze, 13 × 20½ × 6¾ in. (base 4½ × 24½ × 10¼ in.)
Arts Council Collection, Hayward Gallery, London
(LH 298)

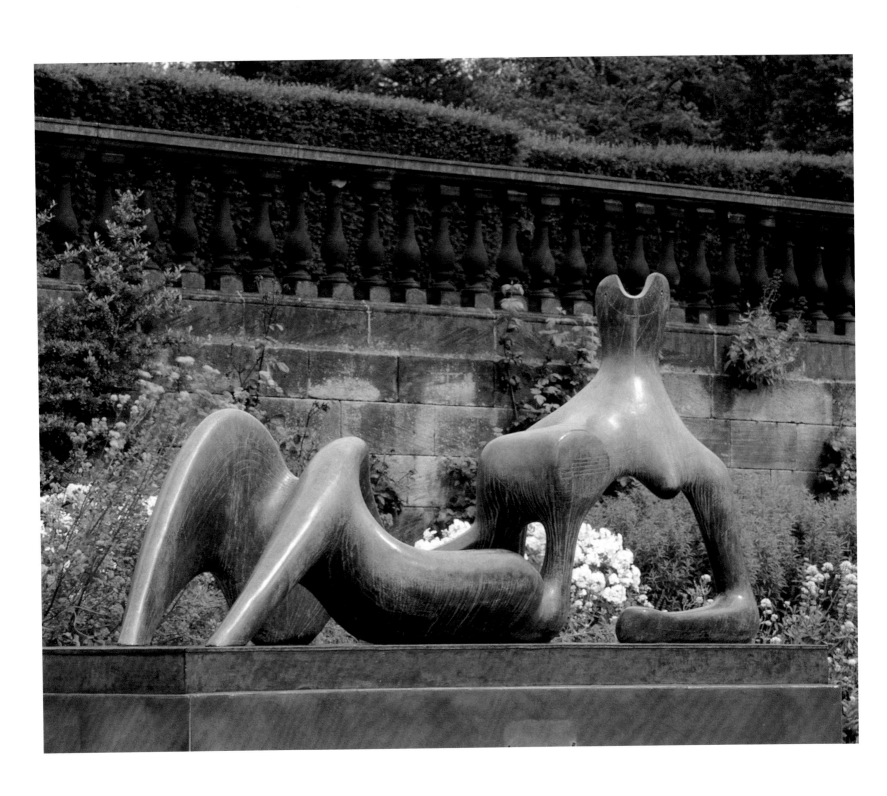

55. *Reclining Figure: Festival,* 1951
Bronze, length 90 in.
The Moore Danowski Trust
(LH 293)

185. *Ideas for Sculpture in Landscape,* 1951
Watercolor, chalk, and crayon on paper, 18½ × 13⅜ in.
Modern Art Museum of Fort Worth,
gift of Mr. and Mrs. Stanley Marcus, Dallas
(HMF 2703)

186. *Mother and Child and Reclining Figure in Landscape,* 1951
Ink, watercolor, and chalk on paper, 14¼ × 11¾ in.
Dallas Museum of Art, Foundation for the Arts Collection,
gift of Mr. and Mrs. Stanley Marcus
(HMF 2706)

184. *Sculpture Settings by the Sea,* 1950
Ink, watercolor, gouache, colored crayons, and
white crayon on wove paper, 21¾ × 15½ in.
Collection, Art Gallery of Ontario, Toronto.
Gift of Mrs. Mary R. Jackman, 1988
(HMF 2621)

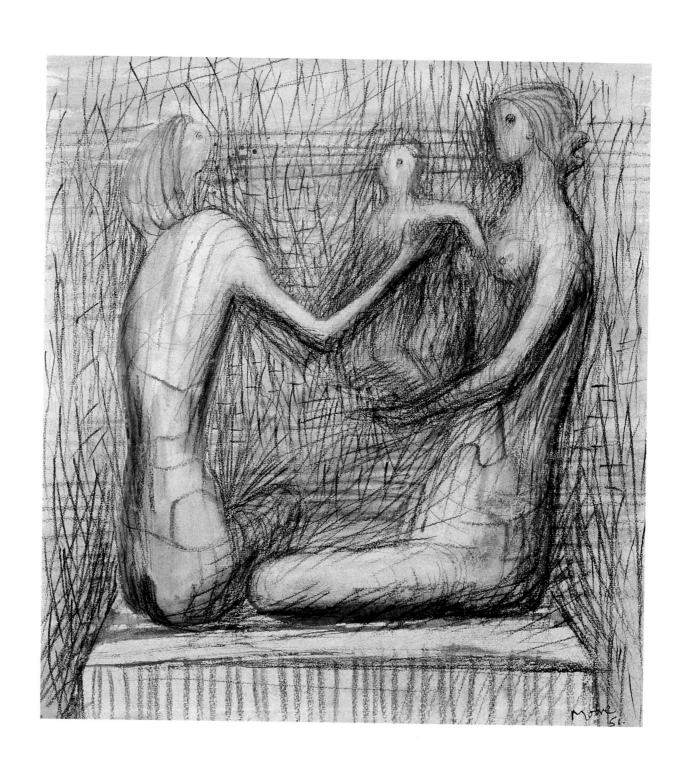

187. *Two Women and a Child,* 1951
Crayon, pastel, and wash on cream
heavyweight wove paper, 13¼ × 12⅜ in.
The Henry Moore Foundation: gift of the artist 1977
(HMF 2727)

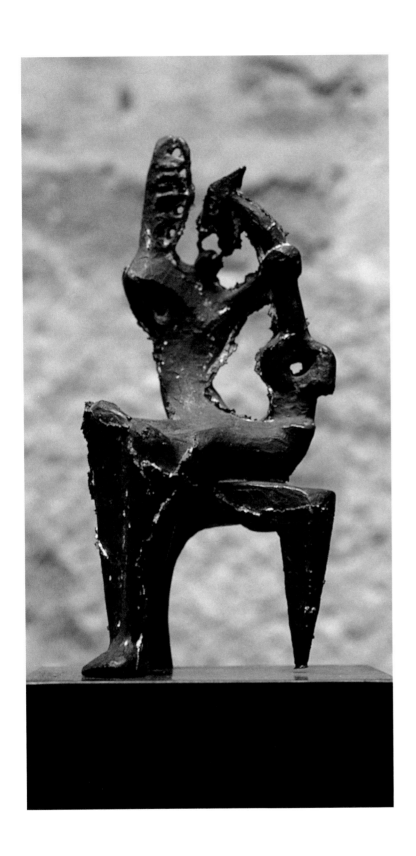

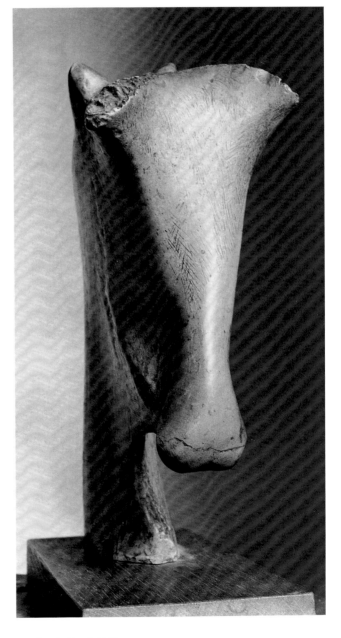

59. *Maquette for Mother and Child,* 1952
Bronze (unnumbered [9/9]), height 8½ in.
The Henry Moore Foundation: gift of Irina Moore 1977
(LH 314)

58. *Goat's Head,* 1952
Plaster, height 8 in.
The Henry Moore Foundation:
gift of the artist 1977
(LH 302)

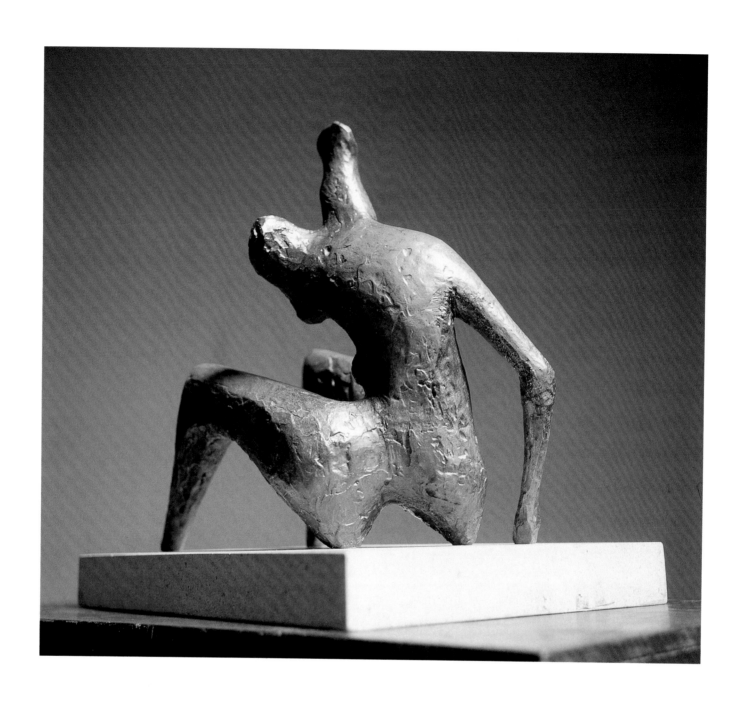

63. *Seated Torso,* 1954
Plaster with surface color, length 19½ in.
The Henry Moore Foundation: gift of the artist 1977
(LH 362)

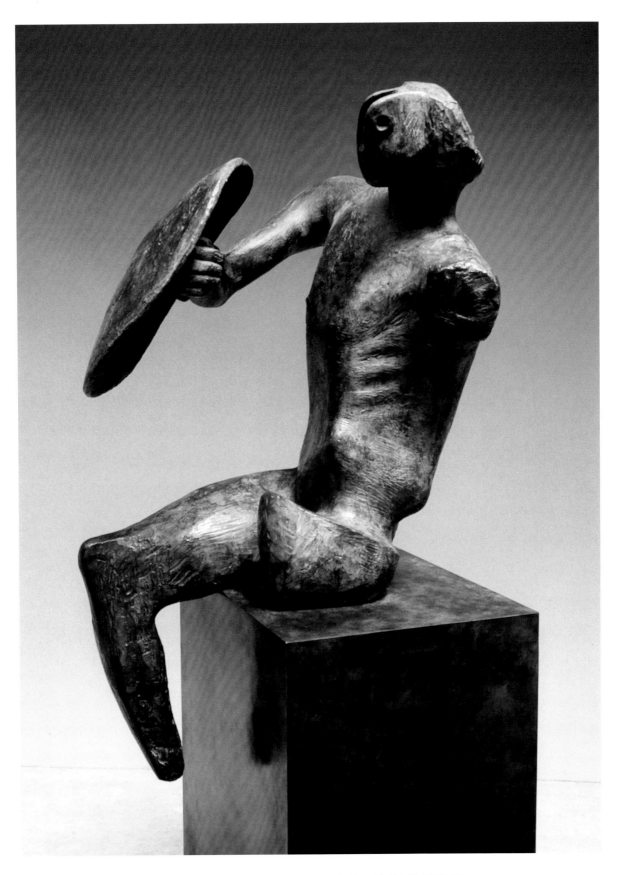

62. *Warrior with Shield,* 1953–54
Bronze, height 61 in.
The Moore Danowski Trust
(LH 360)

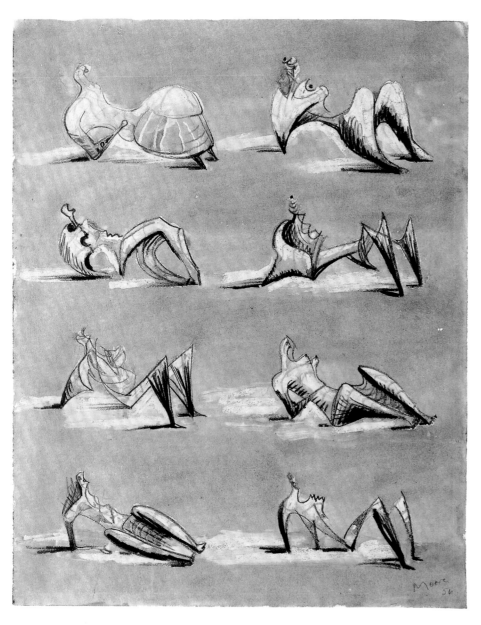

188. *Eight Reclining Figures for Metal Sculpture,* 1956
Crayon, pencil, and watercolor on cream
medium-weight wove paper, 16¾ × 13½ in.
The Henry Moore Foundation: gift of the artist 1977
(HMF 2911a)

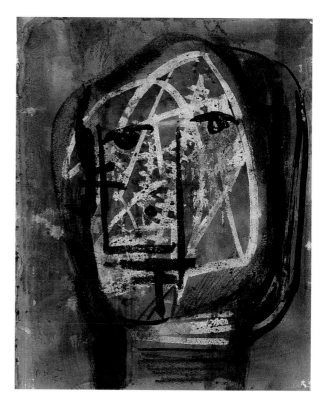

189. *Head,* 1958
Crayon, brush and ink, and watercolor wash on
off-white medium-weight wove paper, 11⅜ × 9⅞ in.
The Henry Moore Foundation: gift of the artist 1977
(HMF 2979)

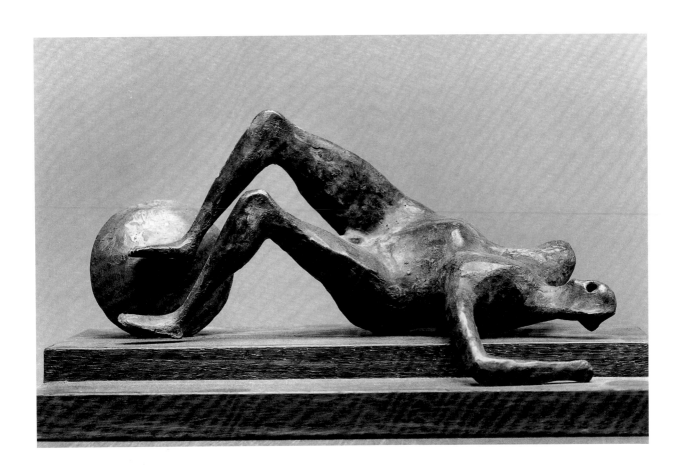

70. *Maquette for Fallen Warrior,* 1956
Bronze, length 9 in.
The Henry Moore Foundation:
gift of the artist 1977
(LH 404)

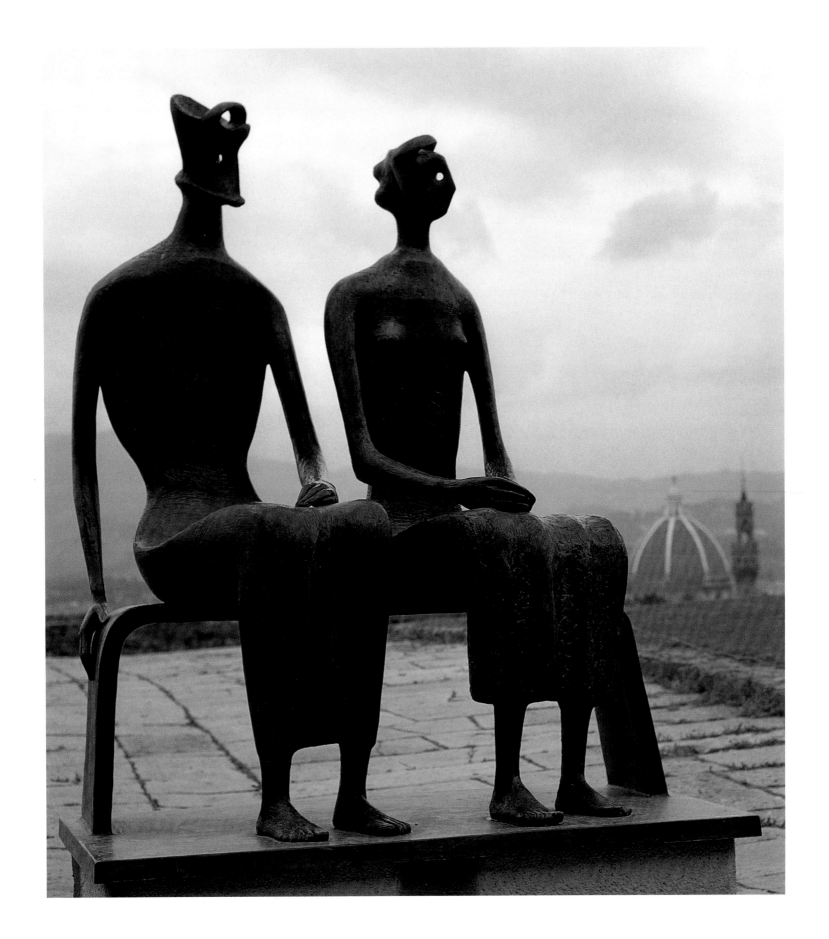

61. *King and Queen,* 1952–53 (cast 1957)
Bronze, 64½ × 54½ × 33¼ in.
Tate. Presented by the Friends of the Tate Gallery
with funds provided by Associated Rediffusion Ltd. 1959
(LH 350)

60. *Working Model for Time-Life Screen,* 1952
Bronze, length 42 in.
San Francisco Museum of Modern Art.
Gift of Charlotte Mack
(LH 343)

64. *Wall Relief: Maquette No. 1,* 1955
Bronze, length 22 in.
Dallas Museum of Art, Foundation for the Arts Collection,
bequest of Margaret Ann Bolinger
(LH 365)

65. *Wall Relief: Maquette No. 2,* 1955
Bronze, length 17½ in.
The Henry Moore Foundation:
gift of the artist 1977
(LH 366)

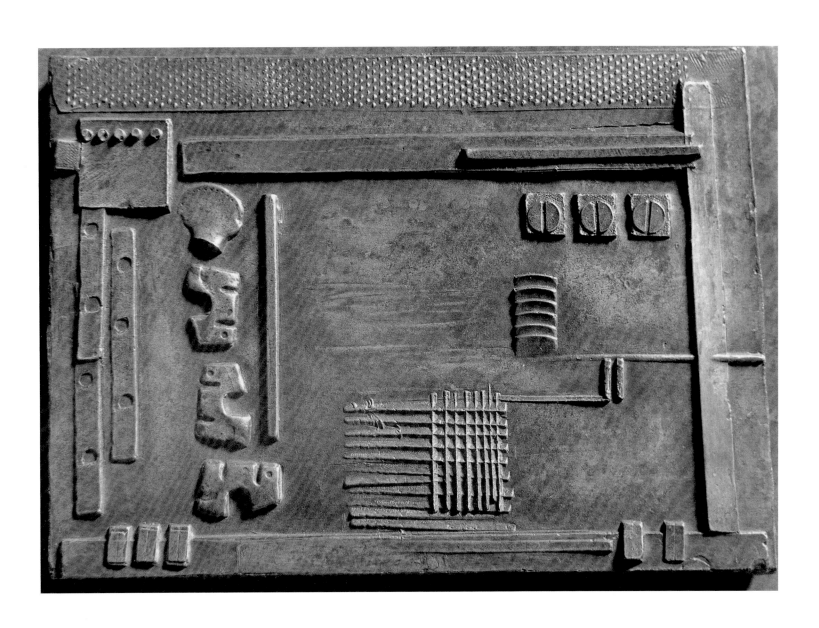

66. *Wall Relief: Maquette No. 7,* 1955
Bronze, length 18½ in.
The Henry Moore Foundation:
transferred from the Henry Moore Trust 1978
(LH 371)

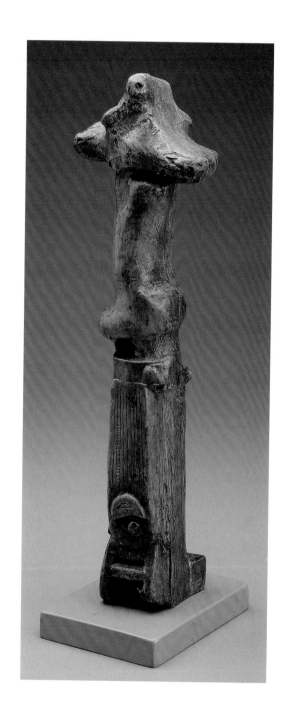

67. *Upright Motive: Maquette No. I,* 1955
Plaster, 12⅛ × 3⅜ × 3⅜ in.
Collection, Art Gallery of Ontario, Toronto.
Gift of Henry Moore, 1974
(LH 376)

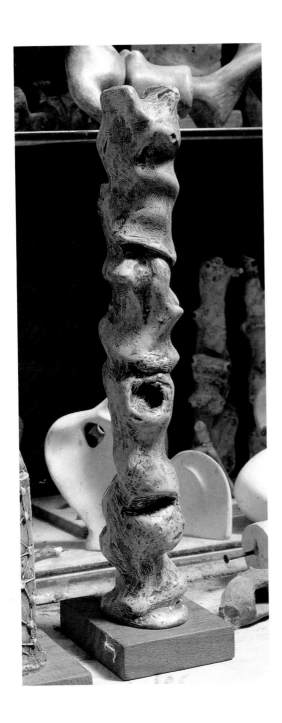

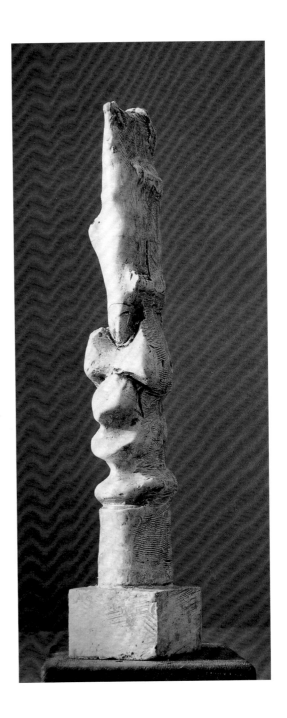

68. *Upright Motive: Maquette No. 10,* 1955
Plaster with surface color, height 12 in.
The Henry Moore Foundation: gift of the artist 1977
(LH 390)

69. *Upright Motive: Maquette No. 7,* 1955
Plaster with surface color, height 12⅝ in.
The Henry Moore Foundation: gift of the artist 1977
(LH 385)

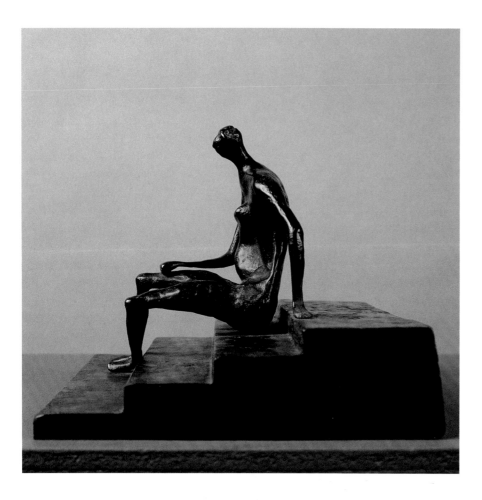

71. *Seated Figure on Square Steps,* 1957
Bronze, 8 × 9½ × 9¼ in.
Dallas Museum of Art, Foundation for the Arts Collection,
bequest of Margaret Ann Bolinger
(LH 436)

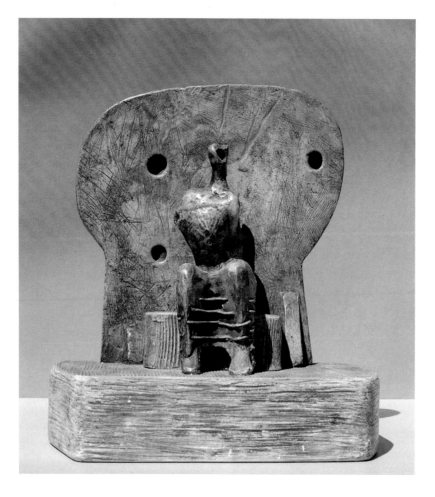

72. *Armless Seated Figure against
Round Wall,* 1957
Plaster with surface color, height 11 in.
The Henry Moore Foundation:
gift of the artist 1977
(LH 438)

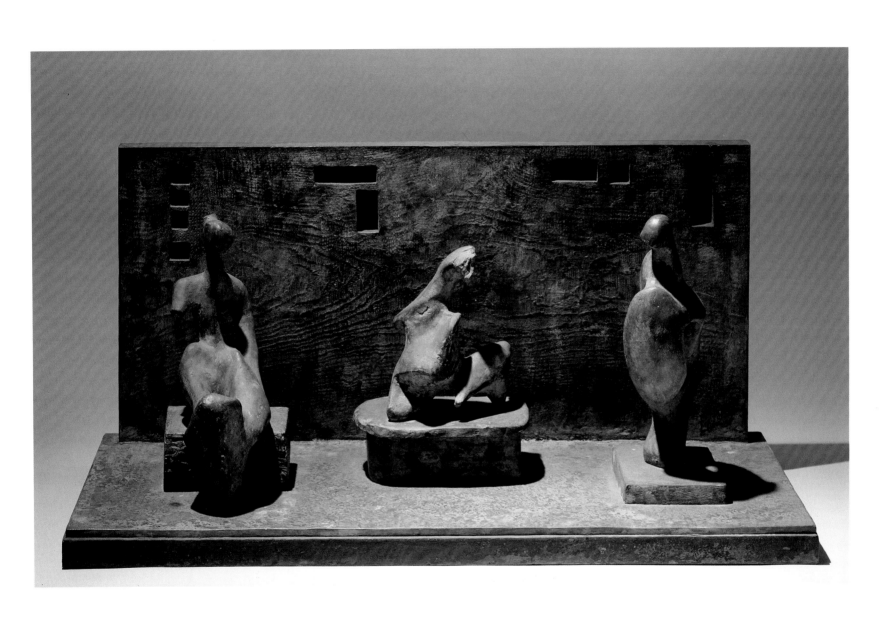

73. *Three Motives against Wall No. 1,* 1958
Bronze, length 42 in.
The Henry Moore Foundation:
gift of the artist 1977
(LH 441)

1960

Large British Council traveling exhibition visits Hamburg, Essen, Zurich, Munich, Rome, Paris, Amsterdam, Berlin, Vienna, and Copenhagen. In Germany, civic authorities now see a Moore bronze as an inevitable complement to a new public building. Publication of Will Grohmann's *The Art of Henry Moore.* Reappointed to the Royal Fine Arts Commission.

> "When you try to think clearly about Henry Moore you are deafened by the applause. The picture is not man-size, but screen-size. It is as if the build-up into a great public figure has got out of hand, and, like a film star's big 'front,' has clouded our view of the real Moore. . . . In his later works it sometimes appears that he is affected by a consciousness of his greatness. My generation abhors the idea of a father-figure, and his work is bitterly attacked by artists and critics under forty when it fails to measure up to the outsize scale it has been given." [27]–Anthony Caro

Death of Moore's old teacher Alice Gostick.

John F. Kennedy elected president of the United States.

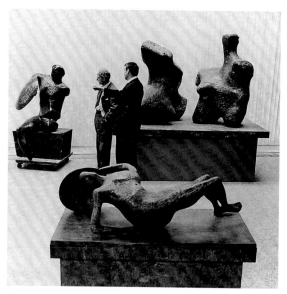

Moore and Brian Robertson looking at *Warrior with Shield* at Whitechapel Art Gallery exhibition, 1960; a review of the exhibition by Anthony Caro attacks Moore's star status

1961

Elected member of the Akademie der Künste in West Berlin. Exhibition at Scottish National Gallery of Modern Art in Edinburgh. Produces *Large Standing Figure: Knife Edge* (cat. 77), inspired by a bird's breastbone: "I would like to think that others see something Greek in this *Standing Figure*." [28] Buys a small Cézanne painting.

> "Perhaps another reason why I feel for it is that the type of woman he portrays is the same kind as I like. Each of the figures I could turn into a piece of sculpture, very simply. . . . Not young girls but that wide, broad, mature woman. Matronly. Look at the back view of the figures on the left [with reference to Cézanne's *Three Bathers* from Henry Moore's collection]. What a strength . . . almost like the back of a gorilla, that kind of flatness. But it has also this, this romantic idea of women. Four lots of long tresses, and the hair he has given them." [29]

Mark Rothko retrospective at The Museum of Modern Art, New York.

Man Ray receives the Gold Medal for Photography at the Venice Biennale.

USSR and US space flights; Soviets launch first human into space.

Exhibition of Moore's sculpture at Marlborough Fine Art Gallery, London, 1961

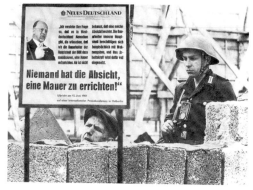

1961: Construction of the Berlin Wall. Under armed supervision, an East German worker adds another brick to the wall. The sign, on the western side of the wall, recalls the June 15 statement by the head of the East German Socialist Unity Party, Walter Ulbricht, that "No one has the intention of building a wall"

1962

Created Honorary Freeman of Castleford, his birthplace. Arts Council show travels in England.

> Christo installs his *Iron Curtain*, 249 oil barrels piled on top of each other, in a narrow Parisian street.
>
> Miró retrospective at the Musée national d'art moderne, Paris.
>
> John Glenn is the first American to orbit the earth.
>
> Cuban missile crisis.

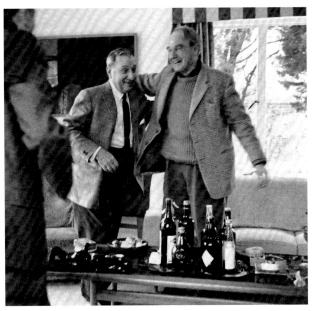

Moore with Joseph Hirshhorn in Moore's home, Hoglands, in Perry Green, November 1962

1962: Opening of the new Eero Saarinen–designed TWA terminal at John F. Kennedy Airport

1963

Holidays in Yugoslavia. Queen Elizabeth II confers the Order of Merit. Develops his interest in printmaking. Exhibits at Wakefield City Art Gallery.

> First exhibition of the sculpture of George Segal at the Sonnabend Gallery, New York.
>
> Francis Bacon retrospective at the Guggenheim Museum in New York.
>
> Assassination of President John F. Kennedy.

Moore's wife Irina standing in front of the outdoor studio Moore used to work on the large *Reclining Figure* for Lincoln Center, 1963

1964

British Council exhibition travels to Mexico City, Caracas, Rio de Janeiro, and Buenos Aires. Interview with David Sylvester published as "The Michelangelo Vision," in which Moore praises Michelangelo's "grandeur of gesture and scale." Motoring holiday in France. His bronzes are displayed to great effect in gardens and churchyards in the Norfolk town of King's Lynn. In a review of a New York show, Brian O'Doherty criticizes the gigantism of the recent work.

> Barbara Hepworth complains about the relative pricing of her sculpture in comparison to that of Henry Moore: "It seemed to me that there is one set of rules for Henry and another set for me."[30]
>
> Claes Oldenburg exhibits at the Sonnabend Gallery, New York.
>
> Rauschenberg awarded first prize at the Venice Biennale.
>
> Martin Luther King awarded Nobel Peace Prize.
>
> Start of the Vietnam War.

1965

Buys house at Forte dei Marmi, near the Carrara quarries in Italy, where he will spend most summer holidays henceforth. Exhibits at the Rome branch of Marlborough Fine Art. Travels to New York to install a two-piece *Reclining Figure* at Lincoln Center.

> Death of Le Corbusier.
>
> Calder exhibition at the Musée national d'art moderne.
>
> Magritte retrospective at the Museum of Modern Art, New York.
>
> First retrospective of Willem de Kooning at Smith College, Northampton, Massachusetts.
>
> Op Art exhibition at the Museum of Modern Art, New York.

1966

Visits Toronto, Canada, for installation of controversial *Three Way Piece No. 2: Archer* in Nathan Phillips Square. Publication of *Henry Moore on Sculpture,* a compilation of his articles and other pronouncements on sculpture, edited by Philip James.

Deaths of Giacometti and Jean Arp.

Exhibition of Minimalist art at the Jewish Museum, New York.

Opening of the new Whitney Museum building, designed by Marcel Breuer.

First bombing of Hanoi by the United States.

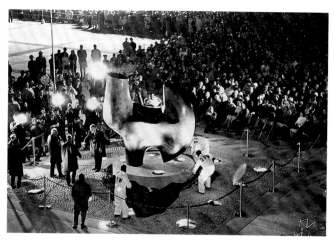

The unveiling of *Three Way Piece No 2: Archer* on 26 October 1966 in Toronto

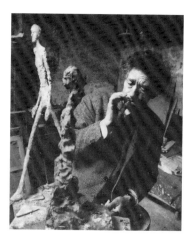

Giacometti in his studio

1967

Visits United States for unveiling of controversial *Nuclear Energy* at University of Chicago. Unveiling of *Sundial* at the Times Building, London, 23 November. Painted polyurethane replicas of his sculptures

Moore with *Nuclear Energy* in situ at the University of Chicago, 30 November 1967

appear on stage in a production of *Don Giovanni* in Spoleto, Italy. Takes part in the homage to Rodin organized by the Galerie Lucie Weil in Paris. Works by Moore included in Expo 67 in Montreal and in the *International Sculpture Exhibition* at the Solomon R. Guggenheim Museum in New York.

Death of Zadkine.

Death of Magritte.

Retrospective exhibition of Joseph Cornell at the Solomon Guggenheim Museum, New York.

First retrospective of Louise Nevelson at the Whitney Museum, New York.

Bruce Nauman embraces the legacy of Henry Moore in his photograph *Light Trap for Henry Moore, No. 1*, the culmination of a series of drawings and sculptures done in 1966–67 on the subject of Henry Moore.

Patsy and Raymond D. Nasher visit Moore at Perry Green, September 1967

1968

Retrospective at Tate Gallery, London, to mark his seventieth birthday, with 142 sculptures and 90 drawings. Awarded Erasmus Prize for exhibition in Otterlo, which travels on to Rotterdam, Düsseldorf, and Baden-Baden. Awarded the Albert Einstein Commemorative Award for the Arts, Yeshiva University. Begins using polystyrene to facilitate enlargement of maquettes. A vast hangar covered in plastic sheeting is constructed to provide shelter for the largest pieces while these are being worked. The gift of an elephant skull prompts a cycle of etchings.

Death of Herbert Read.

Death of Marcel Duchamp.

Assassinations of Martin Luther King Jr. and Robert F. Kennedy.

Release of Stanley Kubrick's *2001: A Space Odyssey.*

Exhibition titled *Art and the Machine* at The Museum of Modern Art, New York.

1969

Successful exhibition in Tokyo. Installs an enlarged version of *The Arch* outside Bartholomew County Public Library, Columbus, Indiana, designed by I. M. Pei. Elected Honorary Member of the Vienna Secession.

Theft of the Penrose Collection in London.

Samuel Beckett wins the Nobel Prize for literature.

Woodstock Festival.

American astronauts walk on the moon.

First experimental flight of the Concorde.

De Gaulle resigns.

Qadhafi comes to power in Libya.

1970

With the artist Michael Ayrton, publishes a study of the seventeenth-century sculptor Giovanni Pisano, whose work he had seen in Pisa during recent years. Exhibition at Knoedler and Marlborough Gallery in New York.

Death of Rothko.

Death of Newman.

Photograph of Moore (center) with Naum Gabo and Barbara Hepworth attending memorial presentation for Herbert Read at the Tate Gallery, London, 1970

1970: Robert Smithson completes *Spiral Jetty* at the Great Salt Lake, Utah

1971

Visits Toronto to discuss a sculpture center, which will house his work. Exhibitions in Iran and Turkey. Begins lithograph series on the theme of Stonehenge.

Elected Honorary Member of the Royal Institute of British Architects.

Opening of the Rothko chapel in Houston.

Francis Bacon retrospective in Paris.

1972

Visits Italy for a major and spectacular retrospective at the Forte di Belvedere, high above Florence: 168 sculptures and 121 drawings are shown, as well as graphics and sketchbooks. Produces *Sheep Sketchbook,* containing drawings of sheep grazing outside his Perry Green studio. Visits his hometown of Castleford to unveil his *Draped Reclining Figure.* The Henry Moore Trust is set up to regulate his affairs. Many other international medals and honors are bestowed.

Olympic Games in Munich marred by terrorist attack.

Moore with Sophia Loren and Carlo Ponti in Italy, 1972

1972: Jean Dubuffet installs his *Group of Four Trees* on the plaza in front of Chase Manhattan Bank in New York

1973

Large show at Los Angeles County Museum.

Deaths of Picasso and Lipchitz.

Cease-fire declared in Vietnam; US forces leave the country.

Watergate scandal.

Jasper Johns's *Double White Map* (1965) sells at auction for $240,000. Barnett Newman's *White Fire* sells for $155,000. Jackson Pollock's *Blue Poles* (1953) sold to Canberra Museum in Australia for $2,000,000.

Moore on election as a member of the Académie des Beaux-Arts, 1973

Joan Miró visiting Moore in his studio, 1973

1974

Michael Lambeth, chairman of the Toronto chapter of the Canadian Artists Representation, writes his "Dear Sir Henry" letter, in which he asks Moore to withdraw his name from the Moore Center (to be renamed the Tom Thomson Wing) and to forbid the permanent display of his work at the Art Gallery of Ontario. Canadian artists viewed the Moore Center as a potential threat to contemporary Canadian art. The petition is unsuccessful, and the Art Gallery of Ontario goes ahead with the Moore Center.

Visits Canada for inauguration of the Henry Moore Sculpture Center at the Art Gallery of Ontario. Show of lithographs at the British Museum in London alongside manuscripts by the recently deceased poet W. H. Auden. *Goslar Warrior* (cat. 94) installed in Goslar, Germany.

David Hockney exhibition at the Musée des arts décoratifs.

President Richard M. Nixon resigns.

1975

Graphics show at Tate Gallery, London, on occasion of gift of graphics by the artist. Awarded the Kaiserring of the City of Goslar.

Barbara Hepworth dies in a fire.

Anthony Caro retrospective at The Museum of Modern Art in New York.

End of the Vietnam War.

Death of Generalísimo Francisco Franco in Spain.

1976

Exhibition of wartime drawings at Imperial War Museum, London. Exhibition in Zurich, with *Sheep Piece* installed beside the lake. His daughter Mary marries Raymond Danowski. A series of tapestries based on his drawings is initiated at West Dean College in Sussex. There are now nine studios on the Perry Green estate.

Death of Max Ernst.

Death of Man Ray.

1976: Christo and Jeanne-Claude complete *Running Fence,* Sonoma and Marin Counties, California

1977

Inauguration of the Henry Moore Foundation at Perry Green, which will henceforth manage his creative output as well as support the arts at large. Exhibition at the Orangerie in Paris. Exhibition of 261 drawings shown in Toronto, then at four venues in Japan, and finally in London in 1978. His grandson Gus is born. Travels to Paris, Berlin, Oslo, Copenhagen, Vienna, Bonn, Frankfurt, and Florence for various openings, sitings, and unveilings.

Inauguration of the Centre Georges Pompidou.

1978

Major donation of three dozen sculptures to Tate Gallery, London. Eightieth birthday shows at Tate Gallery and Serpentine Gallery in London, as well as in Bradford, near Castleford. Installs huge three-part *Dallas Piece* (cat. 88) outside the new Dallas City Hall, designed by I. M. Pei.

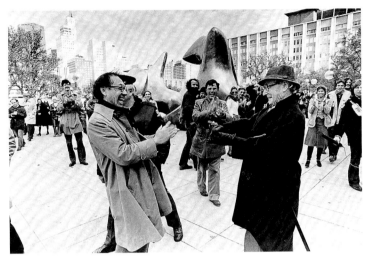

I. M. Pei and Moore applaud each other after placing the *Dallas Piece,* 1978

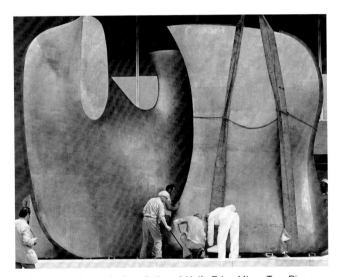

1978: Moore directs the installation of *Knife Edge Mirror Two Piece* (cat. 99) in front of the new East Wing of the National Gallery of Art, designed by I. M. Pei

1978: Alexander Calder's *Stabile* installed on the Place de la Défense in Paris

1979

Travels to Bonn to install *Large Two Forms* in front of the German State Chancellery, at invitation of Chancellor Schmidt. The Mother and Child theme becomes dominant. Suffers from arthritis and has to work in smaller formats; one evening, loses his way in the dark on the snowy estate.

Retrospective exhibition of Salvador Dalí at the Centre Georges Pompidou.

Margaret Thatcher elected prime minister.

Joseph Beuys exhibition at the Guggenheim, New York.

1980

The Arch donated for permanent display in Kensington Gardens, London. Exhibition at Victoria and Albert Museum, London, of tapestries made after the artist's drawings. Mary and her husband emigrate to South Africa. Despite arthritis in his fingers, produces 350 drawings. His niece Ann Garrould begins to work for the Henry Moore Foundation.

Receives Grand Cross of the Order of Merit from the West German Chancellor, Helmut Schmidt, at the West German Embassy in London.

Death of Graham Sutherland.

Ronald Reagan elected president of the United States.

1981

Granddaughter Jane born in South Africa. Elected full member of Académie Européenne des Sciences, des Arts et des Lettres, Paris. Exhibition in Madrid, which goes on to Lisbon and to the Miró Foundation in Barcelona. Exhibition in Sofia. Publication of *Henry Moore at the British Museum,* illustrating his favorite items from the collection.

Assassination of Anwar Sadat.

First AIDS cases diagnosed in New York.

1982

Last visit to Italy. Henry Moore Centre for the Study of Twentieth Century Sculpture opens in Leeds. Exhibitions in Leeds, Mexico City, and Seoul. Auctioned in New York, his 1946 elmwood carving *Reclining Figure* fetches a record figure of over $1,000,000.

Death of Ben Nicholson.

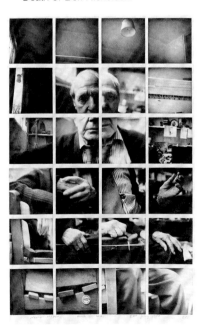

David Hockney's composite polaroid, *Henry Moore Much Hadham 23rd July 1982*

1983

Exhibitions at Caracas, Venezuela and at Metropolitan Museum of Art in New York. His health continues to deteriorate following a prostate operation; for some time, he still insists on drawing every day.

Death of Kenneth Clark.

First traveling exhibition of the sculpture of Henri Gaudier-Brzeska.

Exhibition at the Tate Gallery titled *The Essential Cubism*, 1907–1920.

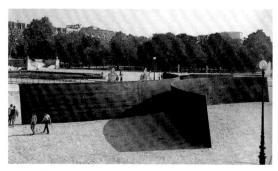

1983: Richard Serra exhibits at the Tuileries and at the Centre Georges Pompidou in Paris. Pictured here: *Clara-Clara*, 1983, at the Tuileries Gardens

1984

Traveling exhibition through East Germany: Berlin, Leipzig, Halle, and Dresden. Grandson Henry born. His largest ever *Reclining Figure* is installed outside a Singapore bank. Exhibition on the Reclining Figure theme at Columbus, Ohio, and four other American venues. Publication of *The Drawings of Henry Moore* by Alan Wilkinson.

Aristide Maillol's *Trois Nymphes* fetches 9 million French francs at auction at Sotheby's, New York.

President François Mitterrand of France visits Moore at Perry Green to bestow upon him the honor of Commandeur de l'Ordre National de la Légion d'Honneur, October 1984

Moore after dedication of *Mother and Child: Hood* (1983, travertine marble) at St. Paul's Cathedral, London, with the Dean of St. Paul's, Dr. Alan Webster (center), and the Rev. Philip Buckler, sacristan, March 1984. The sculpture was carved by the artisans of Henraux in Italy

1985

Opening of the Musée Picasso, Paris.

Henry Moore, Sculptor of an Age, Dies at 88

By JOHN RUSSELL

Henry Moore, a sculptor pre-eminent in 20th-century art and a particular and longtime favorite in the United States, where he was represented by carvings, bronzes and drawings almost beyond number in both public and private collections, died early yesterday at his home in Much Hadham, England. He was 88 years old.

No cause of death was given, but he had been ill with arthritis and diabetes.

Throughout the latter part of his life, Henry Moore was in many parts of the world the No. 1 choice whenever a public sculpture was needed. This was especially the case with new museums. From Mies van der Rohe's National Gallery in West Berlin to I. M. Pei's East Wing at the National Gallery of Art in Washington, Henry Moore was the man of whom almost everyone thought first.

The same was true of municipalities, large corporations, theaters, opera houses, banks, hotels and luxury apartment houses. In almost every case it was thought that a large Henry Moore work out front would add a final distinction.

Even a masterpiece of European Baroque architecture like the Karlskirche in Vienna came to have a large Henry Moore sculpture in front of it. As at Lincoln Center in Manhattan, that Moore work was reflected in a large pool of water and soon took its place as a prized element in the city's cultural life.

Henry Moore was no less successful

Continued on Page 8, Column 1

Henry Moore at Lincoln Center in 1965 with six-ton bronze sculpture, one of the reclining figures for which he was best known.

Front page, *The New York Times*, September 1, 1986

1986

Traveling exhibition in Hong Kong, Tokyo, and Fukuoka. Moore dies on 31 August at the age of eighty-eight and is buried in the local churchyard at Perry Green. A Service of Thanksgiving is held in Westminster Abbey, London.

"Kenneth Clark once remarked to me that if the inhabitants of this planet found themselves having to send an ambassador representing the human race to the inhabitants of another planet, they could not choose better than to send Henry Moore."[31]—Sir Stephen Spender's eulogy to Moore.

Death of Joseph Beuys.

United States bombs Libya.

Accident at the nuclear power plant Tchernobyl in the USSR.

Inauguration of the Musée d'Orsay, Paris.

1987

Publication of *The Life of Henry Moore* by Roger Berthoud.

British Council exhibition of Henry Moore in New Delhi, India.

1988

Death of Irina Moore.

Major retrospective of Henry Moore at the Royal Academy of Arts, London.

Notes

1. This chronology is based on the chronology of the Henry Moore Foundation, which draws upon earlier chronologies by Celia Houdart, Veronika Wiegartz, and Angela Dyer, and above all on Roger Berthoud's *The Life of Henry Moore* (London: Faber and Faber, 1987).

2. Moore as quoted in Warren Forma, *Five British Sculptors: Work and Talk* (New York: Grossman, 1964), reprinted in Philip James, ed., *Henry Moore on Sculpture* (New York: Viking Press, 1971), 53.

3. Henri Gaudier-Brzeska, "Vortex," *Blast* (June 1914): 155–58.

4. Henry Moore as quoted in John and Vera Russell, "Conversations with Henry Moore," *Sunday Times* (London), 17 and 24 December 1961, reprinted in part in James, 35.

5. Moore as quoted in James Johnson Sweeney, "Henry Moore," *Partisan Review* (New York) 14, no. 2 (March–April 1947), reprinted in part in James, 35.

6. Moore in a letter to Sir William Rothenstein, Principal of the Royal College of Art, dated 12 March 1924; reprinted in part in James, 39.

7. Ibid., 40.

8. Herbert Read, "A Nestle of Gentle Artists," *Apollo* 76, no. 7 (September 1962): 536–40; reprinted in Benedict Read and David Thistlewood, eds., *Herbert Read: A British Vision of World Art* (London: Leeds City Art Galleries, The Henry Moore Foundation, and Lund Humphries Publishers Ltd., 1993), 59.

9. Moore as quoted in "Contemporary English Sculptors: Henry Moore," *Architectural As sociation Journal* 45, no. 519 (May 1930): 408–13, reprinted in part in James, 59–60.

10. Gaudier-Brzeska, 155.

11. Jacob Epstein, *Catalogue of an Exhibition of Sculpture and Drawings by Henry Moore* (London: Leicester Galleries, 1931).

12. "The Art of Mr. Moore," *Morning Post* (London) 14 April 1931.

13. Herbert Read, "Henry Moore," *The Listener* (22 April 1931): 688–89.

14. Herbert Read, ed., *Unit One: The Modern Movement in English Architecture, Painting and Sculpture* (London, Toronto, Melbourne, and Sydney: Cassell and Company, Ltd., 1934), 30.

15. Judith Collins, "An Event of Some Importance in the History of English Art," in Benedict Read and Thistlewood, 66.

16. Margaret Gardiner, *Barbara Hepworth: A Memoir* (Edinburgh: The Salamander Press, 1982), 48–50.

17. John Hedgecoe and Henry Moore, *Henry Spencer Moore* (New York: Simon and Schuster, 1968), 105.

18. Henry Moore as quoted in Carlton Lake, "Henry Moore's World," *Atlantic Monthly* 209, no. 1 (January 1962): 39–45; reprinted in part in James, 226–30.

19. Henry Moore, "Primitive Art," *The Listener* (24 August 1941): 598–99.

20. Philip James, introduction to *Henry Moore on Sculpture.* James, 17–20.

21. Henry Moore, letter to K. and Jane Clark, 28 February 1951; cited in Berthoud, 231.

22. Henry Moore as quoted in *Sculpture and Drawings by Henry Moore* (London: The Tate Gallery, 1951); reprinted in part in James, 115.

23. Henry Moore, "The Sculptor in Modern Society," a speech given at UNESCO International Conference of Artists, Venice, 22–28 September 1952; reprinted in James, 87–93.

24. Henry Moore, letter to S. D. Cleveland, 12 March 1954.

25. Henry Moore and David Finn, *Henry Moore: Sculpture and Environment* (New York: Harry N. Abrams, Inc., 1976), 224.

26. Huw Wheldon, *Monitor, An Anthology* (London: Macdonald, 1962). Transcript of an interview with Moore on the television program *Monitor;* reprinted in part in James, 52.

27. Anthony Caro, "The Master Sculptor," *Observer,* 27 November 1960: 21.

28. Henry Moore, *Standing Figure, 1961* (a statement), 1965; reprinted in part in James, 299.

29. Huw Wheldon, *Monitor, An Anthology* (London: Macdonald, 1962). Transcript of an interview with Moore on the television program *Monitor;* reprinted in part in James, 208.

30. Gimpel Fils Gallery Archive, 7 September 1964, as quoted in Penelope Curtis and Alan G. Wilkinson, *Barbara Hepworth: A Retrospective* (London: Tate Gallery, 1994), 147.

31. Service of Thanksgiving for the Life and Work of Henry Moore, eulogy by Sir Stephen Spender, Westminster Abbey, 18 November; cited in Alan G. Wilkinson, *Henry Moore Remembered* (Toronto: Art Gallery of Ontario, 1987), 3.

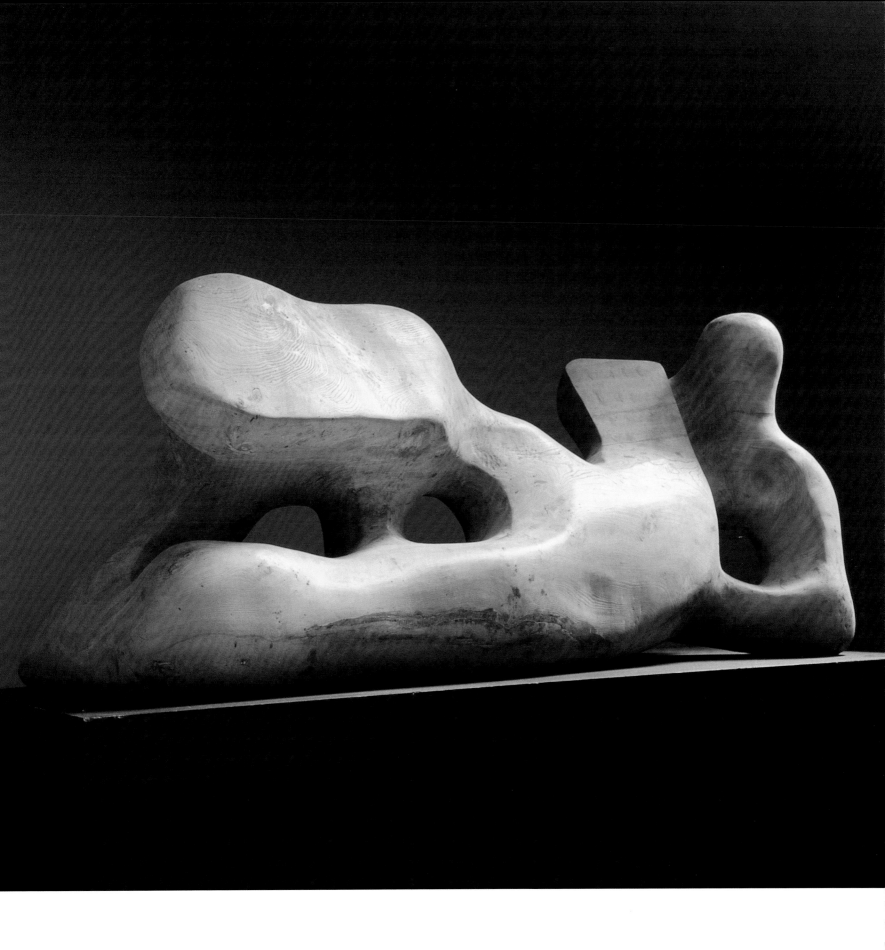

74. *Reclining Figure,* 1959–64
Elmwood, length 103 in.
The Henry Moore Foundation:
gift of Irina Moore 1977
(LH 452)

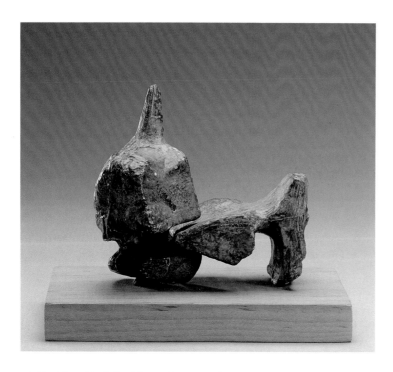

75. *Two Piece Reclining Figure: Maquette No. 5,* 1962
Plaster, 4¾ × 6 × 3¾ in. (including base)
Collection, Art Gallery of Ontario, Toronto. Gift of Henry Moore, 1973
(LH 477)

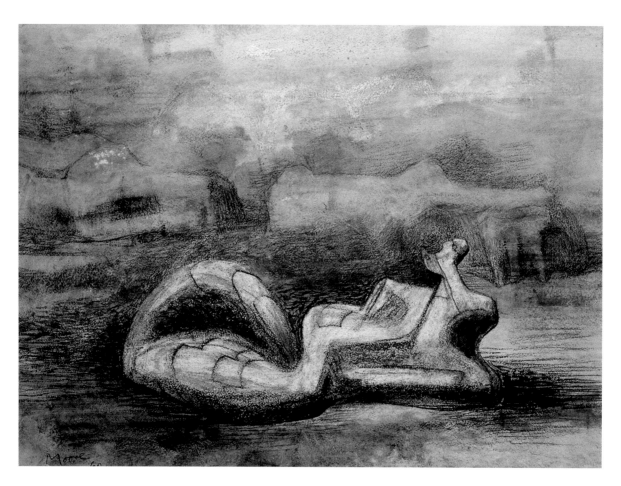

190. *Reclining Figure in Landscape with Rocks,* 1960
Charcoal, crayon, pastel, and watercolor wash on off-white
medium- to heavyweight wove paper, 13⅜ × 17⅝ in.
The Henry Moore Foundation: gift of the artist 1977
(HMF 3023)

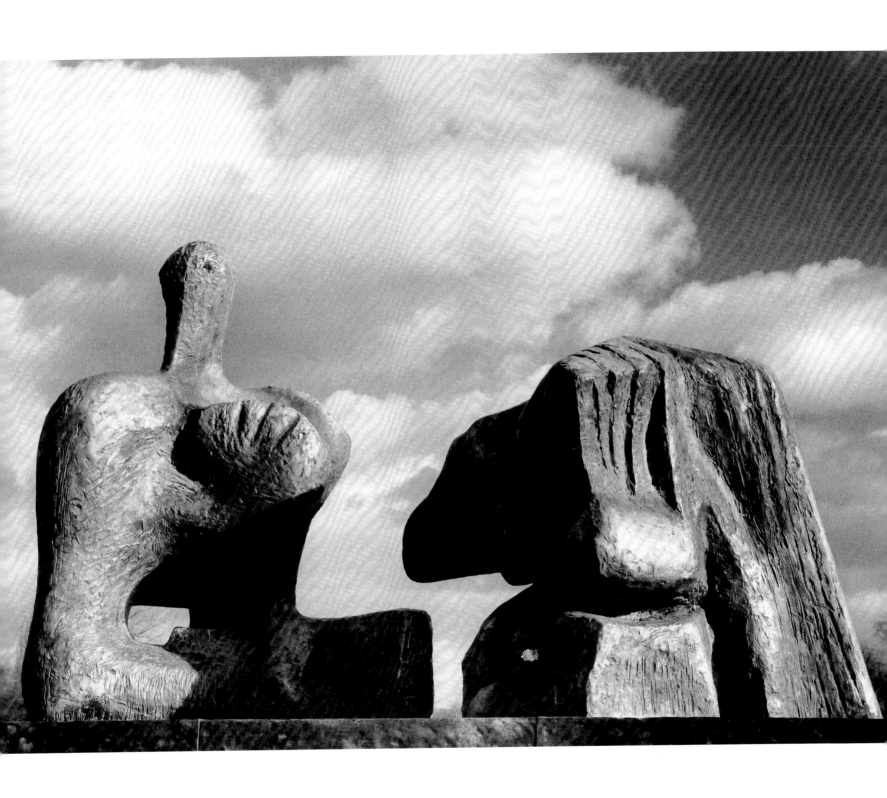

76. *Two Piece Reclining Figure No. 3,* 1961
Bronze, 59¼ × 96⅝ × 44¾ in.
Dallas Museum of Art, Dallas Art Association Purchase
(LH 478)

77. *Large Standing Figure: Knife Edge,* 1976
Bronze, height 141 in.
The Henry Moore Foundation: acquired 1987
(LH 482a)

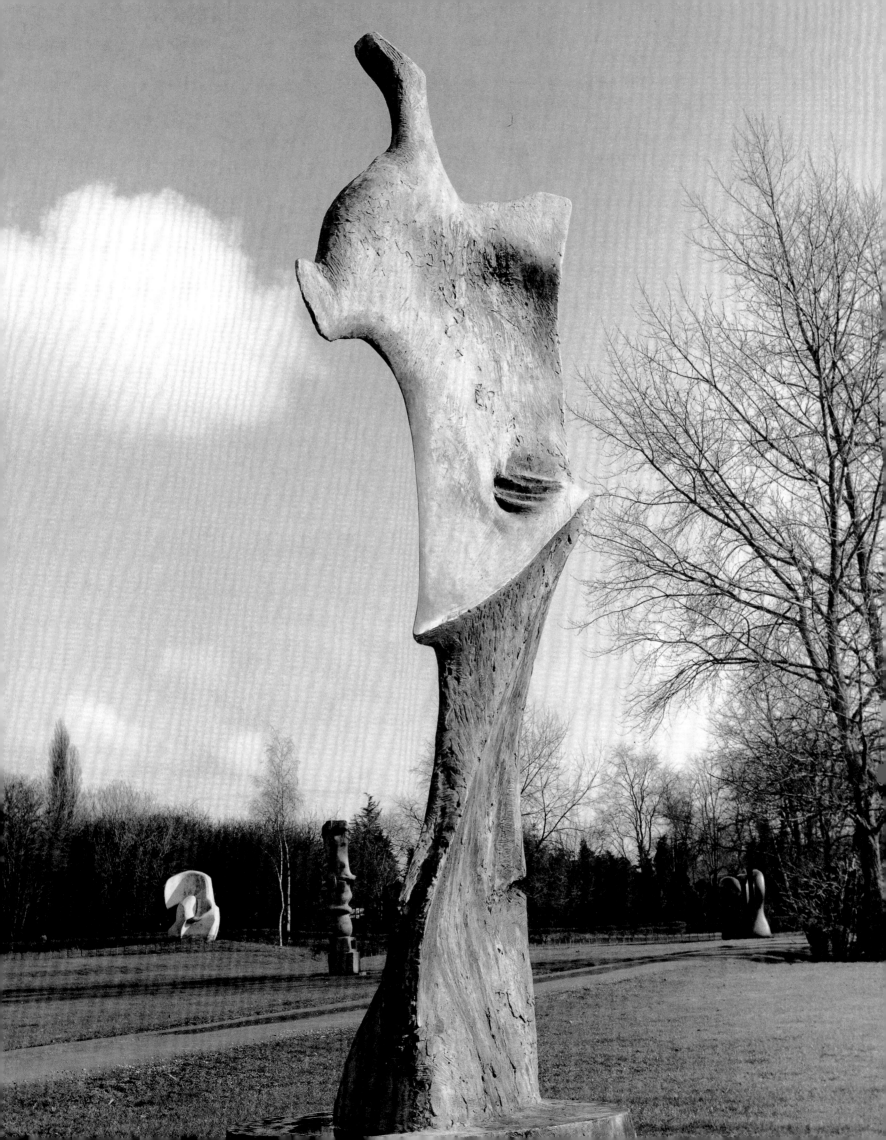

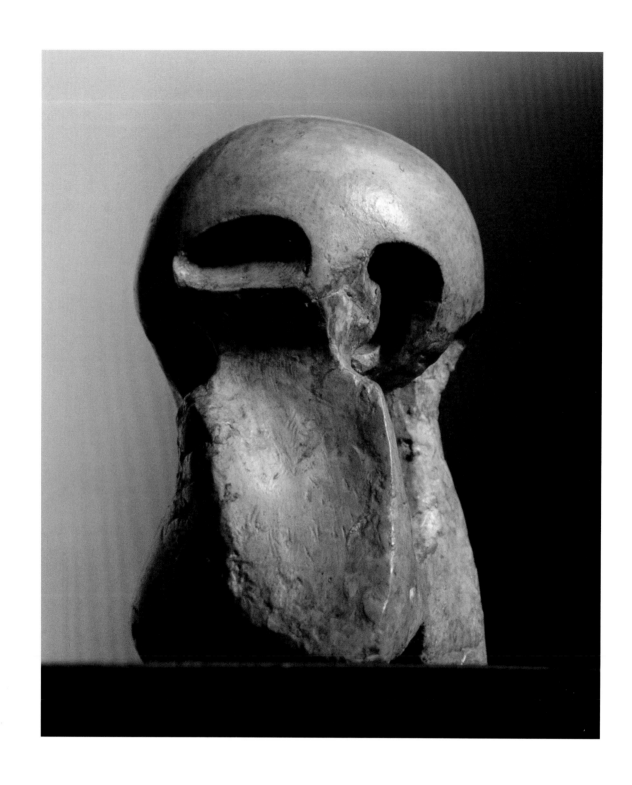

83. *Maquette for Atom Piece,* 1964
Plaster, height 6 in.
The Henry Moore Foundation:
gift of the artist 1977
(LH 524)

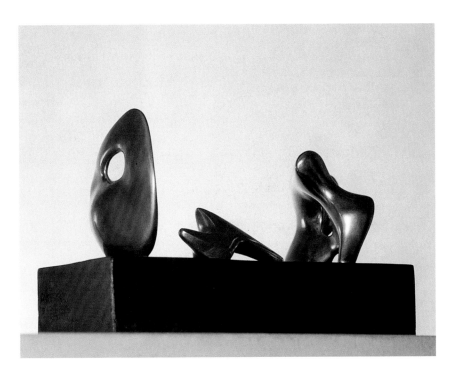

78. *Three Piece Reclining Figure: Maquette No. 2: Polished,* 1962
Bronze (edition of 9 +1), length 8½ in.
The Henry Moore Foundation: gift of Irina Moore 1977
(LH 501)

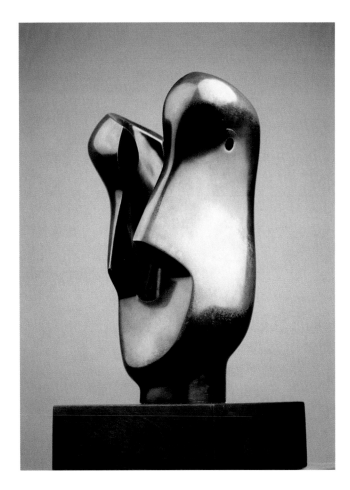

80. *Divided Head,* 1963
Bronze (0/9), height 13¾ in.
The Henry Moore Foundation: acquired 1987
(LH 506)

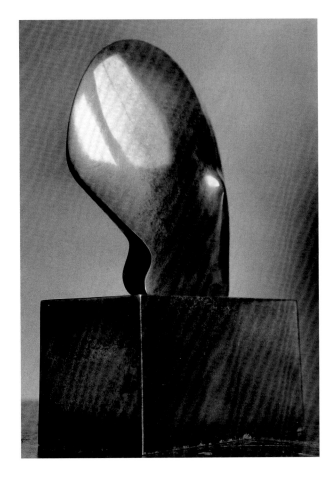

82. *Thin Head,* 1964 (cast 1969)
Bronze, height 4¾ in.
Dallas Museum of Art, Foundation for the
Arts Collection, gift of Mildred G. Tippett
(LH 523)

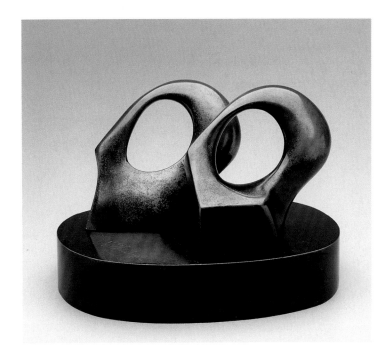

84. *Maquette for Double Oval,* 1966
Bronze, 5 × 9¼ × 5½ in.
Dallas Museum of Art, Foundation for the Arts
Collection, bequest of Margaret Ann Bolinger
(LH 558)

81. *Locking Piece,* 1963–64
Bronze, height 115½ in.
The Henry Moore Foundation:
acquired 1987
(LH 515)

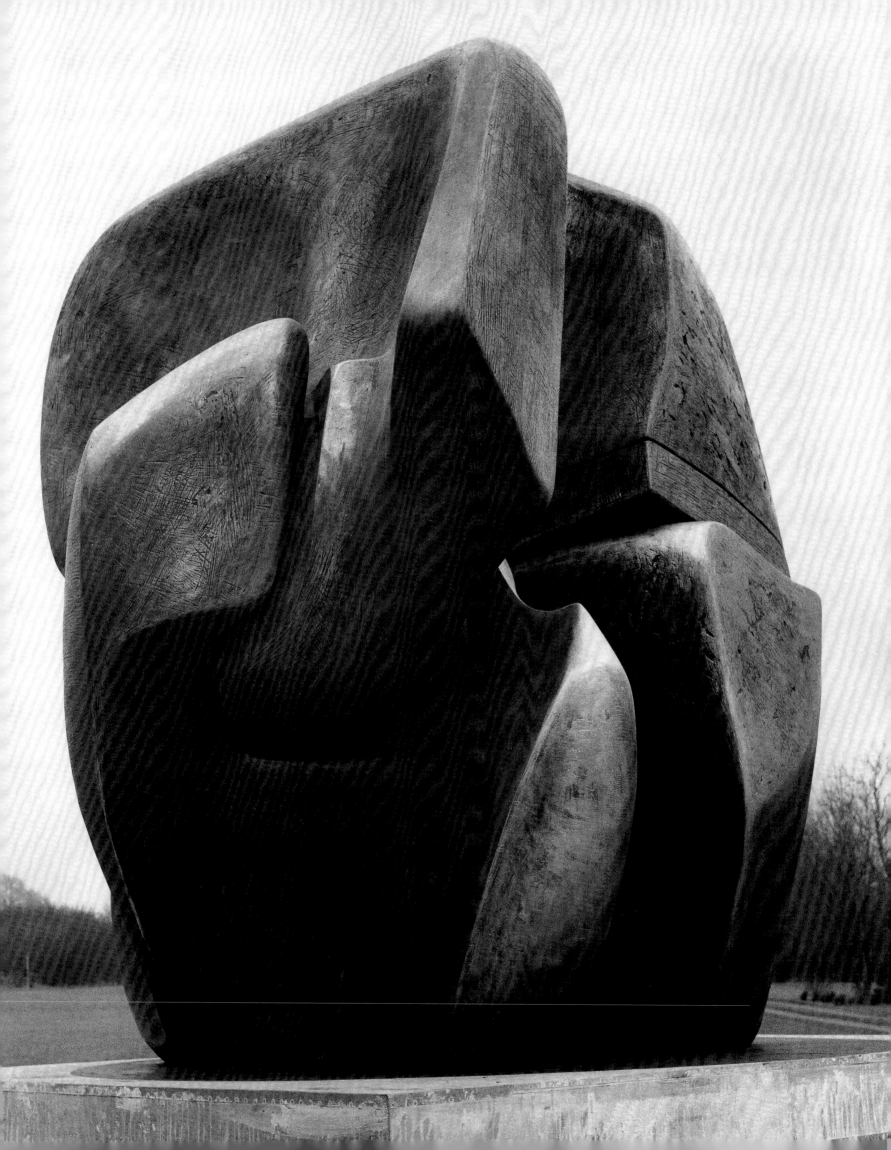

89. *Maquette for Two Piece Sculpture No. 11,* 1968
Bronze, length 4 in.
The Henry Moore Foundation:
gift of Irina Moore 1977
(LH 582)

86. *Two Piece Reclining Figure No. 9,* 1968
Bronze, 56⅜ × 96 × 52 in.
Lent by Robin Quist Gates
(LH 576)

87. *Working Model for Three Piece No. 3: Vertebrae,* 1968
Bronze, 41⅛ × 93 × 48 in.
The Patsy R. and Raymond D. Nasher Collection, Dallas, Texas
(LH 579)

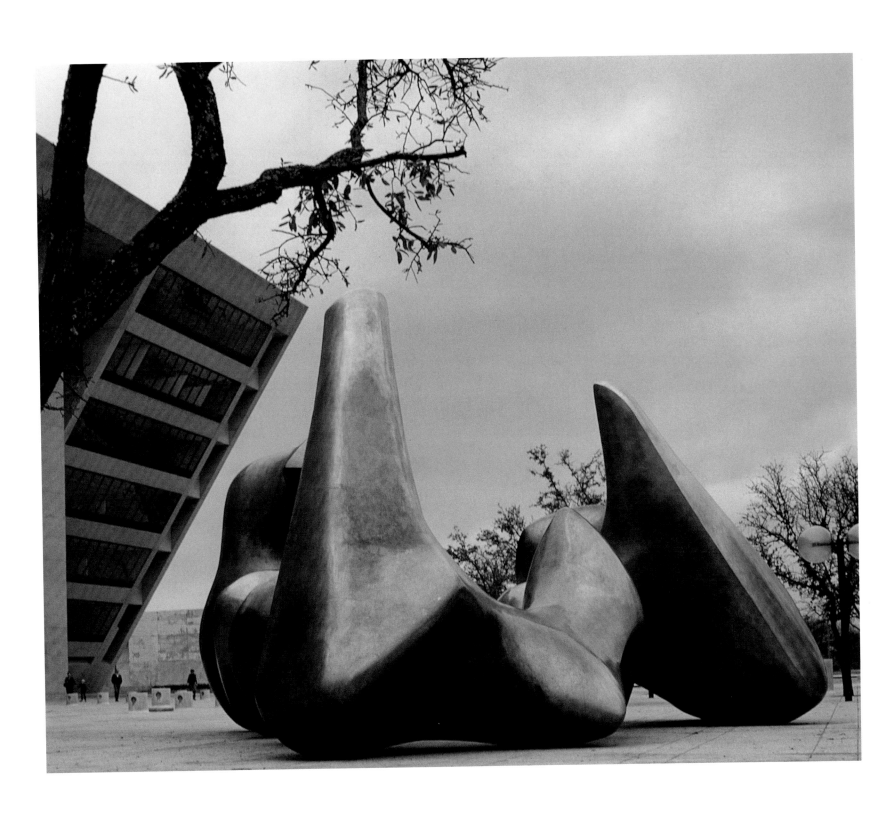

88. *Three Forms Vertebrae (The Dallas Piece),* 1978–79
Bronze (unique cast), length approx. 40 ft.
City Center Park Plaza, Dallas
(LH 580a)

90. *Oval with Points,* 1968–70
Bronze (0/6), height 130¾ in.
The Henry Moore Foundation:
gift of the artist 1977
(LH 596)

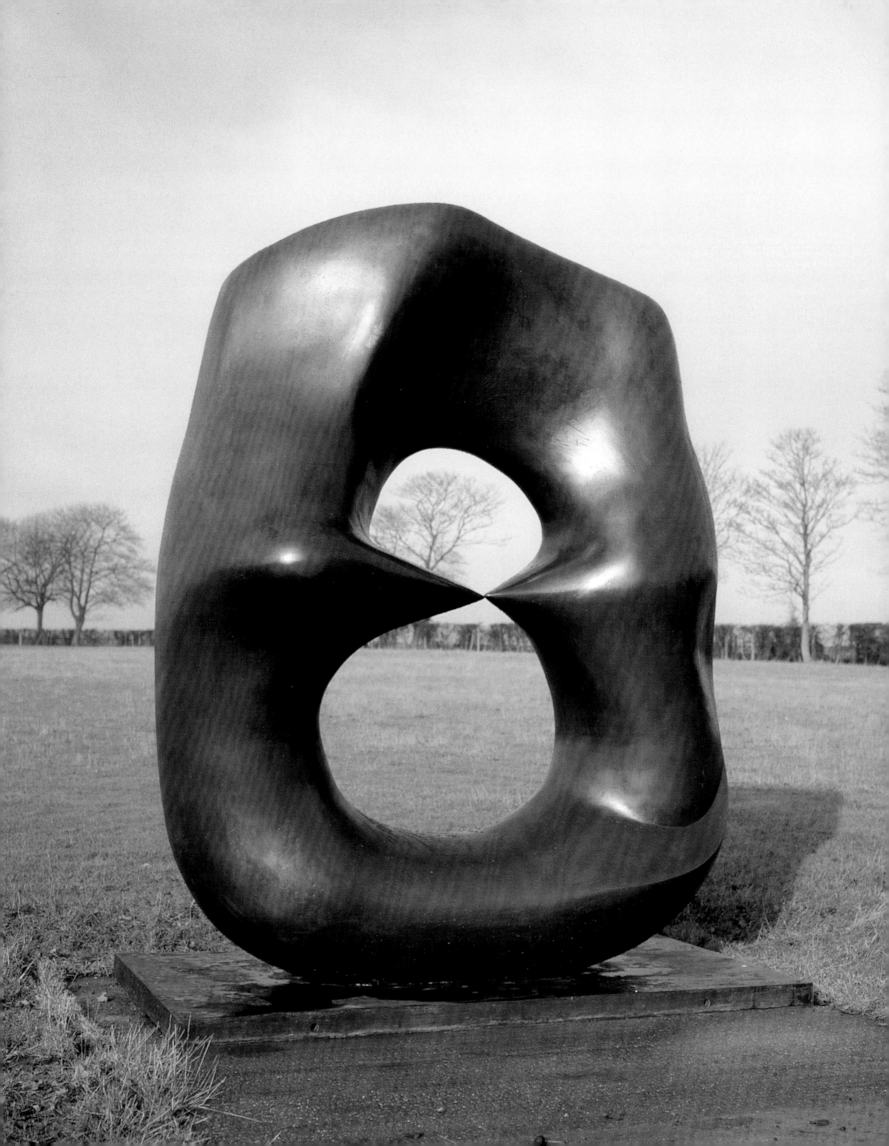

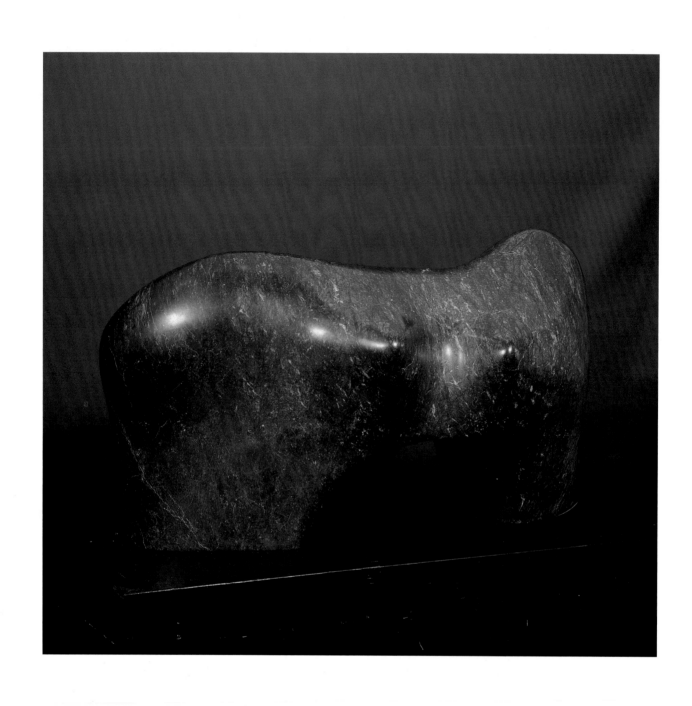

92. *Bridge Form,* 1971
Black Abyssinian marble, 27⅛ × 15¾ × 14⅛ in.
Mr. and Mrs. William Allen Custard
(LH 621)

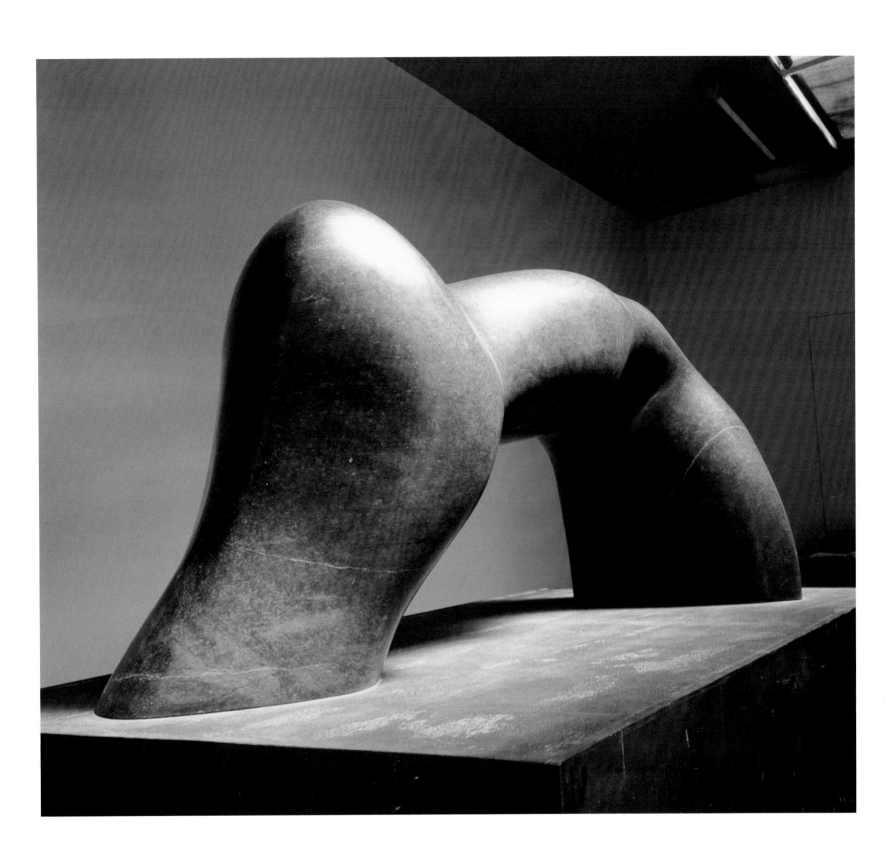

91. *Arch Form,* 1970
Serpentine, length 82¾ in.
Private collection
(LH 618)

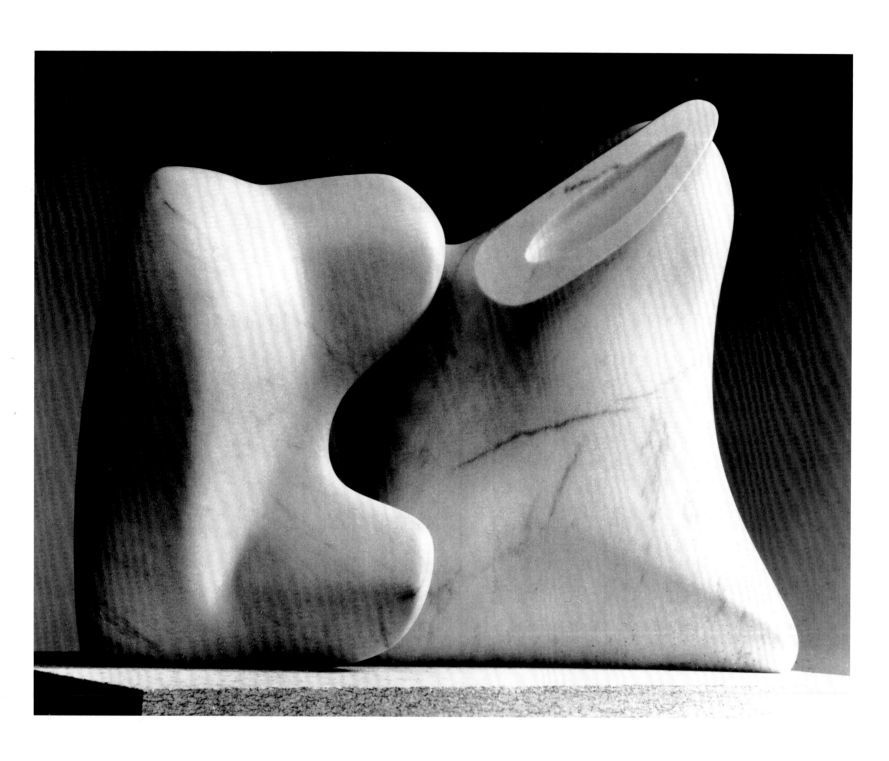

85. *Mother and Child,* 1967
Rosa aurora marble, length 51¼ in.
The Henry Moore Foundation:
gift of Irina Moore 1977
(LH 573)

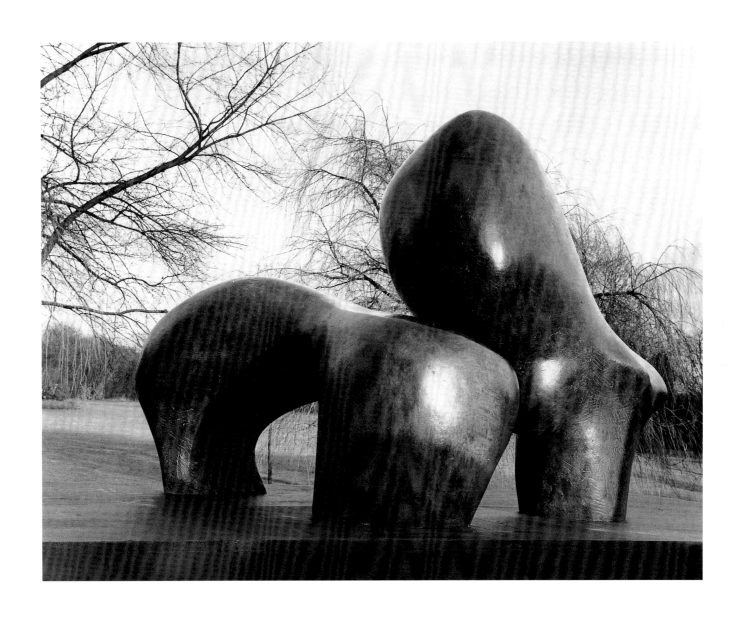

93. *Working Model for Sheep Piece,* 1971
Bronze, length 56 in.
The Henry Moore Foundation:
acquired 1987
(LH 626)

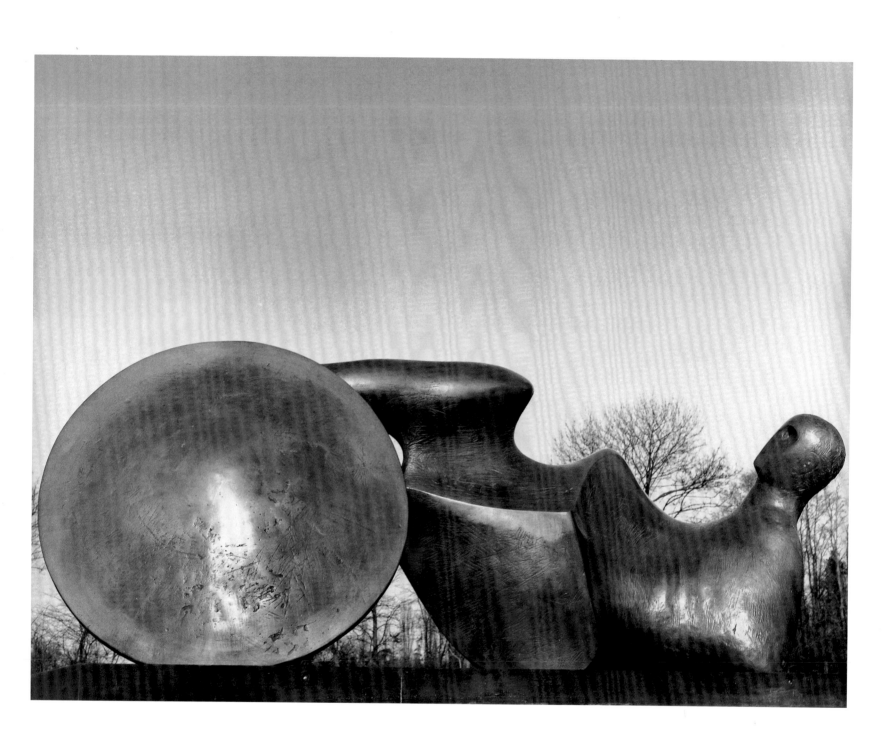

94. *Goslar Warrior,* 1973–74
Bronze, length 118 in.
The Henry Moore Foundation:
gift of the artist 1977
(LH 641)

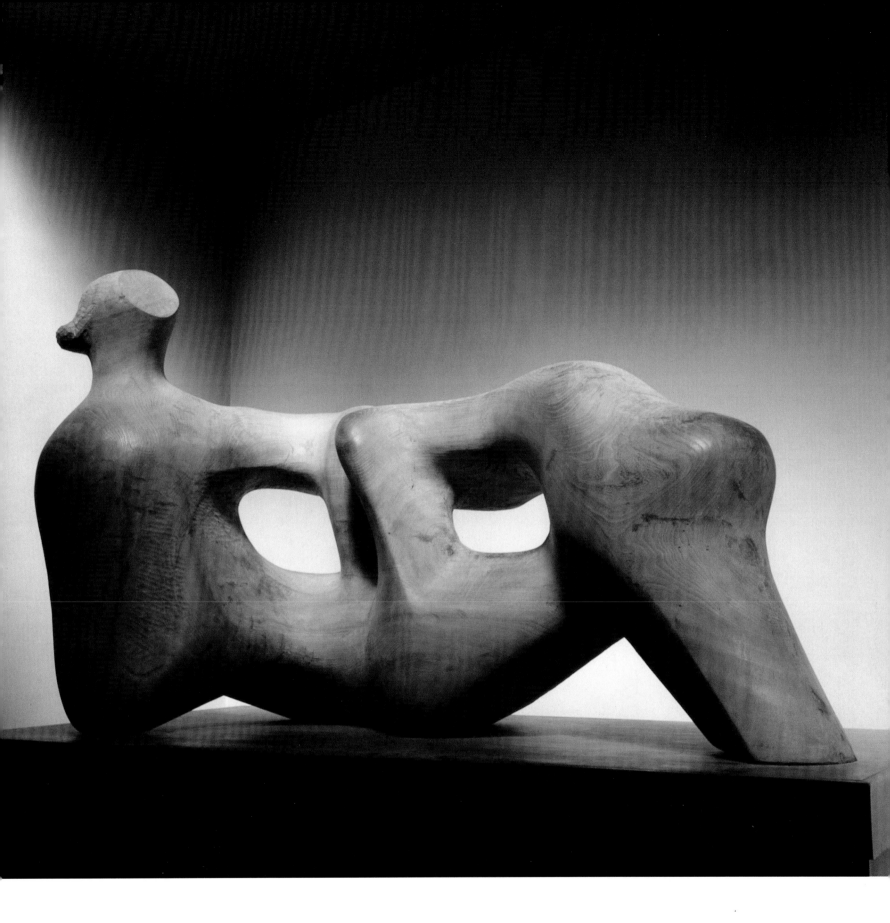

97. *Reclining Figure: Holes,* 1976–78
Elmwood, length 87½ in.
The Henry Moore Foundation:
gift of the artist 1977
(LH 657)

191. *Reclining Woman in a Setting,* 1974
Conté crayon, charcoal, pastel, chinagraph,
and watercolor wash on FABRIANO 2 white
medium-weight wove paper, 13 × 19 in.
The Henry Moore Foundation:
gift of the artist 1977
(HMF 73/4(17))

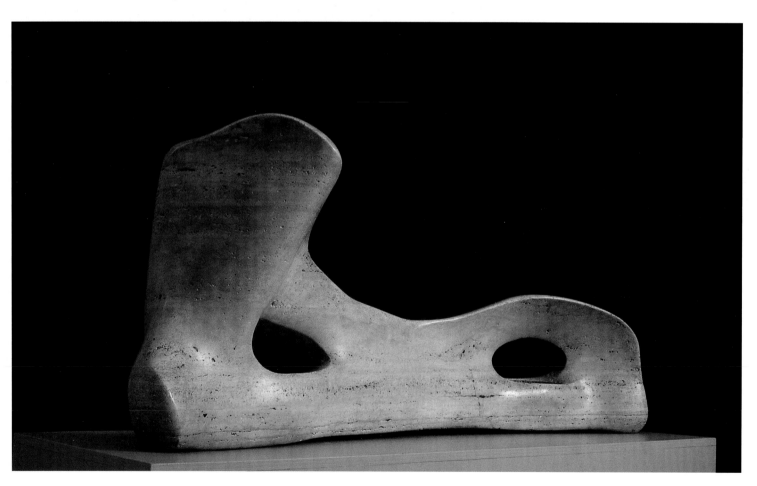

95. *Reclining Figure: Bone,* 1975
Travertine marble, length 62 in.
The Henry Moore Foundation:
gift of the artist 1977
(LH 643)

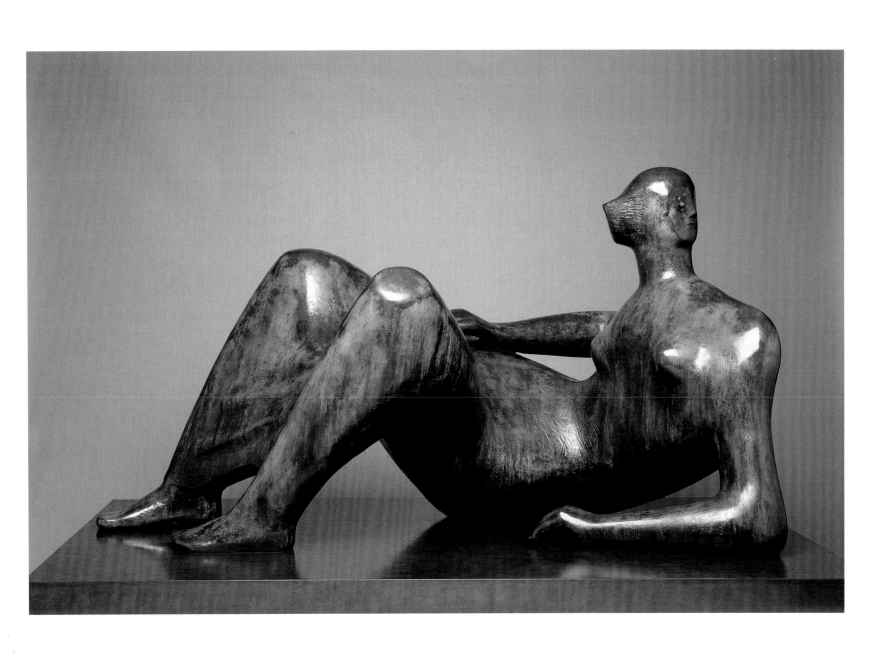

98. *Reclining Figure: Angles,* 1979
Bronze, 48¼ × 90¼ × 61¾ in.
The Patsy R. and Raymond D. Nasher
Collection, Dallas, Texas
(LH 675)

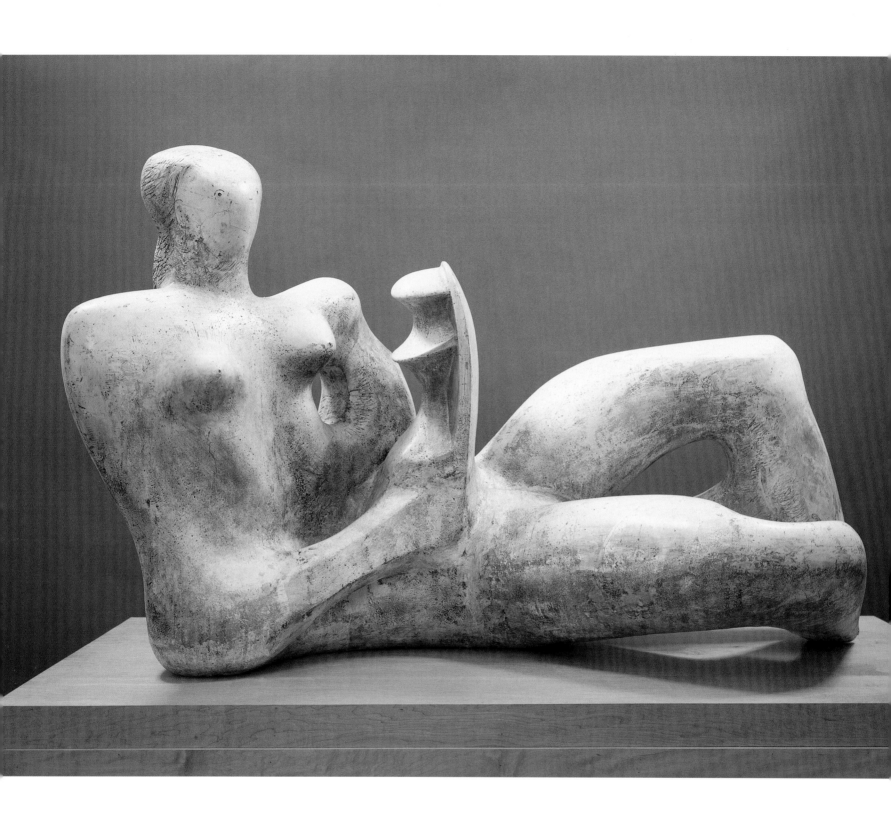

96. *Reclining Mother and Child,* 1975–76
Plaster, 51 × 80 × 41 in.
The Henry Moore Foundation: on long-term
loan to the Dallas Museum of Art
(LH 649)

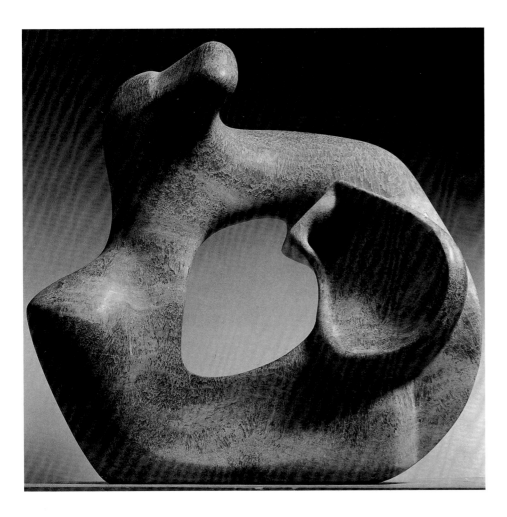

100. **Mother and Child,** 1978
Stalactite, height 33⅛ in.
The Henry Moore Foundation: acquired 1986
(LH 754)

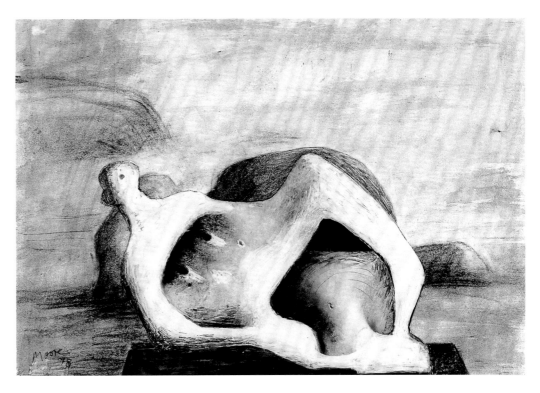

193. **Reclining Figure: Sea Background,** 1978
Watercolor, collaged photograph, gouache, charcoal, and
chalk on T. H. Saunders watercolor paper, 9⅜ × 13⅞ in.
The Henry Moore Foundation: acquired 1987
(HMF 78(13))

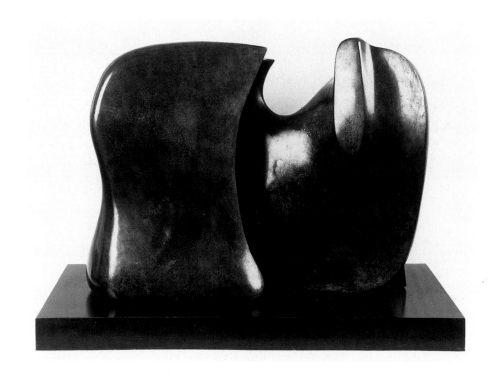

79. *Working Model for Knife Edge Two Piece,* 1962
Bronze, length 28 in.
Aaron I. Fleischman
(LH 504)

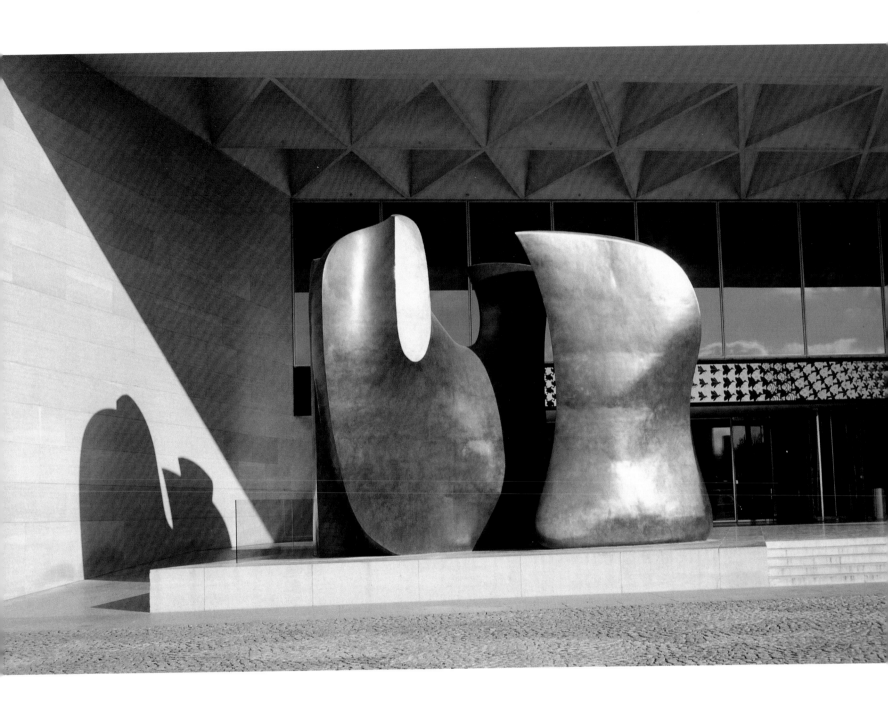

99. *Knife Edge Mirror Two Piece,* 1977–78
Bronze (unique cast), 210½ × 284 × 143 in.
National Gallery of Art, Washington. Gift of
The Morris and Gwendolyn Cafritz Foundation
(LH 714)

192. *Forest Elephants,* 1977
Charcoal and chalk on white heavyweight
wove paper, 12⅛ × 15¼ in.
The Henry Moore Foundation: acquired 1987
(HMF 77(14))

196. *The Artist's Feet: Two Studies,* 1979
Charcoal, ballpoint pen, crayon, and watercolor
on white lightweight wove paper, 8⅛ × 12⅛ in.
The Henry Moore Foundation: acquired 1987
(HMF 79(59))

194. *Standing Figure: Knife Edge,* 1978
Watercolor, charcoal (washed), chalk, collaged photograph, and
ballpoint pen on T. H. Saunders watercolor paper, 12⅛ × 7¾ in.
The Henry Moore Foundation: acquired 1987
(HMF 78(14))

195. *Mother and Child: Idea for Sculpture,* 1978
Charcoal, chalk, gouache, collaged photograph and lithographic
proof on off-white heavyweight wove paper, 15⅜ × 11⅜ in.
The Henry Moore Foundation: acquired 1987
(HMF 78(30))

197. *Standing Figure: Architectural Background,* 1979
Charcoal, watercolor, chalk, ink, gouache, and collaged
photograph on wove paper, 10⅛ × 6⅞ in.
Lent by Dr. M. Alali
(HMF 79(69a))

201. *Imaginary Architecture,* 1981
Charcoal, crayon, chinagraph, and watercolor
on Bockingford white wove paper, 10 × 14 in.
The Henry Moore Foundation: acquired 1987
(HMF 81(258))

198. *Study after Cézanne's 'Bathers,' from the Front,* 1980
Carbon line, wax crayon, watercolor, chalk, and chinagraph on
heavyweight wove paper, 10 × 12½ in.
The Henry Moore Foundation: acquired 1987
(HMF 80(61))

202. *Rock Formation II,* 1982
Carbon line, charcoal (part-rubbed), pastel, ballpoint pen,
and gouache on Bockingford white wove paper, 10 × 12 in.
The Henry Moore Foundation: acquired 1987
(HMF 82(64))

200. *Rhinoceros VII,* 1981
Chalk (rubbed) on T. H. Saunders watercolor paper, 11¾ × 15⅛ in.
The Henry Moore Foundation: acquired 1987
(HMF 81(201))

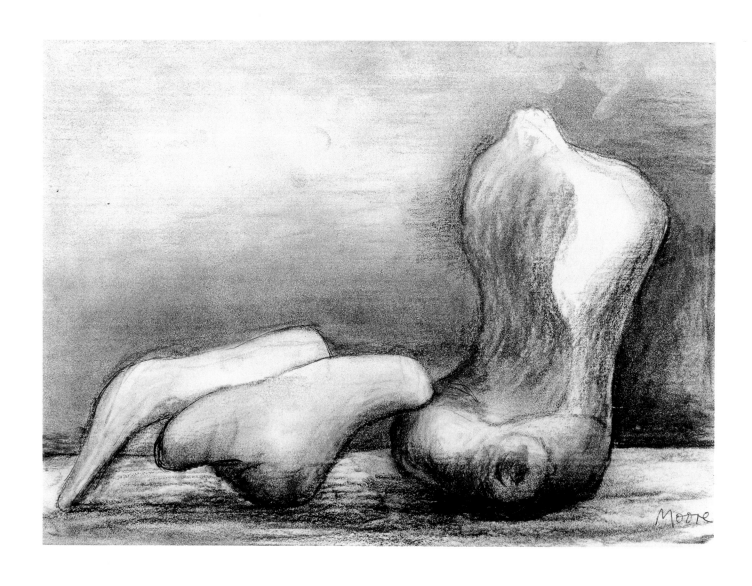

203. *Idea for Sculpture: Reclining Figure,* 1982
Charcoal, chinagraph, ballpoint pen, gouache, and pastel
on white medium-weight wove paper, 8¼ × 11⅜ in.
The Henry Moore Foundation: acquired 1987
(HMF 82(182))

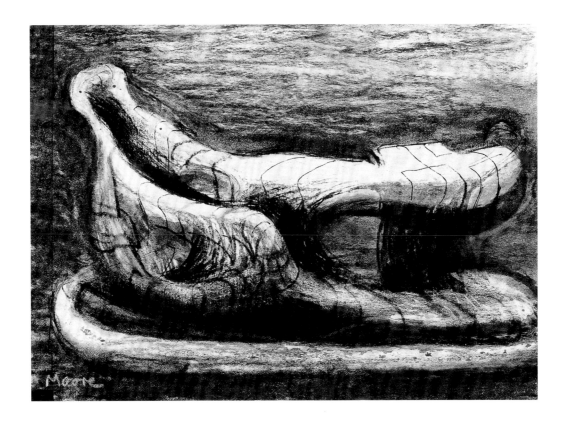

204. *Idea for Sculpture: Reclining Figure,* 1982
Charcoal, pastel, wax crayon, ballpoint pen, and
chinagraph on lightweight wove paper, 7 × 9¾ in.
The Henry Moore Foundation: acquired 1987
(HMF 82(208))

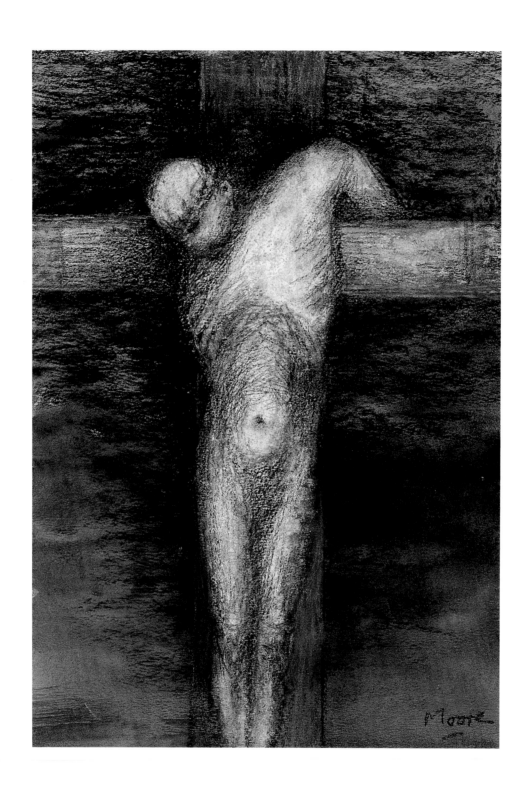

206. *Crucifixion,* 1982
Wax crayon, charcoal, pencil, watercolor wash, and ink
wash on Bockingford white wove paper, 14 × 10 in.
Richard C. Colton, Jr.
(HMF 82(442))

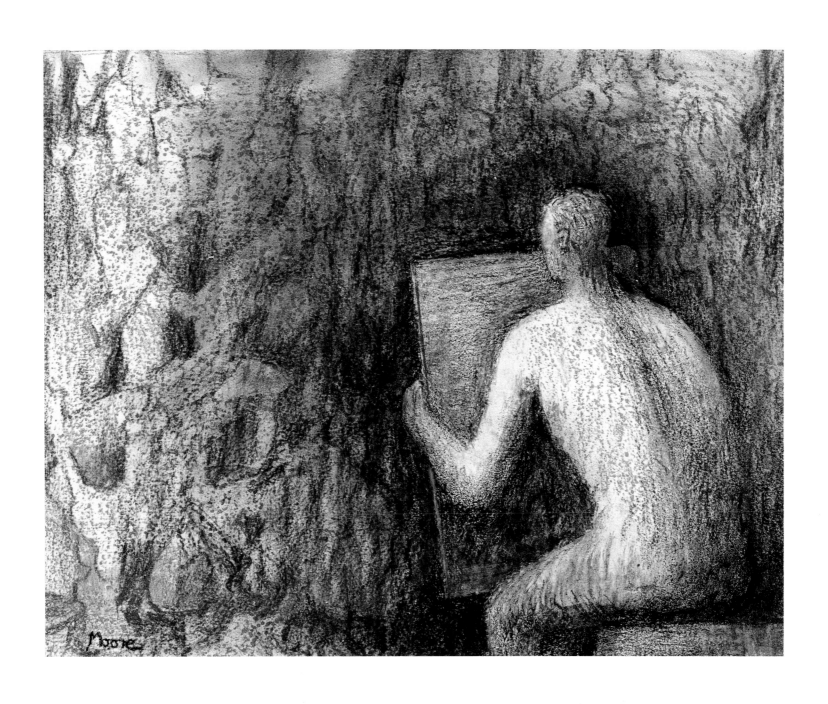

205. *Man Drawing Rock Formation,* 1982
Charcoal, chinagraph, chalk, and pencil over lithographic
frottage on T. H. Saunders watercolor paper, 12⅝ × 15⅞ in.
The Henry Moore Foundation: acquired 1987
(HMF 82(437))

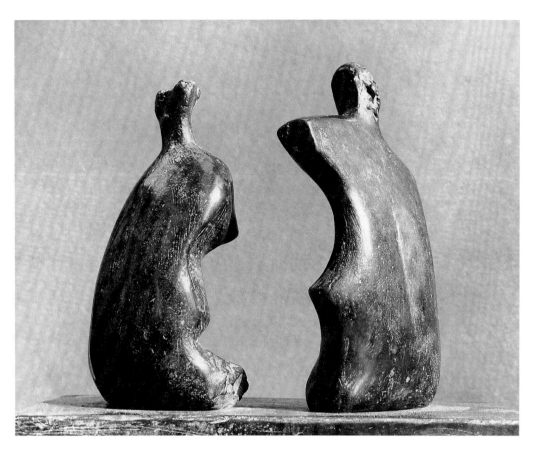

101. *Two Torsos,* 1981
Bronze, height 8 in.
Dallas Museum of Art, Foundation for the
Arts Collection, gift of Mildred G. Tippett
(LH 814)

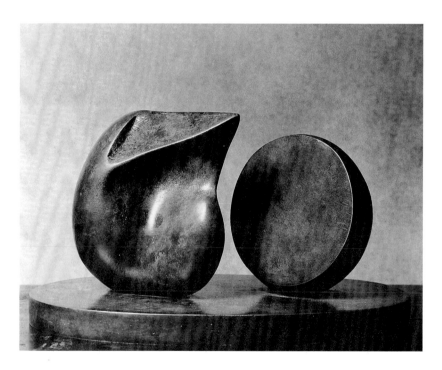

102. *Point and Oval,* 1981
Bronze, 2½ × 4¼ × 2 in.
Dallas Museum of Art, Foundation for the Arts
Collection, bequest of Margaret Ann Bolinger
(LH 819)

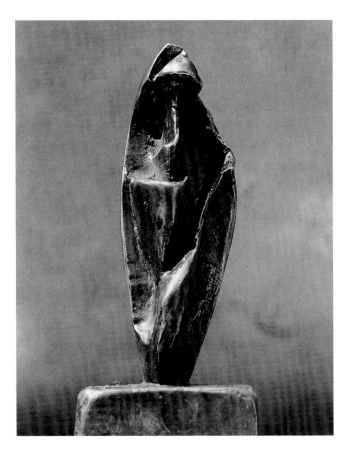

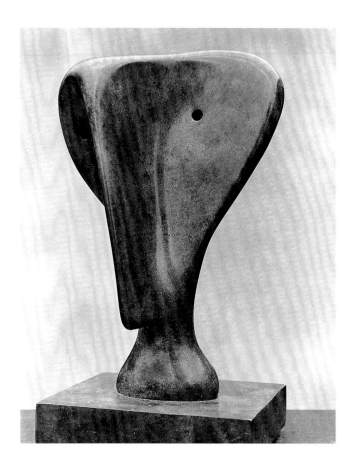

104. *Tube Form,* 1983
Bronze, height 5 in.
Dallas Museum of Art, Foundation for the
Arts Collection, gift of Mildred G. Tippett
(LH 885)

105. *Bone Head,* 1983
Bronze, height 5½ in.
Dallas Museum of Art, Foundation for the
Arts Collection, gift of Mildred G. Tippett
(LH 891)

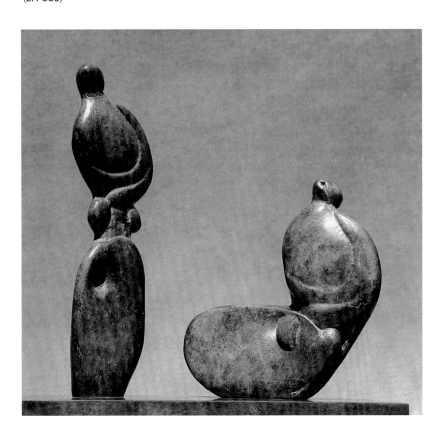

106. *Seated and Standing Figures,* 1983
Bronze, 6⅜ × 6 × 2¼ in.
Dallas Museum of Art, Foundation for the Arts
Collection, bequest of Margaret Ann Bolinger
(LH 895)

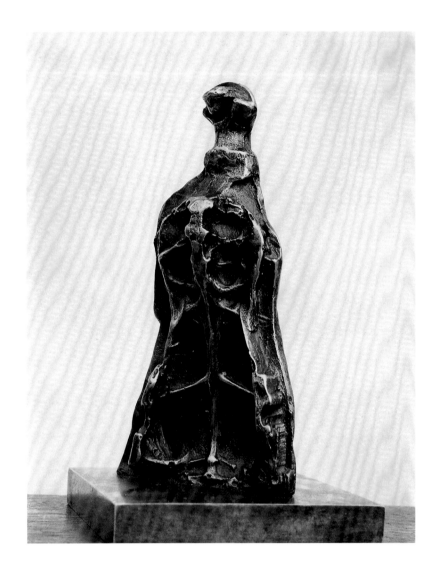

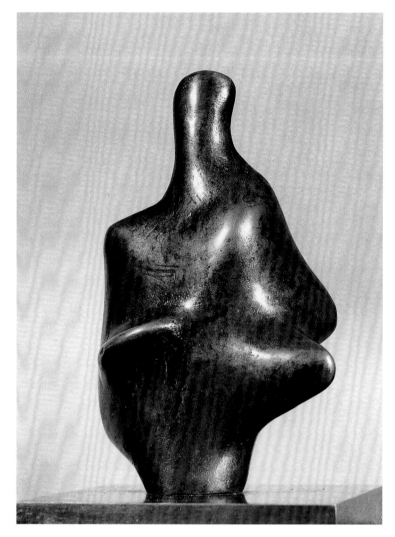

107. *Skeleton Figure,* cast 1984
Bronze, 4⅝ × 2⅜ × 1 in.
Dallas Museum of Art, Foundation for the Arts
Collection, bequest of Margaret Ann Bolinger
(LH 912)

108. *Three-Quarter Figure: Points,* cast 1985
Bronze, height 4¾ in.
Dallas Museum of Art, Foundation for the
Arts Collection, gift of Mildred G. Tippett
(LH 919)

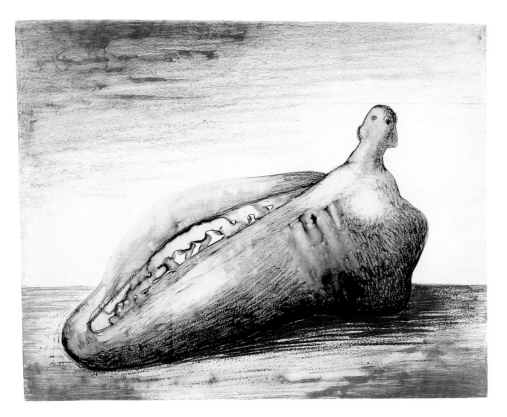

199. *Opening Form I (Reclining Figure: Pea Pod),* 1979
Lithograph, 12½ × 15½ in.
The Patsy R. and Raymond D. Nasher Collection, Dallas, Texas
(CGM 539)

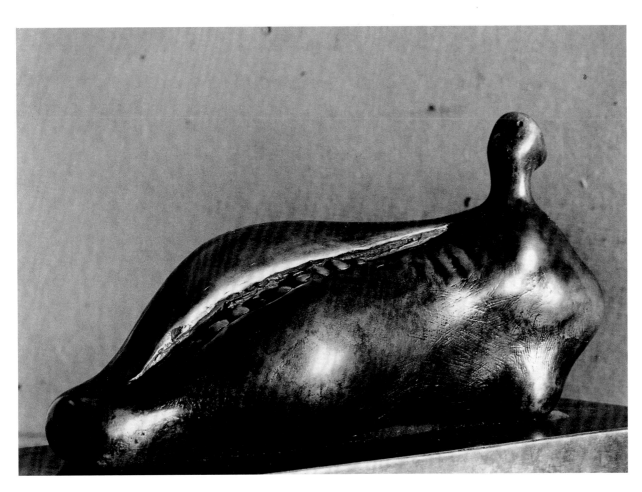

103. *Reclining Figure: Pea Pod,* 1982
Bronze, length 8½ in.
The Henry Moore Foundation:
acquired 1986
(LH 854)

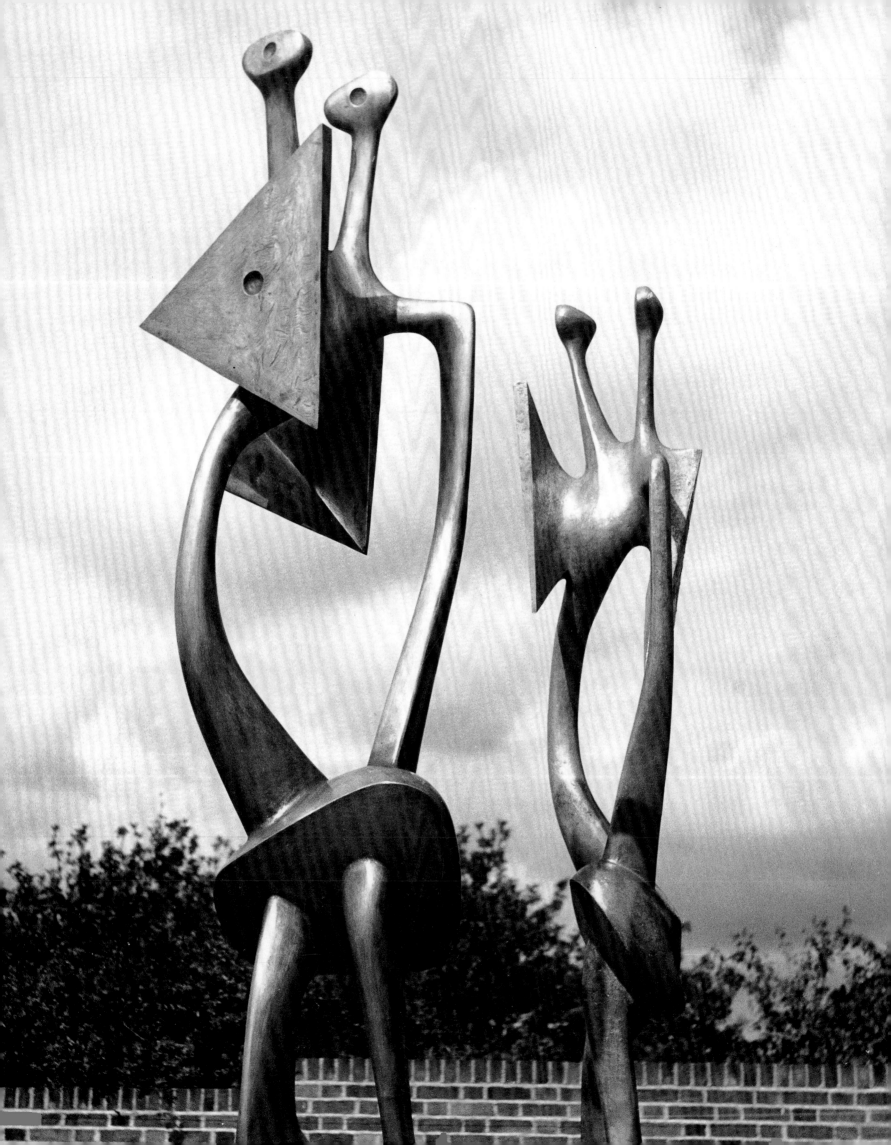

David Cohen

Who's Afraid of Henry Moore?

As early as 1970 Hilton Kramer was writing in the *New York Times* that Henry Moore was loved by the Establishment and ignored by young artists.[1] Today Moore enjoys a genuine popular following, with interest in his work growing in countries where he was not so well known, such as Russia and Latin America, but his reputation in advanced art circles—certainly in Britain, and to a lesser extent the United States as well—is precarious. Among current artists it is barely a generalization to assert that his name is a byword for passéism, and no major figure has emerged recently who claims close kinship with his aesthetic or his formal language. Furthermore, once attention focuses on British artists, a curious fact comes into view: relatively little direct positive influence spread from Moore to his contemporaries or successors, despite the magnitude of his achievements. This essay asks why.

Jealousy and rebellion, though these will be shown to abound, cannot fully explain the problem. Instead, I will contend, Moore's fall from grace and his lack of positive influence, demonstrate an instance of what Harold Bloom famously called "the anxiety of influence." While this anxiety may be seen to operate even with so current an artist as Anish Kapoor, the general malaise in response to Moore's art reflects a more profound alienation from the philosophical values that his art embodied.

It is telling how less acute the problem of Moore's status is outside his native country. When Fred Sandback exhibited in England in 1999, the American minimalist famous for his string installations wrote: "Over the years I have preferred the title 'sculptor.' I like the groundedness of it, referring back to my early love for the sculpture of Michelangelo, Rodin and Henry Moore."[2] That this statement was for a show at the Henry Moore Institute in Leeds (one of several key institutions supporting sculpture in Britain that bears Moore's name and relies on his foundation for funding) does not invalidate the synonymity of Moore with other giants of the monumental sculptural tradition.

This essay has two sections. In the first, I present a variety of reasons why current taste is out of sympathy with Moore. In the

second, I present a chronological survey of several figures, each of whom, for his or her own reasons, felt unease in relation to Moore. This effectively offers two complementary approaches to the problem. While the second half is historically grounded, and takes some account of the critical literature surrounding the artist (in particular the writings of Herbert Read and Erich Neumann, which have bearing on several of the cases discussed), the first half condenses and leaves unattributed generic criticisms. Some word of justification is required for this approach.

While there was a symbiotic relationship between Moore's art and the supportive criticism that accompanied its development, the kind of "critique" of Moore that interests me is pervasive rather than specific to individuals, and has not necessarily been committed to print. Of course, distinct criticisms of Moore's work or conduct can be traced to the published literature, but it is my conviction that the feelings of artists are not usefully linked to these printed records. To give an example: One of the first allegations against Moore's becoming an "official" artist was directed against him by the Surrealist group in 1945, as they were angered at his acceptance of an ecclesiastical commission (the Northampton Madonna).[3] The charge was leveled by new members of the largely dissolved English group of which Moore had once been a leading light. It would be a misrepresentation of subsequent criticism of Moore's "officialness" to trace the sentiment back to anticlericalism on this count.

1.

Kenneth Clark's remark that Henry Moore could serve as an ambassador for the human race not only compliments the decency and down-to-earthness of the sculptor, but also attests to a quality of universalism in his work. His artistic outlook was characterized by a belief in the power of synthesis (drawing on widespread source materials and phenomena, and blending them into a seamless, living whole), and linked to this, a faith in the potential (in his case realized) popular accessibility of work made in such a way. It was not coincidental that his politics were consistently democratic and progressive. His midcentury success and the increasing skepticism about him in advanced circles are equally linked to this ideology and its varying

Double Standing Figure (detail), 1950 (LH 291)

fortunes. His stock, so to speak, has depreciated in tandem with the whole modernist (progressive, democratic, universalist) enterprise of which he was a living icon.

Moore's aesthetic values can virtually be summed up in one sentence from an early statement that epitomizes a romantic-modernist credo: "There are universal shapes to which everybody is subconsciously conditioned and to which they can respond if their conscious control does not shut them off."[4] By "universal shapes" Moore obviously did not just mean the human figure, although to a greater or lesser extent all his work—even his most abstract experiments—has a human or natural reference. Although his work is dominated by the two major figurative themes of the reclining woman and the mother-child relationship, which he acknowledged as his "obsessions," what actually imbues his shapes with universality is the vague, generalized, unspecific sense of growth, of aliveness, which—typically of his generation—he called "vitality." The spread of this term can usefully be traced from Friedrich Nietzsche, Henri Bergson, and other thinkers through the Vorticist theorist T. E. Hulme, and then onward to sculptors like Henri Gaudier-Brzeska and Jacob Epstein, with whose statements Moore was familiar. Hulme's writings were posthumously edited by Moore's friend and intellectual mentor, Herbert Read, who was influenced independently by some of the same philosophers.[5]

Moore's ur-shapes derived from a variety of sources, most especially from nature sources such as plants, bones, and geological formations, but also from human endeavors close in their organic quality to nature, such as prehistory, ancient art, "primitive" (non-European) art, modern art, and even—later in his career—the Renaissance and old master traditions, which with the passage of time and the acceptance of his own form-language Moore no longer felt the need to perceive in intellectual opposition to modernism. Sometimes there are intimations of the original source in Moore's final work, with allusions in the title, but more often there is a Moore-like synthesis, leaving the viewer with a suffused notion of the organic or the primordial. However solid or monumental, a good Henry Moore is imbued with the sensation that it is still growing.

The description of Moore as a "romantic-modernist" identifies him with a trajectory that dates back to Goethe's theory of morphology. Interviewed by the scholar who has traced Goethe's widespread influence on modern art, Christa Lichtenstern, Moore explained how his interest in the great German poet was first aroused by the mathematician Wentworth D'Arcy Thompson's seminal 1917 text, *On Growth and Form,* a book that explores growth patterns across natural species and into the mathematical sphere. Moore was proud to tell Lichtenstern that he had discovered this book in Leeds before he met Read, which in itself signals a degree of unease at an over-identification of his own ideas with Read's particular turn of mind.

Thompson's exposition of common mathematical formulae for growth across otherwise unrelated phenomena suggested how it is possible to reconstruct "transitional stages through which the course of evolution must have successively travelled."[6] Lichtenstern considers this conception a precedent in Moore's imagination to the "related forms" that emerge in the course of his Transformation drawings of around 1930, a time when he was looking very closely at Picasso and also at Surrealist magazines, and developing his most extreme "biomorphic" works.

The notion of form being alive and at the same time following a preordained, universal pattern that people might be programmed, preconsciously, to respond to, is "romantic-modernist" to the extent that it contrasts with the sense of the modern that is rooted in alienation, fragmentation, and the dislocations of the modern city. This more radical, subversive, confrontational modernism—which might be associated with such avant-garde movements as Cubism, Futurism, and Dada—is far removed from the idealistic, near mystical faith in form that characterizes Moore's outlook.

The term *biomorphism,* which ultimately derives from Goethe, and which has been used to describe the fluid, organic, psychologically potent shapes of artists like Jean Arp (Alfred Barr adopted the term in his 1936 catalogue, *Cubism and Abstract Art,* and from there it has entered the critical language) was actually first used in relation to Henry Moore, by the poet Geoffrey Grigson in 1935.[7] Biomorphism was in historical and stylistic terms a synthesis, entailing a "middle way" between Surrealism and abstract art for artists, critics, or curators equally attracted to aspects of these movements when they were pitted against one another. Herbert Read came under attack for involving himself with both groups, comparing himself, in a later memoir of the 1930s, to "a circus rider with his feet planted astride two horses."[8] Read justified his position with the argument that "such dialectical oppositions are good for the progress of art and that the greatest artists (I always had Henry Moore in mind) are great precisely because they can resolve such oppositions."[9] Moore, meanwhile, issued a statement in which he asserted much the same thing: "The violent quarrel between the abstractionists and the surrealists seems to me quite unnecessary. All good art has contained both abstract and surrealist elements, just as it has contained both classical and romantic elements—order and surprise, intellect and imagination, conscious and unconscious. Both sides of the artist's personality must play their part."[10]

This kind of reconciliation, vaunted as a dialectical achievement by Read, could be interpreted by a critic hostile toward Establishment midcentury British modernism as typical of that movement's compromising and equivocal nature. By curtailing the extremism of both movements, the synthesis represents a watering down of the Continental avant-garde, according to this argument. Read provoked antagonism from his Surrealist colleagues by overzealously identifying the revolutionary new movement with English romanticism. "A nation which has produced two such superrealists [Read's preferred term for *Surrealist*] as William Blake and Lewis Carroll is to the manner born. Because our art and literature is the most romantic in the world it is likely to become the most superrealistic."[11] In fact, the opposite occurred, and with the onset of World War II British Surrealism evaporated, some of its activists moving into wistful neoromance.

Moore's own work during and after the war reflected his increasing social consciousness, which entailed a softening of his more abrasive and abstract experiments of the 1930s and the introduction of a more accessible figuration. An old suspicion of "sellout" (to populism and the opportunity to become the nation's leading artist) dates from this period and has escalated as the taste for Surrealist art has veered toward sexual and violent extremes that leave André Breton trailing Georges Bataille, never mind Herbert Read. When biomorphism returned to Moore's art in the 1950s, this did not prevent his art from seeming "safe" and consoling, as his art now contrasted with a new

kind of abrasiveness in younger artists who drew on feelings of angst and alienation. Moore's biomorphism relates too cozily with that period's design artifacts and its utopian aesthetic.

While Moore had entered foreign museum collections in the 1930s, including the Museum of Modern Art in New York and the Albright-Knox Museum in Buffalo (in 1936 and 1937, respectively), his international career can be said to have been launched in earnest in 1948, when he won the Lion d'Or in sculpture at the Venice Biennale. A couple of years later he was taken up by the British Council. This organization, which had been founded to promote British values during the 1930s in order to counter the spread of fascism, became a crucial agency for bolstering Britain's image and leadership in Europe, South America, and the Communist world during the cold war. Moore became their mascot to the extent that the relationship has come to be viewed in a similar way to the link Serge Guilbaut has drawn between the CIA and Abstract Expressionism;[12] somewhat conspiratorially, it is suggested that Moore was press-ganged by the British Council into the role of cold war warrior. This interpretation is bolstered by instances like the speech of the British ambassador who opened an exhibition in Bonn declaring Moore to be an expression of "the Christian culture of Western Europe"[13] (the Berlin Wall was erected during the run of that exhibition). Whatever the historic viability of this view (the experts advising the council on its choice of artists included, at various times, Read and Clark), the fact remains that Moore's work was open to such ideological use because of its generalized sense of wholesomeness, quite apart from its being "advanced" and thus a counter to the sterile academicism of Communist art. Of course, art can be available to prevailing ideology in this way without detracting from its intrinsic quality.

So far the criticisms of Moore described here have been of a philosophical or institutional nature. The effects of Moore's career successes, detractors argue, translated to his work in specific, technical ways. These have to do with medium, scale, multiplication, and repetition.

Detractors frequently point wistfully to Moore's early carvings (from the 1920s and 1930s) as work of integrity compromised by his turn, in the 1940s, to bronze casting as his preferred medium. This allegation is bolstered by the rhetoric of "truth to materials," a doctrine to which Moore energetically subscribed in his period of direct carving. From the pioneer direct carvers in Britain, Jacob Epstein, Henri Gaudier-Brzeska, and Eric Gill, Moore inherited a whole mythopoeic notion of the carver's symbiotic relationship with tool and material. Stone was worked directly, eschewing the academic technique of pointing-up. Stones were chosen for their specific character—generally avoiding the classical Italian marbles in favor of native British stones—and the romantic idea that the material itself dictated the evolution of the image was given credence. The platonic fantasy of the carver liberating the sculpture from within the stone was given a modern twist. Herbert Read, in one of Moore's earliest reviews, set out the "truth to material" credo as it relates to the sculptor: "[Moore] will imagine . . . what a reclining woman would look like if flesh and blood were translated into the stone before him—the stone which has its own principles of form and structure. The woman's body might then, as it actually does in some of Moore's figures, take on the appearance of a range of hills."[14]

Moore's adoption of bronze, detractors argue, compromised his "truth to material" in several ways. The building up from maquette through working models to the final state is exactly analogous to pointing-up, which translates an idea resolved at one scale to another. Bronze, meanwhile, is an old-fashioned "art" material, like marble. And while bronze may have some qualities of its own, it is in the literal sense a medium—that is to say, it has a kind of transparency through which the image works entirely by appearance, unlike stone, which is opaque, in the sense of coming between the image and the visual expectations it arouses.

Such criticism clearly has validity. Moore himself must have agonized over the implications of switching to bronze. His 1951 statement on the subject justified his move by admitting that the vehemence of his earlier avowal of "truth to material" could have been overdogmatic. If taken to its logical extreme, he argued, "a snowman made by a child would have to be praised at the expense of a Rodin or a Bernini."[15] But the crucial point to make in relation to Moore is that, for him, the distinction between a carver and a modeler was not merely technical: like Michelangelo, he saw an almost moral distinction between the two activities. The art theorist Adrian Stokes—who was a member of the Hampstead circle in the 1930s, which also included Moore, Read, and Hepworth—added psychological significance to the dichotomy. It can be argued that, despite moving into bronze casting, Moore retained all the essential characteristics of a carver: his sculptural vision proceeded through a process of subtraction, not addition; through bold and decisive steps, not tentative ones. Furthermore, he had a superb understanding of the hitherto untapped metaphorical qualities of bronze. The brittle, encrusted folds in his draped figures of the early 1950s, for example, extended his woman-landscape equation with its associations of lava and geological encrustation. His bronzes, moreover, were cast from plaster originals that entailed carving when in a hardened state. Later, he would cast from polystyrene originals. While this medium could not be further detached, in actual weight and surface quality, from the eventual, resulting bronze, the original would be entirely carved (actually, sliced).

Moore began to work in metal in the late 1930s because his need to experiment in opened-out form tested the endurance of wood or stone. Then the outbreak of war curtailed possibilities and even the appetite for carving: materials were in short supply, and the mood was not conducive for long-term projects. Moore began to work in clay, on a miniature scale, producing maquettes for future realization at greater scales. This divorce of primary object and conception, therefore, was brought about by the historic situation rather than opportunism. But there is evidence of Moore's having earlier entertained grandiose visions of his work out of proportion to their initial realization. A photograph by the sculptor of his lead *Reclining Figure* of 1938 (cat. 39) taken shortly after it was made in his studio in Kent succeeds, through a sleight of camera, in making this small sculpture seem like a sprawling gargantuan whose limbs are on a par with the surrounding hills. In 1983 he cast the same piece thirty-five feet long for the Overseas Chinese Banking Corporation in Singapore.

From a leftist perspective, the international export of Moore became emblematic of a kind of new colonialism. Thus, according to Paul Overy, "just as massive statuesque representations of Queen Victoria could be found in the public spaces of the Raj and other key sites of imperial power, sculptures by Moore now recline outside the offices of the world's current centers of power, the multinationals

Fig. 1. Howard Hodgkin, *A Henry Moore at the Bottom of the Garden,* 1975–77. Private collection, Geneva

and other corporations."[16] Rather than viewing Moore as an artist corrupted by success, it could be argued that his ambitions as a sculptor, and for his sculpture, were remarkably consistent. The same heroic impulse that led him toward direct carving also drove him, when opportunity presented itself, to fill city plazas across the globe with large bronze casts of his work. Perhaps it is the feminine nature of his subject matter—maternity and earth goddess motifs—that jars with the sculptor's protean output, whereas in an artist like Richard Serra aggrandizement follows naturally from the aesthetic of the work.

More serious than the charges of overeditioning and inflation of scale is the charge of repetitiveness: that his works became so synonymous with architectural projects and sculpture gardens that they were lost to sight. The typical Moore in an architectural setting was seen as an afterthought, a mediation between the brutalist design and its human users. Moore's desire was to site his work wherever possible in landscape. The implicit jibe in Howard Hodgkin's painting *A Henry Moore at the Bottom of the Garden* (fig. 1) is of his work being lost in the shrubbery. It could actually be argued, however, that in insisting on the relative independence of his work from the architecture (architects were encouraged to choose from existing works in progress or maquettes rather than have Moore make things specifically for their projects), Moore retained the integrity of his work in the urban environment. Even if the Moores stationed in the world do now seem to some sensibilities ubiquitous, the same charge does not bear up to the experience of a large body of his work when viewed in a retrospective exhibition. His "fascinated monomania," as Erich Neumann termed his preoccupation with his twin themes, gave rise to a multiplying exploration of formal and metaphoric possibilities. Indeed, it could be argued, the real reason Moore did not have followers of caliber within his own formal and thematic territory is that he developed his personal language so fully. He himself could say anything in his language, whereas anyone else who began to speak it was

trapped in mimicry. This factor, more than jealousy or "anxiety of influence," ensured that sculptors who came after him were virtually obliged to define themselves in opposition to him.

2.

It would not be fanciful to identify a recurring oedipal struggle in the family tree of British sculpture.[17] This plays itself out in Moore's attitude toward his mentor Epstein—and in a form of sibling rivalry with his contemporary Barbara Hepworth—only to be repeated in turn toward Moore by his assistant Anthony Caro, and others, with the rebellious activities of Caro's students at St. Martin's School of Art extending the process. Within a modernist tradition, it could be argued, vitality can almost be measured by the struggle of "strong voices" (in Bloom's conception). This feels especially appropriate in relation to modern sculpture, which has been so concerned to test the boundaries of the medium. As artists seek at once to "expand the envelope" and to be sure that their efforts remain valid within the bigger tradition, hostility is aroused toward immediate forebears, compounding natural competitiveness.

Epstein

Moore enjoyed early and crucial support from Jacob Epstein at a time when the American-born artist occupied a position of leadership within British sculpture secured as much through notoriety as acclaim. His work was continually attacked in the press for its "primitivism" and erotic charge. As Moore would later say of him in an obituary, "He took the brickbats, he took the insults, he faced the howls of derision with which artists since Rembrandt have learned to become familiar. And as far as sculpture in this century is concerned, he took them first."[18]

Epstein's patronage of the young Moore took the form of a catalogue foreword for his second gallery exhibition, at the Leicester Galleries in 1931, as well as an early purchase of his work, and a recommendation to architect Charles Holden for his London Underground building in 1928. Moore's work of this period shows an undoubted awareness of Epstein's example, as their respective carvings for the London Underground, *Night* and *North Wind* (figs. 2, 3), amply demonstrate. Moore would quickly experience the kind of "brickbats" meted out to Epstein. The headline in a tabloid newspaper accompanying a reproduction of one of Moore's early carvings ran "Epstein Out-Epsteined."[19]

Epstein was an important conduit to tribal art for Moore, as he possessed one of the finest private collections of African and Oceanic material in Britain, and was at the forefront of referencing such art in his own work. It is once more telling, however, that Moore should specifically have drawn upon an area that Epstein did not collect, namely, Mexican art.

The mentor, however, would soon rue what he perceived as a lack of reciprocity from the younger artist. At the time of renewed agitation concerning his controversial carvings for the British Medical Association Building (another Holden project), he looked to Moore for public backing, but found him as unwilling to be drawn into the debate as others within the Hampstead circle. This second round of controversy was sparked by the decision of Rhodesia House (the inheritors of the BMA building) to disfigure Epstein's carvings on dubious safety grounds. The silence of the Royal Academy on this

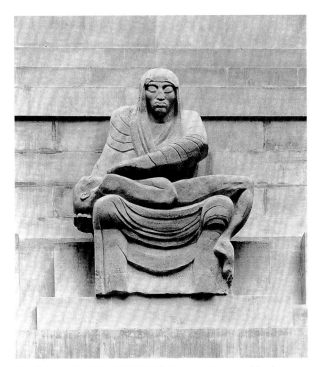

Fig. 2. Jacob Epstein, *Night,* 1929. London Transport Head-
quarters, St. James's Park Underground Station

Fig. 3. Henry Moore, *West Wind* (also called *North Wind*), 1928–29. London Transport
Headquarters, St. James's Park Underground Station (LH 58)

issue led to the significant resignation from that institution of W. R.
Sickert, but while Epstein was used to antagonism from this stuffy
institution toward his work (the Academy had been against him in the
earlier controversy surrounding *Rima,* his memorial to the ornitholo-
gist W. H. Hudson), the indifference toward his plight of the emerg-
ing generation stung, especially in the case of Moore, whom he felt
he had done so much to promote.

In his first published article on Henry Moore, in the BBC publica-
tion *The Listener,* Herbert Read acknowledged Epstein among others
as a precursor, but nonetheless made the bold assertion that "in virtue
of his sureness and consistency, [Moore] is at the head of the mod-
ern movement in England."[20] This set what would be a consistent
tone in his intellectual patronage of Moore. To Epstein it must have
appeared an affront. Read's prejudice against Epstein may not have
been entirely generational. In the same column on another occasion
(these articles would later be collected as *The Meaning of Art*) Read
marginalized the work of Marc Chagall on racial grounds that could
have led Epstein to recall his own bitter exclusion at the hands of
Eric Underwood in the latter's influential account of English sculp-
ture, where he was classed as "oriental" and "exotic," and thus alien
to the subject at hand.[21]

Epstein forthwith sold the Moore carving in his collection and
added his errant disciple to a burgeoning list of those whom he
classed as ingrates (his sometime collaborator Eric Gill already
topped this list). Whatever justice there was to this charge, it is dif-
ficult not to balk at Moore's assertion, in the obituary already quoted,
that Epstein was "a modeller not a carver." Epstein's career actually
divided uncomfortably between his portraiture, which was indeed
modeled, and cast in bronze, and the works to which he attached
more personal significance, his carvings in stone. Earlier in his career
this second category included unfelicitous public commissions (such
as the BMA figures), but later he worked on such pieces in private.
Of course, the public/private, bronze/carving dichotomies do not

neatly map one on top of another—there were, for example, public
commissions later in his career executed in bronze, such as the
Social Consciousness figures in Fairmount Park, Philadelphia—but
it nonetheless remains an idiosyncrasy of Epstein's thwarted output
that his public reputation (his knighthood, for example) was secured
in an intimate medium, while his private vision (which generally earned
him contumely) took a monumental form. Success and vilification could
go hand in hand for him: he had already made busts of such Estab-
lishment personalities as Joseph Conrad, Albert Einstein, Admiral Lord
Fisher, and James Ramsay MacDonald when he suffered the indig-
nity of his monumental alabaster carving *Adam,* 1938–39, being
purchased for display as a fairground curio, to give just one example.
Moore's tribute could have healed this wound but instead reopened
it. It is difficult to suppress the suspicion that his own discomforts at
the implications of his perceived compromises of public and private
vision, of "truth to material" and the adoption of bronze, colored his
thinking.

Hepworth

At a crucial period for both artists in the late 1920s and early
1930s, Henry Moore and Barbara Hepworth worked in a degree
of artistic proximity that bears comparison with the relationship of
Pablo Picasso and Georges Braque in the formative years of Cub-
ism. Their careers had already launched in virtual parallel when both
came from the Leeds School of Art (where there was some "flirta-
tion" between them, according to Moore) to continue their training
at the Royal College of Art in 1921. At various later stages their ca-
reers would continue as if in tandem, though the younger, female
artist would always be perceived as following in the other's foot-
steps. Hugh Gordon Porteus set an extreme precedent with a vitu-
perative swipe in 1935: "Take away from Barbara Hepworth all that
she owes Moore, and nothing would remain but a solitary clutch of
Brancusi eggs, and a few Arp scraps."[22]

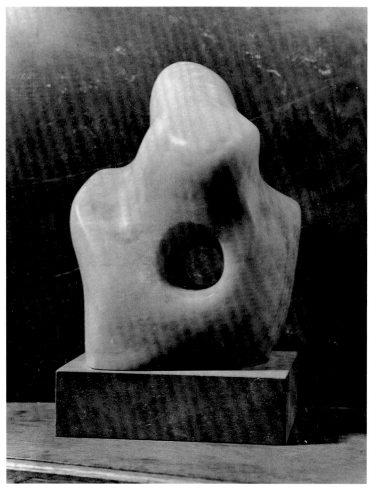

Fig. 4. Barbara Hepworth, *Pierced Form*, 1932. Destroyed

Fig. 5. Barbara Hepworth, *Figure of a Woman*, 1929–30. Tate. Presented by the artist, 1967

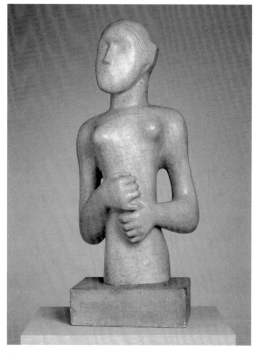

Cat. 18. Henry Moore, *Girl*, 1931. Tate. Purchased 1952 (LH 109)

The writer Leo Walmsley has recalled visits from the two young artists in the mid-1920s, when they would talk about all aspects of sculpture together, noting especially that Jacob Epstein's work was a hot topic for both of them.[23] Under Epstein's influence, they both began sculpting "primitive" figures with heavy limbs (fig. 5, cat. 18). Both were attracted to the mother-child theme. Then they began experimenting with abstraction simultaneously. By the time they both moved to Hampstead in the 1930s, their work was, briefly at least, indistinguishable.

In view of the critical perception of her standing in relation to Moore, it is little wonder that Hepworth would later insist on the priority of her formal discoveries, laying particular emphasis on the fact that in her *Pierced Form*, 1932 (fig. 4), she had tunneled a hole through her carving a year before Moore's first "breakthrough" with this device, which, in the popular imagination, became the defining hallmark of his formal language. A similar anxiety of precedence attached to the issue of who introduced string first. That in both these matters Continental artists (Aleksandr Archipenko and Naum Gabo, respectively) had already led the way only serves to marginalize such anxiety. Even as the individuality of each artist became clearer, Hepworth began to shadow Moore in terms of theme, stylistic development, career achievement, and technical experiment. Her figurative drawings on medical subjects in the late 1940s inescapably recall Moore's Shelter Drawings and Coalmining series, while her late adoption of bronze for the fulfillment of monumental commissions also relates to Moore. The choice of Hepworth as one of Britain's

representatives at the 1950 Venice Biennale had the disastrous consequence of making her look like a Moore disciple, and she enjoyed none of the kudos heaped on Moore in 1948.

Another commonality that only served to accentuate Hepworth's sense of relegation was the support of Herbert Read. This was arguably more crucial for Hepworth's promotion, though Moore was clearly Read's favorite. Read would invariably mention Moore in texts about Hepworth,[24] without feeling any obligation to do the same in a reverse situation. Furthermore, Read's tendency to quote an artist's stated intentions at face value and base analysis of the work on these had the effect of cramping Hepworth's aesthetic in comparison with

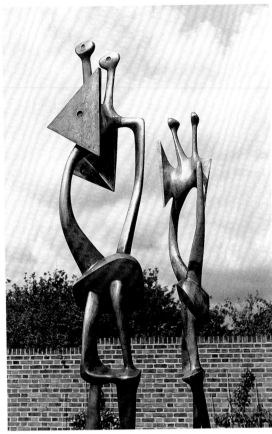

Fig. 6. Henry Moore, *Double Standing Figure* (detail), 1950
(LH 291)

Fig. 7. Sculpture and works on paper by Bernard Meadows in the *New Aspects of British Sculpture* (the "geometry of fear") exhibition. British Pavilion, Venice Biennale, 1952

Moore's. By contrasting Hepworth's desire for "loveliness" and a "sense of mystery" with Moore's striving for "power" and "vitality," Read effectively identified Hepworth with beauty, Moore with the sublime, to follow a Burkean distinction conducive to Read's dualistic outlook. Katy Deepwell has made a convincing case for reading this difference in gendered terms, showing, for instance, how contemporary critics such as Patrick Heron and J. P. Hodin read Hepworth as coolly ideal-ist in contrast to Moore's romantic, humanistic depth of feeling (each sculptor responding, in other words, to their masculine or feminine Other).[25] As Read's critical theory became increasingly Jungian and existentialist, and as he became more concerned with the idea of art embodying archetypal and epochal significance, Hepworth receded even further in significance next to Moore. Ironically, while Moore re-fused to read psychological interpretations of his work (on the quaint hypothesis that knowing too much about the source of his inspiration might impede his creativity) Hepworth was a keen student of Jung, about whom she corresponded with Read in the early 1940s.

The Geometry of Fear

An effect of consigning Hepworth to the realm of pure form and beauty was to downplay her influence on an emerging group of younger sculptors who were building on a formal language indebted to Moore. The eight emerging sculptors who along with Moore filled the British Pavilion at the 1952 Venice Biennale—Robert Adams, Kenneth Armitage, Reg Butler, Lynn Chadwick, Geoffrey Clarke, Bernard Meadows, Eduardo Paolozzi, and William Turnbull (fig. 7)—came to be called the "geometry of fear" group, taking their name from a catalogue note by Read that described the art in terms of postwar (and by implication, cold war) angst:

These new images belong to the iconography of despair, or of defiance; and the more innocent the artist, the more effectively he transmits the collective guilt. Here are images of flight, of ragged claws "scuttling across the floors of silent seas," of excoriated flesh, frustrated sex, the geometry of fear.[26]

While implying that both Moore and Hepworth were at a remove from these younger men, Moore is cited as "in some sense no doubt the parent of them all," whereas Hepworth, with her "transcendental values of abstract form," is by implication closer to the classical tradi-tion of "monumental calm" that is "gone for ever."

Moore's sculpture stationed outside the pavilion, *Double Standing Figure,* 1950 (fig. 6), actually related closely in form and mood to the existentially anguished images of the younger sculptors. Its totemic, primitive quality ushered in a period of renewed surrealism in his work, with the alienated weirdness of his leaf figures and Upright Motives. In the Biennale year he produced one of his most abrasive and disturbing images, *Mother and Child,* 1952 (cat. 59), all the more shocking in its edginess for being a mother-child piece. Draw-ing on motifs from a Peruvian pot, as Alan Wilkinson has demon-strated,[27] Moore gave the mother a head like a serrated comb, while the child is held in a ferocious headlock as it attempts to attack her erect breast. The fierce articulation of the negative space between the conjoined mother and child and the spindly, tortuous quality of the piece's surfaces share something of the brutalism and open form of the younger sculptors working in forged metal. These artists sub-scribed to a prevailing "existentialist" style defined by Jean Dubuffet, Alberto Giacometti, and Germaine Richier, and the interpretation of such artists by Jean-Paul Sartre and others. Their work also closely resembles that of such Americans as Herbert Ferber, David Hare, and Ibram Lassaw. But individual motifs and aspects in their work do undoubtedly relate to Moore: the reductive protruding heads of Lyn Chadwick and Kenneth Armitage, for instance. It has been sug-gested that the frontality and exclusionary nature of these artists' hieratic figures, though obviously recalling Moore's *King and Queen,* 1952–53 (cat. 61), was a reaction against the empathy-inducing, in-the-round quality in Moore.[28]

Caro

Anthony Caro has often referred to David Smith and Henry Moore as his "fathers in sculpture." His "genetic" link with Smith was almost literal, as he was given thirty-seven tons of raw materials that Kenneth Noland had purchased from Smith's family when the sculptor was killed, and that he used in works such as *Homage to David Smith,* 1966. While a student at the Royal Academy in 1950 Caro presented himself to Moore wishing to be an assistant, and he was taken on the following year. He later recalled: "I had gone into sculpture thinking I would be one of the chaps who does statues of Montgomery, or the very highest thing was Epstein. Then you suddenly realise there are better people to look at. I think I took the very best model."[29] Not only did Moore's work have a direct influence on Caro's early reclining figures, it was in Moore's library that he first encountered tribal art and became aware of the importance of Picasso. His later relations with this "father" were more ambiguous than those with David Smith, however. In 1960 he wrote in the *Observer:* "My generation abhors the idea of a father-figure, and his [Moore's] work is bitterly attacked by artists and critics under 40 when it fails to measure up to the outsize scale it has been given."[30] Although Moore's achievements were undisputed historical fact, he wrote, the future lay with a new generation, and a new kind of sculpture.

This self-consciously new style was influenced by Clement Greenberg's criticism and marked a significant break from the figuration and object focus still represented by Moore. As an extension of the idea that sculpture should concern itself with "internal and exhaustive relations," as Michael Fried, a consistent champion of Caro, put it, Caro attached significance to placing work directly on the floor, as the plinth was viewed as hierarchical and obstructive. The use of found components and commercial paints deliberately deflated the cult of "truth to material." Materials were chosen that were free of inherent metaphorical possibilities, as well as "beaux-arts" implications; stone and bronze were avoided. (As it happens, in Smith's handling, welding did have a politicized metaphorical association with proletarian labor, but this was "lost in translation" by the time, through Greenberg's formalist mediation, the technique crossed the Atlantic.) The technological and industrial feel of Caro's breakthrough works (fig. 8) clearly distanced itself from Moore's pastoralism.

Greenberg's patronage of Caro took a combative turn comparable to Read's support of Moore, only Greenberg's attitude toward Moore was more decisively dismissive (he labeled Moore a "sincere academic modern"). Where Read had placed Moore at the head of the modern movement in England, Greenberg pitched his claims for Caro more ambitiously. "Without maintaining necessarily that he is a better artist than Turner, I would venture to say that Caro comes closer to a genuine grand manner—genuine because original and unsynthetic—than any English artist before him."[31] Synthesis, so beloved by Read the dualist and romantic, is here turned against Moore, whose ability to reconcile competing movements earns him the epithets "sincere" and "academic."

Whether or not Moore noticed this challenge to his artistic leadership, he was certainly chagrined by his protégé's signature among those of forty emerging artists writing to the London *Times* in opposition to a proposed Moore Wing at the Tate Gallery. Public money was available for this project, and Moore was willing to donate the "plaster originals" from which his bronze editions were cast, but the

Fig. 8. Anthony Caro, *Early One Morning,* 1962. Tate, London

Times letter complained that a permanent display of Moore would stifle the Tate's efforts to represent "living culture." Phillip King, another former Moore assistant, and former students Eduardo Paolozzi and Elizabeth Frink were also among the signatories. The affair ended with the plans being scrapped, and Moore made the intended donation to the Art Gallery of Ontario instead, in gratitude to Toronto over the *Archer* affair.

Caro's attitude toward assistants was markedly different from Moore's. Direct carving and "truth to material" both engendered a work ethic that had to do with breaking down the old academic atelier practices and placing significance on the artist's direct, personal rapport with his tools and materials. Assistance was merely a necessary evil to Moore as he took on more commissions and his career blossomed. His first helpers in the 1930s were Arthur Jackson (a cousin of Hepworth) followed by Bernard Meadows. In the postwar period, when bronze casting took over as the principal medium, a regular team of assistants was maintained. A carved commission like the UNESCO figure of 1957–58 was entirely carried out by artisans in Querceta, Italy. The photograph of Moore (fig. 9) wearing the traditional paper hat of the *artegiano* and chiseling away was merely a pose for the camera. While there is no inherent shame in this change of practice, there was clearly a feeling among the younger generation for more transparency and openness regarding issues of collaboration and assistance. The catalogue of Caro's watershed exhibition at the Whitechapel Gallery in 1963 notes that Isaac Witkin, David Annesley, and Michael Bolus helped in the construction of the sculptures. It is ironic that the stockbrocker's son should have treated his workers in a more egalitarian fashion than the coal miner's. Caro's catalogue acknowledgment served to underline what was obvious enough from the work itself, that he attached no significance to touch and felt distant from any mystique of the originating hand of the artist.

Caro began his teaching association with St. Martin's School of Art in 1953, and continued teaching there two days per week until as late as 1979. His radical change of artistic course after visiting the United States in 1959 (when he met Smith and Greenberg) led him to take welding lessons. What is significant is that his class of 1959 learned with him. Witkin, Annesley, and Bolus were among their

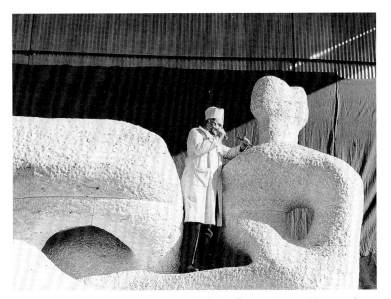

Fig. 9. Henry Moore at work on *Unesco Reclining Figure* at the marble quarry in Querceta, Italy, 1958

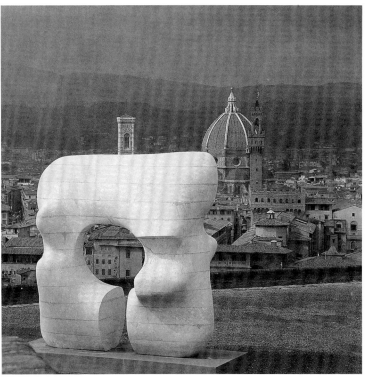

Fig. 10. *Large Square Form with Cut* at Henry Moore exhibition, *Moore e Firenze,* Forte di Belvedere, Florence, 1972

number; these artists, together with Phillip King, William Tucker, and Tim Scott, who were all pupils or associates of Caro at St. Martin's, were exhibited at the Whitechapel Gallery in 1965 as the "New Generation" (along with William Turnbull). All worked in or close to the trademark Caro style: brightly colored welded metal (or synthetic materials); industrial components; angular, geometric forms; decentered compositions; placement in radical relationship to the floor or other support. In contrast to Moore, Caro had tremendous and perceptible stylistic influence. Arguably, it was the democratic, open-ended nature of his aesthetic, as much as the charisma of his teaching, that made this possible. Moore's language was personal, and his forms, though "vital" in the sense of conveying growth, entailed closure. This is not suggested to be read literally, as some Moores were arranged in several parts (the multiple-piece reclining figures, for example) while others took as their theme the internal-external relationship of opened-out form. But even these images seem to follow an evolution or morphology determined from within, whereas Caro's aesthetic dispensed with any metaphor of growth. Caro's associates understood the nature of his influence in terms of democratization and participation, as is suggested by William Tucker's comment in 1969 that "In the past there were very few sculptors and the ones that really stood out did so as great isolated mythic heroic figures. I think that one of the things that Tony's helped to do is to make it possible for lots more to be done in sculpture and lots more sculptors to be working creatively."[32]

The *Times* letter, which Caro signed, stated that "The radical nature of art in the twentieth century is inconsistent with the notion of an heroic and monumental role for the artist."[33] This sentiment has not survived Caro's development. Twenty years to the day after the opening of Moore's monumental and heroic exhibition at the Forte di Belvedere (fig. 10), overlooking Florence, a similarly conceived exhibition of Caro opened at the Trajan Markets in Rome, organized by the same man, Giovanni Carandente. While he maintains a preference for the delicacy and subtlety of Donatello over Michelangelo, Caro's aesthetic has heavied up in relation to a Moore-like international stature: it is not just that his language is more metaphorical and his materials are denser and more expressive than the pioneering,

reductive works of the 1960s; he has also begun to make series of works on heroic, classical themes (fig. 11) (the Trojan War, the Last Judgment), to transcribe old master paintings in sculptural terms, and to bridge the divide between sculpture and architectural projects—making "sculptitecture" that the viewer climbs through, and collaborating with Norman Foster on the design of a footbridge. Since assuming the role of Henry Moore, Caro has distanced himself from his earlier criticism to speak of his mentor in consistently admiring and grateful terms.

Post-Caro

While Caro's teaching and collaborative methods created a proliferating circle of followers around the world (he maintained a presence in the United States at this time, and had students from other countries), it also generated a backlash. Some of his students took his

Fig. 11. *Triumph of Caesar* at Anthony Caro exhibition, Trajan Markets, Rome, 1993

Fig. 12. Tony Cragg, *New Forms*, 1991–92, The Museum of Fine Arts, Houston; Museum purchase with funds provided by the Schissler Foundation

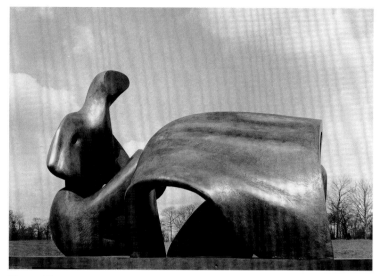

Fig. 13. Henry Moore, *Three-Piece Reclining Figure: Draped,* 1975, The Henry Moore Foundation (LH 655)

own eagerness to test the boundaries of the medium further than he envisaged. Caro has since regretted that whereas he believed "anything could be sculpture," some of his pupils interpreted this to mean "sculpture could be anything," a different proposition. At a conference of art historians in the 1980s he declared: "I would hate to sound reactionary. I broke barriers myself and scared people, but because of quality, not because of iconoclasm for its own sake."[34]

Students in the St. Martin's sculpture department, which Caro ran with Frank Martin, included Jan Dibbets, Braco Dimitrijevic, Barry Flanagan, Hamish Fulton, Gilbert and George, Tim Head, Richard Long, and Bruce McLean, all pioneers of performative, conceptual, antiformal strategies that sought to undermine any traditional conception of sculpture. Gilbert and George, to take an extreme example, declared themselves to be living sculptures and had themselves filmed singing a popular music hall ballad.[35] Whatever other influences stimulated such adventures, a sense of frustration with the earnestness and near-scholasticism of the Formalist aesthetic has been cited by the artists themselves. As Bruce McLean later recalled: "The St. Martin's sculpture forum would avoid every broader issue, discussing for hours the position of one piece of metal in relation to another. Twelve adult men with pipes would walk for hours around sculpture and mumble."[36]

At one point, McLean's crusade against earnestness extended to a performance, from which a set of still photographs was produced, in which the artist, dressed in black, sprawls in agonized awkwardness on white plinths. The target of this satire was Moore's *Falling Warrior.*

Tony Cragg, who is of a later generation than Caro's rebellious pupils, provides a case of an artist who began his career indebted to the aesthetics of dematerialization pioneered during the 1960s but who has developed a sculptural identity that now bears useful comparison with Moore. Cragg, incidentally, was an early beneficiary of the munificence of the Henry Moore Foundation. His early work, drawing on ideas from Arte Povera, was made out of recycled materials.

This often gave his images a political edge. A map of Britain turned on its side was made from colored fragments of plastic bric-a-brac (*Britain Seen from the North,* 1981). More recently, however, his work has taken on three-dimensional, sculptural qualities. Although based loosely on casts of found objects such as scientific instruments and receptacles, a fluidity has entered the work that recalls Moore's morphology (fig. 12). Furthermore, his work has a formal interest in the phenomenology of the internal-external relationship that directly recalls Moore. Conceptually, Cragg's work *Secretions,* 1996, concerns itself with DNA, coating the entire surface of an undulating biomorphic form with dice. Although this treatment of materials reflects an attitude remote from Moore's, the updated vitalism of this work demonstrates that it is possible for a highly original and distinctive artist to relate to Moore without the intermediaries of irony or deconstruction.

Kapoor

More than any of his contemporaries, Anish Kapoor emulates Moore's ambition to make work of subliminal, universal appeal. And yet despite obvious affinities—an obsession with the maternal and a fascination with the void—the Indian-born sculptor is brusquely dismissive of Moore's legacy. "How can you make sculpture about women for fifty years and not make one of them sexy?" he has quipped.[37] This glibness might have been intended to discourage linkage to a national tradition because the artist was keen to define his career globally, although as an artist seeking to engage with Hindu aesthetics, especially the juxtaposition of the transcendental and the erotic, Kapoor's chagrin with Moore's neutrality is understandable. On a purely formal level, however, the juxtaposition of a piece like Kapoor's *Mother as a Mountain,* 1985 (fig. 14), with an uncharacteristically "sexy" Moore from just ten years earlier, *Three-Piece Reclining Figure: Draped,* 1975 (fig. 13), surprises the viewer with visual similarities.

In keeping with a Beuysian self-conception, Kapoor has positioned himself at the forefront of a cultural and spiritual migration of millennial significance while defining his own practice in relation to his identity. This ties in closely with Moore—not with how Moore saw himself, but with Moore's interpretation by Herbert Read and more especially the analytical psychologist Erich Neumann, to whom Read introduced

Sculpture

January–February 1993 $5 / £5 1800

Anish Kapoor

Pleasure:
In Memoriam

Interview:
John Frohnmayer

Fig. 14. Cover of *Sculpture* magazine, January–February 1993, featuring Anish Kapoor's *Mother as a Mountain* (detail), 1985

Moore's work. According to Neumann, Moore is the most significant modern example of an artist-seer. A comparable statement by Kapoor defines his own role in shamanistic terms: "I don't think of the artist as an expresser or teller of tales . . . but as a receiver and transmitter of collective information."[38]

For Neumann, Moore's sculpture is "dedicated to an archetype that is only just looming up on the conscious horizon of our age,[39] —that is, the feminine archetype, in the guises of the great mother, the earth mother, the terrible mother. Moore brings to the level of consciousness aspects of human character that have been suppressed to the realm of the unconscious in an overmechanized, overly rational patriarchal age. These beliefs were held just as strongly by Read, whose anarchist and pacifist outlook came to the fore in later writings that were also increasingly informed by a Jungian perspective. For Read, as for Neumann, Moore's archetypal images came to assume apocalyptic urgency.

Like Moore's apologists, Kapoor relates his own artistic efforts to a broad historical trend: "If we accept that Western culture is in crisis, then there are some issues which throw this into relief. For example, decoration in Indian art is written into a philosophical view of the world. It is about abundance, fecundity, about the world as a generative unity. Taken out of context in the West it is merely decorative, there is no other way of dealing with it."[40] He sees his own work as spearheading the change of sensibility in Europe that is being produced by an influx of Asians.

As already noted, Moore refused to read past the opening pages of Neumann's book about him, whereas Kapoor is well versed in Jungian ideas. Herein lies a significant generational difference in how ideas and art interrelate: while Moore, Read, and Neumann formed a network in which each had his separate function, Kapoor has taken upon himself all three roles of maker, explainer, and interpreter. Since minimalism, it could be argued, the intellectual work in sculpture has shifted from the artist to the viewer. Whereas Moore synthesizes a plethora of form-ideas into a centered object pregnant with associations, Kapoor does the opposite, simplifying the sculptural effect so that intuited meanings are diffuse. "A sculpture," he declares, "is like a vessel offered to the viewer to fill with meaning. What makes a good work is the range of these references."[41]

There remain, however, striking coincidences between the compounded Moore-Read-Neumann mythology and that promoted by Anish Kapoor. One is a conception of the artist as a cipher, a vehicle for archetypal forces, primarily feminine ones, due to a specific receptivity. Great importance is attached to the notion of duality, which is to be creatively exploited, or resolved. While Moore culls metaphors of universality from a plethora of sources, it is the decorative, spiritual, and sexual aspects of Kapoor's Indian heritage that are distilled into a postmodern art.

Just as Moore was heavily promoted by the British Council as an icon of British resilience and renewal after World War II, so Kapoor became a mascot of Britain's multiculturalism in a period when politicized issues of identity gripped the international art agenda. He represented Britain at the 1990 Venice Biennale.

Anish Kapoor is the most recent artist in whom "anxiety of influence" is conceivable. To younger artists, Moore is merely a figure in the canon who can be referred to or ignored with peace of mind. Moore has a monopoly on neither the mother-child relationship nor sheep, though Damien Hirst's *Mother and Child Divided,* 1993, and *Away from the Flock,* 1994, could each be making passing references to Moore. If one were looking to place Rachel Whiteread in the context of modern sculpture, some commonality could be found between her preoccupation with casts and the formal themes of internal-external relationship, and the absent presence of Moore's negative internal spaces. When André Breton wrote, "Apollinaire had dreamed of a unique statue, one that would be a hollow wrought within the earth itself: this is the statue which Moore's art has succeeded in wedding to its opposite, the solid statue, so that they embrace each other in perfect harmony,"[42] his comment could be deemed to prefigure Whiteread. But none of this requires acknowledgment of Moore on Whiteread's part, nor would antagonism or indifference expressed by the younger artist be significant.

It would be difficult to envisage a major rediscovery of Moore in the British art world in the near future. Partly this is because he is not yet neglected enough: he is still a favorite among the public, an aesthetically "safe" taste. It is telling, for example, that Mrs. Thatcher, who expressed her horror of her political supporter Francis Bacon, kept a rotating display of pieces from the Henry Moore Foundation at 10 Downing Street. Twentieth-century figures who, in recent years, have begun to enjoy generous reappraisal were mavericks who stood out for a provincial style—modern artists despite modernism, like L. S. Lowry or Stanley Spencer—rather than mainstream modernists like Moore. It is telling that today one is more likely to encounter

enthusiasm for the traditionalist William Nicholson than his modernist son Ben, who is perceived to be the more academic.

One attempt to champion Moore self-consciously as a radical alternative to perceived Establishment taste came from the British critic Peter Fuller in the years after the sculptor's death.[43] Fuller was able to interpret positively Moore's turn away from modernism in the 1940s and his new humanism, which troubles current commentators, by seeing this in terms of the Neoromantic revival of the period. He held up Moore in Ruskinian moral contrast to such figures as Francis Bacon or Anthony Caro, whose art personified for him, respectively, sordid degradation and crass materialism. Interestingly, Peter Fuller's chosen successor to Moore, Glynn Williams, recently delivered a keynote lecture at a symposium on Moore's work that gave vent to many of the kinds of objection explored in the first section of this essay.[44]

These considerations of reputation do nothing, however, to diminish the intrinsic quality of Moore's art, its integrity and enduring power. The hope for his reputation, and for his chance to exert new influence, lies with artists able to respond to the work afresh, to see the work unpatinated, so to speak, by historical association. The devotee of Moore will do well to reflect on the cases of J. M. W. Turner and John Constable, who were largely dismissed by younger British artists, but who two generations later galvanized French painting. There is the opportunity for an exhibition like the present one to set off sparks.

Notes

1. Hilton Kramer, "Two New Shows Confirm Henry Moore's Greatness," *New York Times,* 15 April 1970.

2. "Here and Now: Fred Sandback," exh. cat. (Leeds: Henry Moore Institute, 1999), n.p.

3. Moore was one of several members of the Surrealist group expelled at this time, in his case for becoming a "Church furnisher." See Conroy Maddox, *E. L. T. Mesens,* exh. cat. (London: Acoris Gallery), 30 January–1 March 1974.

4. Henry Moore, "The Sculptor Speaks," in *The Listener* (London) 18, no. 449 (18 August 1937); quoted in Philip James, *Henry Moore on Sculpture: A Collection of the Sculptor's Writings and Spoken Words* (London: Macdonald, 1966), 64.

5. T. E. Hulme, *Speculations: Essays on Humanism and the Philosophy of Art,* ed. Herbert Read (London: K. Paul, Trench, Trubner and Company), 1924.

6. Wentworth D'Arcy Thompson, *On Growth and Form* (Cambridge, England: Cambridge University Press, 1917), 756.

7. Geoffrey Grigson, "Henry Moore and Ourselves," in *Axis* (London), no. 3 (July 1935): 9–13. In the same magazine the poet David Gascoyne offered a quirky dictionary definition of Moore in the following enigmatic terms: "MOORE: Product of the multiform inventive artist, abstraction-surrealism nearly in control, . . . the biomorphist producing viable work, with all the techniques he requires."

8. Herbert Read, "A Nest of Gentle Artists," *Apollo* 86 (September 1962): 536–40; quoted in *Herbert Read: A British Vision of World Art,* exh. cat., ed. Benedict Read and David Thistlewood (Leeds: Leeds City Art Gallery, 1993), 60.

9. Benedict Read and Thistlewood, 60.

10. Henry Moore, "The Sculptor Speaks"; quoted in James, 67.

11. Herbert Read, introduction to *The International Surrealist Exhibition,* exh. cat. (London: New Burlington Galleries, 1937).

12. Serge Guilbaut, *How New York Stole the Idea of Modern Art: Abstract Expressionism, Freedom and the Cold War,* trans. Arthur Goldhammer (Chicago and London: University of Chicago Press, 1983).

13. See Roger Berthoud, *The Life of Henry Moore* (London: Faber and Faber, 1987), 286.

14. Herbert Read, *The Meaning of Art* (London: Faber and Faber, 1931), 151.

15. *Sculpture and Drawings by Henry Moore,* exh. cat. (London: Arts Council of Great Britain, 1951); quoted in James, 113.

16. Paul Overy, "Lion and Unicorns: The Britishness of Postwar British Sculpture," *Art in America* 79, no. 9 (September 1991): 106.

17. See my own essay, "Identité nationale et différences: Immigrés et émigrés," in *Un siècle de sculpture anglaise,* exh. cat. (Paris: Galerie Nationale du Jeu de Paume, 1996). The theme of oedipal struggle was adopted by the exhibition's curator, Daniel Abadie, in his introductory essay, "De l'assassinat considéré comme un des beaux-arts."

18. Henry Moore, "Jacob Epstein: An Appreciation," in *Sunday Times* (London), 23 August 1959; quoted in James, 194.

19. *Daily Herald* (London), 23 May 1931.

20. Herbert Read, *The Meaning of Art,* 149.

21. Eric G. Underwood, *A Short History of English Sculpture* (London: Faber and Faber, 1933), 153–54: "It is wholly exotic, and for this reason cannot appropriately be dealt with at length in a history of English sculpture."

22. "New Planets," *Axis,* no. 3 (July 1935): 22–23.

23. Sally Festing, *Barbara Hepworth: A Life of Forms* (London: Penguin Books, 1995), 46.

24. See, for example, Read's foreword to *Exhibition of Sculpture and Drawings by Barbara Hepworth* (Halifax: Bankfield Museum, 1944), 2.

25. Katy Deepwell, "Hepworth and Her Critics," in David Thistlewood, ed., *Barbara Hepworth Reconsidered* (Liverpool: Liverpool University Press and Tate Gallery Liverpool, 1996). See J. P. Hodin, *Barbara Hepworth* (London: Lund Humphries, 1961), and Patrick Heron, *Barbara Hepworth: Sculpture and Drawings,* exh. cat. (Wakefield City Art Gallery, 1951).

26. Herbert Read, "New Aspects of British Sculpture," in *The XXVI Venice Biennale, The British Pavillion,* exh. cat. (London: Westminster Press, 1952), n.p. Read's quotation is from T. S. Eliot's "The Love Song of J. Alfred Prufrock."

27. Alan G. Wilkinson, *Henry Moore Remembered: The Collection of the Art Gallery of Ontario in Toronto* (Toronto: Art Gallery of Ontario, 1987), 142.

28. John Glaves-Smith, "Sculpture in the 1940s and 1950s: The Form and the Language," in Sandy Nairne and Nicholas Serota, eds., *British Sculpture in the Twentieth Century,* exh. cat. (London: Whitechapel Art Gallery, 1981), 133.

29. Conversation with the author, 1992.

30. Anthony Caro, "The Master Sculptor," *Observer,* 27 November 1960.

31. Clement Greenberg, "Contemporary Sculpture: Anthony Caro" in *Arts Yearbook 8* (1965); quoted in Clement Greenberg, *The Collected Essays and Criticism,* vol. 4, *Modernism with a Vengeance, 1957–69* (Chicago: University of Chicago Press, 1993), 207.

32. David Annesley, Roelof Louw, Tim Scott, and William Tucker, "Anthony Caro's Work: A Symposium by Four Sculptors," *Studio International* (January 1969): 20.

33. "Henry Moore's Gift," *Times* (London), 26 May 1967.

34. Anthony Caro, "The Sculptural Moment," Sotheby's lecture, delivered at the Association of Art Historians annual meeting, Leeds, April 1992.

35. The performance *Our New Sculpture,* 1969, was later titled *Underneath the Arches* and eventually filmed as *The Singing Sculpture,* 1970.

36. Bruce McLean quoted in David Cohen, "The Last Modernist: Sir Anthony Caro," in *Sculpture* (January–February 1995): 25.

37. See Sarah Kent, "Mind Over Matter," in the British magazine *20:20* (May 1990): 37–38.

38. Kent, 40.

39. Erich Neumann, *The Archetypal World of Henry Moore,* trans. R. F. C. Hull, Bollingen Series, no. 68 (Princeton, N.J.: Princeton University Press, 1959), 60.

40. "'Mostly Hidden': An Interview with Marjorie Allthorpe-Guyton," in *Anish Kapoor,* exh. cat. (British Pavilion, XLIV Venice Biennale, May–September 1990), 48.

41. Kent, 40.

42. André Breton, *Surrealism and Painting,* trans. Simon Watson Taylor (London: Macdonald, 1972; first French edition, 1965), 73.

43. See Peter Fuller, *Henry Moore: An Interpretation,* ed. Anthony O'Hear (London: Methuen, 1993). This is a posthumous collection that draws on various texts, including the manuscript of a prospective monograph on Moore that Fuller was working on at the time of his death in 1990.

44. Professor Williams, head of sculpture at the Royal College of Art, delivered a paper entitled "Moore Relevance: Influence on Contemporary Practice" at *Contemporary Views on Henry Moore: Place, Body, Script,* a symposium held at the University of East Anglia, Norwich, in December 1998.

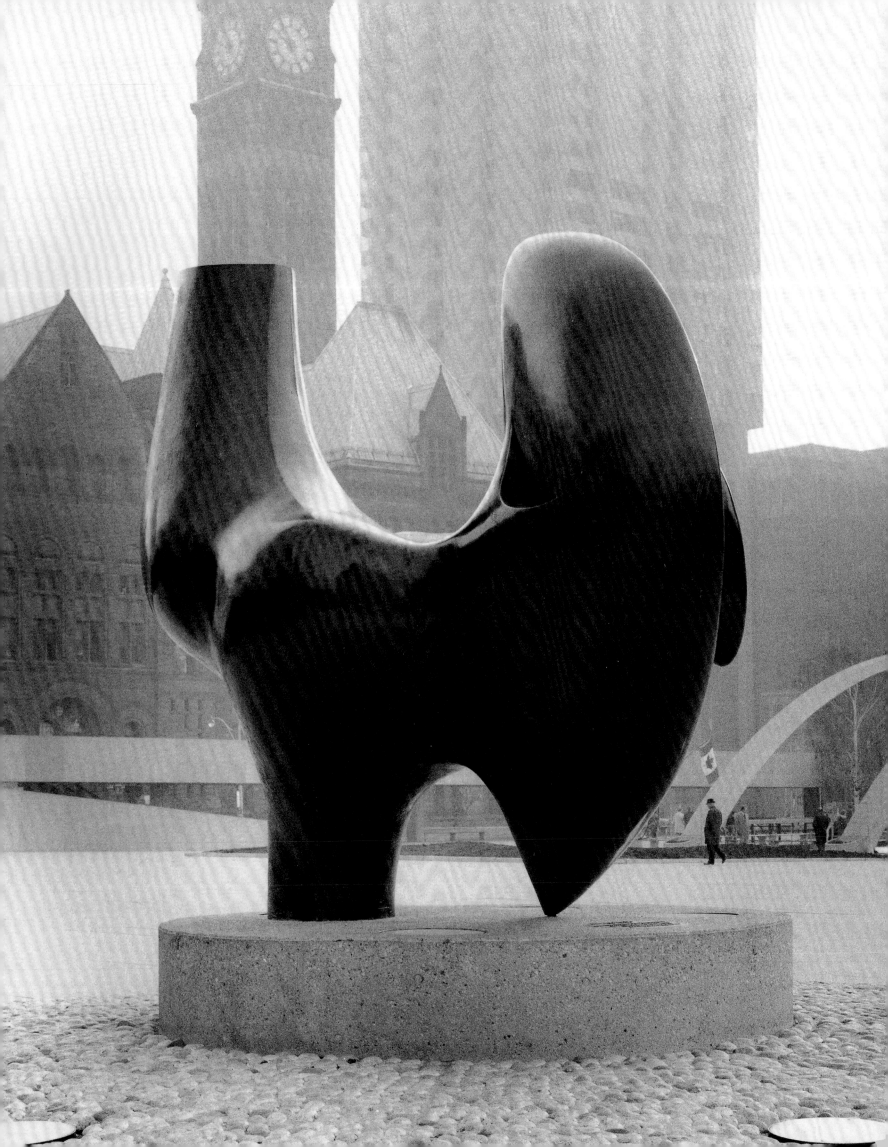

Harriet F. Senie

Implicit Intimacy: The Persistent Appeal of Henry Moore's Public Art

Most everything I do, I intend to make on a large scale if I am given the chance. So when required to make a work larger, I am always pleased. Size itself has its own impact, and physically we can relate ourselves more strongly to a big sculpture than to a small one. At least I do.

Henry Moore[1]

Born in the closing years of the nineteenth century, Henry Moore fought in World War I, served England again as an official War Artist in World War II,[2] and was nearly sixty years old at the time of his first internationally significant public art commission. His most critically acclaimed sculpture was nearly two decades behind him, a product of the 1930s, when he and his work were closest to contemporary critical concerns. Even as his critical reputation waned, Moore became one of the most honored and prolific public artists of the twentieth century, represented in countless public spaces of the Western world. To what does he owe his success, and what precisely is the nature of his appeal to public art audiences?

Moore's career as a major public artist was launched by critical support in high places. Though far from well connected at birth, he was extraordinarily successful in attracting the attention of influential individuals (notably museum directors and architects) and forming lasting friendships with a significant number of them. In 1955 Moore was chosen to create the most prominent artwork for the much publicized UNESCO headquarters in Paris, a sculpture for the main plaza. The organization's first director-general, Julian Huxley, was a close friend; the art committee included Herbert Read, Moore's first and foremost British supporter as well as the champion of modern art in England, and Georges Salles, France's director of museums. Salles was also a friend of Kenneth Clark, another famous British Moore supporter, at one time director of London's National Gallery and arguably one of the most influential art historians of all time. Moore was in good artistic company: the other commissions went to Jean Arp, Alexander Calder, Joan Miró, Isamu Noguchi, and Pablo Picasso.[3]

All the artists were given copies of the organization's aims, which they were free to interpret (or not) as they wished.

For his first international commission and his largest public sculpture thus far, Moore, striving for a non-narrative universal form, created a *Reclining Figure* sixteen feet, eight inches long (fig. 1) of white Roman travertine, a material selected for maximum visibility.[4] Moore had struggled for some years with the theme, enlisting the advice of Herbert Read, and considering groups as well as single figures in a variety of poses.[5] Given the prominent location and figural reference of the UNESCO piece, it could also be understood in the tradition of allegorical sculpture, in which the work conveys attributes of the structure it adorns. In front of the world's educational, scientific, and cultural organization, it might be seen as a latter-day version of Athena (the Greek goddess of wisdom) grounded in the earth that had so recently been ruptured by war (which she also ruled). Although Athena was known as a virgin goddess and not historically portrayed in a recumbent position,[6] Moore often combined and conflated sources and forms in an eclectic, impulsive manner, following only his artistic imperatives. At UNESCO the figure's pose of "exalted relaxation,"[7]

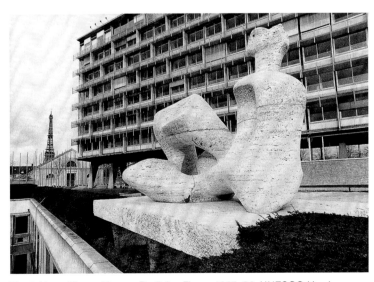

Fig. 1. Henry Moore, *Unesco Reclining Figure,* 1957–58. UNESCO Headquarters, Paris (LH 416)

Three Way Piece No. 2: Archer, 1964–65. Nathan Phillips Square, Toronto (LH 535)

in which she reclines on a benchlike base, served to counter the inherent monumentality of the commission by conveying a sense of approachability actually denied by the site.

Although Moore had long disparaged the classical tradition, a trip to Greece in 1951 changed his attitude. But Moore did not have to travel to foreign shores to absorb the impact of Athena. As the model for Justice, Prudence, Fortitude, and Temperance she adorned the facade of both the National Gallery in London, where Moore was appointed trustee in 1955, and the Tate Gallery, where he served as a trustee from 1941 to 1957. Athena also was featured prominently at the entrances of "various life insurance companies in Britain's great cities, where her presence pledges the integrity of their conduct."[8] But Athena was almost omnipresent in England in the form of her iconographic descendant, the national symbol Britannia. Moore, by now so often a cultural ambassador for England, could not fail to see himself as the representative of Athena/Britannia. What better symbol to anchor an institution dedicated to a new and better world?

The year of its installation, 1958, Moore was awarded the second Sculpture Prize at the Carnegie International in Pittsburgh. A year later Erich Neumann published *The Archetypal World of Henry Moore,* a Jungian interpretation of the artist's work that posited him as a creator of universal images uniquely in tune with the time, a reading supported by Moore's comment: "There are universal shapes to which everyone is subconsciously conditioned and to which they can respond if their conscious control does not shut them off."[9] In 1964 Read, following Neumann, also defined Moore's career as a "development in archetypal consciousness."[10]

Moore's enshrinement, in certain influential circles, continued unabated. As John Hedgecoe observed, the UNESCO commission appeared to "inaugurate the phase in Henry's career when he became above all *the* sculptor for work in public spaces."[11]

British Beginnings

Moore, a miner's son born in industrial Yorkshire and educated in local and London schools, was in many ways a product of England. Well before he became a public artist, he was committed to working out of doors and spoke of the desirability of viewing his work in a landscape setting. From 1941 on he lived and worked at Perry Green in the village of Much Hadham in the county of Hertfordshire north of London, where his sculpture was sited in a landscape shaped by his wife, Irina. Moore's early insistence on the merits of open-air sculpture is closely related to contemporary social values as well as architectural and urban planning practices equating fresh air with "the health and freedom of the modern citizen."[12]

Although Moore insisted that his public works not compromise his personal style, he nevertheless was concerned with public accessibility; this was especially true of his six-foot-high *Madonna and Child* of 1943–44 (fig. 2), commissioned by the Reverend Walter Hussey to celebrate the fiftieth anniversary of St. Matthew's Church in Northampton.[13] The vicar had been especially impressed with Moore's Shelter Drawings, which had been exhibited at the National Gallery the previous year. Abjuring abstraction, the sculptor sought to convey "an austerity and nobility and some touch of grandeur (even hieratic aloofness) which is missing in the everyday Mother and Child idea"[14] through a grand naturalism and a sense of massive weight. To many, however, he appeared to flout religious convention. The controversy

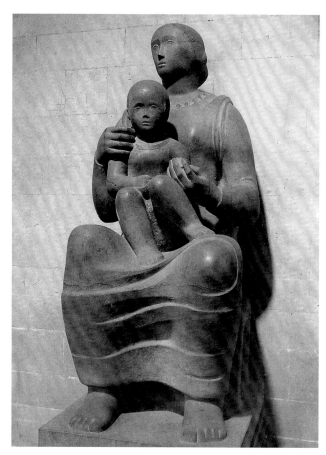

Fig. 2. Henry Moore, *Madonna and Child,* 1943–44. Church of St. Matthew, Northampton (LH 226)

surrounding the Northampton Madonna attracted a large audience and helped establish Moore's national fame. It became the first Moore bronze to be editioned. A year later Herbert Read, in the introduction to *Henry Moore: Sculpture and Drawings,* "proposed a future social role for sculpture, as an agency for national and spiritual reconstruction. . . . The *Mother and Child,* a rare example of a current modern work of public sculpture, was illustrated prominently in the book."[15]

Moore's national reputation as a public artist was considerably enhanced by his participation in significant outdoor exhibitions. He was involved with the planning of the 1948 open-air sculpture exhibition in Battersea Park, and contributed its widely discussed centerpiece. The seven-foot-high, monumentally draped *Three Standing Figures,* 1947–48 (fig. 3), evoked the classical subject of the three Graces, substituting monumentality for grace.[16] That year the British Council chose Moore and J. M. W. Turner as Britain's greatest artists, living and dead, to represent the nation at the twenty-fourth Venice Biennale. Moore won the Sculpture Prize, "transforming his reputation in Europe as suddenly as the MOMA [Museum of Modern Art, New York] show had in the USA"[17] two years earlier.

In 1951 Moore's sculpture once again occupied the central location of another significant event, the Festival of Britain at South Bank. Although the Arts Council had asked for a family group representing the theme of discovery, Moore provided a bronze *Reclining Figure* (cat. 55) for a site opposite the main entrance. The controversy that greeted the piece shows how much the interpretation of public art is a factor of time as well as place. People saw "a human form in an advanced state of decomposition which has been disemboweled, partially decapitated and had both feet severed. It is sadly reminiscent

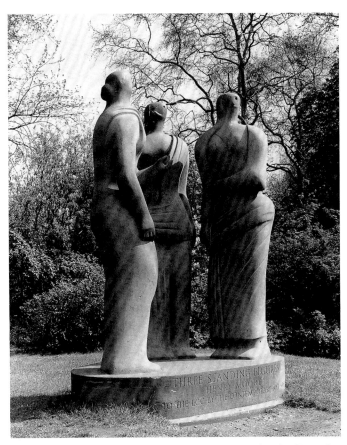

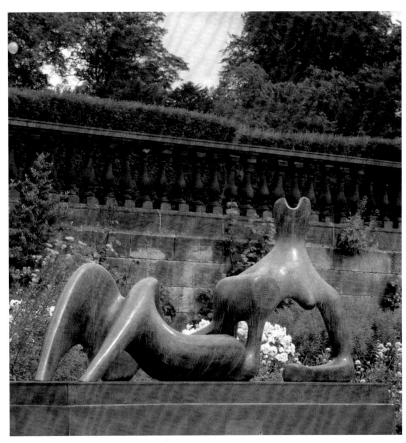

Fig. 3. Henry Moore, *Three Standing Figures*, 1947–48. London Borough of Wandsworth, sited in Battersea Park (LH 268)

Cat. 55. Henry Moore, *Reclining Figure: Festival*, 1951. The Moore Danowski Trust (LH 293)

of the pitiful human remains found after the Hiroshima bomb explosion and among the dreadful discoveries at Belsen."[18]

Because *Reclining Figure: Festival* was seen as an expression of modern art, it was denounced as an artistic outrage by a former president of the Royal Academy but defended by the directors of the National Gallery and the Tate. When it was later exhibited at the Leeds City Art Gallery, flanked by a guard, it attracted a huge audience. Then it moved to a landscape setting in 1952, and was vandalized a year later, the first such incident for a Moore sculpture. At each juncture, publicity abounded, augmented by international exhibitions of his work.

Moore benefited enormously from official art patronage, and became something of a national export. After 1948 "there had hardly been a year when an exhibition planned, organized or sponsored by the British Council was not traveling or being curated for a specific venue."[19] These exhibitions created public familiarity and prompted sales, laying the ground, as it were, for his public art career.

The decade of the 1960s, that era of social and cultural change, was marked in the art world by the introduction of Pop Art with its commercial references and Minimal art with its industrial forms. It also saw the proliferation of Moore's public art in the form of memorials, civic sculptures, and institutional emblems. In these commissions, largely secured through architects, his sculpture functioned as an icon of modernism, a sign of culture. By the middle of the decade, when significant Moores were unveiled in Chicago, Toronto, and New York, his work had a decided look of the past for the informed avant-garde art audience; in other official circles, it was used to unseat an incumbent mayor in Toronto and barely passed the Art Commission in New York. But how did the general public respond?

Memorials

Nuclear Energy, 1964–66 (fig. 4), in Chicago is among the least known of Moore's public works in the United States, perhaps because, as Roger Berthoud observed, it was "a sinister image for a sinister event."[20] In 1963 Moore was commissioned by the University of Chicago to create a sculpture to commemorate Enrico Fermi's splitting of the atom in 1942, considered by some "the most important scientific discovery of this century."[21]

Moore, as was customary, proceeded to develop an idea that he had worked on earlier, a variation on the theme referred to as helmet heads.[22] The bronze working model for the memorial, at first called *Atom Piece,* measured some four to five feet; eventually *Nuclear Energy,* cast and installed in 1967, rose to a height of 12 feet. Before finalizing its form Moore carefully considered existing and planned buildings at the site and observed the patinations on existing Chicago bronzes. After the initial placement he decided to rotate the piece 180 degrees for more effective lighting.

Like all Moore's public pieces, the work was designed to offer continually changing contours when seen in the round. But here there is also a vertical shift. As Moore explained:

> The top is like some large mushroom, or a kind of mushroom cloud. Also it has a kind of head shape while the top of the skull but down below is more an architectural cathedral. One might think of the lower part of it being a protective form and constructed for human beings and the top being more like the idea of the destructive side of the atom. So between the two it might express to people in a symbolic

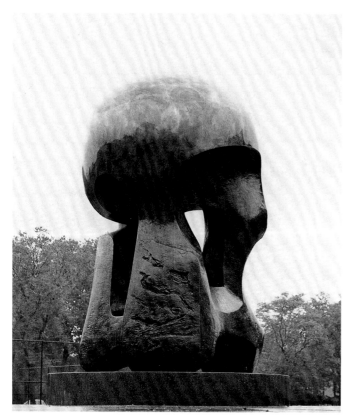

Fig. 4. Henry Moore, *Nuclear Energy,* 1964–66. University of Chicago (LH 526)

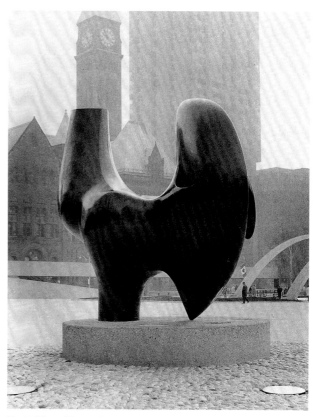

Fig. 5. Henry Moore, *Three Way Piece No. 2: Archer,* 1964–65. Nathan Phillips Square, Toronto (LH 535)

way the whole event. . . . How successful or how much this can be conveyed to other people I don't know, it's just my interpretation.[23]

Tougher than most of Moore's public art, it seems deliberately ominous in form, beautiful in some of its surfaces, and conveys a powerful imploded energy. As John Read observed of *Atom Piece,* "It is a deeply thought through symbol for the moral dilemmas of the twentieth century."[24]

When I viewed the sculpture in August 1989, it was mounted on a stepped platform that was near tennis courts in an area that seemed quite remote. Like so much of Moore's sculpture, it was being climbed on, through, and under by two young girls who were blissfully unaware of its darker implications.

Civic Sculpture

One of the more curious uses of modern public sculpture has been its adoption as civic emblem.[25] The sculpture that inaugurated the public art revival of the late 1960s in the United States, Picasso's untitled sculpture in Chicago's Civic Center, is the focal point for many local celebrations and is periodically adorned with the headgear of winning sports teams. Commissioned during the reign of Mayor Richard J. Daley, the sculpture was depicted as shedding a tear at his death. It is now known simply as the Chicago Picasso. In Grand Rapids, Michigan, Calder's *La Grande Vitesse*–Grand Rapids translated into Franglais–has become a logo emblazoned on civic stationery and garbage trucks alike. Its site was eventually renamed Calder Plaza. Moore sculptures functioned similarly in both Toronto and Dallas.

Three Way Piece No. 2: Archer (fig. 5), installed on Nathan Phillips Square in front of Toronto's new city hall in 1966, could hardly have been more publicized or more controversial. The commission began, as was customary at the time, with the architect. Viijo Revell, a former assistant to Alvar Aalto, had won what was in 1958 the biggest architectural competition in the world, and he wanted a Moore for his plaza. In 1961, proceeding on his own, the architect approached Moore about the project. Although the sculptor was not initially enthusiastic, he and Revell finally agreed on an existing maquette for enlargement in 1964. The architect died the next day. Although the purchase was subsequently approved by the Art Advisory Committee and the Toronto Board of Control, it failed to pass the Toronto City Council by a vote of 13 to 10.

Mayor Philip Givens then made the acquisition a personal mission, enlisting Joseph Hirshhorn to talk to Moore. The sculptor diplomatically dropped the price by twenty percent "as an expression of his great esteem for Revell as a man and artist; [and] for the creative daring of the City Hall concept,"[26] and the necessary funds were raised from private donors. Support for the sculpture was based on the significance of the art, the prerogative of the architect to select the appropriate sculpture for the building and the square, and on the fact that Montreal already had a Moore of note.

The ensuing controversy cost Mayor Givens the next election. Politicians argued that the funds should have been spent elsewhere, even though it was repeatedly stated that there was no public money involved. This specious argument was coupled with the charge that the work represented the imposed taste of "elitist advocates of modern art."[27] Nevertheless, Moore's central presence in Toronto eventually led to the establishment of the Henry Moore Sculpture Center in Toronto.[28]

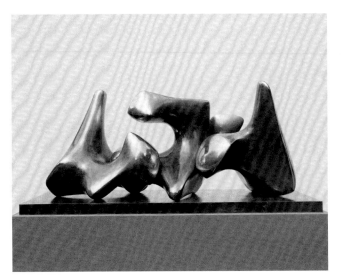

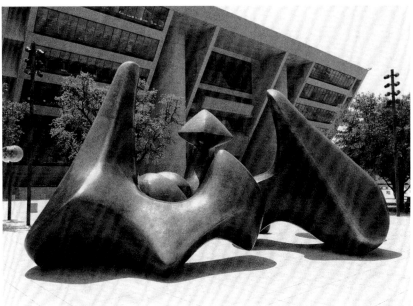

Cat. 87. Henry Moore, *Working Model for Three Piece No. 3: Vertebrae,* 1968. The Patsy R. and Raymond D. Nasher Collection, Dallas, Texas (LH 579)

Cat. 88. Henry Moore, *Three Forms Vertebrae (The Dallas Piece),* 1978–79. City Center Park Plaza, Dallas (LH 580a)

But how much did any of this have to do with the sculpture itself? Moore initially called the work the *Archer* "because the sweeping curve of one profile reminded him of the art of an archer's bow."[29] But the other part of its title, *Three Way Piece,* suggests that it is related to other Moore sculptures that are variations on this theme. The architect and sculptor selected it for its formal qualities, its perceived aesthetic appropriateness for an urban space already defined by complex visual parameters. They wanted something that looked good (to the artistic eye) and gave a large open space a focus. The mayor and his coterie wanted a new image for the city. As Mayor Givens explained it years later: "Toronto was a hick town, and I was interested in seeing that it turned the corner of becoming a great metropolis. Having a Henry Moore work was to be the dawn of a new era."[30] And since, as Michael Parke-Taylor observed, "For the general Canadian public in the mid-sixties, Moore was associated with what it meant to be modern and contemporary, forward-looking, even radical,"[31] the *Archer* was on target. It could be argued, however, that any number of Moore sculptures might have served the same artistic and civic purpose.

More than a decade later little seemed to have changed.[32] I. M. Pei, commissioned to build a new city hall for Dallas in the early seventies, had already selected Moore sculptures for two other buildings: *Arch* for Bartholemew County Public Library in Columbus, Indiana (installed 1969), and *Two Piece Mirror Knife Edge* for the East Wing of the Washington National Gallery (installed, like Dallas, in 1978). He wanted a Moore for this one as well. Again, as he had for the National Gallery commission, Pei suggested rearranging the elements of an existing piece. The elements of the bronze *Three Piece Sculpture: Vertebrae,* 1968 (cat. 87) were displayed in a linear fashion,[33] but a triangular cluster appropriately enlarged would result in a sculpture people could walk through (cat. 88). Thinking of Stonehenge, Moore was engaged by the opportunity "to make a sculpture people might 'inhabit.'"[34]

The ensuing controversy echoed Toronto's, and private collectors once again stepped in to foot the bill. The installation of the work in 1978 was carefully choreographed. Local aspects of the process involving final welding and patination were open to the public, a video was made, and a Moore exhibition was held at the Dallas Museum of Art at the time of the installation. The press, too, was in full attendance. Nevertheless, public appreciation was peppered with the customary complaints about the work's visual appearance. Not being able to answer the basic "What is it?" question, people compared it to "a classy pigeon perch," "Paul Bunyan's jacks," and "dinosaur bones," among other things.[35] Moore himself offered a "looks like" interpretation: "It may seem to some people abstract but it's not. It's all organic form. You might say it's like a whale. Sea animals have to be smooth to go through the water, or you might think it's something entirely different."[36]

Although expressed public opinion was once again mixed, tactile participation was a constant. As one local critic stated, "Hardly anyone passes by without rubbing or thumping the piece, and a good many people walk through the space within the sculpture."[37] Another writer observed, "Moving within it gives adults the same experience of participation children derive from climbing on sculpture."[38] In this case, participation also extended to graffiti and worse.

By 1996 so many had carved their initials into the surface of the piece, while others had used its sheltered spaces as "semi-private restroom facilities," that the piece required massive restoration, now paid for by a combination of private and public money.[39] *Three Forms Vertebrae* had become "The Dallas Piece," as Moore himself had called it at its installation. In the local press one writer, while taking citizens to task for the vandalism, also saw the sculpture as a sign of Dallas's coming of age: "In many ways, the Moore sculpture reflects the maturation of Dallas from a railroad crossing in the middle of the prairie to an international center of commerce. It's a statement about this city's pride. When people are allowed to trash such an asset in the heart of the city, Dallas' reputation is defaced as well."[40]

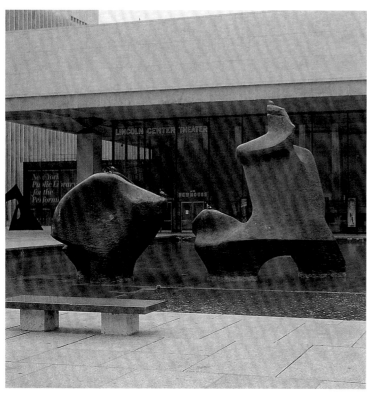

Fig. 6. Henry Moore, *Reclining Figure*, 1963–65. Lincoln Center for the Performing Arts, New York (LH 519)

Institutional Emblems

As at UNESCO, Moore was once again called upon to create an institutional emblem. This time he chose a two-piece *Reclining Figure*, 1963–65 (fig. 6), for New York's Lincoln Center for the Performing Arts. Moore was the first artist selected by an art committee that included René d'Harnoncourt (director of the Museum of Modern Art, which in 1946 had given Moore his first retrospective in the United States), Dr. Frank Stanton (president of the Columbia Broadcasting System, or CBS), John D. Rockefeller III, and the architect Gordon Bunshaft (of the firm Skidmore Owings Merrill, and who had worked on the Vivian Beaumont Theater and personally owned a number of Moores).

A 1960 drawing of a sculpture in the pool in front of the Beaumont Theater "suggests something like a Lipchitz may have been envisioned"[41] in the early planning stages. Eventually Moore was the unanimous selection of the committee and the principal architects (Eero Saarinen, Philip Johnson, and Wallace Harrison), with Jacques Lipchitz and Alberto Giacometti apparently alternates. However, Moore was also under discussion for three other New York commissions: the Seagram Building, Columbia University School of Law, and the headquarters of the Chase Manhattan Bank. According to Moore's biographer, it was Bunshaft (also the architect of Chase) who convinced the sculptor that the idea of a Moore in each of the twin pools in the Seagram plaza "would make them look like candelabra."[42]

The Lincoln Center commission offered Moore the opportunity to create his largest work to date, one nearly twice the size of the UNESCO piece. It prompted him to build a studio with transparent walls and roof, making it possible to consider various views of the work from afar. He also used the small swimming pool built for his daughter to gauge the effects of the intended water setting.

At the opening ceremony Frank Stanton quoted Kenneth Clark's statement: "If I had to send one man to another planet to represent the human race, it would be Henry Moore."[43] Although his public apotheosis was apparently complete, necessary approval by the New York City Art Commission had been a near miss. At first Parks Commissioner Newbold Morris (brother of the artist George L. K. Morris) was reluctant to submit it, appearing to make anti-abstraction a departmental policy. His views were largely shared by the painter and sculptor members of the Art Commission (Frank Reilly and Eleanor Platt, respectively), who were affiliated with conservative art organizations (the Art Students League and the National Sculpture Society). In July 1965, at a time when New York was often defined as the art capital of the world, and Moore and Calder had for decades been recognized by major art institutions, their sculptures for Lincoln Center passed New York's official body only after intense behind-the-scenes lobbying.[44]

Public Art/Public Response

> "I like it but I don't know what it is."
>
> African American woman in her forties

In May 2000 Sheila Gerami, an artist and a candidate for a master's degree in the Museum Studies program at City College of the City University of New York, observed and engaged about a hundred people at Lincoln Center to learn about their response to the Moore in the pool. Over sixty percent liked or loved the piece, variously appreciating its "power," "rounded volumes," "smooth surface," "relaxing, fluid lines," and "the curves and textures." They found it "very big and impressive," "mystical and really cool to look at," "very calming," and "beautiful." They compared it to bones, "the legs of an animal in the water," "something in the ocean," a walrus, a rabbit, an elephant, a glacier, and a faucet.

Several individuals, clearly regulars at the site, appreciated that ducks had "chosen this sculpture as a point in their migratory pattern." Some longed to touch it and climb on it; a few students confessed that they had done so. But most interesting, as Gerami observed, were those individuals who insisted the sculpture did nothing for them but went out of their way to sit as close to it as possible, lured there for no other apparent reason.

Critical Issues

Moore's concerns seem to have become increasingly out of sync with contemporary critical issues. Modern art has since its outset been a largely intellectual enterprise; postmodern art, grounded in theory, is arguably even more so. Moore, however, refused to talk about or present his art in this way. He suggested that his work might be open to any number of readings and offered only a few, oft-repeated story lines when asked to discuss its origins.

He also refused to be drawn into art world battles over the relative merits of abstraction and figuration, or the related debate concerning Abstraction and Surrealism. According to Moore, "There is both a surrealist and abstract element in all good art. There is the mixture of emotional or imaginative non-logical inspiration which is the surrealist point of view, combined with the artist's experience and idealism about the art he practices. . . . I would not myself want to be called a purely

surrealist or a purely abstract artist."[45] Apparently seeing both sides, he would not serve as partisan spokesman, but by thus trying to remain above the argument, he could also be perceived as irrelevant to it.[46]

Moore also did not fit the general idea of a modern artist as agonized genius. As his biographer observed: "No one could have been further from the popular conception of the artist as Bohemian, as outsider or as obsessed egocentric than this down-to-earth family man with his preference for regular working hours, his extrovert, unpretentious manner, his sometimes slightly squeaky voice, unfinished sentences, and engaging giggle."[47] In the realm of public art Moore's personality was a real plus. Not only did he serve on museum boards, his friendship with architects generated commissions, and he seemed to meet the general public more than halfway: "I've always tried to give serious answers to questions about my work to whomever might want to ask. I can understand why people come to ask why are my women always fat ones, never thin or why they have holes in them."[48] He never spoke in jargon, occasionally indulged in "looks like" comparisons of his work, and didn't disparage those who did.

Moore's remarks about public art were also at odds with contemporary critical issues that increasingly focused on its appropriateness to its site and the necessity of public involvement and interaction. Moore insisted, "I dislike the idea of making a work for a particular place. . . . I think you should make something that is right anywhere—and then find a happy place for it."[49] He also balked at the idea of commissions: "I don't like doing commissions in the sense that I go and look at a site and then think of something. Once I have been asked to consider a certain place where my sculptures might possibly be placed, I try to choose something suitable from what I've done and from what I'm able to do. But I don't sit down and try to create something especially for it."[50] Instead he thought about aesthetic issues required by the visual parameters of the site: form, scale, color, available light. Although site specificity in public art was initially defined in formal terms as Moore saw it, it evolved to consider elements of local history far more important.[51]

Another problematic aspect of Moore's public art is the number of multiples he authorized. "Gradually, as I became successful, I made bigger editions of my sculptures—after all, it enabled me to go on working. But one has to know where to draw the line. If you make a mold and it can be cast into bronze you could make thirty—even a hundred—casts and they would all be as good as each other. There's nothing wrong in that, it's just that numbers make something less valuable, less unique, so I've always tried to keep these numbers down to below ten."[52] Three is a more customary number for sculpture "editions"; the greater the number, the more likely the same work may serve different purposes in different locations. The Toronto and Dallas Moores (like the Grand Rapids Calder and the Chicago Picasso) have become civic emblems, containers of meaning totally devoid of local content yet also separate from the artist's concerns. Nevertheless, the reputation of the artist appears to bestow a cultural identity, as private ownership of a Moore (or any other artist with a recognizable brand name) confers personal or institutional prestige.

But what role does the public play in all this? Audience participation, in public art parlance, came increasingly to consist of community participation in the selection process and, ideally, in the development and even execution of the work itself. Contemporary public art often

has a social mission, even a political agenda.[53] While the public was rarely involved in the selection of Moore's work, their participation after the fact was very much a "hands-on" affair.

Implicit Intimacy

> Tactile experience is very important as an aesthetic dimension in sculpture. Our knowledge of shape and form remains, in general, a mixture of visual and tactile experiences. . . . Our sense of sight is always closely associated with our sense of touch.
>
> Henry Moore[54]

Moore's creative process began with drawing or with the shaping of small maquettes for larger works. Moore, working these handheld sculptures, began with a visceral connection to his art, regardless of the size or material it would eventually take. The often told (and therefore suspect) tale that is now a standard part of the artist's biography (or mythology) is that the first inspiration for his work came from his childhood chore of rubbing his mother's large back to relieve her rheumatism. However, this sensual (latently sexual) activity and the relative scale of his mother's back to his small hand may indeed be central to much of his work.[55] The issue of scale was certainly a constant.

While many modern public artists implicitly envisioned an admiring or moving viewer, Moore seems to have conceived of a sensate one.[56] One may admire the formal ingenuity of a Calder or smile at its whimsy; one may climb on Mark di Suvero's constructions or move with awe and apprehension through the spaces of Richard Serra's huge sculptures. But one is not moved to touch them. To touch, you must come close and stop. You experience the work, absorb its surfaces and contours, through your hands—much as Moore initially did in making his small maquettes.

The segue from sensual to sexual is an easy one, all the more so in Moore's work because of its frequently androgynous nature. His major breakthrough in sculpture was his 1929 *Reclining Figure,* a female version of the male Chacmool traditionally associated with the Mayan rain god Chaac.[57] The artist himself commented: "My sculptures of women look monumental, like big men."[58] Moore's biographer observed of the Lincoln Center piece: "Like many of Moore's best works . . . [it] can be interpreted in several different ways. The torso is a mother looming over a boulder-like child. It is a male figure, legs parted, body braced for a thrust into the cleft bent temptingly below. . . ."[59] Androgyny as such is apparent in many Moore works, suggestions of phallic forms and breasts coexist comfortably. In his reclining figures, regardless of multivalent gender references, legs are usually open, an indication of sexual readiness.

But the viewer's experience is never voyeuristic, as might be the case with more realistic images. Consider the distinctions in, say, touching the "breasts" of a Botero sculpture and a Henry Moore. The Moore appeals to our sense of touch; his figures are not specific enough to evoke the sense of a "feel." I am suggesting that we apprehend Moore's public sculptures primarily in a tactile, not visual, way. And, furthermore, given the chance, people do more than touch; they nestle, climb, and experience the work in as visceral a way as possible.[60] Hence also the urge to sit near the work even if its appeal is not consciously acknowledged.

Moore's public art career blossomed at a time when an established reputation in the art world was a prerequisite. Nowadays artists are trained to think about public art in graduate school, a recognition that it is in many respects a distinct endeavor. Public art is expected to fulfill different functions from museum or gallery art. It must take into account the expectations of a non-art audience—or, to put it a different way, the apparent vagaries of public response. Although today potential social and political concerns are often discussed in the development phase, public interaction after installation is still largely ignored.

The implicit intimacy of Moore's public art is both seductive and comforting. His sculpture conveys the essence of stability in a notoriously unstable age and familiarity in a period defined by change. Inviting direct contact, or suggesting its possibility, it subverts art's customary "don't touch" status. Yet in many ways his figural abstractions, anchored in early modernism, today seem to belong to another time.[61] So is Moore the consummate public artist or a relic of a more romantic age? Is what you think what you experience?

Notes

I would like to thank my student assistants Sheila Gerami (for her excellent survey of public response at Lincoln Center), Jeanne Kolva (for her useful references and observations), and Pete Mauro, as well as Jed Morse at the Dallas Museum of Art, and researchers at the Henry Moore Foundation for their prompt assistance with a range of queries. I am also grateful to the following individuals who were kind enough to share their unpublished manuscripts with me: Robert Burstow, Margaret Garlake, Steven Gartside, Arie Hartog, Michael Parke-Taylor, Glynn Williams, and Gordon Williams. My mother, Gerda Freitag, provided timely translations of German texts. As always I am indebted to Elke Solomon for many provocative conversations and valuable insights, and, above all, to Burt Roberts, my first and foremost editor.

1. The Moore quotation is from William S. Lieberman, *Henry Moore: Sixty Years of His Art* (New York: Thames and Hudson/Metropolitan Museum of Art, 1983), 13.

2. Moore's so-called Shelter Drawings of individuals observed in London's Underground during German bombardment remain among his most popular works. They played a central role in establishing his reputation in England.

3. For the UNESCO commission, see, for example, "Le Siège de L'Unesco à Paris," *Architecture d'Aujourd'hui* (December 1958): 4–33. See also "UNESCO Headquarters in Paris," *Art and Architecture,* (December 1951): 14–15, and (December 1958): 10–11.

4. Moore observed, "I solved the factor of the sculpture disappearing into darkness by not doing a bronze, but a carving from the same kind of stone as was used on the top of the building but stayed away from the stone that would be immediately behind the sculpture. Your don't want your sculpture to disappear into the architecture." Quoted in Henry Seldis, *Henry Moore in America* (New York: Praeger, 1973), 177.

5. The evolution of this piece in the context of Moore's earlier public art in England is discussed by Margaret Garlake, "Moore's Eclecticism," unpublished paper delivered at the conference *Place Body Script: Contemporary Views on Henry Moore,* University of East Anglia, Norwich, England, 4–6 December 1998 (hereafter referred to as *Place Body Script).*

6. My thanks to Joan Mertens, curator of Greek Art, Metropolitan Museum of Art, for a discussion of traditional depictions of Athena and other possible sources of Moore's reclining figures.

7. John Russell, *Henry Moore* (Middlesex, England: Penguin Books, 1973), 189.

8. Marina Warner, *Monuments and Maidens: The Allegory of the Female Form* (New York: Atheneum, 1985), 87.

9. Erich Neumann, *The Archetypal World of Henry Moore,* trans. R. F. C. Hull (New York: Pantheon Books, 1959).

10. Herbert Read, *A Concise History of Modern Sculpture* (New York: Praeger, 1964), 168.

11. John Hedgecoe, *A Monumental Vision: The Sculpture of Henry Moore* (New York: Stewart, Tabori & Chang, 1998), 73.

12. Robert Burstow, "Henry Moore and 'Open-Air Sculpture': Sunlight, Fresh Air and the Modern Movement in Britain," unpublished paper, *Place Body Script,*

convincingly argues that this value, obvious in Moore's own physical fitness and preference for working out of doors, is also linked to his development of pierced, or what he called "opened out," sculpture.

13. For an account of this commission, see Roger Berthoud, *The Life of Henry Moore* (London: Faber and Faber, 1987), 185 ff.

14. Walter Hussey, *Patron of Art* (London: Weidenfeld and Nicolson, 1985), 33.

15. Gordon Williams, "Herbert Read's Henry Moore: A Historical Fiction?" unpublished paper, *Place Body Script,* 4.

16. For an excellent discussion of its significance, see Margaret Garlake, *New Art, New World* (New Haven: Yale University Press, 1998), 212. In postwar London the sculpture was understood as a reference to "the endurance of the civilian population in wartime" and "taken as a prototype for a new kind of public art . . . one that would complement the reconstructed cities, and, most importantly, proclaim the values of the New Britain." Garlake, "Moore's Eclecticism," sees the left-hand figure as resembling "an upright version of the *Memorial Figure* (1945); she finds "the others are ambiguous in gender and have lumpish, ungraceful draperies."

17. Berthoud, 212–15. He concludes, "Moore returned home from his five days in Italy a stage further in his emergence as a National Treasure."

18. Quoted in Dorcas Taylor and Axel Lapp, *Sculpture for a New Europe: Public Sculpture from Britain and the Two Germanies: 1945–68* (Leeds: Leeds City Art Gallery, 1999), n.p. I follow their account here.

19. David Mitchinson, introduction to *Celebrating Moore: Works from the Collection of The Henry Moore Foundation,* ed. David Mitchinson (Berkeley: University of California Press, 1998), 31. The exhibitions are discussed here in some detail.

20. Berthoud, 338.

21. The initial impetus for the competition came from the director of the university public relations office, who had recently worked for Argonne National Laboratory. Eventually approved by the university president, it became a reality when the Italian government became part of the commission. The Fermi committee approached both Moore and Jacques Lipchitz in 1963. The latter refused to think about the commission without a contract, while Moore agreed to proceed without a commitment and even donate the work should it be approved. For a detailed account of the commission, see David H. Katzive, "*Nuclear Energy*: The Genesis of a Monument," *Art Journal* (spring 1973): 284. My account of the commission is largely based on this article.

22. For a full account of Moore's development of this theme, see Michael Kausch, "Henry Moore—Mensch und Natur," in Wilfried Seipel, *Henry Moore 1898–1986: Ein Retrospektive zum 100. Geburtstag* (Vienna: Kunsthistorisches Museum, 1998), 46–48.

23. Katzive, 286.

24. John Read, "Maquette for Atom Piece, 1964," in David Mitchinson, *Celebrating Moore,* 281.

25. See Harriet F. Senie, *Contemporary Public Sculpture: Tradition, Transformation, and Controversy* (New York: Oxford University Press, 1992), chapter 3, 93–139.

26. Quoted in John Wetenhall, "The Ascendency of Modern Public Sculpture in America," unpublished Ph.D. dissertation, Stanford University, 1988, 260.

27. Wetenhall, 262.

28. The negotiations with Toronto were also facilitated by Moore's concurrent problematic negotiations with the Tate for a large donation of his work. The unfolding of these events is presented in Michael Parke-Taylor, "Cultural Ambassador or Cultural Imperialist?: The Reception of Henry Moore in Toronto," unpublished paper, *Place Body Script.*

29. Wetenhall, 258.

30. Quoted in Berthoud, 315, from an interview in 1982. For an account of the Toronto commission, see Berthoud, 314–29. See also Wetenhall, 257–270.

31. Parke-Taylor, 2.

32. See Berthoud, 380–82, for an account of the commission.

33. For a discussion of this piece see Norbert Lynton, in Mitchinson, *Celebrating Moore,* 288–89.

34. Janet Kutner, "Moore's 'Inhabitable' Sculpture," *Artnews* (March 1979): 12.

35. Helen Parmley, "Dallas in Awe of Sculpture—Whatever It's Supposed to Be," *Dallas Morning News,* 5 December 1978, 3A. More positive feedback was reported by Jere Longman, "City's New $450,000 Sculpture Stirs Comments from Passersby," *Dallas Times Herald,* 5 December 1978.

36. Bill Marvel, "The Dallas Piece: It Just Fits the City," *Dallas Times Herald,* 6 December 1978.

37. Lorraine Smith, "Moore Installs His 'Vertebrae' in Front of Dallas City Hall," *Architectural Record* 165 (February 1979): 39.

38. Kutner, 12.

39. Michael E. Young, "Bronze Sculpture Retakes Its Place near City Hall," *Dallas Morning News,* 17 November 1996, 23A, 29A. See also Todd J. Gillman, "Much-Needed Face Lift: Charity Funds to Help Taxpayers Repair City Hall Sculpture Marred by Graffiti," *Dallas Morning News,* 26 October 1996, 33A, 38A.

40. "Moore Sculpture: Vandalism of Work Also Defaces Dallas," *Dallas Morning News,* 1 November 1996.

41. Wetenhall, 189.

42. Berthoud, 295.

43. Quoted in Berthoud, 299.

44. Donald Gormley, in a conversation with the author on 9 February 1978, recalled some of the backstage maneuvering that went on in the summer of 1965. Gormley, who was secretary of the Art Commission in 1965, reported that August Heckscher, director of the Twentieth Century Foundation, called Mayor Robert F. Wagner to tell him that Morris was making a fool of himself. Alfred H. Barr Jr., director of collections at The Museum of Modern Art, New York, had dinner with the mayor to discuss the issue. The mayor in turn told Morris to go ahead and submit the sculptures to the Art Commission as requested. In the meantime the entire Art Commission was brought to Lincoln Center to view the intended locations, together with enlarged photographs of the sculptures. The general response seemed ambivalent; many felt that better examples of the artists' work could have been found. However, the night before the Art Commission meeting of 12 July 1965, Heckscher personally telephoned all the members and told them they would be laughed out of town if they voted down the two sculptures. Apparently the Moore was already on its way at the time of the meeting. For a more complete account of the circumstances of the commission, see Senie, 106–10.

45. Hedgecoe, 72.

46. Berthoud, 151, observed that Moore "contrived to sound both statesmanlike and disdainful. . . . It was by rising above the battle in this very self-assured way that Moore was able . . . to keep a foot in both camps."

47. Berthoud, 14.

48. Hedgecoe, 160.

49. David Finn, *Henry Moore: Sculpture and Environment* (New York: Harry N. Abrams, 1976), 190.

50. Seldis, 176–77.

51. For various interpretations of the evolution of the concept of site specificity see Erika Suderburg, ed., *Space, Site, Intervention* (Minneapolis: University of Minnesota Press, 2000).

52. Hedgecoe, 159.

53. See, for example, Mary Jane Jacob et al., *Culture in Action* (Seattle: Bay Press, 1995); Suzanne Lacy, ed., *Mapping the Terrain: New Genre Public Art* (Seattle: Bay Press, 1995); and Arlene Raven, ed., *Art in the Public Interest* (Ann Arbor: UMI Research Press, 1989).

54. Henry Moore, in an interview published in the *Observer,* 10 April 1960; quoted in Philip James, ed., *Henry Moore on Sculpture* (New York: Viking Press, 1967), 131.

55. Berthoud, 26, observes that this experience "with all its Oedipal undertones doubtless played no small role in shaping his preoccupation with the female figure as a theme." I am emphasizing the sensual, visceral experience rather than its sexual connotations as the more influential aspect.

56. Neumann, 71, observed: "The movement of the eye becomes a sort of stroking movement, a caress, through which we experience mass and volume with the sense of touch, that is, as a true spatial structure. . . . By forcing us into a tactile experience, he calls awake the archaic—and infantile—experience of man, who now lets his touch play lingeringly round the immensity of woman."

57. Kausch, 19 ff., discusses the evolution of the theme of the male/female in Moore in terms of Jungian archetypes, going back to Neumann's approach.

58. Hedgecoe, 117.

59. Berthoud, 300.

60. Kate Wagenknecht-Harte, *Site + Sculpture: The Collaborative Design Process* (New York: Van Nostrand Reinhold, 1989), ix, dates her involvement with public art to her days at Princeton University, when "there was always someone curled up in Henry Moore's *Oval with Points.*"

61. This argument is convincingly presented in Arie Hartog, "Ein Bildhauer in der Modernen Gesellschaft: Beobachtungen zu einem beruhmten Bildhaur: 1945–1960," in Ferdinand Ullrich, and Hans-Jurgen Schwalm, eds., *Henry Moore* (Recklinghausen: Ruhrfestspiele Recklinghausen, 1999), 27–37.

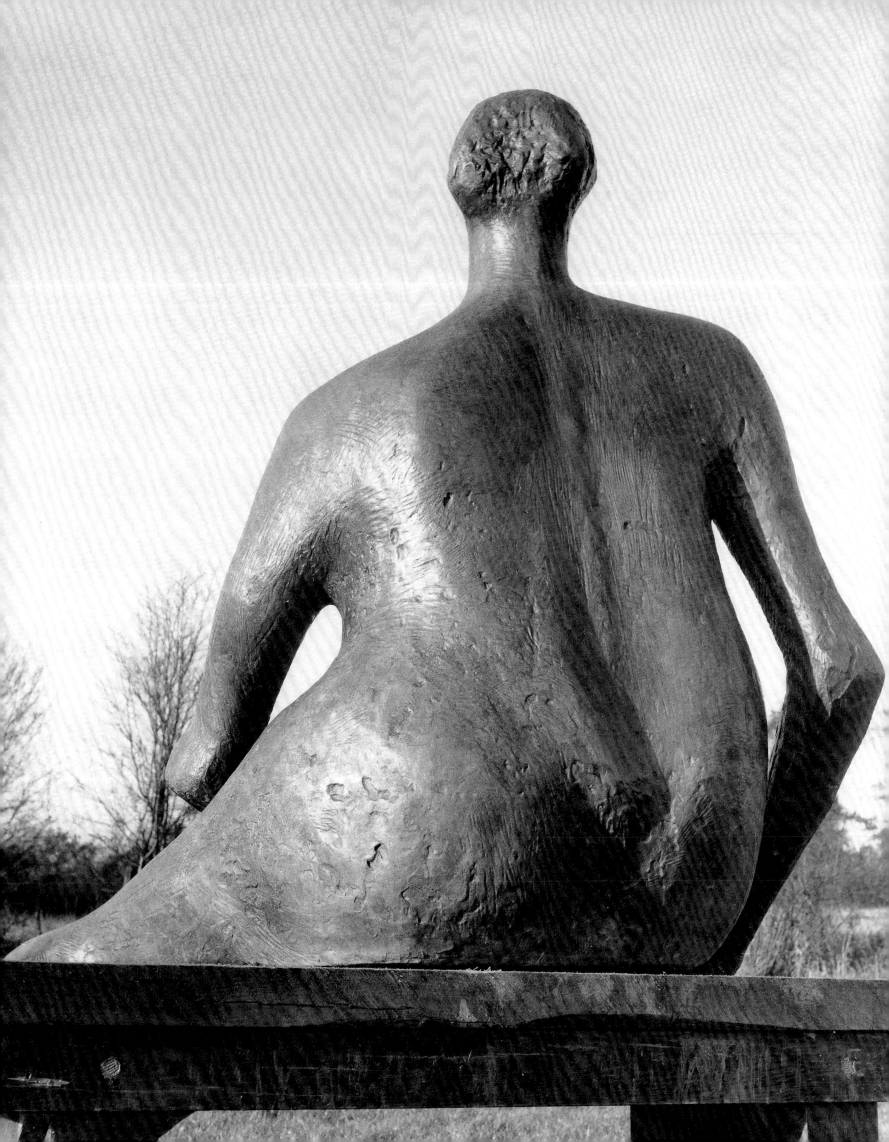

Elizabeth Brown

Moore Looking: Photography and the Presentation of Sculpture

Investigating Henry Moore's photographs promises a kind of direct access to the workings of his mind. Ostensibly documentary, the images Moore took of his own sculptures reveal—and sometimes revel in—details of texture, juxtaposition, and allusion. His extensive photographs gloss and modify the work in scale, lucidity, and mood. Moore spoke and wrote cogently about his goals at the same time, and saw them published in 1966 in *Henry Moore on Sculpture,* a compilation of his observations, statements, speeches, and interviews edited by Philip James.[1] Tracking the relationship of Moore's photographs to these writings provides an interesting path into the artist's career. The close examination of two examples, one from his early work and one representing the intense achievement of the post-war period, reveal an inquisitive artist who thought visually, who began with specific ideas about what he could accomplish and often fell in love with his own creations. These works show Moore at his best: open-minded, nuanced, and complex.

Moore's reputation has suffered intensely from his successes. The fact that his work was at once archetypally modern and totally accessible helped him to be conceptualized and marketed as the Great White Hope of British art. It assured no resistance to massive works being erected in public spaces, as Harriet F. Senie chronicles. Anthony Caro and Bill Woodrow, erstwhile studio assistants, alongside many others of their generation, were empowered to define a new aesthetic *against* the strong identity of Henry Moore. It has become difficult, and sometimes impossible, to "see" the work any more. One piece melts into the next until all seem to be the same large mass, corporate decoration, visual furniture. But Moore's work deserves better. Fifteen years after his death marks the ideal time to reconsider a long, rich, and varied career. The way we do that now is by deconstructing the apparatus and seeking to examine those forces alongside—rather than on top of—the art objects themselves. This is one process where the artist's photographs are eminently useful. They provide a direct viewing of the sculpture, stripped from its corporate (or museum) sanction, isolated from the comments of others. The voice behind these images is Moore's own, twice over, his view of his own work. It speaks volumes.

There are two sets of problems in the intricate relationship between sculptures and their reproductions. One is the complexity of translation, the myriad ways a photograph of an object misleads the viewer about the actual nature of that object. The other is the ubiquity of photographs. Today it is second nature to expect that we can identify, track, and analyze any number of things based on their photographic record, from people—identified by their driver's license, passport, or website portrait—to places and products. No matter how often art historians evoke the inherent lie of photography, none of them can resist the ease and clarity of working from slides, plates, or scans. It is important to try to reconstruct when this habit moved from unprecedented to workable and then from novel to commonplace. By the early 1920s several art magazines such as *Cahiers d'art* (France) and *Magazine of Art* (United States) regularly published photographic reproductions of works of art, both two- and three-dimensional. Their images represent one of the first speeded up means of international art exchange. By the second quarter of the twentieth century, the international art world was one stage upon which artistic fame was negotiated and achieved.

As a consequence few artists remain naive about the power and potential of the camera. Because photography is the medium by which most viewers see most (important) sculptures, the relationship between these two practices is crucially important. Moore, familiar with sculpture through the camera's eye in his training, brought enormous subtlety and openness to the question of reproducing his own sculpture. He seems to have documented a high percentage of his work: several early works are known only because he photographed them. Over the first fifteen years of his career, roughly from 1923 to 1938, his photographic practice was irregular and often minimal. Beginning in the mid-1930s, his photographs become more regular. Each of the major works from the decisive period following the end of World War II is the subject of extensive photographic examination. Comparing early and mature practice will contribute substantially to comprehending the artist's intentions.

Seated Woman, 1957 (LH 435)

Moore's art was always involved with photography, beginning with the historical reproductions he saw in books and *Burlington Magazine* and the modern art he viewed in contemporary magazines such as *Minotaure, Formes,* and *Studio.* By 1919, when he was studying at the Leeds School of Art, he was familiar with the major developments across the Channel, including the work of Auguste Rodin and Paul Cézanne. Moore chose to emphasize the influence of the "primitive" carvings he viewed at the British Museum, which he could refer back to in photographs. He also acknowledged the impact of his countryman Henri Gaudier-Brzeska, work he discovered in the monograph by Ezra Pound. Many of his earliest works, carved directly in blocks of stone, attest to those crucial forces, but also suggest a familiarity with André Derain and especially Constantin Brancusi. By the early 1930s Surrealism entered his vocabulary with a vengeance: we can track elements from Pablo Picasso and Joan Miró, Alberto Giacometti and Jean Arp, at play in his formal inventions.

Henry Moore photographed his own sculptures frequently, often beginning with a specific function in mind. Some of these images appear "neutral" or dispassionate; others editorialize or comment poetically with great liberty. All of them, from the straight images to the dramatized, indicate important evidence about the relationship between the object and its maker. In their choice of viewing angles and lighting conditions, they reveal a certain mood and visual effect. By manipulating the setting and the internal scale Moore was able to experiment with the ultimate presentation and effect of his creation. Not infrequently the artist found myriad details of interest in a single sculpture, returning again and again to picture parts, angles, and qualities that retained his interest. Some of these images likely reveal Moore's unconscious response to the figure, although the artist was careful not to question his deep-seated intentions, preferring instead just to indulge them. He avoided others' analyses as well, as he recounts:

> . . . there was a book published on my work by a Jungian psychologist; I think the title was *The Archetypal World of Henry Moore.* He sent me a copy which he asked me to read, but after the first chapter I thought I'd better stop because it explained too much about what my motives were and what things were about.[2]

In 1934 Moore, as a participant in the artistic group Unit One, contributed a manifesto of sorts that laid out five principles central to his art.[3] Throughout the rest of his career the artist's photographs evidenced the importance and the persistence of these principles. The first in his statement and in his photography as well, was "truth to material." From as early as 1929 Moore's photographs convey specific qualities of the different stones and woods he was carving. His image of the Leeds *Reclining Figure* (fig. 1), in brown Horton stone, emphasizes the blockiness of the sculpture, permitting the viewer to imagine the original stone block from which it was carved. Each internal form recalls the action of chisels and other carving tools: the right angles of elbows, neck and shoulder, breast and belly; the wedge shapes of the canted legs; the abrupt drill holes of eyes, nipples, and navel. Also visually engaging is a range of finishes, from the roughed block left to serve as pedestal to the relatively fine-grained passages of long muscles and rounded flesh. The background of this image seems to be a wall of the studio. Lines and motifs behind the figure may attest to Moore's working process in these early years, whether

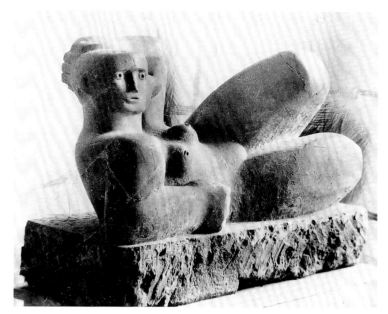

Fig. 1. Henry Moore, *Reclining Figure,* 1929. Leeds Museums and Galleries (City Art Gallery) (LH 59)

he drew directly on plaster walls or hung large drawings near the carving area. This trace of process furthermore contributes to the vitality of the image, where the figure can be read as assuming three-dimensional form and gaining consciousness.

Comparing this image to a similar, slightly later *Reclining Figure* (cat. 10) reveals Moore's use of simile as another expressive device in the early photographs. The topography of both figures evokes rolling terrain and abrupt hills, making reference to the English landscape, redolent in meaning for centuries. These allusions further accentuate the artist's responsiveness to his materials and their intrinsic qualities, in form as well as meaning: "It is only when the sculptor works direct, when there is an active relationship with his material, that the material can take its part in the shaping of an idea."[4] Later in his career Moore sought to soften his dogma of "truth to material."

> When I began to make sculptures thirty years ago, it was very necessary to fight for the doctrine of truth to material (the need for direct carving, for respecting the particular character of each material, and so on). So at that time many of us tended to make a fetish of it. I still think it is important, but it should not be a criterion of the value of a work—otherwise a snowman made by a child would have to be praised at the expense of a Rodin or a Bernini. Rigid adherence to the doctrine results in domination of the sculpture by the material. The sculptor ought to be the master of his material. Only, not a cruel master.[5]

"Full three-dimensional realisation," the second principle in Moore's Unit One manifesto, seems to have been somewhat harder to achieve. For several sculptures before 1934 Moore tried out two, and occasionally three distinct viewing angles, nearly always identifying one primary view. His photographs either select the "face" or a three-quarter view; a second image usually approaches the figure from its foot, again at a three-quarter angle. *Four-Piece Composition: Reclining Figure* from 1934 (cat. 26) may be the first sculpture that Moore's camera could really examine "fully in the round [finding] no

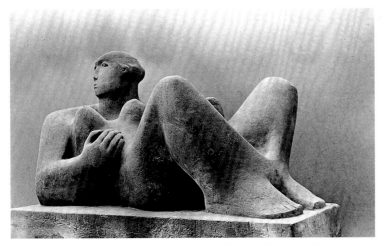

Cat. 10. Henry Moore, *Reclining Woman,* 1930. National Gallery of Canada, Ottawa, Purchased 1956 (LH 84)

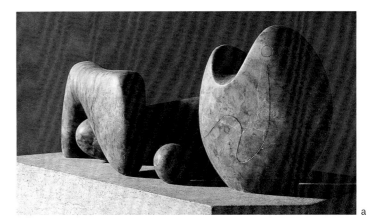

a

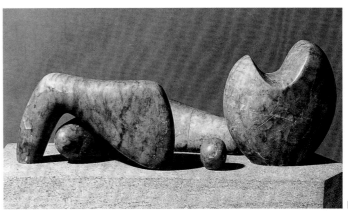

b

two points of view alike."[6] Examining the photographic record helps us track his learning curve on spatial complexity. Earlier sculptures by Moore have one view or occasionally two. Both fig. 1 and cat. 10, for example, have two views that we can link to the artist, and they follow the same model: three-quarters from the head, three-quarters from the foot. The four images by which Moore circled *Composition* establish a fuller sense of multiple viewing angles. Furthermore, he employed most if not all of them, selecting different images for reproduction in two of the monographs that celebrated his seventieth birthday. Exploiting this variety can be seen as establishing a model for later photographic documentation.

Moore's photographic experimentation with *Composition* is recorded for posterity. One of the artist's notebooks (Small Notebook, c. 1934–35, HMF 57) preserves pages of notes recording shutter speed, light conditions, and viewing angles, which he tracked to compare their effects. Presumably Moore's original intention focused more on improving his photographic technique than on expanding the theoretical depth of his sculpture. Each entry is annotated—evidently at different times—"good," "v. good," "not very good," "underexposed," and so on. Perhaps the artist sought to establish rules for achieving attractive images. However, this session also revealed the benefits of making several different images of one sculpture. *Composition* was one of Moore's most abstract works to that date. It is also one of the first where he breaks up the body into constituent parts, each a metonymy for certain properties of the body. Influenced by the fragmentation of biomorphic Surrealism, this analysis also depends on the shifting signifiers and cumulative meanings of Cubist representation. Each of the parts is abstracted, suggesting organic form and anatomical structure. But the components are disposed on a plinth as if scattered. Instead of a central spine or core, the middle of the sculpture is more or less empty, its elements flowing off in every direction. Thus Moore's photographic series contributes substantially to the viewer's understanding of his concept. Each photograph essentially presents a wholly new and different composition. Each juxtaposes familiar details or passages alongside the uncanny ones. In view b the head reads as clearly as Brancusi's *Newborn,* and the legs are disposed casually, like those of a Matisse nude. In view c the parts seem to function more mechanically, as if linked by gears and shafts. Space feels most generous in view d. The ways

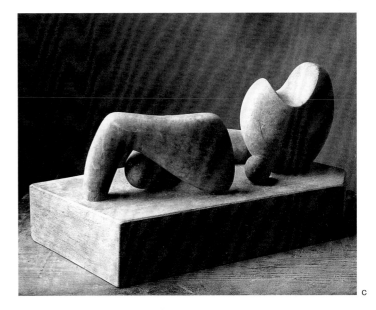

c

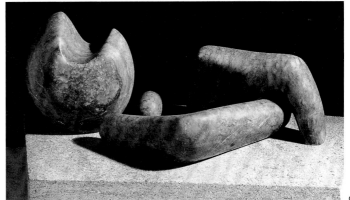

d

Four views of cat. 26, Henry Moore, *Four-Piece Composition: Reclining Figure,* 1934. Tate. Purchased with assistance from the National Art Collections Fund 1976 (LH 154)

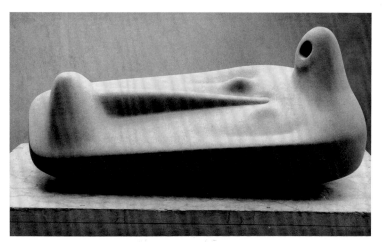

Cat. 27. Henry Moore, *Reclining Figure*, 1934–35. The Moore Danowski Trust (LH 155)

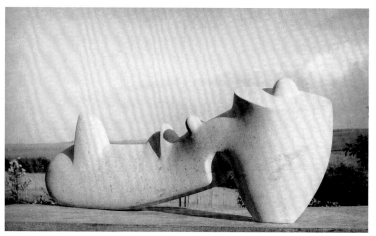

Cat. 33. Henry Moore, *Reclining Figure*, 1937. Fogg Art Museum, Harvard University Art Museums, Gift of Lois Orswell (LH 178)

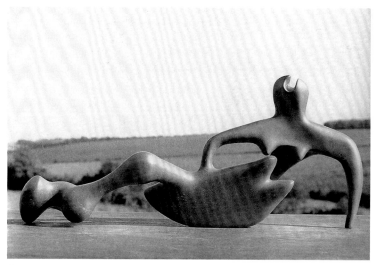

Cat. 39. Henry Moore, *Reclining Figure*, 1938. The Museum of Modern Art, New York, Purchase, 1939 (LH 192)

these photographs adjudicate between abstraction and representation is clarified by comparing one of Moore's images of the next sculpture he made, *Reclining Figure,* 1934–35 (cat. 27). Drawing on the visual puns of Picasso's early Cubism, Moore plays up a secondary reading of the figure as a squared-off African mask, or perhaps a face drawn in the Nasca lines.

Another model Moore establishes here is a way of exploring scale, particularly as a means of evoking monumentality. By placing the sculpture's plinth in the extreme foreground against a neutral background, he eliminates clues about its actual size. *Composition* may be read as being as large as Moore's public installations, although it is in fact a tabletop piece. The artist was able to explore the possibility of enlarging many subsequent works using this technique: the sculpture is massive in the pictorial scale of the photograph to test its suitability as an oversized piece. Such lyrically odd sculptures as *Reclining Figure,* 1937 (cat. 33), and *Reclining Figure,* 1938 (cat. 39), were photographed under very similar conditions. Each sits on a pedestal in the extreme foreground, with a vast landscape behind. Although the *Reclining Figure* (cat. 33) only exists in this marble version, thirty-three inches long, the latter was re-created as a monumental work: as the bronze sculpture raised on a grass mound, it is the summation of the installation at Moore's estate in Much Hadham.

> There is a difference between scale and size. A small sculpture only three or four inches big can have about it a monumental scale, so that if you photographed it against a blank wall in which you had nothing to refer it to but only itself— or you photographed it against the sky against infinite distance—a small thing only a few inches big might seem, if it has a monumental scale, to be any size. Now this is a quality that I personally think all really great sculpture has.[7]

Moore's successive photographs of *Four-Piece Composition: Reclining Figure* (cat. 26) cull its representational features at the same time they deny them. For example, view b, which he called a front view, evokes the choppy angles and episodic representation of the earlier reclining figures. Moore describes view a, reproduced in John Russell's monograph, "3/4 view from head end." This view is perhaps the hardest to read as figural but easy to parse in relation to intact figures: two legs, both generalized and odd forms, condense

the functions of knees, long muscles, and feet into inflected form and a single juncture. The largest form, a late crescent moon, round with a bite out of the top, stands in for the curve and mass of a back, yet the shallow etched lines that articulate its surface identify the features of the face. The fourth component, a free-standing ovoid, is at once the most allusive and the most mysterious. It recalls the densely meaningful use of egg-shaped forms in the work of several contemporary artists. Two examples should suffice: Joan Miró and Constantin Brancusi. Miró's poetic paintings of the 1920s frequently include ovoid motifs, variously identified as a flower-egg, sun-egg, or sex organs. Brancusi's egg-shaped *Beginning of the World,* executed first in marble, is usually dated around 1920. The specific and highly poetic title evokes dense associations with the reductive form: we are reminded that all creation grows from a zygote. At the same time the ovoid suggests the general form of bodies, particularly the central core of the female body. Moore cited *The Beginning of the World* both to acknowledge and to dismiss Brancusi's influence.

Both Moore and his mentor Jacob Epstein were indebted to Brancusi's example. Their definition of sculpture as carving, their use of radical or drastic abstraction—particularly in eliminating whole segments of bodies—and their artistic identities seen in opposition to the workaday world all depend on the image and achievement

Fig. 2. Edward Steichen, Constantin Brancusi's *The Beginning of the World,* c. 1926, gelatin silver print, Musée national d'art moderne, Centre Georges Pompidou, Paris

Fig. 3. Arrangement of shells and crab claws in Moore's studio

of the sculptor from Romania. Moore preferred to emphasize his differences:

> Since the Gothic, European sculpture had been overgrown with moss, weeds—all sorts of surface excrescences which completely concealed shape. It has been Brancusi's special mission to get rid of this overgrowth, and to make us once more shape-conscious. To do this he has had to concentrate on very simple direct shapes, to keep his sculpture, as it were, one-cylindered, to refine and polish a single shape to a degree almost too precious. Brancusi's work, apart from its individual value, has been of historic importance in the development of contemporary sculpture. But it may now be no longer necessary to close down and restrict sculpture to the single (static) form. We can now begin to open out. To relate and combine together several forms of varied sizes, sections and directions into one organic whole.[8]

Enabling that reading was the photograph Moore reproduced several times (fig. 2), notably in the first volume of the Lund Humphries catalogue raisonné of his work. Believed until recently to be one of Brancusi's own photographs, this abstracted and highly dramatized image is actually by Edward Steichen. The latter was much more invested in seeing Brancusi as abstract, spiritual—in a word, radical. Moore uses this photograph, rather than a much more open-ended and multifaceted image of Brancusi's *Sorceress,* for example, usually photographed surrounded by many other sculptures. He creates a direct opposition between himself and a symmetrical, static, closed Brancusi, thereby clearing a wide territory for his own work. But this is a false opposition. None of Brancusi's sculptures is truly symmetrical, few cleave to the closed outlines Moore attributes (and reproduces). Although they are highly reductive in comparison to Moore, although Brancusi processes and reworks forms to the point

where their connection to the natural world is nearly severed, his sculptures always retain a link to the irregularity and vitality of nature.

This leads us to Moore's third principle, the "observation of natural objects": "There is in nature a limitless variety of shapes and rhythms (and the telescope and the microscope have enlarged the field) from which the sculptor can enlarge his form-knowledge experience."[9] In 1934 Moore might have intended this statement to underscore the importance of representation and to emphasize that no matter how reductive or abstract his figures, they always retained some link to human bodies in the real world. As his work developed through the ecstatic experimentation of the middle to late 1930s and the more serious, self-consciously monumental art produced following World War II, Moore's process of observing natural objects shifted and deepened. He collected stray naturalia, unusually shaped stones, animal bones, driftwood, and various fragments as inspiration, provoking new formal notions as the basis for his sculptures. His studios at Much Hadham, which have been preserved and are open to visitors, are replete with this stuff, intermingled with *ébauches* and sketch models they inspired. Several photographs also preserve Moore's apperception of found objects: shells and crab claws arranged in a single row (fig. 3), portrait-like views of a piece of driftwood shaped like an antelope head or an openwork entwined ivy branch.

> I think a sculptor is a person who is interested in the shape of things. A poet is somebody who is interested in words; a musician is somebody who is interested in or obsessed by sounds. But a sculptor is a person obsessed with the form and the shape of things, and it's not just the shape of any one thing, but the shape of anything and everything: the growth in a flower; the hard, tense strength, although delicate form of a bone; the strong, solid fleshiness of a beech tree trunk. . . . They're all part of the experience of form and therefore, in my opinion, everything, every shape, every bit of natural form, animals, people, pebbles, shells, anything you like are all things that can help you to make a sculpture. And for me, I collect odd bits of driftwood—anything I find that has a shape that interests me—and keep it around in

that little studio so that if any day I go in there, or evening, within five or ten minutes of being in that little room there will be something that I can pick up or look at that would give me a start for a new idea.[10]

In the back room of the Bourne maquette studio are shelves, drawers, and cabinets packed with these found objects. Fragments and pieces of every sort of found object jostle maquettes made of plaster or jury-rigged from these primary materials. Shells and crab claws, among other flotsam, were lined up and photographed to remind Moore of suggestive form. Frequently he worked out an idea by casting these elements or adding to one directly in plaster or other materials. *Reclining Figure: Hand* (LH 709), *The Arch* (*Large Torso*, LH 503), and many other figures were invented in Moore's extended contemplation of his collections of forms. Many of his sculptures retain these traces proudly. The inventive and improbable heads of *King and Queen* (cat. 61) are another example. The two figures show Moore at his most classical. Their bodies are very similar, largely flat and wide, with broad shoulders, narrow waists, and attenuated limbs. Besides his slightly larger size and somewhat more active gesture, the King is virtually identical to the Queen, who is distinguished as female by the application of two bumps across her chest. But the heads are distinctive and unprecedented, purely invented forms that are at once otherworldly and plausible. These odd arrangements of bands, rods, and hollows were inspired by fragments of bones, bovine vertebrae, or elephant skulls stocked among the contents of this inspirational studio.

In a photograph by Gemma Levine, the aged Moore demonstrated the inspiration such found objects provide. Her photograph (fig. 4) focuses lovingly on the craggy, massive, yet delicate hands of the aged sculptor. This is a characteristic image, a trope of sculptural admiration, comparable to numerous images by Eugène Druet and other photographers, of modeled hands by Auguste Rodin. In Levine's image Moore's hands cradle a familiar form, gently biomorphic curves that suggest the figure of a reclining woman. Moore produced dozens of versions of the reclining (female) figure, working through the infinite visual allusions of abstracted curvilinear form. However, in this photograph Moore holds not a realized sculptural idea but its source. He presents two or three irregular stones, or possibly eroded bone fragments. In this temporary juxtaposition the pieces compose a figure, one reminiscent of the *Reclining Figure: Hand,* for example. A figure seems to spring into being by virtue of the artist's activity, or simply his volition. This recorded performance provides a perfect metaphor for the ways Moore defined the act of creation: weaving together an inspired study of natural form—which included recognizing the principles of form, materials, and growth—with the personal vision and agency of the artist.

Levine was only one of several talented photographers who worked closely with Moore, increasing his fame and celebrating his achievement. Many photographers were able to develop their own standing in the art community by their proximity to the master, finding inspiration by matching their vision against his and honing their strengths by the collaboration. For decades Errol Jackson worked directly with Moore and photographed the artist's studio and his works, in sketch form, in progress, and once completed. Jackson met Moore in 1961 and worked with him continuously until Moore's

Cat. 61. Henry Moore, *King and Queen* (detail), 1952–53 (cast 1957). Tate, presented by the Friends of the Tate Gallery with funds provided by Associated Rediffusion Ltd. 1959 (LH 350)

death; his archives are now part of the Henry Moore Foundation. Moore's bibliography teems with such collaborations: seven books by or with David Finn, three each with John Hedgecoe and Levine, among other examples. His numerous associations suggest a deep sophistication about the uses of photography to define and promote the artistic career. Early sculptures in Moore's own archives are recorded by photographs stamped with a variety of names, including Maurice Ambler, A. C. Cooper, Alfred Cracknell, Ida Karr, Paul Laib, Lidbrooke, E. J. Mason, Roger Maynes, O. E. Nelson, Nathan Rabin (New York), S. Reed, Adolf Studly (New York), and Soichi Sunami (Museum of Modern Art, New York). These numerous names and endless piles of images reveal an extraordinary sophistication about the power of photography to promote and explicate sculpture. Moore himself often selected the work of photographers over his own images. Perhaps he preferred the professional's finer grain, greater depth of field, more precise control of light. To my eyes, however, Moore's photographs are always more interesting and more telling.

Fig. 4. Gemma Levine, *Henry Moore's Hands,* gelatin silver print

Fig. 5. Installation of ten photographs of *Standing Figure* (LH 290)

When shadows obscure some of the details of a large figure, or highlights stress outline over the surface texture, these factors contribute to the meaning of the image, to the significance of that sculpture seen at that moment.

The other two principles of Moore's artistic credo may be thought of as more involved with value judgments of quality. "Vision and expression" and "vitality and power of expression" both seek to define the content of the work, as opposed to its form. "My aim in work is to combine as intensely as possible the abstract principles of sculpture along with the realisation of my idea. . . . Abstract qualities of design are essential to the value of a work, but to me of equal importance is the psychological, human element."[11] Thus Moore defined what he meant by "vision and expression." The ideal sculpture would possess an effective and affective form, yet retain its "humanist" connection to figuration. Evidence of this concern persists throughout Moore's career. During the late 1920s and early 1930s, while experimenting with strategies of abstraction, his photographs often help to restore a sense of the personal in selected views of the sculpture. The numerous photographs of *Standing Figure* (fig. 5) demonstrate how sculptured metal could take on a lively unpredictability. In the context of postwar Britain, this solitary figure assumes a mythic heroism, bravely facing the unknown in a vast and barren space. Moore delighted photographically in this sculpture, which changed dramatically with only slight adjustments in his viewing angle. Preserved in the Bourne maquette studio is a board with seven different photographs of *Standing Figure*, juxtaposed to two shots of the so-called *Glenkiln Cross* (*Upright Motive No. 1,* 1955–56, LH 377). Its presence suggests that the photographic variants also helped to provide inspiration, reminding Moore of the infinite variability of his own inventions.

Moore's photographs seek ways to demonstrate the vitality of his sculptures and the power of his expression. In so doing, they also signal the ways he wanted his art to function. As we have seen, his photographic experience helped Moore refine and emphasize the viewer's discovery of each sculpture in the round. As he photographed certain figures repeatedly, in essence he led the viewer through a comparable process, one of lavishing endless attention on an individual work of art. One can begin to chart the relative importance Moore

imputed to specific works by the complexity of their photographic exploration. Thus the *Madonna and Child* for Northampton, the Dartington Memorial, the two public Family Groups, *King and Queen, Reclining Figure: Festival,* and several other public installations following the end of World War II all prompted extensive photographic exploration. Moore charted the realization of the Northampton Madonna and also the elmwood *Reclining Figure* in numerous images. When Rodin had photographers image his unfinished sculptures, he had been experimenting with different solutions for finish or gesture. Moore's intention seems rather different, to emphasize the intrinsic interest—both technical and sensory—of the carving process. *King and Queen* he explored differently, using the camera to scan the sculpture, examining details closely as if admiring them. Other images test the ways the group functions differently in different settings and when approached from various sides.

Moore's expanded official role during the war is explored by Julian Andrews. Inevitably affected by those experiences, his world was also rocked by two personal events: the death of his mother in 1943 and the birth of his first and only child, Mary, in 1946. Moore's postwar art is enormously modified by his (most likely fantasy) experience of childbirth. Postures and gestures of birthing recur far more in the sculptures devised between 1946 and the late 1950s than do images of the "damaged man," as in Francis Bacon and Graham Sutherland, to name only two examples. The subtext of childbirth can be read perhaps most clearly by comparing *Reclining Figure: Festival,* 1951 (view a, cat. 55) with the prewar *Reclining Figure,* 1938 (cat. 39). Both share one of Moore's most effective kinetic devices, his metaphorical association of the figure's shoulders to the arched span of a bridge. In both images, this forceful gesture thrusts the head to the summit, the fullest extension of the neck. The abstracted mouth opens like a beak to shout at the skies. Whereas in cat. 39 the props read ambiguously as complete arms, in cat. 55 the figure clearly supports herself on her elbows, which provides the lower abdomen with more downward thrust. In Moore's most employed photograph, only the head of cat. 39 breaks the horizon. The rest of the body alternately echoes and enframes the placid landscape behind it. Particularly shapely is the lower body, a unified thorax and undulating leg, which delineates equally biomorphic negative spaces. In many different photographs the back and chest of cat. 55 open up to contain and embrace the landscape, whether tree branches in view b or the line of the horizon in view a. In the greatest contrast to the earlier figure, the hip region is activated rather than relaxed: the pelvis is opened, the legs separated, and the entire thorax thrust forward. The figure receives but also produces, as if in the middle of birthing a new nation.

Festival intermingles the primary motifs of Moore's wartime experiences, conflating the birthing potential of the opened-up female body with the barrel-vault motif of his Shelter Drawings. The photograph shot from the figure's back (see p. 12) reads the echoing ribs of architectural vaulting in the bony structure of her body. Reminiscent of the engineering of the London Tube, which had been transformed into shelters to house the thousands of citizens driven from their homes by German bombardment, this view articulates a passageway. The telescoping space urges us to crawl in and through, promising a liberating rebirth at the other end. In this comparison cat. 39 is the classic object of desire, signifying lyrical pleasure and voluptuous sensation. The matte gleam of the polished lead, used for

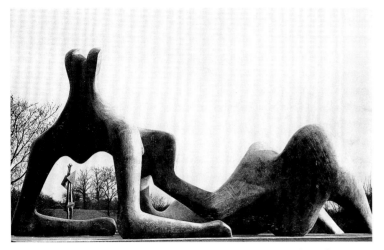

View a, cat. 55, Henry Moore, *Reclining Figure: Festival,* 1951, in Perry Green (LH 293)

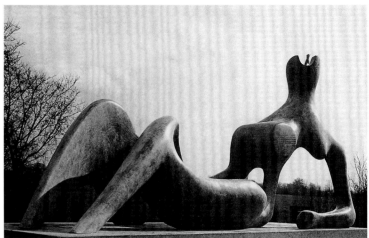

View b, cat. 55, Henry Moore, *Reclining Figure: Festival,* 1951, in Perry Green (LH 293)

Moore's first cast of the sculpture, suggests close-grained, smoothly caressable forms. Cat. 55 explicitly associates triumph with fertility, positing England as the great mother who heals the earth by her embrace as she engenders future generations. The texture of the figure is much more worked, almost as if scarred. Both of these, however complimentary their intentions, are objectifications. The Woman remains a symbol, the embodiment of motherhood, fecundity, erotic desire, or another of the essentialist qualities frequently imputed to female persons. No matter how deeply he observed, empathized with, and enthused about his female subjects, Moore had a decidedly phallocratic perspective that he never came close to shedding. Both women and landscape represented territory to be explored and appropriated to bolster the strength of the nation. In fact, the biggest obstacle to recuperating Moore's reputation is his objectification of women. Intrinsic to his iconography and a product of his time, this male chauvinism needs to be reexamined, recontextualized, and read critically and deeply before we will be able to see Moore clearly once again.

Moore's art objectifies women to the ultimate degree. He adopts—and loves—all the poetic devices: reclining women become landscape, the earth to penetrate. Women all are curves and hollows, and his camera seems to explore every hole and penetration. According to David Sylvester, the forms are not allusive but rather explicit representation:

> The female genitals are imaged frequently, in abstractions such as the rose aurora *Three Rings* and the Pynkado wood *Two Forms,* in the tunneled forms of reclining figures: they are precisely imaged; it is not at all a matter of indiscriminately seeing holes as sexual symbols. If there is one constant which distinguished Moore's language of ambiguous biomorphic forms from those of his contemporaries, it probably lies in the coincidence of landscape with oral and genital references. The human body becomes at the same time its own most secret parts and a part of its own elementary environment.[12]

Moore's earlier formal inventions further the objectification of their desired subject: the stringed figures, for example, evoke the guitar-as-girl (or vice versa) puns of Cubist Picasso and Braque. He takes a pure joy in this representation that begs to be considered unproblematic, but of course it is anything but innocent. The relationship Moore

continually refines between the reclining female and the landscape is unavoidably the British discourse of territory: exploration and colonization have been shown to employ the vocabulary of seduction and rape. To explore is to get to "know" in the biblical sense. Deeply embedded in his thinking is the direct association of penetration and desire. Moore's obsession with holes represents a charged leitmotif for the artist. Innumerable photographs of his sculptures and his sculptural inspirations evoke other natural forms, particularly the dark landscape of hidden desire, caves and craggy trees and female genitalia. This and the sister cathexis of surface are both undoubtedly sexualized in his psychology, a territory that the artist, for all his theoretical interest in the subject, declined to explore.

> At one time the holes in my sculpture were made for their own sakes. Because I was trying to become conscious of spaces in the sculpture—I made the hole have a shape in its own right, the solid body was encroached upon, eaten into, and sometimes the form was only the shell holding the hole. Recently I have attempted to make the forms and the spaces (not holes) inseparable, neither being more important than the other. In the last bronze *Reclining Figure* (1951) I think I have in some measure succeeded in this aim. What I mean is perhaps most obvious if this figure is looked at lengthwise from the head end through to the foot end and the arms, body, legs, elbows, etc. are seen as forms inhabiting a tunnel in recession. Seen in plan the figure has "pools" of space.[13]

Erich Neumann's monograph, the one Moore snapped shut after scanning the first chapter, rejects a sexualized reading of these forms and ideas. Consistent with the themes of Jungian psychology, he prefers to discuss the elemental consciousness from which such motifs spring. For Neumann, as for Jung, the female essence represents creativity itself: "To penetrate into the 'inside of nature,' to unravel her deepest secrets through an experience that today we would call an 'inner' one, an experience of psychic transformation—that is the hidden meaning of all those arcane paths leading into the 'womb' of mystery. It is absurd to try to reduce this profound inborn striving of man to discover and understand the mystery of the Great Mother to the sexual curiosity of the infant."[14] Methinks he protests too much. The inchoate mysteries of desire, the shifting notion of identity in relation to memories of birth and childhood, the trajectory of a developing

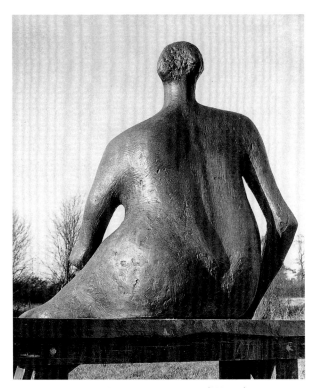

Fig. 6. Henry Moore, *Seated Woman,* 1957 (LH 435)

sense of self, and the ways consciousness is wrapped up with sexuality—all these questions seem far from simple or reductive. There remains a need for a psychoanalytic investigation of Moore's iconography and his development. One factor would probably be his relationship with his mother.

> Whenever I see [*Seated Woman*, 1957 (fig. 6)] I am reminded of a boyhood experience that contributed towards the conception of its form. I was a Yorkshire miner's son, the youngest of seven, and my mother was no longer so very young. She suffered from bad rheumatism in the back and would often say to me in winter when I came back from school, "Henry, boy, come rub my back." Then I would massage her back with liniment. When I came to this figure which represents a fully mature woman, I found that I was unconsciously giving to its back the long-forgotten shape of the one that I had so often rubbed as a boy.[15]

The same broad back recurs frequently in Moore's female subjects, reclining and seated figures as well as those identified as Mother and Child. It seems to represent the artist's physical ideal; only examples of his early work feature markedly slim women, the fashion ideal of the late 1920s. Moore uses these figures more dispassionately; when they are dissected or rearranged there is no sense of personal involvement. Moore's later figures possess a vivid sensory charge. The sculptures are intensely tactile: countless writers talk about touching the figures, feeling their textures, establishing a haptic connection. Overwhelmingly Moore's subject is the supine female body, its fecundity either implicit in its mounds and hollows or explicit in the form of a child accessory. His photographs promote precisely this sexualized reading by caressing, nudging, and even penetrating the figures. This is especially powerful in the photographic series that celebrate many of his most distinctive figures, including *Internal and External Motifs* (LH 297, see pp. 14 and 15) and the

Reclining Figure that is its variant (LH 298, see pp. 17, 18 and 19). The photo essay that introduces this catalogue, constructed out of Moore's own photographs, begins with works created after World War II. One might commence a psychoanalysis with the hypothesis that Moore's preoccupation with hollows grows following the shock of his mother's death in 1943. These images evoke in most viewers a powerful desire to crawl inside, as if returning to the safety and comfort of the womb. Whatever the artist's intention, this surely defines an appropriate and helpful postwar imagery.

These examples represent a brief sampling of the answers and questions provided by Moore's photographs. Anyone who has used a camera has perhaps experienced it, if only momentarily, as directly connected to the act of vision—the sensation of an apparatus as an extension of one's own faculties. In Moore's photographs every decision is potentially informative: which sculptures he depicted and how often; which images he chose to provide to critics and monographists. Reading his sculptures through photographs he himself framed, shot, and selected brings the intelligence of those three activities to bear on a self-interpretation. Throughout his career Moore used the camera to review and examine his figures in endless, loving detail. Lingering over the grain of his woods or the finish of a bronze surface; delighting in the variety of points of view he could picture; evidencing the rhythms of nature and the vitality of life in the figures he had created represent an extended engagement between maker and object. It is an ideal version of the relationship he intends for his viewers. Occasionally, his photographs enable just that.

Notes

My study was made possible by the extraordinary generosity and kindness of The Henry Moore Foundation, whose charming staff answered endless questions, provided insightful pathways through mountainous archives, opened crates, sought out photocopies and bibliographical references, and even proffered tea at strategic moments. I would particularly like to acknowledge the indispensable help of Emma Stower in navigating and appreciating the photographic archives, as well as the insider's view and counsel shared by curator Anita Feldman Bennet. I am also deeply grateful to Philip Koplin, who edited my draft with his usual tact and aplomb.

1. Philip James, ed., *Henry Moore on Sculpture,* rev. ed. (New York: Viking Press, 1971).

2. James, 52, originally published 1962. See note 14 below for the book he discusses.

3. First published in Herbert Read, ed., *Unit One: The Modern Movement in English Architecture, Painting and Sculpture* (London, Toronto, Melbourne and Sydney: Cassell and Company, Ltd., 1934). Reprinted as "The Sculptor's Aims" in David Sylvester, ed., *Henry Moore: Complete Sculpture,* vol. 1, *Sculpture 1921–48* (London: Lund Humphries, 1988), xxx–xxxi; and in James, 72–73, 75, from which all quotations are cited.

4. James, 72.

5. James, 115, originally published 1951.

6. James, 73.

7. James, 129, originally published 1964.

8. James, 67, originally published as "The Sculptor Speaks," *The Listener* (London) 18, no. 449 (18 August 1937): 589–99.

9. James, 75.

10. James, 60 and 62, originally published 1964.

11. James, 75.

12. David Sylvester, *Henry Moore* (New York and Washington, D.C.: Frederick Praeger, 1968), 38.

13. James, 120, originally printed in 1953.

14. Erich Neumann, *The Archetypal World of Henry Moore,* trans. R. F. C. Hull (New York: Bollingen, 1959), 50–51.

15. James, 131, interview originally published in 1960.

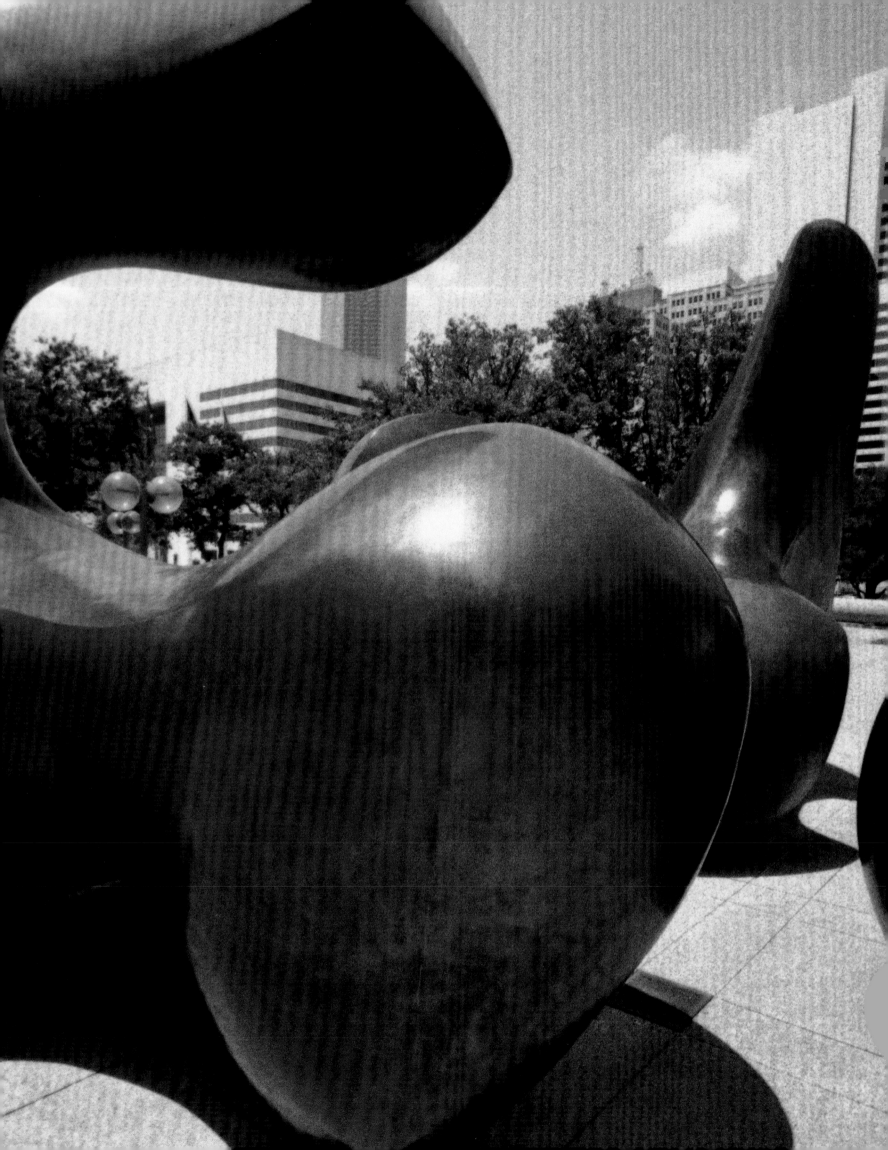

The Dallas Piece

Tom Jenkins

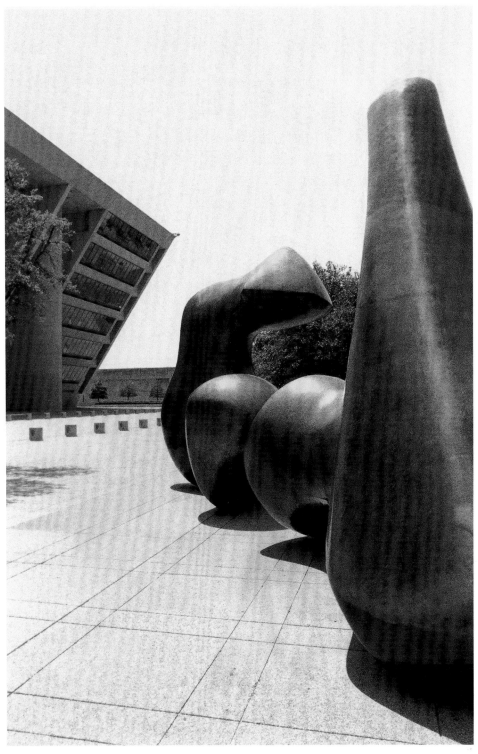

Henry Moore, *Three Forms Vertebrae (The Dallas Piece),* 1979, commissioned
for the plaza of the new Dallas City Hall, designed by I. M. Pei.

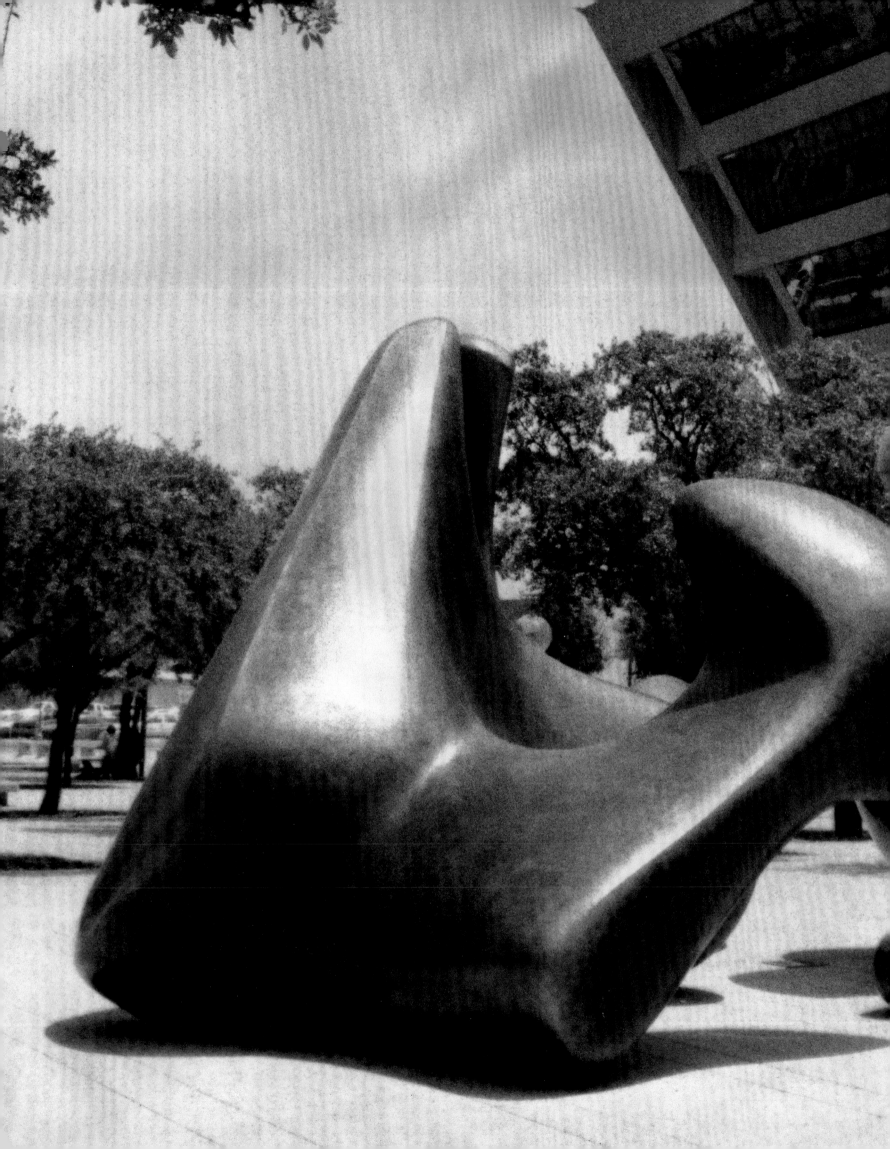

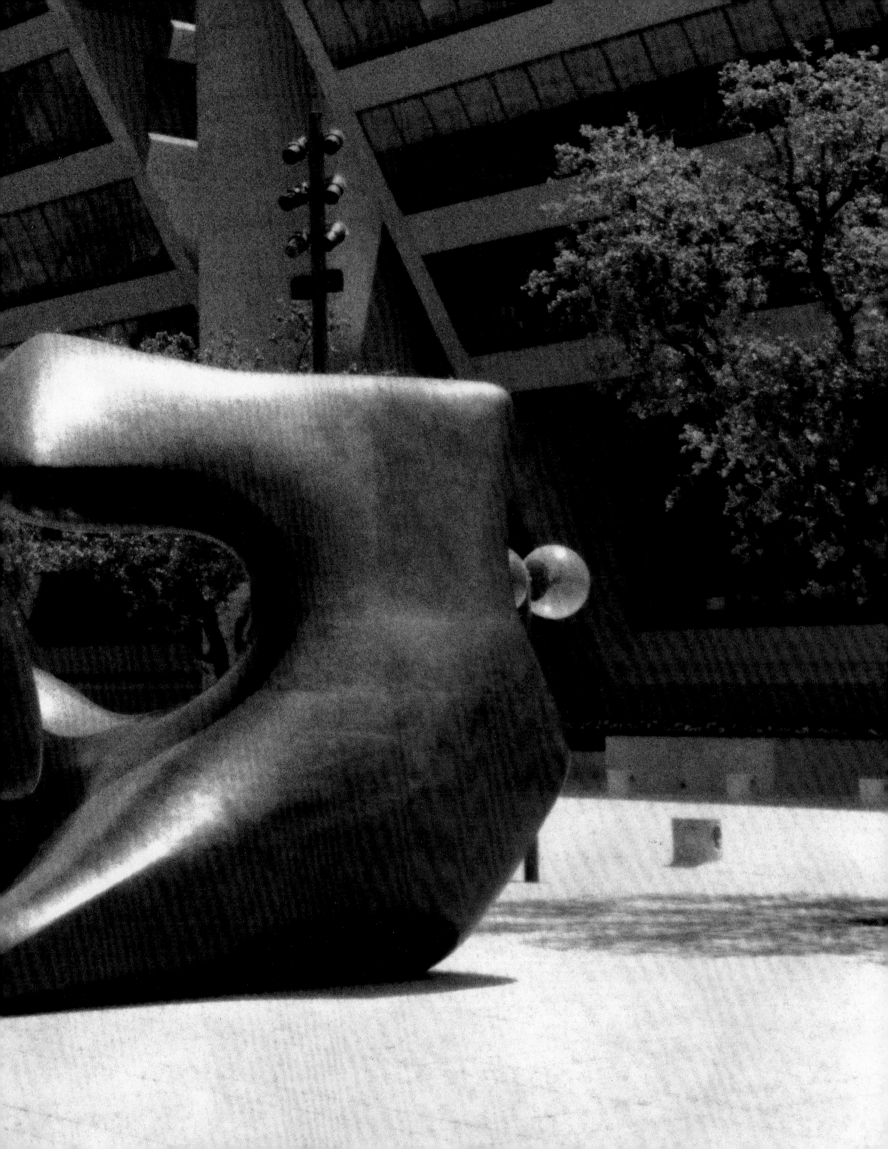

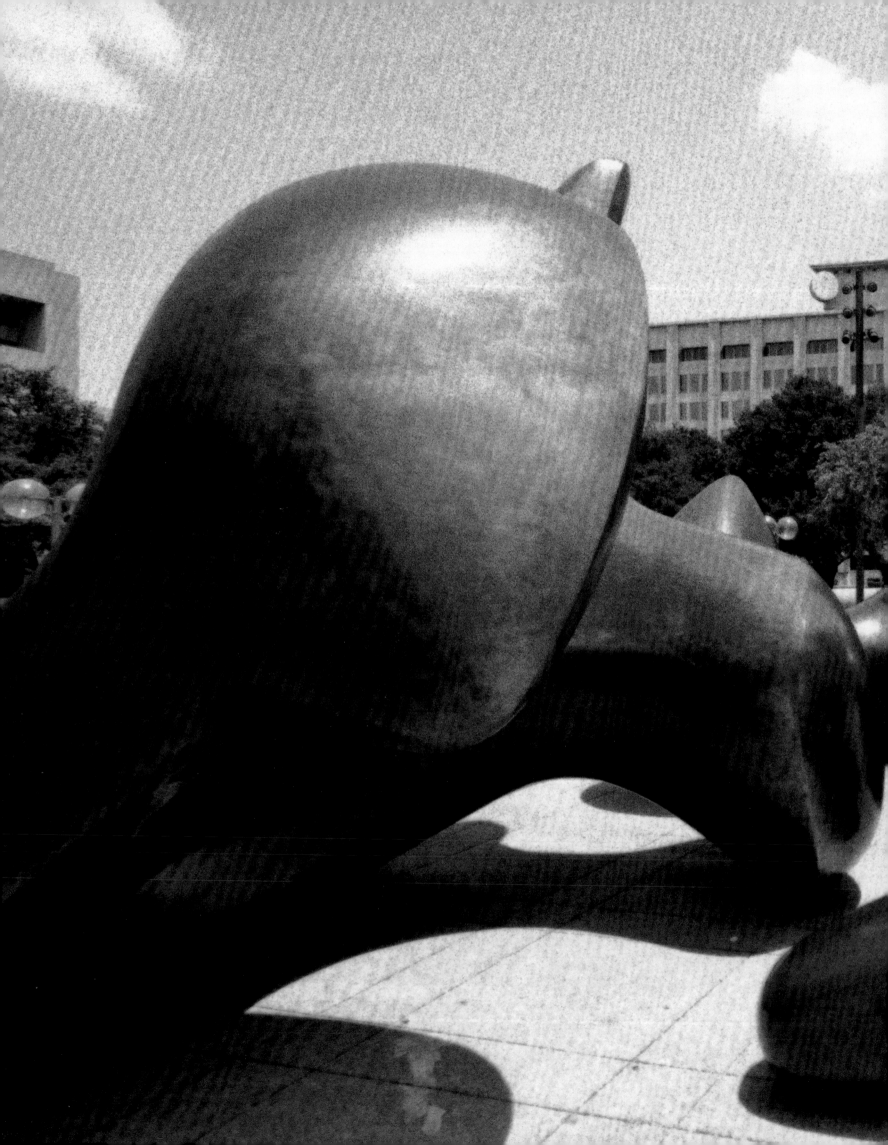

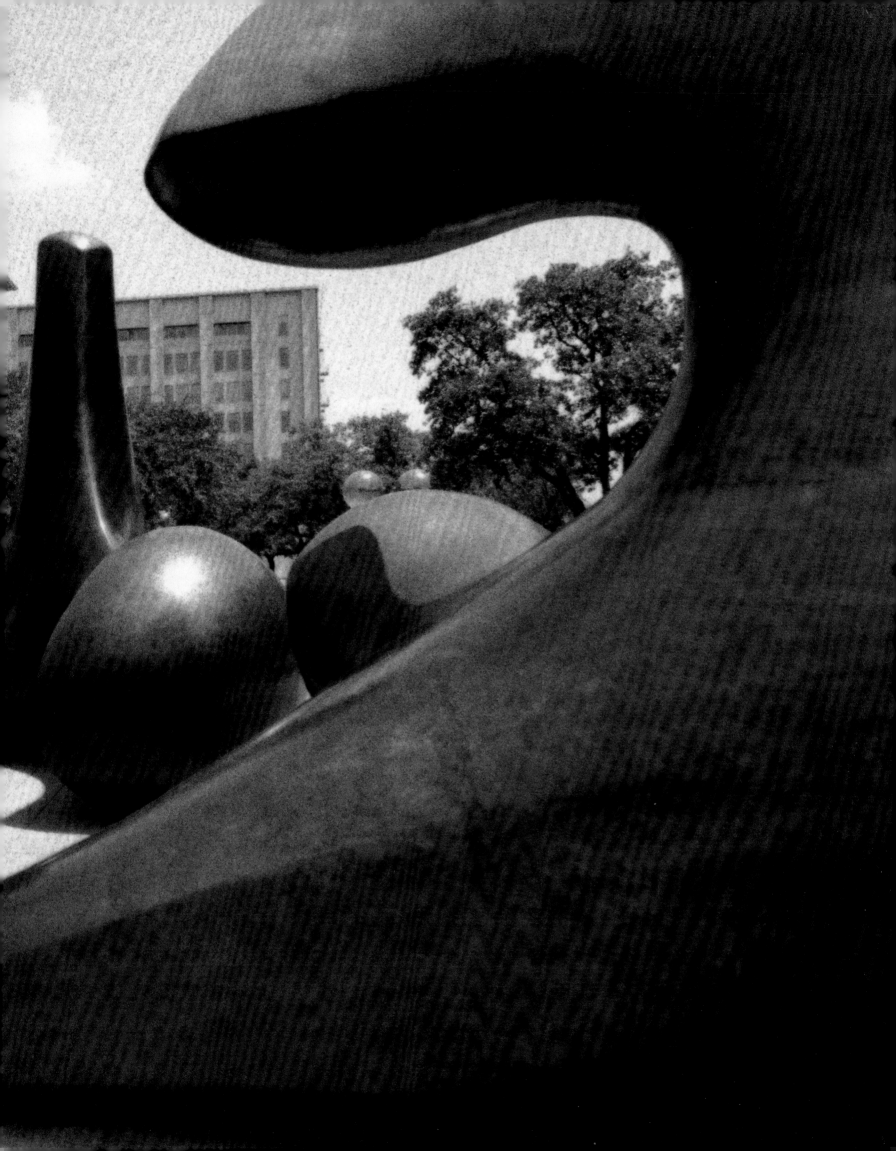

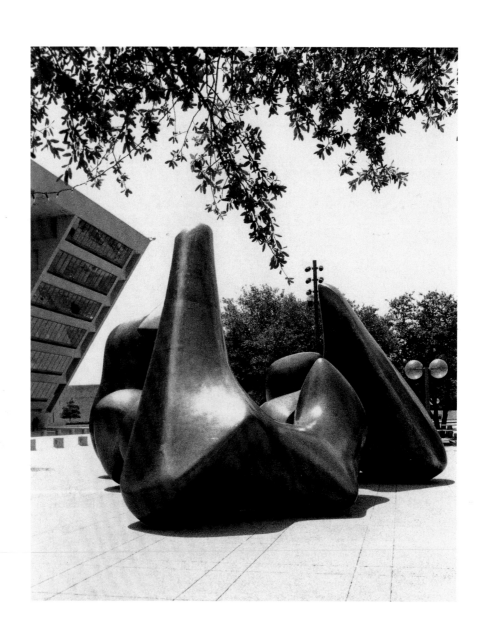

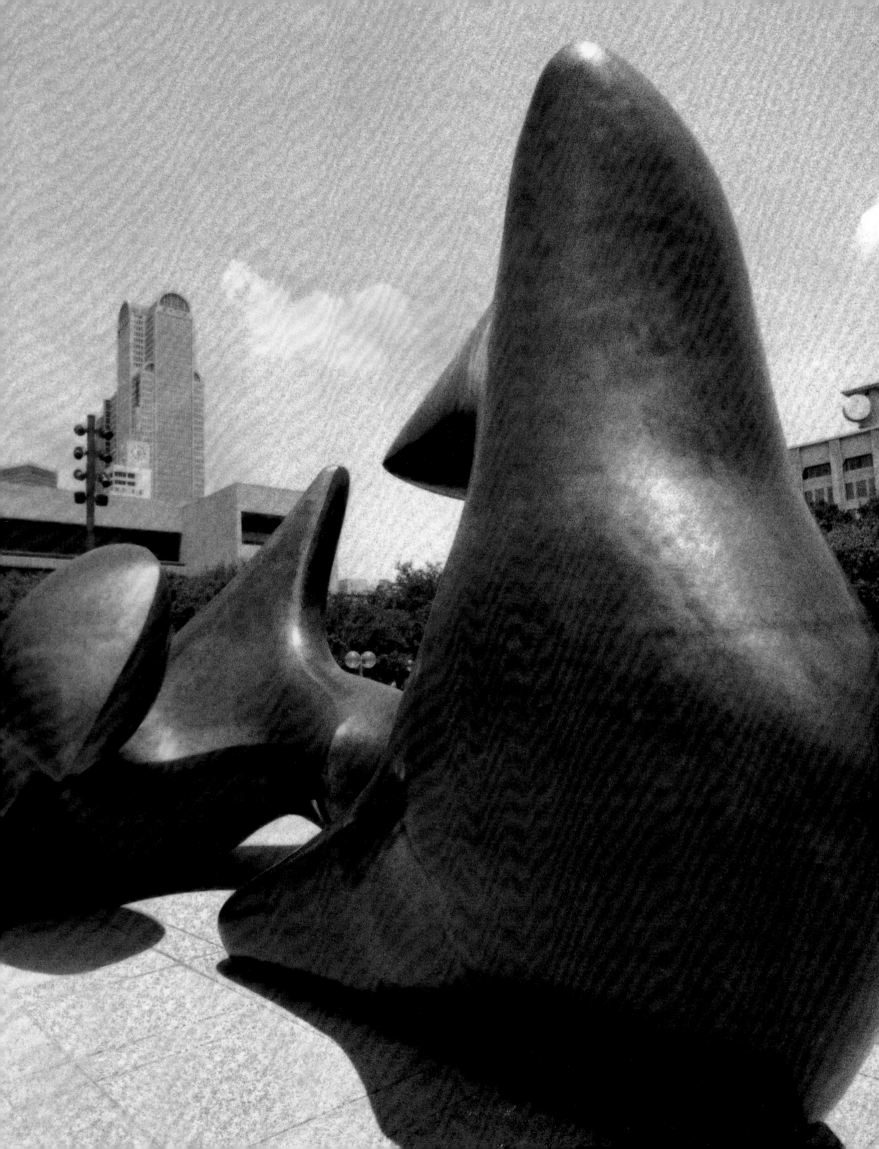

Checklist of Sculpture and Drawings

All works by Henry Moore

Sculpture

Cat. 1
Dog, 1922
Marble, height 7 in.
The Henry Moore Foundation: gift of the artist
1977
(LH 2)

Cat. 2
Head, 1923
Alabaster, height 4¾ in.
The Henry Moore Foundation: acquired 1998
(LH 10)

Cat. 3
Snake, 1924
Marble, height 6¾ in.
Private collection
(LH 20)

Cat. 4
Maternity, 1924
Hopton Wood stone, height 7¾ in.
Leeds Museums and Galleries (City Art Gallery)
(LH 22)

Cat. 5
Woman with Upraised Arms, 1924–25
Hopton Wood stone, height 17 in.
The Henry Moore Foundation: gift of the artist
1977
(LH 23)

Cat. 6
Reclining Woman, 1927
Cast concrete, length 25 in.
The Moore Danowski Trust
(LH 43)

Cat. 7
Mask, 1927
Green stone, height 8¼ in.
The Henry Moore Foundation: acquired 1997
(LH 46)

Cat. 8
Seated Figure, 1929
Cast concrete, height 17¾ in.
The Henry Moore Foundation: gift of Irina Moore
1979
(LH 65)

Cat. 9
Half-figure, 1929
Cast concrete, height 14½ in.
Courtesy Ivor Braka Limited, London
Washington, D.C. venue
(LH 67)

Cat. 10
Reclining Woman, 1930
Green Hornton stone, 23½ × 36½ × 16¼ in.
National Gallery of Canada, Ottawa. Purchased
1956
(LH 84)

Cat. 11
Reclining Figure, 1930
Bronze, height 6¾ in.
The Henry Moore Foundation: gift of the artist
1977
(LH 85)

Cat. 12
Mother and Child, 1930
Ironstone, height 5 in.
The Henry Moore Foundation: acquired 1998
(LH 86)

Cat. 13
Composition, 1931
Green Hornton stone, height 19 in.
The Moore Danowski Trust
(LH 99)

Cat. 14
Reclining Figure, 1931
Bronze, length 17 in.
The Henry Moore Foundation: gift of the artist
1977
(LH 101)

Cat. 15
Composition, 1931
Cumberland alabaster, length 16⅜ in.
The Henry Moore Foundation: gift of Irina Moore
1979
(LH 102)

Cat. 16
Relief, 1931 (cast 1968)
Bronze (unnumbered [2/3]), height 18¼ in.
The Henry Moore Foundation: gift of the artist
1979
(LH 103)

Cat. 17
Half-figure, 1931
Veined alabaster, 13½ × 4⅝ × 3¾ in.
Private collection
(LH 108)

Cat. 18
Girl, 1931
Ancaster stone, 29 × 14½ × 10¾ in.
Tate. Purchased 1952
Dallas venue
(LH 109)

Cat. 19
Girl, 1931
Boxwood, 14½ × 3⅛ × 2⅝ in.
Dallas Museum of Art, Foundation for the Arts
Collection, gift of Cecile and I. A. Victor
(LH 112)

Cat. 20
Composition, 1932
Beechwood, 14 × 4⅛ × 6⅜ in.
High Museum of Art, Atlanta, Georgia, Gift of
Rich's, Inc.
(LH 115)

Cat. 21
Composition, 1932
African wonderstone, 17½ × 18 × 11¾ in.
Tate. Presented by the Friends of the Tate Gallery
1960
Dallas venue
(LH 119)

Cat. 22
Composition, 1933
Bronze (unique cast), height 14 in.
The Henry Moore Foundation: acquired 1991
(LH 132)

Cat. 23
Composition, 1934
Cast concrete, length 17½ in.
The Henry Moore Foundation: gift of the artist
1977
(LH 140)

Cat. 24
Two Forms, 1936
Ironstone, 7¼ × 6 × 2½ in.
Private collection
(LH 146)

Cat. 25
Bird and Egg, 1934
Cumberland alabaster, 8⅛ × 22 × 9½ in.
(with base)
Yale Center for British Art, Paul Mellon Collection
(LH 152)

Cat. 26
Four-Piece Composition: Reclining Figure, 1934
Cumberland alabaster, 6⅞ × 18 × 8 in.
Tate. Purchased with assistance from the National
Art Collections Fund 1976
Dallas venue
(LH 154)

Cat. 27
Reclining Figure, 1934–35
Corsehill stone, length 24⅛ in. (with base)
The Moore Danowski Trust
(LH 155)

Cat. 28
Family, 1935
Elmwood, height 40 in.
The Henry Moore Foundation: gift of the artist
1977
(LH 157a)

Cat. 29
Carving, 1936
Travertine marble, height 18 in.
The Henry Moore Foundation: gift of Irina Moore
1977
(LH 164)

Cat. 30
Two Forms, 1936
Hornton stone, 42 × 18 × 8 in. and 40¼ ×
14 × 12 in.
Philadelphia Museum of Art. Gift of Mrs. H. Gates
Lloyd
(LH 170)

Cat. 31
Four Forms, 1936
African wonderstone, 7¼ × 25⅛ in.
Indiana University Art Museum: given in honor
of Dr. Roy Elder by Sarahanne Hope-Davis
(LH 172)

Cat. 32
Reclining Figure, 1936
Elmwood, length 42 in.
Wakefield Museums and Arts. Purchased by
Wakefield Corporation with support from the
Victoria and Albert Museum, Mr. E. C. Gregory,
and the Wakefield Permanent Art Fund, 1942
Dallas venue
(LH 175)

Cat. 33
Reclining Figure, 1937
Hopton Wood stone, 13 × 4 × 38 in.
Fogg Art Museum, Harvard University Art
Museums, gift of Lois Orswell
(LH 178)

Cat. 34
Stringed Relief, 1937 (cast 1976)
Bronze and nylon, length 19½ in.
The Henry Moore Foundation: gift of the artist
1977
(LH 182)

Cat. 35
Stringed Figure, 1937
Cherry wood and string on oak base, 22⅜ ×
5⅜ × 6⅝ in.
Hirshhorn Museum and Sculpture Garden,
Smithsonian Institution. Joseph H. Hirshhorn
Purchase Fund, 1989
(LH 183)

Cat. 36
Mother and Child, 1938
Lead and yellow string (unique cast), height 3¾ in.
The Henry Moore Foundation: acquired by
exchange 1996
(LH 186)

Cat. 37
Stringed Figure, 1938 (cast 1966)
Bronze and string, 4⅞ × 1½ × 1¾ in.
Dallas Museum of Art, Foundation for the Arts
Collection, bequest of Margaret Ann Bolinger
(LH 186e)

Cat. 38
Head, 1938
Elmwood and string, height 8 in.
The National Trust, Willow Road
(LH 188)

Cat. 39
Reclining Figure, 1938
Lead, 5¾ × 13 in.
The Museum of Modern Art, New York.
Purchase 1939
(LH 192)

Cat. 40
Mother and Child, 1938
Elmwood, 30⅜ × 13⅞ × 15½ in.
The Museum of Modem Art, New York. Acquired
through the Lillie P. Bliss Bequest, 1953
(LH 194)

Cat. 41
Stringed Reclining Figure, 1939
Bronze and string, 4½ × 12¼ × 3¾ in.
University of Michigan Museum of Art. Bequest
of Mrs. Florence L. Stol
(LH 197)

Cat. 42
Reclining Figure, 1939
Bronze, length 11 in.
The Henry Moore Foundation: acquired by
exchange with the British Council 1991
(LH 202)

Cat. 43
Bird Basket, 1939
Lignum vitae and string, length 16½ in.
Private collection
(LH 205)

Cat. 44
Reclining Figure: Snake, 1939
Bronze, length 11⅜ in.
The Henry Moore Foundation: gift of the artist
1979
(LH 208a)

Cat. 45
Reclining Figure, 1939
Elmwood, 37 × 79 × 30 in.
The Detroit Institute of Arts, Founders Society
Purchase with funds from the Dexter M. Ferry, Jr.
Trustee Corporation
(LH 210)

Cat. 46
Three Points, 1939–40
Cast iron, length 7⅞ in.
The Henry Moore Foundation: gift of Irina Moore
1977
(LH 211)

Cat. 47
The Helmet, 1939–40 (cast 1959)
Bronze (unique cast), height 11½ in.
The Henry Moore Foundation: gift of Irina Moore
1977
(LH 212)

Cat. 48
Madonna and Child, 1943
Bronze, height 7¼ in.
The Henry Moore Foundation: acquired in honor
of Sir Alan Bowness 1994
(LH 222)

Cat. 49
Family Group, 1944
Bronze, 5⅞ × 4¼ × 2⅞ in.
Dallas Museum of Art, Foundation for the Arts
Collection, bequest of Margaret Ann Bolinger
(LH 230)

Cat. 50
Family Group, 1944
Terra-cotta, height 6⅛ in.
The Henry Moore Foundation: gift of the artist
1977
(LH 231)

Cat. 51
Reclining Figure, 1945
Terra-cotta, length 6 in.
The Henry Moore Foundation: gift of the artist
1979
(LH 247)

Cat. 52
Family Group, 1948–49
Bronze, 60 × 45½ × 30¾ in.
Tate. Purchased 1950
(LH 269)

Cat. 53
Helmet Head No. 1, 1950
Bronze, 14½ × 13½ × 10¼ in. (including base)
Trustees of the Cecil Higgins Art Gallery and
Museum, Bedford
(LH 279)

Cat. 54
Helmet Head No. 2, 1950
Bronze, height 13½ in.
Courtesy Ivor Braka Limited, London
(LH 281)

Cat. 55
Reclining Figure: Festival, 1951
Bronze, length 90 in.
The Moore Danowski Trust
(LH 293)

Cat. 56
*Working Model for Upright Internal/External
Form,* 1951
Plaster, height 24⅞ in.
The Henry Moore Foundation: gift of the artist
1977
(LH 295)

Cat. 57
*Working Model for Reclining Figure: Internal/
External Form,* 1951
Bronze, 13 × 20½ × 6¾ in. (base 4½ × 24½ ×
10¼ in.)
Arts Council Collection, Hayward Gallery, London
(LH 298)

Cat. 58
Goat's Head, 1952
Plaster, height 8 in.
The Henry Moore Foundation: gift of the artist
1977
(LH 302)

Cat. 59
Maquette for Mother and Child, 1952
Bronze (unnumbered [9/9]), height 8½ in.
The Henry Moore Foundation: gift of Irina Moore
1977
(LH 314)

Cat. 60
Working Model for Time-Life Screen, 1952
Bronze, length 42 in.
San Francisco Museum of Modern Art. Gift of
Charlotte Mack
(LH 343)

Cat. 61
King and Queen, 1952–53 (cast 1957)
Bronze, 64½ × 54½ × 33¼ in.
Tate. Presented by the Friends of the Tate Gallery
with funds provided by Associated Rediffusion Ltd.
1959
(LH 350)

Cat. 62
Warrior with Shield, 1953–54
Bronze, height 61 in.
The Moore Danowski Trust
(LH 360)

Cat. 63
Seated Torso, 1954
Plaster with surface color, length 19½ in.
The Henry Moore Foundation: gift of the artist
1977
(LH 362)

Cat. 64
Wall Relief: Maquette No. 1, 1955
Bronze, length 22 in.
Dallas Museum of Art, Foundation for the Arts
Collection, bequest of Margaret Ann Bolinger
(LH 365)

Cat. 65
Wall Relief: Maquette No. 2, 1955
Bronze, length 17½ in.
The Henry Moore Foundation: gift of the artist
1977
(LH 366)

Cat. 66
Wall Relief: Maquette No. 7, 1955
Bronze, length 18½ in.
The Henry Moore Foundation: transferred from
the Henry Moore Trust 1978
(LH 371)

Cat. 67
Upright Motive: Maquette No. 1, 1955
Plaster, 12⅛ × 3⅜ × 3⅜ in. (base ½ × 3¼ ×
4⅝ in.)
Collection, Art Gallery of Ontario, Toronto. Gift of
Henry Moore, 1974
(LH 376)

Cat. 68
Upright Motive: Maquette No. 10, 1955
Plaster with surface color, height 12 in.
The Henry Moore Foundation: gift of the artist
1977
(LH 390)

Cat. 69
Upright Motive: Maquette No. 7, 1955
Plaster with surface color, height 12⅝ in.
The Henry Moore Foundation: gift of the artist
1977
(LH 385)

Cat. 70
Maquette for Fallen Warrior, 1956
Bronze, length 9 in.
The Henry Moore Foundation: gift of the artist
1977
(LH 404)

Cat. 71
Seated Figure on Square Steps, 1957
Bronze, 8 × 9½ × 9¼ in.
Dallas Museum of Art, Foundation for the Arts
Collection, bequest of Margaret Ann Bolinger
(LH 436)

Cat. 72
Armless Seated Figure against Round Wall,
1957–58
Plaster with surface color, height 11 in.
The Henry Moore Foundation: gift of the artist
1977
(LH 438)

Cat. 73
Three Motives against Wall No. 1, 1958
Bronze, length 42 in.
The Henry Moore Foundation: gift of the artist
1977
(LH 441)

Cat. 74
Reclining Figure, 1959–64
Elmwood, length 103 in.
The Henry Moore Foundation: gift of Irina Moore
1977
(LH 452)

Cat. 75
Two Piece Reclining Figure: Maquette No. 5,
1962
Plaster, 4¾ × 6 × 3¾ in. (including base)
Collection, Art Gallery of Ontario, Toronto.
Gift of Henry Moore, 1973
(LH 477)

Cat. 76
Two Piece Reclining Figure No. 3, 1961
Bronze, 59¼ × 96⅝ × 44¾ in.
Dallas Museum of Art, Dallas Art Association
Purchase
(LH 478)

Cat. 77
Large Standing Figure: Knife Edge, 1976
Bronze, height 141 in.
The Henry Moore Foundation: acquired 1987
(LH 482a)

Cat. 78
*Three Piece Reclining Figure: Maquette No. 2:
Polished,* 1962
Bronze (edition of 9 +1), length 8½ in.
The Henry Moore Foundation: gift of Irina Moore
1977
(LH 501)

Cat. 79
Working Model for Knife Edge Two Piece, 1962
Bronze, length 28 in.
Aaron I. Fleischman
Washington venue
(LH 504)

Cat. 80
Divided Head, 1963
Bronze (0/9), height 13¾ in.
The Henry Moore Foundation: acquired 1987
(LH 506)

Cat. 81
Locking Piece, 1963–64
Bronze, height 115½ in.
The Henry Moore Foundation: acquired 1987
(LH 515)

Cat. 82
Thin Head, 1964 (cast 1969)
Bronze, height 4¾ in.
Dallas Museum of Art, Foundation for the Arts
Collection, gift of Mildred G. Tippett
Dallas venue
(LH 523)

Cat. 83
Maquette for Atom Piece, 1964
Plaster, height 6 in.
The Henry Moore Foundation: gift of the artist
1977
(LH 524)

Cat. 84
Maquette for Double Oval, 1966
Bronze, 5 × 9¼ × 5½ in.
Dallas Museum of Art, Foundation for the Arts
Collection, bequest of Margaret Ann Bolinger
Dallas venue
(LH 558)

Cat. 85
Mother and Child, 1967
Rosa aurora marble, length 51¼ in.
The Henry Moore Foundation: gift of Irina Moore
1977
(LH 573)

Cat. 86
Two Piece Reclining Figure No. 9, 1968
Bronze, 56⅜ × 96 × 52 in.
Lent by Robin Quist Gates
San Francisco venue
(LH 576)

Cat. 87
Working Model for Three-Piece No. 3: Vertebrae,
1968
Bronze, 41⅛ × 93 × 48 in.
The Patsy R. and Raymond D. Nasher Collection,
Dallas, Texas
Dallas venue
(LH 579)

Cat. 88
Three Forms Vertebrae (The Dallas Piece),
1978–79
Bronze (unique cast), length approx. 40 ft.
City Center Park Plaza, Dallas
Dallas venue
(LH 580a)

Cat. 89
Maquette for Two Piece Sculpture No. 11, 1968
Bronze, length 4 in.
The Henry Moore Foundation: gift of Irina Moore
1977
(LH 582)

Cat. 90
Oval with Points, 1968–70
Bronze (0/6), height 130¾ in.
The Henry Moore Foundation: gift of the artist
1977
(LH 596)

Cat. 91
Arch Form, 1970
Serpentine, length 82¾ in.
Private collection
(LH 618)

Cat. 92
Bridge Form, 1971
Black Abyssinian marble, 27⅛ × 15¾ × 14⅛ in.
Mr. and Mrs. William Allen Custard
(LH 621)

Cat. 93
Working Model for Sheep Piece, 1971
Bronze, length 56 in.
The Henry Moore Foundation: acquired 1987
(LH 626)

Cat. 94
Goslar Warrior, 1973–74
Bronze, length 118 in.
The Henry Moore Foundation: gift of the artist
1977
(LH 641)

Cat. 95
Reclining Figure: Bone, 1975
Travertine marble, length 62 in.
The Henry Moore Foundation: gift of the artist
1977
(LH 643)

Cat. 96
Reclining Mother and Child, 1975–76
Plaster, 51 × 80 × 41 in.
The Henry Moore Foundation: on long-term loan
to the Dallas Museum of Art
(LH 649)

Cat. 97
Reclining Figure: Holes, 1976–78
Elmwood, length 87½ in.
The Henry Moore Foundation: gift of the artist
1977
(LH 657)

Cat. 98
Reclining Figure: Angles, 1979
Bronze, 48¼ × 90¼ × 61¾ in.
The Patsy R. and Raymond D. Nasher Collection,
Dallas, Texas
Dallas venue
(LH 675)

Cat. 99
Knife Edge Mirror Two Piece, 1977–78
Bronze (unique cast), 210½ × 284 × 143 in.
National Gallery of Art, Washington. Gift of
The Morris and Gwendolyn Cafritz Foundation
Washington venue
(LH 714)

Cat. 100
Mother and Child, 1978
Stalactite, height 33⅛ in.
The Henry Moore Foundation: acquired 1986
(LH 754)

Cat. 101
Two Torsos, 1981
Bronze, height 8 in.
Dallas Museum of Art, Foundation for the Arts
Collection, gift of Mildred G. Tippett
Dallas venue
(LH 814)

Cat. 102
Point and Oval, 1981
Bronze, 2½ × 4¼ × 2 in.
Dallas Museum of Art, Foundation for the Arts
Collection, bequest of Margaret Ann Bolinger
Dallas venue
(LH 819)

Cat. 103
Reclining Figure: Pea Pod, 1982
Bronze, length 8½ in.
The Henry Moore Foundation: acquired 1986
(LH 854)

Cat. 104
Tube Form, 1983
Bronze, height 5 in.
Dallas Museum of Art, Foundation for the Arts
Collection, gift of Mildred G. Tippett
Dallas venue
(LH 885)

Cat. 105
Bone Head, 1983
Bronze, height 5½ in.
Dallas Museum of Art, Foundation for the Arts
Collection, gift of Mildred G. Tippett
Dallas venue
(LH 891)

Cat. 106
Seated and Standing Figures, 1983
Bronze, 6⅜ × 6 × 2¼ in.
Dallas Museum of Art, Foundation for the Arts
Collection, bequest of Margaret Ann Bolinger
Dallas venue
(LH 895)

Cat. 107
Skeleton Figure, cast 1984
Bronze, 4⅝ × 2⅜ × 1 in.
Dallas Museum of Art, Foundation for the Arts
Collection, bequest of Margaret Ann Bolinger
Dallas venue
(LH 912)

Cat. 108
Three-Quarter Figure: Points, cast 1985
Bronze, height 4¾ in.
Dallas Museum of Art, Foundation for the Arts
Collection, gift of Mildred G. Tippett
Dallas venue
(LH 919)

Drawings

Cat. 109
Four Studies of a Seated Figure, 1922
Pencil, brush and ink, and watercolor on paper,
17½ × 14½ in.
The Henry Moore Foundation: gift of the artist
1977
Dallas venue
(HMF 81v)

Cat. 110
Studies of Sculpture from the British Museum
(Page 105 from Notebook No. 3), 1922–24
Pencil on paper, 8⅞ × 6¾ in.
The Henry Moore Foundation: gift of the artist
1977
(HMF 123)

Cat. 111
Standing Girl, 1924
Pen and ink, crayon, and wash on cream medium-
weight wove paper, 20 × 7⅝ in.
The Henry Moore Foundation: gift of the artist
1977
(HMF 214)

Cat. 112
Standing Figure: Back View, c. 1924
Pen and ink, brush and ink, chalk, and wash on off-
white medium-weight wove paper, 17¾ × 11 in.
The Henry Moore Foundation: gift of the artist
1977
(HMF 228)

Cat. 113
Mother and Child, 1924
Brush and ink, crayon, and chalk on cream
medium-weight wove paper, 22⅛ × 14⅞ in.
The Moore Danowski Trust
(HMF 264)

Cat. 114
The Artist's Sister Mary, 1926
Pen and ink, chalk, watercolor, and wash on
lightweight manila paper, 17½ × 13 in.
The British Council
(HMF 470)

Cat. 115
The Artist's Mother, 1927
Pencil (rubbed), pen and ink, brush and ink wash
on cream medium-weight wove paper, 11 × 7½ in.
The Henry Moore Foundation: gift of Mary Moore
Danowski 1979
(HMF 488)

Cat. 116
Ideas for West Wind Relief, 1928
Pen and ink, brush and ink on wove paper,
14½ × 9 in.
Collection, Art Gallery of Ontario, Toronto.
Gift of Henry Moore, 1974
Dallas venue
(HMF 647)

Cat. 117
Reclining Figure with Child, 1928
Pen and ink, and watercolor wash on off-white
lightweight wove paper, 12⅞ × 16¾ in.
The Henry Moore Foundation: gift of the artist
1977
(HMF 682)

Cat. 118
Montage of Mother and Child Studies,
c. 1929–30
Pencil, pen and ink, brush and ink, colored pencils,
chalk, watercolor, and collage on wove paper,
19 × 14⅝ in.
Collection, Art Gallery of Ontario, Toronto.
Purchase, 1976
(HMF 731)

Cat. 119
Woman in an Armchair, 1930
Brush and ink, and oil paint on cream-buff
wove paper, 13½ × 16 in.
The Moore Danowski Trust
(HMF 774)

Cat. 120
Ideas for Sculpture, 1930
Pen and ink on wove paper, 7⅛ × 4½ in.
Collection, Art Gallery of Ontario, Toronto.
Gift of Henry Moore, 1974
(HMF 808)

Cat. 121
*Ideas for Composition in Green Hornton Stone
(Page from No.1 Drawing Book 1930–31),*
1930–31
Pencil on cream lightweight wove paper,
6⅜ × 7⅞ in.
The Henry Moore Foundation: gift of the artist
1977
(HMF 832)

Cat. 122
Seated and Reclining Figures, 1931
Pen and ink, brush and ink, watercolor, wash,
and gouache on cream heavyweight wove paper,
22 × 15 in.
The Henry Moore Foundation: acquired 1999
(HMF 853)

Cat. 123
*Ideas for Sculpture: Studies for Boxwood
Standing Girl,* 1931
Chalk, brush and ink, pen and ink, and wash on
off-white wove paper, 14¾ × 10¾ in.
Dallas Museum of Art, Foundation for the Arts
Collection, gift of Cecile and I. A. Victor
(HMF 870a)

Cat. 124
Ideas for Boxwood Carving, 1932
Ink on paper, 15¼ × 11½ in.
The Hunt Museum, Limerick
(HMF 922b)

Cat. 125
Ideas for Sculpture, 1932
Pencil on off-white lightweight wove paper,
9½ × 7 in.
The Henry Moore Foundation: gift of the artist
1977
(HMF 944)

Cat. 126
Ideas for Sculpture, 1932
Pencil on off-white lightweight wove paper,
9½ × 7 in.
The Henry Moore Foundation: gift of the artist
1977
(HMF 949)

Cat. 127
Ideas for Sculpture, 1932
Pencil on off-white lightweight wove paper,
9½ × 7 in.
The Henry Moore Foundation: gift of the artist
1977
Dallas venue
(HMF 951)

Cat. 128
*Figure Studies: Seated Mother and Child,
Standing Man,* 1933
Pencil, charcoal, pen and ink, and wash on cream
medium-weight wove paper, 14⅞ × 22 in.
The Henry Moore Foundation: gift of the artist
1977
Dallas venue
(HMF 1015)

Cat. 129
Two Seated Women, 1934
Pen and ink, charcoal, crayon, watercolor, and
wash on off-white lightweight wove paper,
14⅝ × 21¾ in.
The Henry Moore Foundation: acquired 1983
(HMF 1077)

Cat. 130
Reclining Figures, 1934
Charcoal, watercolor, wash, and pen and ink on
paper, 14⅝ × 21⅝ in.
Kröller-Müller Museum, Otterlo, The Netherlands
(HMF 1085)

Cat. 131
Study for Recumbent Figure, 1934
Black pencil, brush and ink, and wash on wove
paper, 11 × 15¼ in.
Collection, Art Gallery of Ontario, Toronto. Gift
from the Junior Women's Committee Fund, 1961
(HMF 1089)

Cat. 132
Drawing for Metal Sculpture, 1934
Pencil, chalk, watercolor, wash, and pen and ink
on paper, 10¾ × 14¾ in.
The Moore Danowski Trust
(HMF 1097)

Cat. 133
Ideas for Metal Sculpture, 1934
Pen and ink, colored chalks and watercolor on
wove paper, 11 × 24¾ in.
Collection, Art Gallery of Ontario, Toronto.
Gift of Henry Moore, 1974
Dallas venue
(HMF 1098 and 1099)

Cat. 134
*Studies for Several-Piece Compositions and
Wood Carvings,* 1934
Crayon (part-rubbed) on off-white lightweight
wove paper, 8⅜ × 10¾ in.
The Henry Moore Foundation: gift of the artist
1977
(HMF 1102)

Cat. 135
Monoliths, 1934
Pencil, crayon, pen and red ink, watercolor, and
wash on cream medium-weight wove paper,
11 × 7¼ in.
The Henry Moore Foundation: acquired 1996
(HMF 1127)

Cat. 136
Eleven Ideas for Sculpture: Reclining Figures,
1935
Pencil, charcoal (rubbed and washed), crayon,
pen and ink, brush and ink, and watercolor wash
on cream lightweight wove paper, 14⅞ × 10⅞ in.
The Henry Moore Foundation: acquired by ex-
change 1981
(HMF 1150)

Cat. 137
Square Form Reclining Figures, 1936
Chalk and wash on cream medium-weight wove
paper, 21⅞ × 15½ in.
The Henry Moore Foundation: gift of the artist
1977
(HMF 1242)

Cat. 138
Two Upright Forms, 1936
Pencil, chalk, pen and ink, and wash on off-white
heavyweight wove paper, 22¼ × 15⅛ in.
The Henry Moore Foundation: acquired 1998
(HMF 1253)

Cat. 139
Two Upright Forms, 1936
Crayon, charcoal (rubbed), wash, wax crayon, and
pen and ink on cream heavyweight wove paper,
19½ × 14 in.
The British Museum, London
(HMF 1254)

Cat. 140
Five Metal Forms, 1937
Crayon and chalk on paper, 15¾ × 22⅝ in.
Wakefield Museums and Arts. Given by Mrs. Hazel
King-Farlow through the Wakefield Permanent Art
Fund, 1937
(HMF 1317)

Cat. 141
Sculpture in a Setting, 1937
Chalk on off-white heavyweight wove paper,
22 × 15 in.
The Henry Moore Foundation: gift of the artist
1977
(HMF 1318)

Cat. 142
Five Figures in a Setting, 1937
Charcoal (rubbed), pastel (washed), and crayon on
cream medium-weight wove paper, 15 × 21⅞ in.
The Moore Danowski Trust
(HMF 1319)

Cat. 143
Drawing for Stone Sculpture, 1937
Pencil, chalk, watercolor, and wash on cream
heavyweight wove paper, 19½ × 23⅞ in.
The Henry Moore Foundation: bequeathed by
Gérald Cramer 1991
(HMF 1320)

Cat. 144
Seventeen Ideas for Metal Sculpture, 1937
Pencil, pastel (washed), watercolor, pen and ink,
and gouache on cream medium-weight wove
paper, 26¼ × 20⅜ in.
The Henry Moore Foundation: gift of the artist
1977
(HMF 1321)

Cat. 145
Drawing for Sculpture, 1937
Chalk, watercolor, and gouache on cream heavy-
weight wove paper, 19 × 21½ in.
The Henry Moore Foundation: gift of the artist
1977
(HMF 1325)

Cat. 146
Mechanisms, 1938
Chalk and wash on cream heavyweight wove
paper, 15⅝ × 22½ in.
The Henry Moore Foundation: acquired 1988
(HMF 1367)

Cat. 147
Ideas for Sculpture in a Setting, 1938
Charcoal (washed), chalk, and ink wash on
heavyweight wove paper, 15 × 22 in.
The Moore Danowski Trust
(HMF 1374)

Cat. 148
Four Forms, 1938
Chalk, crayon, wash, and pen and ink on paper,
11 × 15 in.
Tate. Purchased 1959
Dallas and San Francisco venues
(HMF 1379)

Cat. 149
Ideas for Sculpture in Landscape, c. 1938
Pencil, wax crayon, watercolor, and pen and ink
on cream medium-weight wove paper, 11 × 15 in.
The Henry Moore Foundation: acquired 1990
(HMF 1391a)

Cat. 150
Studies for Sculpture in Various Materials, 1939
Pencil, wax crayon, pen and ink, crayon, and water-
color wash on off-white lightweight wove paper,
10 × 17 in.
The Henry Moore Foundation: acquired 1983
(HMF 1435)

Cat. 151
Two Heads: Drawing for Metal Sculpture, 1939
Charcoal, chalk, watercolor, wash, and pen
and ink on cream heavyweight wove paper,
10⅞ × 15⅛ in.
The Henry Moore Foundation: acquired 1997
(HMF 1462)

Cat. 152
Ideas for Sculpture, 1940
Pencil, wax crayon, watercolor, crayon, pen and
ink, and gouache on paper, 17 × 10 in.
Fogg Art Museum, Harvard University Art
Museums, Gift of Lois Orswell
Dallas venue
(HMF 1489)

Cat. 153
September 3rd, 1939, 1939
Pencil, wax crayon, chalk, watercolor, and pen and
ink on heavyweight wove paper, 12⅛ × 15¾ in.
The Moore Danowski Trust
(HMF 1551)

Cat. 154
Eighteen Ideas for War Drawings, 1940
Pencil, wax crayon, pen and ink, chalk, watercolor,
and wash on cream medium-weight wove paper,
10⅞ × 14⅞ in.
The Henry Moore Foundation: gift of the artist
1977
(HMF 1553)

Cat. 155
*Standing, Seated, and Reclining Figures against
Background of Bombed Buildings,* 1940
Pen and ink, colored chalks, and watercolor on
paper, 11 × 15 in.
By kind permission of the Provost and Fellows of
King's College, Cambridge. King's College
(Keynes Collection), on loan to the Fitzwilliam
Museum, Cambridge
Dallas venue
(HMF 1556)

Cat. 156
Morning After the Blitz, 1940
Crayon, watercolor, and gouache on paper,
25 × 22 in.
Wadsworth Atheneum, Hartford, Connecticut.
The Ella Gallup Sumner and Mary Catlin Sumner
Collection Fund
Dallas and San Francisco venues
(HMF 1558)

Cat. 157
Grey Tube Shelter, 1940
Pen and ink, chalk, wash, and gouache on paper,
11 × 15 in.
Tate. Presented by the War Artists Advisory
Committee 1946
(HMF 1724)

Cat. 158
Row of Sleepers, 1941
Crayon, chalk, pen and ink, watercolor, and
wash on off-white medium-weight wove paper,
21½ × 12⅝ in.
The British Council
(HMF 1799)

Cat. 159
A Tilbury Shelter Scene, 1941
Pen, chalk, wash, and gouache on paper,
16½ × 15 in.
Tate. Presented by the War Artists Advisory
Committee 1946
(HMF 1800)

Cat. 160
Tube Shelter Perspective, 1941
Pen, chalk, watercolor, and gouache on paper,
19 × 17¼ in.
Tate. Presented by the War Artists Advisory
Committee 1946
(HMF 1801)

Cat. 161
Group of Draped Figures in a Shelter, 1941
Chalk, crayon, pen and ink, gouache, and water-
color on cream medium-weight wove paper,
12¾ × 22½ in.
The Henry Moore Foundation: acquired 1982
(HMF 1807)

Cat. 162
Group of Shelterers During an Air Raid, 1941
Graphite, pen and ink, brush and ink, wax
crayon, chalks, and scraping on wove paper,
15⅛ × 21⅞ in.
Collection, Art Gallery of Ontario, Toronto.
Gift of the Contemporary Art Society, 1951
Dallas venue
(HMF 1808)

Cat. 163
Shelter Drawing: Sleeping Figures, 1941
Pencil, wax crayon, pen and ink, and watercolor
wash on off-white medium-weight textured wove
paper, 12 × 12⅛ in.
The Henry Moore Foundation: acquired 1983
(HMF 1816)

Cat. 164
Woman Seated in the Underground, 1941
Pen, chalk, and gouache on paper, 19 × 15 in.
Tate. Presented by the War Artists Advisory
Committee 1946
Dallas and San Francisco venues
(HMF 1828)

Cat. 165
Pink and Green Sleepers, 1941
Pen, wash, and gouache on paper, 15 × 22 in.
Tate. Presented by the War Artists Advisory
Committee 1946
(HMF 1845)

Cat. 166
Miner at Work, 1942
Ink, chalk, and gouache on paper, 19½ × 19½ in.
Imperial War Museum, London
(HMF 1987)

Cat. 167
*Miners Resting During Stoppage of Conveyor
Belt,* 1942
Pen and ink, chalk, wax crayon, watercolor, and
pencil on paper, 13⅜ × 20 in.
Leeds Museums and Galleries (City Art Gallery)
Dallas venue
(HMF 1997)

Cat. 168
Miner at Work, 1942
Pencil, crayon, pen and ink, watercolor, and
wash on cream medium-weight wove paper,
12¼ × 10½ in.
The Henry Moore Foundation: gift of the artist
1977
Dallas venue
(HMF 1999)

Cat. 169
Four Studies of Miners at the Coalface, 1942
Pencil, wax crayon, pen and ink, watercolor, and
wash on off-white medium-weight wove paper,
14⅜ × 22⅛ in.
The Henry Moore Foundation: acquired 1984
(HMF 2000a)

Cat. 170
Miner Drilling in Drift, 1942
Crayon, pen and ink, and watercolor on paper,
20¼ × 15⅛ in.
Portland Art Museum. Gift of Francis J. Newton
in memory of his brother Joseph Newton
Dallas and San Francisco venues
(HMF 2007)

Cat. 171
Crowd Looking at a Tied-up Object, 1942
Pencil, wax crayon, watercolor wash, crayon,
and pen and ink on paper, 17 × 22 in.
The British Museum, London
(HMF 2064)

Cat. 172
Reclining Figure and Pink Rocks, 1942
Pen and ink, watercolor, and wax crayon on
paper, 22 × 16½ in.
Albright-Knox Art Gallery, Buffalo, New York.
Room of Contemporary Art Fund, 1943
(HMF 2065)

Cat. 173
Sculpture and Red Rocks, 1942
Crayon, wash, and pen and ink on paper,
19⅛ × 14¼ in.
The Museum of Modern Art, New York.
Gift of Philip L. Goodwin
Dallas venue
(HMF 2066)

Cat. 174
Reclining Figure and Red Rocks, 1942
Pencil, wax crayon, watercolor wash, crayon,
and pen and ink on paper, 11 × 15 in.
The British Museum, London
(HMF 2067)

Cat. 175
Figures in a Setting, 1942
Wax crayon, watercolor, pen and ink, white
gouache, and graphite pencil on wove paper,
14¼ × 20¼ in.
The Phillips Collection, Washington, D.C.
(HMF 2093)

Cat. 176
Figures in a Setting, No. 1, 1942
Ink, watercolor, crayon, and graphite on
wove paper, 14¾ × 21⅛ in.
Fine Arts Museums of San Francisco.
Bequest of Ruth Haas Lilienthal
(HMF 2095)

Cat. 177
Three Figures in a Setting, 1942
Ink and wax crayon on gray paper, 17¾ × 16¾ in.
Santa Barbara Museum of Art, Gift of Wright S.
Ludington
Dallas venue
(HMF 2099)

Cat. 178
Family Group, 1944
Watercolor, ink, crayon, and chalk on paper,
20 × 16⅝ in.
Scottish National Gallery of Modern Art, Edinburgh
Dallas venue
(HMF 2237a)

Cat. 179
Women Winding Wool, 1948
Watercolor, pencil, and chalk on paper,
21½ × 22 in.
Arts Council Collection, Hayward Gallery, London
(HMF 2497)

Cat. 180
Two Women Bathing a Child, 1948
Chalk, pen and ink, and watercolor on paper,
28 × 23 in.
Private collection, New York
(HMF 2501)

Cat. 181
Six Studies for Family Group, 1948
Pencil, wax crayon, pen and ink, gouache, and
watercolor wash on cream heavyweight wove
paper, 20¾ × 15⅛ in.
The Henry Moore Foundation: acquired 1984
(HMF 2501a)

Cat. 182
Women Winding Wool, 1949
Crayon and watercolor on paper, 13¾ × 25 in.
The Museum of Modern Art, New York. Gift of Mr.
and Mrs. John A. Pope in honor of Paul J. Sachs
(HMF 2530)

Cat. 183
*Studies for Sculpture: Ideas for Internal/External
Forms,* 1949
Pencil, wax crayon, chalk, pen and ink, gouache,
and watercolor on cream heavyweight wove paper,
23 × 15¾ in.
The Henry Moore Foundation: acquired 1990
(HMF 2540a)

Cat. 184
Sculpture Settings by the Sea, 1950
Ink, watercolor, gouache, colored crayons, and
white crayon on wove paper, 21¾ × 15½ in.
Collection, Art Gallery of Ontario, Toronto.
Gift of Mrs. Mary R. Jackman, 1988
(HMF 2621)

Cat. 185
Ideas for Sculpture in Landscape, 1951
Watercolor, chalk, and crayon on paper,
18½ × 13⅜ in.
Modern Art Museum of Fort Worth, gift of Mr. and
Mrs. Stanley Marcus, Dallas
Dallas venue
(HMF 2703)

Cat. 186
*Mother and Child and Reclining Figure in
Landscape,* 1951
Ink, watercolor, and chalk on paper,
14¼ × 11¾ in.
Dallas Museum of Art, Foundation for the Arts
Collection, gift of Mr. and Mrs. Stanley Marcus
Dallas venue
(HMF 2706)

Cat. 187
Two Women and a Child, 1951
Crayon, pastel, and wash on cream heavyweight
wove paper, 13¼ × 12⅜ in.
The Henry Moore Foundation: gift of the artist
1977
Dallas venue
(HMF 2727)

Cat. 188
Eight Reclining Figures for Metal Sculpture, 1956
Crayon, pencil, and watercolor on cream medium-
weight wove paper, 16¾ × 13½ in.
The Henry Moore Foundation: gift of the artist
1977
Dallas venue
(HMF 2911a)

Cat. 189
Head, 1958
Crayon, brush and ink, and watercolor wash
on off-white medium-weight wove paper,
11⅜ × 9⅞ in.
The Henry Moore Foundation: gift of the artist
1977
Dallas venue
(HMF 2979)

Cat. 190
Reclining Figure in Landscape with Rocks, 1960
Charcoal, crayon, pastel, and watercolor wash
on off-white medium- to heavyweight wove paper,
13⅜ × 17⅝ in.
The Henry Moore Foundation: gift of the artist
1977
(HMF 3023)

Cat. 191
Reclining Woman in a Setting, 1974
Conté crayon, charcoal, pastel, chinagraph, and
watercolor wash on FABRIANO 2 white medium-
weight wove paper, 13 × 19 in.
The Henry Moore Foundation: gift of the artist
1977
(HMF 73/4(17))

Cat. 192
Forest Elephants, 1977
Charcoal and chalk on white heavyweight wove
paper, 12⅛ × 15¼ in.
The Henry Moore Foundation: acquired 1987
(HMF 77(14))

Cat. 193
Reclining Figure: Sea Background, 1978
Watercolor, collaged photograph, gouache,
charcoal, and chalk on T. H. Saunders watercolor
paper, 9⅜ × 13⅞ in.
The Henry Moore Foundation: acquired 1987
Dallas venue
(HMF 78(13))

Cat. 194
Standing Figure: Knife Edge, 1978
Watercolor, charcoal (washed), chalk, collaged
photograph, and ballpoint pen on T. H. Saunders
watercolor paper, 12⅛ × 7¾ in.
The Henry Moore Foundation: acquired 1987
(HMF 78(14))

Cat. 195
Mother and Child: Idea for Sculpture, 1978
Charcoal, chalk, gouache, collaged photograph
and lithographic proof on off-white heavyweight
wove paper, 15⅜ × 11⅜ in.
The Henry Moore Foundation: acquired 1987
(HMF 78(30))

Cat. 196
The Artist's Feet: Two Studies, 1979
Charcoal, ballpoint pen, crayon, and watercolor
on white lightweight wove paper, 8⅛ × 12⅛ in.
The Henry Moore Foundation: acquired 1987
(HMF 79(59))

Cat. 197
Standing Figure: Architectural Background, 1979
Charcoal, watercolor, chalk, ink, gouache, and
collaged photograph on wove paper, 10⅛ × 6⅞ in.
Lent by Dr. M. Alali
Dallas venue
(HMF 79(69a))

Cat. 198
Study after Cézanne's 'Bathers,' from the Front,
1980
Carbon line, wax crayon, watercolor, chalk,
and chinagraph on heavyweight wove paper,
10 × 12½ in.
The Henry Moore Foundation: acquired 1987
(HMF 80(61))

Cat. 199
Opening Form I (Reclining Figure: Pea Pod),
1979
Lithograph, 12½ × 15½ in.
The Patsy R. and Raymond D. Nasher Collection,
Dallas, Texas
Dallas venue
(CGM 539)

Cat. 200
Rhinoceros VII, 1981
Chalk (rubbed) on T. H. Saunders watercolor
paper, 11¾ × 15⅛ in.
The Henry Moore Foundation: acquired 1987
(HMF 81(201))

Cat. 201
Imaginary Architecture, 1981
Charcoal, crayon, chinagraph, and watercolor
on Bockingford white wove paper, 10 × 14 in.
The Henry Moore Foundation: acquired 1987
(HMF 81(258))

Cat. 202
Rock Formation II, 1982
Carbon line, charcoal (part-rubbed), pastel,
ballpoint pen, and gouache on Bockingford white
wove paper, 10 × 12 in.
The Henry Moore Foundation: acquired 1987
(HMF 82(64))

Cat. 203
Idea for Sculpture: Reclining Figure, 1982
Charcoal, chinagraph, ballpoint pen, gouache,
and pastel on white medium-weight wove paper,
8¼ × 11⅜ in.
The Henry Moore Foundation: acquired 1987
Dallas venue
(HMF 82(182))

Cat. 204
Idea for Sculpture: Reclining Figure, 1982
Charcoal, pastel, wax crayon, ballpoint pen, and
chinagraph on lightweight wove paper, 7 × 9¾ in.
The Henry Moore Foundation: acquired 1987
Dallas venue
(HMF 82(208))

Cat. 205
Man Drawing Rock Formation, 1982
Charcoal, chinagraph, chalk, and pencil over litho-
graphic frottage on T. H. Saunders watercolor
paper, 12⅝ × 15⅞ in.
The Henry Moore Foundation: acquired 1987
(HMF 82(437))

Cat. 206
Crucifixion, 1982
Wax crayon, charcoal, pencil, watercolor wash,
and ink wash on Bockingford white wove paper,
14 × 10 in.
Richard C. Colton, Jr.
(HMF 82(442))

Index